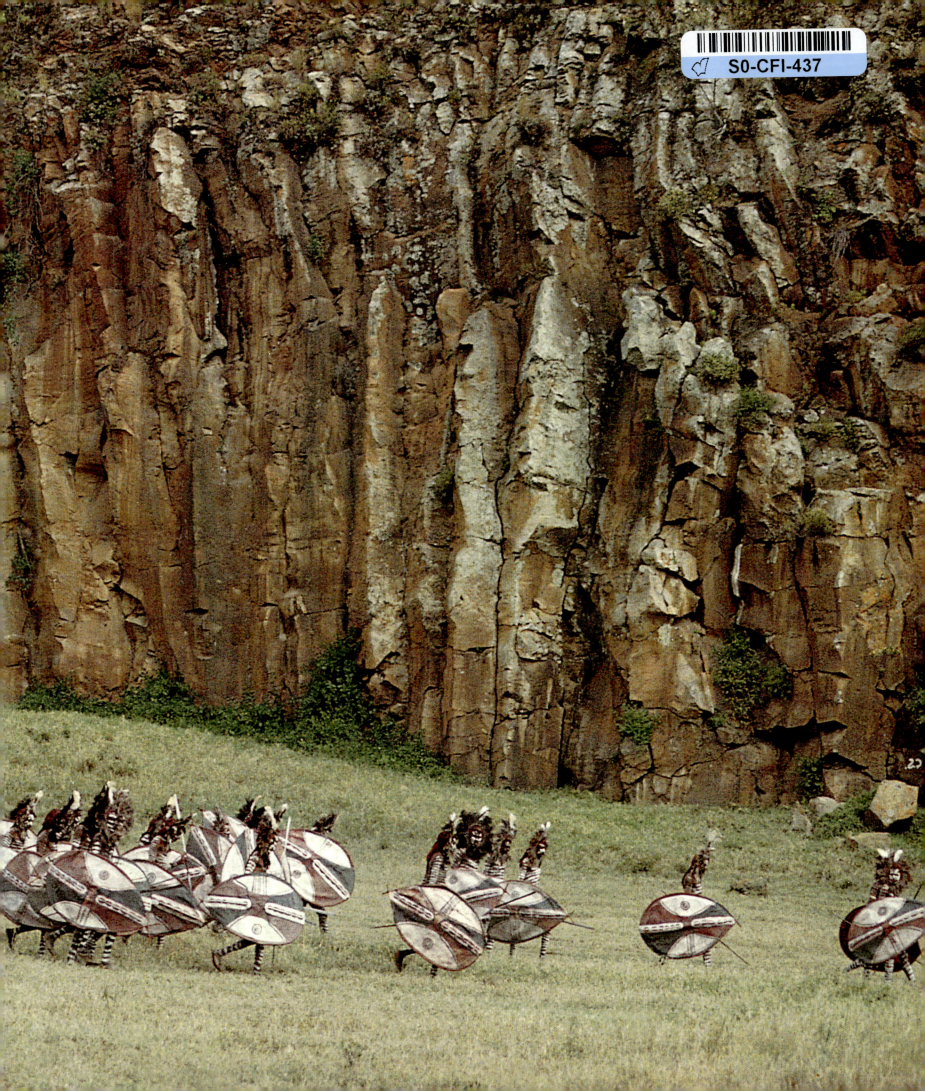

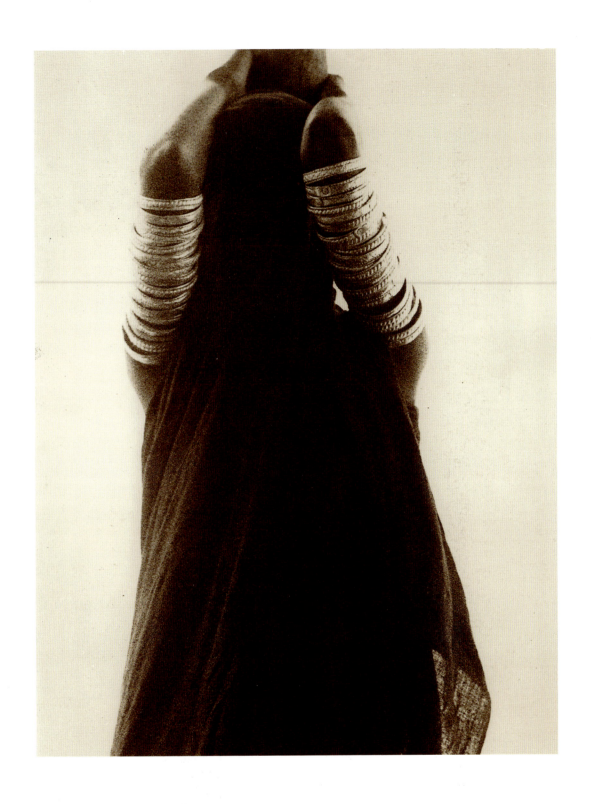

AFRICAN VISIONS

The Diary of an African Photographer

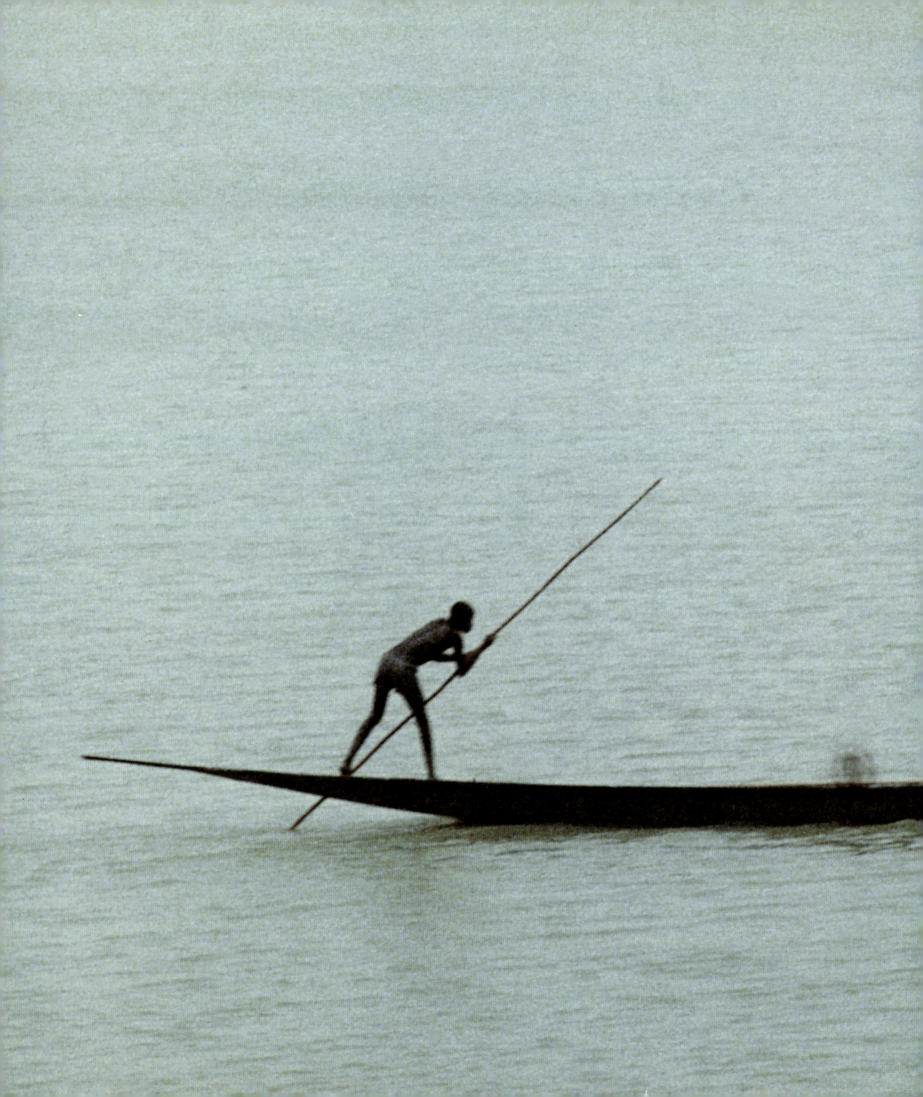

AFRICAN VISIONS

The Diary of an African Photographer

MIRELLA RICCIARDI

CASSELL&CO

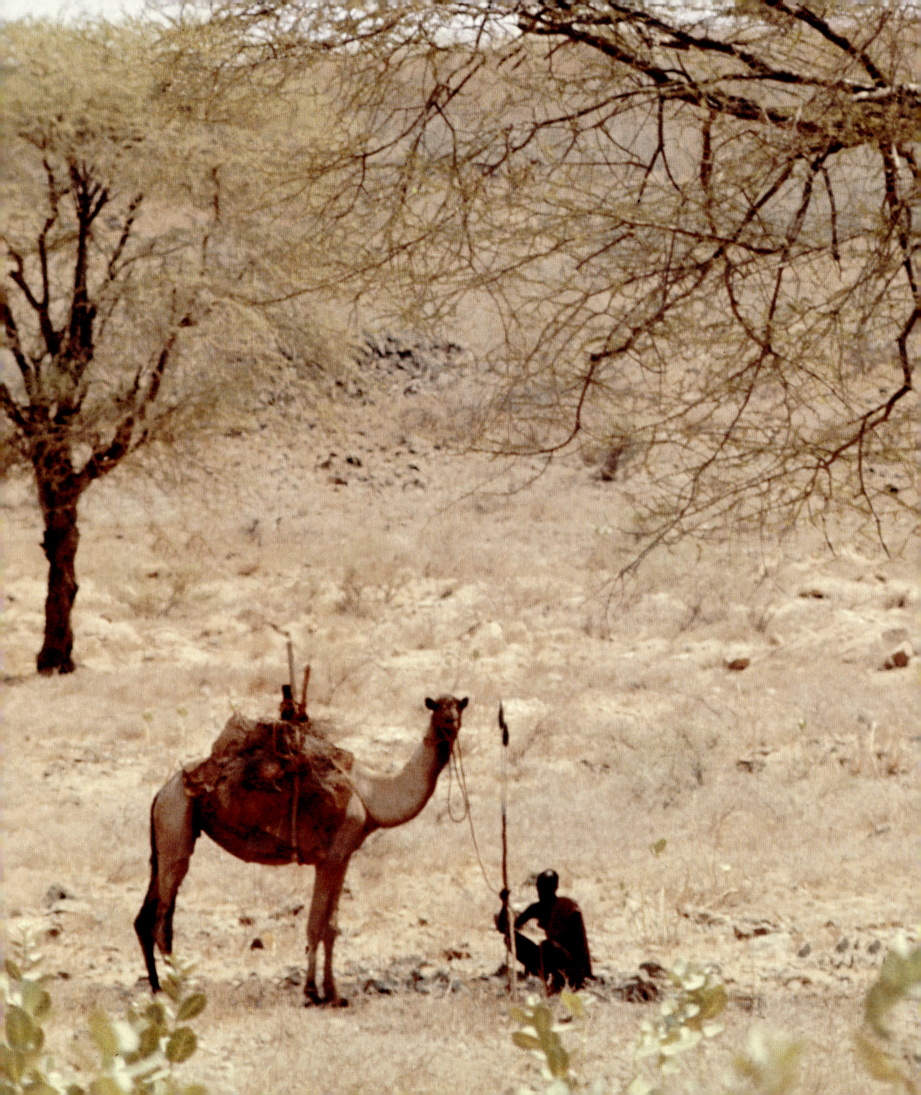

Contents

I was born in Africa on the 14th of July,
142 years after a Paris mob tore down the hated Bastille in Paris
and started the French Revolution.
For the first week of my life my name was 'Bastiglia'.

Foreword

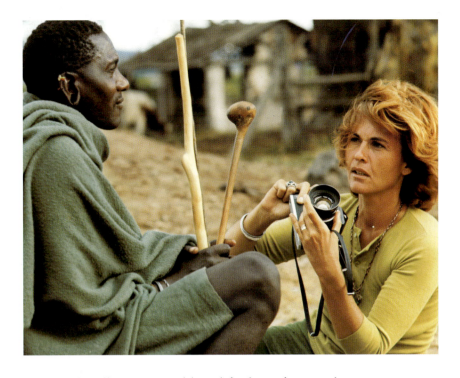

'Families, like trees, have roots.
Seeds blown by the wind create new trees.
Children, like branches, spread out and multiply.
Families and trees have similar destinies.'

THE ROOTS OF my family tree sank deep into the soil of Africa and for three generations, Africa was home to us. I grew up with my brother and sister on the shores of Lake Naivasha, a volcanic lake with deep subterranean derivations, on the floor of the great Rift Valley of East Africa. It was here that the seeds of my family tree fell, blown by the icy winds of European winters and the urge that drives people into the unknown in search of the light missing in their lives. Our lives were bathed in that light.

But this was not white man's country and as I became an adult the winds of change began to blow; the land from which our three generations drew life became threatened, dark clouds gathered on our horizons and gradually infiltrated the light, until the Africa we had been born to

became hardly recognisable. I lifted my face to the sun one day and knew that it was time to move on, to move away, but to where? When you have been born in Africa you are marked by Africa and wherever you go, you are a displaced person, for you have two identities; you are a white man with a black man's soul. When you meet a kindred spirit you recognise one another, for you have both drunk from the magic chalice whose mysterious alchemy creates a bond that sweeps aside unnecessary prelude.

Karen Blixen, one of the great writers on Africa, drank so deeply from this chalice, she never recovered. 'My own relationship to the world of ancient Africa,' she wrote in *Out of Africa* after she left, 'was indeed like a kind of love affair: love at first sight and everlasting...its landscape had not its like in all the world...Africa distilled through the ages, like the strong and refined essence of a continent... everything you saw made for greatness and freedom and unequalled nobility...you woke up in the morning and thought: here I am where I ought to be.' Her words, like Circe's song, awoke the sleeping adventurer and beckoned him into the unknown; fearless, confident and unaware, towards the Garden of Eden, towards the continent of wisdom, dignity and poetry, equally expressed in nature, beast and man.

My own love affair with Africa had far deeper roots, for it was not love at first sight and everlasting, but a gentle and

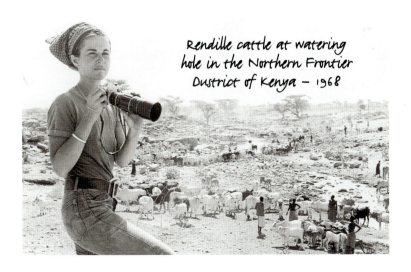

Rendille cattle at watering hole in the Northern Frontier District of Kenya – 1968

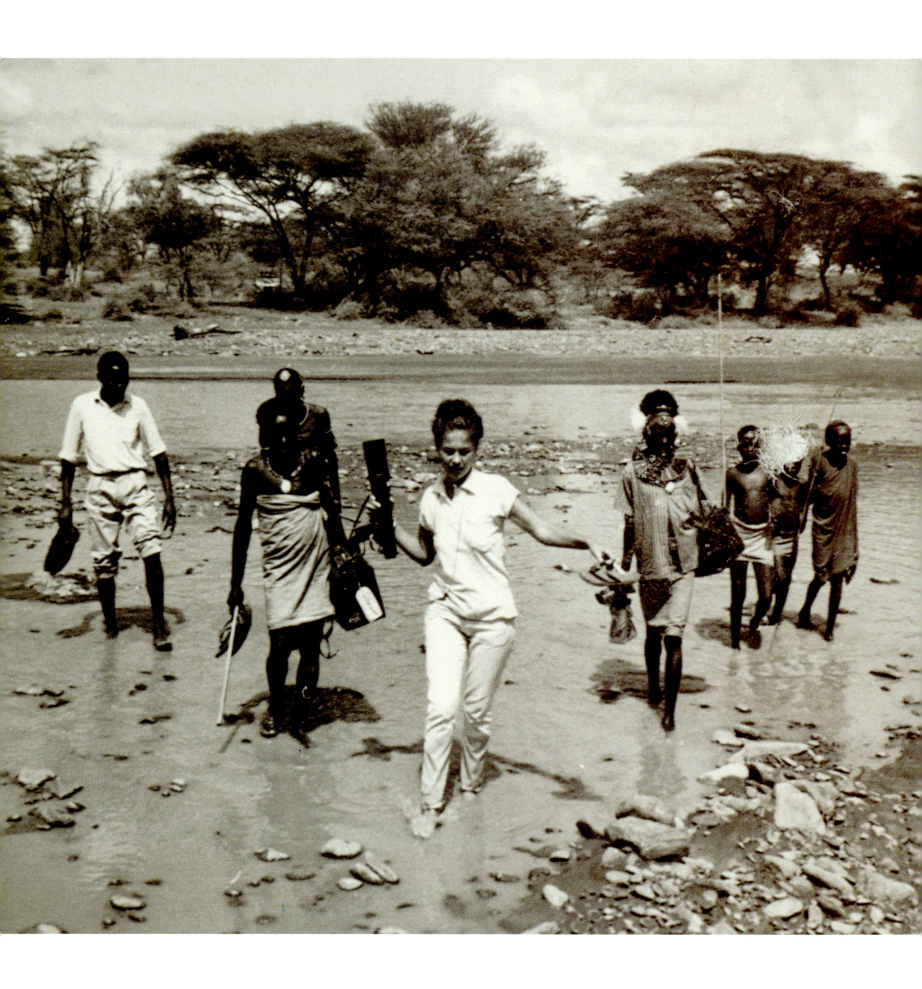

progressive ripening of many summer fruits which slowly soured and fermented into fetid waste; a symphony of sounds that rose to a crescendo and then degenerated into noise. It became one of unrequited love with all its ensuing torment that tore me apart and left me aching, but it also widened my horizons and made me a wiser being.

Long contact with Africa has put into perspective the human folly of its evolution, from the Arab occupation and subsequent slave trade in the sixteenth century to the Berlin Conference of 1884–5 that carved up Africa, apportioning it among the foreign invaders. It was this conference which created the colonial frontiers that disregarded existing tribal and racial boundaries and led to what Joseph Conrad aptly termed in *Heart of Darkness*, 'the vilest race to plunder ... in the history of European colonisation of Africa, neglecting the human element and environment of the people they colonised'. That was the worst of it – this suspicion of their not being human. Conrad wrote of the prehistoric men who appeared from the trees, hands clapping, feet stomping, bodies swaying, eyes rolling under the heavy droop of motionless foliage, as Conrad's alter ego, Marlow descended the Congo River in 1890 to rescue Kurtz, the ivory agent degraded from idealism to savagery, taken back to the earliest ages of man by wilderness, solitude and power, his house surrounded by impaled human heads, half crazed by fever and disease.

Seventy years later V. S. Naipaul wrote in *A Bend of the River*, 'Something like Conrad's fantasy came to pass. But the man with the inconceivable mystery of a soul, was black not white. He had been maddened, not by contact with wilderness and primitivism, but by the civilisation established by those white pioneers who now lie on Mount Ngaliema, above the Stanley Rapids in the Congo capital of Kinshasa.'

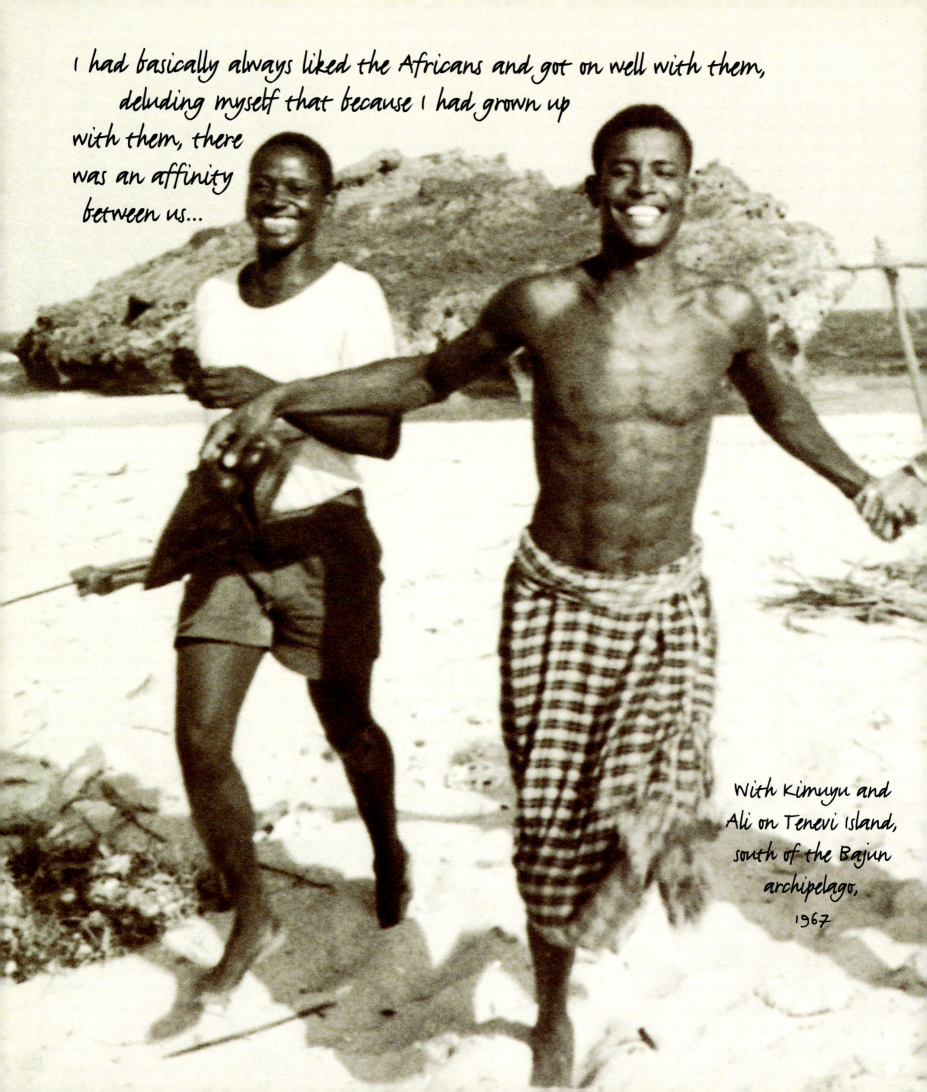

I had basically always liked the Africans and got on well with them, deluding myself that because I had grown up with them, there was an affinity between us...

With Kimuyu and Ali on Tenevi Island, south of the Bajun archipelago, 1967

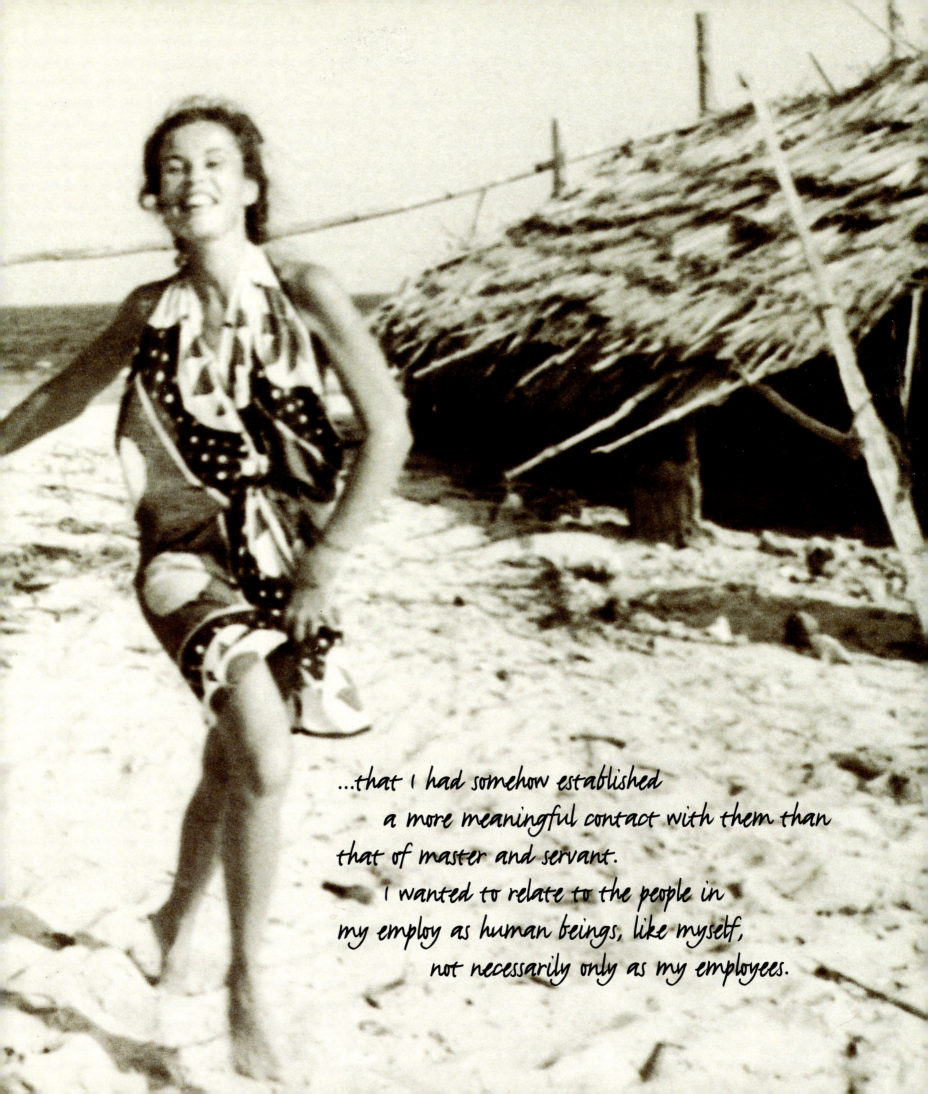

...that I had somehow established
 a more meaningful contact with them than
that of master and servant.
 I wanted to relate to the people in
my employ as human beings, like myself,
 not necessarily only as my employees.

In the beginning...

'I have met a woman who may change the direction of my life'

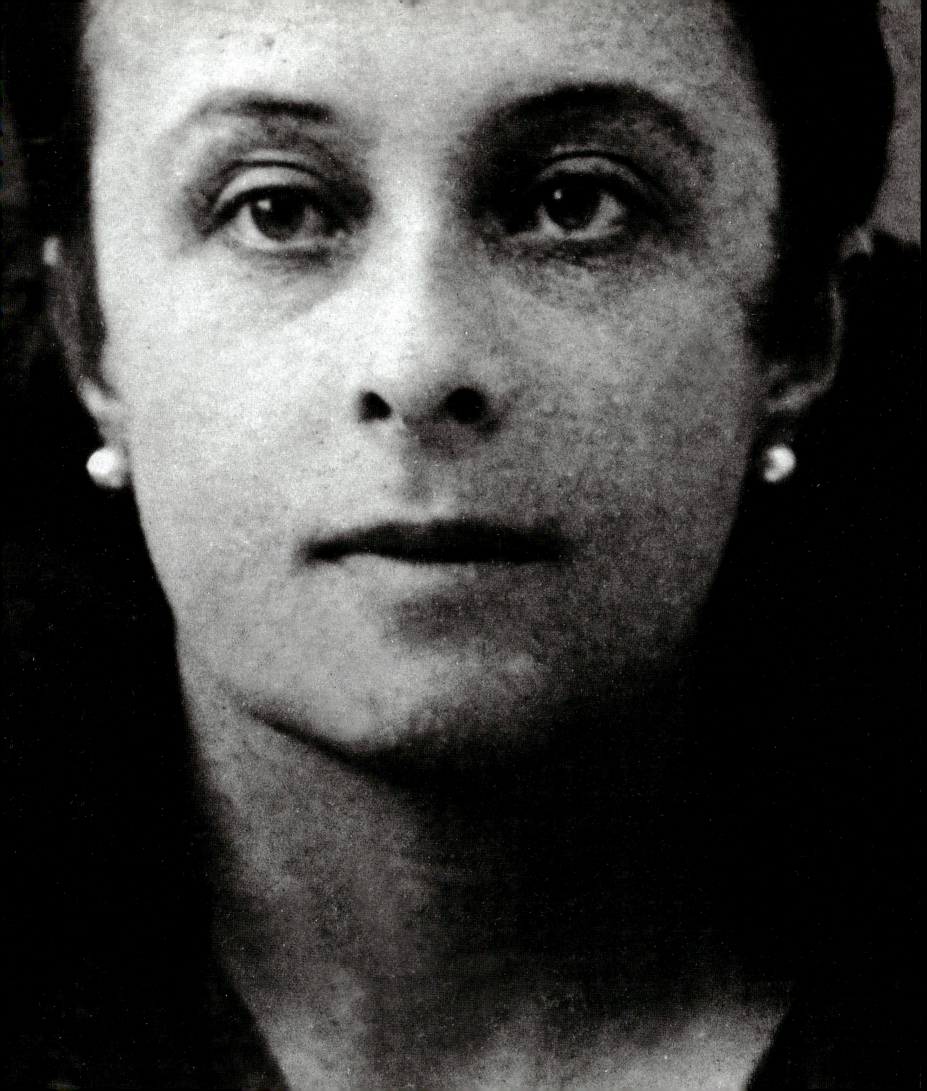

I AM A CHILD OF AFRICA. I grew up in a kind of sophisticated wilderness and took for granted all that Karen Blixen so eloquently described in her writing. The star-filled sky was my roof at night and the rising sun my early morning call. Nature was my teacher and from her I learned my greatest lesson; that in Africa, God and the Devil are one. She taught me at an early age how all things, good and bad, in light and in darkness, walk hand in hand in the simple rhythms of life and death; from flowering to decay, from childhood to old age, in sorrow and in joy. For most of my teenage years I led a quintessentially physical existence, with instinctive visceral responses that sharpened my senses and heightened my awareness of all things beautiful and ugly; attracted by the first, I shrank from the other.

Exposure to the extremes of Africa made me more of an observer than a participant. I can now understand how the lyrical writers of Africa, inspired and impassioned by such extremes of raw nature, fed the fantasies of their readers and drew so many to her siren song. From the great explorers who went in search of the source of the Nile, to the adventurers, empire-builders, writers and eccentrics, the story of Africa is riddled with names such as Livingstone and Stanley, Baker, Burton and Speke. The names of Conrad, Gide and de Brazza were later followed by colourful figures like Von Lettow-Vorbeck, the invisible enemy commander in the Kaiser's war who frustrated and ultimately captivated the British. There was Cape-to-Cairo Grogan, who undertook a two-year walk for the railway builders in 1898, from one end of Africa to the other, in order to claim the hand of his lady love. And Hugh Delamere, the English lord and founding father of Kenya, the British colony in East Africa, who arrived before the railway was built, became a blood brother to the Maasai, developed agriculture in a land riddled with disease, tsetse, flies and locusts and opened up the area to the ways and resources of the new world. There was John Boyes, the cabin boy from Hull who bought Mount Kenya from the Kikuyu for a dozen goats and cows, and was thereafter known as the king of the Wakikuyu and Denys Finch-Hatton, the upper-class Etonian big-game hunter immortalised by Karen Blixen in *Out of Africa*. Johann Ludwig Krapf, the German missionary became the first white man to behold the spectacle of the snow-capped peaks of Mounts Kenya and Kilimanjaro shimmering in the middle of the African jungle. He went on to inspire fellow-adventurers Burton, Speke and Grant to undertake a search for the sources of the Nile. Krapf was followed fifty years later by Halford McKinder, the first man to stand on the summit of the snow-clad Mount Kenya and look down at the equator. In his diary he wrote 'our thoughts and our words were divided between our conquest and the red cinders of the camp fire that spoke of home. As the fire dulled and our feet grew chilly the bark of a leopard ringing in the hillside opposite reminded us of the early rise on the morrow'.

These were the men of action, the explorers whose effect on the interior was to be almost biblical in its conclusiveness; for what other reason did it exist, they asked, than to be penetrated. It is their writing, like that of Hemingway and Blixen later on, that enveloped the savage continent in a dark cloak of daring and hardship, of emotional marvel and haunting memories, for they had all drunk from the same magic chalice. Some returned to their birthplace to write their memoirs, others remained in Africa where their remains mingled with the sands, swept by the wind, across the continent they had penetrated.

'We are now part of the Dark Continent where time and money, direction and communication, hold no more meaning' my own father wrote home to his mother in 1928. 'The giant trees of the forest, the mountains and the valleys and the great white plains have become our world, the distant horizons and misty mountain outlines our only focal point.'

From the glittering dinner party in her uncle's mansion on the Avenue du President Wilson in Paris where she was seated beside the man who first spoke to her of black Africa, to the steaming jungles of the Dark Continent, the step she took that night changed her life forever. She never looked back. He was le Baron Empain, principal shareholder of the Katanga Copper Mines in the Belgian Congo. She was my mother. His words, like those of his predecessors, cast their spell and when he invited her to visit him there, she convinced my father to join her adventure. A year later, together, they set their sights on the Dark Continent.

My mother belonged to a powerful and wealthy family in Paris. Her father, Philippe Bunau-Varilla had come to the notice of Ferdinand de Lesseps, who had built the Suez Canal and was now the man behind the French excavation of the Panama Canal. At the age of twenty-one Philippe applied for a post on de Lesseps' Panama adventure. At twenty-seven he headed the French canal excavation works and the de Lesseps' project. The Panama project became Philippe's obsession and when de Lesseps French enterprise collapsed, Philippe managed to convince the president of the United States, Theodore Roosevelt, to continue with the work in Panama started by the French, rather than pursuing the original North American plan to build the canal in Nicaragua. He was thus able to save the French honour and sell the remaining assets of de Lesseps' failed enterprise to the United States government in 1903 for the sum of $40 million. His

intervention led to the creation of the Republic of Panama and the political clout he earned eventually led to the signing of the Hay/Bunau Treaty that granted the Canal Zone to the US in perpetuity. From their suite in the Waldorf Astoria in New York, his wife Ida triumphantly stitched the first Panama flag.

His involvement in the Panama venture brought huge financial rewards to the family. With his brother Maurice, Philippe Bunau-Varilla bought *Le Matin*, then a small Parisian newspaper, and together they turned it into the leading daily paper in France. The rapid rise of *Le Matin* made Maurice, who, with his brother had been born into abject poverty, one of the stars of the Parisian political scene and the Bunau-Varilla name gained enormous status. The brothers' success in these two ventures laid the foundation of my mother's family fortune and was the base from which our own family tree was able, so far away, to grow as it did.

My mother Giselle was conditioned by the norms of her era and the stifling restrictions imposed on a *jeune fille* of her *milieu*, where so much was forbidden to the wives and daughters of the society she grew up in. Proud of the wealth and achievements of her family, she nevertheless grew contemptuous, as she matured, of a world in which a woman's mind was shaped to the acceptance of selfish masculine indulgence. So marked was she by it, that her attitude towards men thereafter remained one of open scorn, and she later made sure that her own daughters would never be thus conditioned. In so doing she also paved the way for me and gave me the perspective by which I later chose to lead my own life – never to depend on anyone for my deliverance, for dependency implied loss of freedom. It became my credo and in turn I passed it on to my own girls.

Subjugated she might have been, but my mother had also inherited her father's adventurous genes. After two failed marriages to fortune-hunters, as she referred to them, she took up the bohemian lifestyle of a single artist in Paris. She studied under Auguste Rodin, by then a very old man, and later prompted her uncle Maurice to launch the intensive campaign which was taken up by *Le Matin* that led to the creation of the Rodin Museum in Paris. She travelled to North Africa with her numerous cousins and friends and spent long periods in Morocco and Tunisia drawing and sculpting the people in the streets. She met the famous archaeologist Howard Carter in a cafe in Cairo, who invited her to visit Tutankhamun's tomb with him before it was officially opened. This visit awoke in her a deep passion for Egyptian art which greatly affected her later work and sharpened her curiosity for the African continent as a whole. She had tasted the nectar of freedom and moved into a studio at No. 9, rue Notre Dame des Champs, where she lived alone, free from family restraints, happy and fulfilled as an artist, if not yet entirely as a woman. It was to this studio that Mario Rocco, the man who would become my father, came to lunch with a gathering of artists, one of whom was Amedeo Modigliani. The next day Mario wrote to his mother in Naples 'I have met a beautiful and important woman who may change my life'. Little did he know at the time what he had let himself in for.

A rootless exile from Mussolini's fascist Italy, Mario had landed in Paris at the age of twenty-six, after *il Duce* had had him escorted to the French frontier for insubordination. The heady whirlwind romance with Giselle Bunau-Varilla waltzed him through dinner parties and luncheons in Paris, on offbeat holidays in her converted fort on the Mediterranean island of Port Cros and on her uncle Maurice's yacht, the *Orion*, where he frequented the artists' communities and met the salty fishermen she befriended around the island. With his dashing good looks and winning Neapolitan laughter, he soon became a favourite everywhere he went, but he quickly realised his reckless nature was leading him out of his depth. In a letter I found many decades later, he wrote to his mother: 'The lesson learned from this tumultuous existence is never to think of tomorrow and to forget yesterday...but the two Is within me – *das Ich* and *der Ich* – are constantly at war with each other; the one involuntarily succumbs to her influence and is happy to confide in her, the other instinctively tears itself away...she tells me she is in love with me, says she wants to marry me, but how can I marry a woman who is worth a million dollars, I am but a penniless exile...a piece of clay in her artist hands...the sweetness of this last thought, nevertheless, makes me drunk...'.

His instinct for preservation finally got the better of him and he abandoned her on her island. He boarded a ship in Marseilles and sailed for the United States. A year later she cabled him in New York where he was struggling to survive, and suggested he join her in accepting the invitation to Africa. After much deliberation and much insistence on her part, he succumbed and threw caution to the winds, giving in to his reckless nature and his fatalistic credo. At the end of 1927, he sailed back to Naples on the *SS Biancamano* from New York where awaiting him on the quay stood his adoring mother, his two sisters Lisa and Nina and his brother Renato. To one side, dressed in a fashionable long dark woollen skirt and a silver fox fur round her shoulders, Giselle Bunau-Varilla waited with a wistful triumphant gleam in her pale green eyes. She had arrived by train from Paris the day before. The memorable account of this moment recounted to me by both my parents more than fifty years later, remains as vivid

to me as it did to them.

Provisions, guns, ammunition, tents, sleeping gear and safari clothes had been bought in Brussels and on Empain's suggestion packed in tin cases weighing no more than twenty-five kilograms, the weight an African porter could carry on his head. On 20 January 1928, in heavy fog and freezing weather, they boarded a steamer of the Messageries Maritimes and sailed for Dar es Salaam in Tanganyika. Together they turned their backs on the northern hemisphere and a life to which neither had adjusted, and headed towards the Dark Continent.

With them the seeds of our family tree drifted south and fell two years later on the rich dark soil of Lake Naivasha at the bottom of the Rift Valley in Kenya, the British colony of East Africa. Random phrases from their letters and diaries, and old photographs carefully stuck in antique family albums, like pieces of a rich mosaic, tell a tale of daring and adventure, so similar in spirit to that of the illustrious men and women whose names and exploits colour the pages of the history of exploration. These images from their albums are a testament to our family saga and speak for themselves. They are the first growth on our tree.

When Mario and Giselle reached Nairobi, the capital of the Crown colony of Kenya in December of 1929 for the birth of their first child, my brother Dorian, it was the largest possesion in British East Africa, and still had the flavour of a frontier town, with a large community of 20,000 white inhabitants and several thousand Indians who had remained after the completion of the railway from Mombasa. It boasted three hotels, two hospitals and a stately Government House overlooking a beautifully mown English-style lawn and luscious tropical gardens. The European residential area of Muthaiga, with its English homes and gardens, was aloof and segregated. Its country club and golf course were strictly out of bounds to Africans and Jews. It was here that the white upper-class residents gathered at the end of the day to sip their sundowners and dine and dance into the night. Collar and tie were *de rigeur* in the dining room and a pious hush hung all about. Conversations were conducted in low voices, punctuated now and then by a loud guffaw from the bar. The silent bare-foot black servants were well trained by English staff and moved, mute and respectful, about their business.

In contrast, the town centre with its quaint wooden buildings and corrugated iron roofs was shabby and unkempt. The main street was tarmaced and named after Lord Delamere, the prominent pioneer who had established the white highland farming community. Mauve jacaranda trees hung with scarlet bouganvillea provided shade and colour to the dusty brown sunbaked surroundings. Africans in dishevelled European cast-off clothes and rickshaw boys jostled for space among the Model-T Fords and Chevrolets. Ochre-coloured Maasai warriors clad in scanty cotton cloth knotted on one shoulder strode like arrogant peacocks, fingers loosely intertwined, down the porticoed sidewalks, their well-endowed genitals uncovered, gaping wide-eyed and amused at the motley array of *mzungus* (white folk) and at the shop windows filled with white mens' trinkets, and departed before dusk to rejoin their *manyattas* (villages) and herds on the outskirts of the town. Nairobi then was a colourful frontier town, alive with prospects and expectations.

While my mother recuperated in the Maria Carberry Nursing Home after the birth of her son, my father, a fighter pilot in the First World War, decided he would use the time to look at the new country they had just entered. He hired a single-engine Tiger Moth from the Wilson Aero Club which belonged to an intrepid Englishwoman whose name the club carried, and set his sights on Lake Naivasha, the home of a couple they had travelled with on the train from Kisumu to Nairobi. Within a few moments of take-off, the arid brown and golden African landscape spread like a great Fauvist carpet beneath him, with the five Ngong hilltops on his left and the distant grey-blue Aberdares to his right. He floated over the steep edge of the escarpment and dropped to the bed of the Rift Valley. The Longonot volcano rose straight ahead of him and beyond it, Lake Naivasha shone like a piece of discarded glass. As he approached Longonot, the aircraft engine began to cough. He peered down into the tree-covered crater, its flanks scarred with ravines cut by the lava flow many centuries before and suddenly the lake was beneath him. Pale grey shadows from the clouds moved across it. The Eburru hills rose ahead, and on either side the misty Mau and Aberdare ranges formed a great semi-circle around its northern end.

A dense band of papyrus, like yellow and green stitches in a giant tapestry, floated along the lake edge, and as he descended the ribbon came alive with feathery papyrus heads waving in the breeze. On the other side of the lake, beneath the Eburru range, the land was flat and dotted with small huts and flocks of sheep and goats tended by chocolate-coloured children. Tall yellow fever trees stood in groups, casting their shade on the huts.

As he searched for the Carnelley's black and white Tudor-style house, the oil pressure suddenly dropped and the engine cut. He scanned the terrain beneath him in search of a suitable place, if necessary, to crash-land. He turned and glided downwind until he touched down to a bumpy landing. The flocks and their shepherds scattered, their scanty cloths, knotted on one shoulder, flapped like tiny wings behind their hard naked bodies. Then they returned, shy and hesitant, and swarmed around the plane;

moving timidly backwards as my father jumped out of the cockpit. He smiled and laughingly reassured them. '*Hakuna matata*,' he said in Swahili that he had learned in the Congo.

An old man with long pierced ear lobes and a toothless grin, wearing a brown and white cowhide around his shoulder, approached and pushed through the children towards the plane. He held out his hand in greeting and pointed with his lips to a bunch of fever trees when asked whose land this was. He offered to accompany my father to Bwana Harvey.

Harvey was standing waiting for him at the front door of his African abode; a semi-circle of thatched mud and wattle huts joined together by a portico erected on poles. 'It was not often that an aircraft dropped out of the sky on to his farm,' he said jovially as he invited my father in. Over a simple lunch and several ice cold beers he told him that he was selling his land and moving back to South Africa from where he had come. 'I'll buy it,' my father said impulsively. They discussed the price and when Harvey heard that my father's offer was to be in cash, he halved the price and they shook hands on the deal. Together they returned to the plane and quickly found the particles of dust that had clogged the fuel pump. My father took off back across the lake, leaving behind a map of upturned faces and waving arms.

He never found the Carnelley's house and flew straight to Nairobi and my mother's bedside. 'I've bought you a piece of Africa,' he announced triumphantly as he burst into her room. That day the first seeds of our family tree found their resting place. A piece of Africa filled with untamed people and wild game and African goats. They named the place *Dominio de Doriano* after their newborn son.

I appeared eighteen months later, on 14 July, 142 years after the fall of the Bastille and the onset of the French Revolution. For the first week my name was '*Bastiglia*', but it was soon changed to the less flamboyant Mirella. When I married, my husband told me that the only thing he did not like about me was my name. 'All the maids in Italy are called Mirella,' he explained grandly. Until then my name had never bothered me.

Naivasha became our family abode and for the first few years we lived in the mud and wattle huts built by Harvey. Then in 1933 the foundations of our home were laid, inspired by the design of the West African Pavilion at the 1932 Colonial Exhibition in Paris that my mother had visited. A vast Mediterranean pink Italian-style palazzo rose against the barren African hill behind it and my parents lived there for the rest of their lives. They are buried in the unruly garden they hacked out of the bushes, beneath the mighty trees they had grown from seeds, in front of the cypress tree avenue they planted leading to the lake. For three generations of our family this was our refuge.

Naivasha was full of wild creatures that roamed fearless across the land; herds of eland, buffalo, zebra and long-horned impala lived in the hills; tiny dikdik and clipspringers capered on the black rocks scattered among the candelabra euphorbia. At night they came down to the lake's edge to drink and joined the hippos grazing on the lush Kikuyu grass and young papyrus shoots. The trees were filled with chattering, chirping birds and monkeys of all sorts, and thousands of bats lived beneath the thatch of the roof. They swarmed out in great sheets at exactly 6.45 every evening and returned just before the break of dawn.

The lake was home to every sort of African water bird: spur-wing geese, yellow-bill and green-necked ducks, pelicans, flamingos, crested cranes, Goliath herons and cormorants, coots and lily trotters wove their lives among the fat mauve water lilies that opened and closed with the sun. These spread for miles across the shallow water, their fat green leaves forming platforms for the delicate long-legged aquatic birds who chased after dragonflies hovering over the blooms. Beneath them tilapia and black bass, introduced to Kenya by President Roosevelt on one of his safaris in the 1920s, thrived and multiplied on the mosquitos and little insects that hung everywhere. Lake Naivasha was a pulsating miracle of nature, renowned for the largest variety of birds on any lake in the world. The black and white fisheagle dominated it. They were the monarchs of the lake. Perched precariously on the tall fever trees, they gazed haughtily across the water, and with their heads thrown back, hurled their hunting cries into the sky. When the sun rose and set these great birds took to the sky. They rode the wind and circled like kites around their feeding grounds, swooping down on to the surface of the water with incredible speeds to pick out fish they had spied from high above, rising again on unbroken swoops with their prey wriggling in their powerful claws, then landed like ballet dancers on the tops of the acacia trees. The pelicans came and went, to and from their feeding and nesting grounds, gliding silently across the sky in perfect triangular formations, casting great moving shadows on the ground below. Sometimes they flew so low we could hear the air swooshing through their wings and when they flew away from the sun, their shadows preceded them, the only sign of their passage overhead.

We visited our friends around the lake in fast speed boats putting birds to flight, like winged runners ahead of us and wove among the sleeping hippos that sometimes plunged after us at great speeds. Tormenting the hippos to elicit a chase became one of our favourite water sports. It was fast and dangerous and scared us stiff. My mother set up her studio away from the house

where she drew and sculpted the beautiful Africans who wandered through our lives. For hours her models sat motionless as she carefully transposed their beauty on to her paper or moulded it from the soft brown clay collected from the nearby river. My father set up a horse-racing stable where he trained his English thoroughbreds for the tracks in Nairobi and one day he won five races at the same meeting. Racing days, I remember clearly, were heady days filled with excitement and anticipation.

I grew up with my brother Dorian and my sister Oria on Lake Naivasha. We were part of it, we shared it with the animals and the birds. It was our private playground. We knew nothing and cared little for the things that European children had. Our friends were black, our toys were made from bits of stick and string. We played with live animals instead of dolls and were cared for by a bevy of laughing black servants who were always there to amuse us, tell us stories, play with us and clean up after us. There was little discipline or restriction in our lives. We grew up naturally like the trees and the flowers that surrounded us. For the first few years we spoke only Swahili, and later, when an Austrian nanny called Adelina who spoke no English, joined us, we added German to our vocabularies before we spoke English.

Then in 1939 the war came and took my father away from us. I was eight years old. The magic bubble burst and the first dark clouds began to infiltrate the light that until then had enveloped us, although for us youngsters they were still unnoticeable. Our mother took the brunt of the blow, when overnight she found herself having to face life without her husband and with three young children to care for. All funds from Europe were instantly frozen and for the first time in her life, she found herself with no money. She had never yet had to confront such a situation and had no idea how to cope.

The memories of that singular night in 1940 are still locked somewhere deep in the recesses of my mind. A sense of nervous anticipation hung in the air, which we did not recognise, but intuitively detected. My parents were careful to keep the fearful details from us. The human folly which was unfolding in Europe was beyond our comprehension. We had never ever heard of war and hardly knew the meaning of the word. That night we were sent off to bed with an extra pat on the cheek and a promise that if the nine o'clock news on the radio was good we would be awoken to share the celebration champagne with our parents.

When we arose the next morning we were told by Adelina that our father had been taken away during the night and the horrible reality of the war was carefully explained to us at the breakfast table. Italy had allied herself to Germany and had thus made an enemy alien of our Italian father in the British colony in which we were living. So far away from the epicentre of world events, we too, were inadvertently being affected by them. 'An enemy alien, whatever was that?' we wondered. They were new words in our vocabulary. We had heard them the previous evening after we had crawled out of bed to listen on the stairs to Mussolini's clipped tones bellowing through the Art Deco radio in our African living room. '*Attenzione, attenzione, Italiani, militari, camicie nera della rivoluzione, la dichiarazione di guerra e gia partita*,' from the balcony of the Palazzo Venezia in Rome to the thousands of upturned faces waiting in anticipation below.

My mother and father sat in silence opposite each other in the large arm chairs on either side of the wooden radio set, their fists clenched in apprehensive anticipation. We had crawled out of bed in our pyjamas and sat on the stairs watching them, huddled together in the semi-darkness of the great room. 'I'm caught,' I heard my father mutter in a broken voice. I could see tears running down his face as he looked at my mother. I had never seen him cry before. Outside the nightjars called to each other from the candelabra trees in the garden, the hippos munched the lawn and punctuated the peaceful night with their raucous grunts. A crescent moon hung in the star filled sky.

A sharp knock on the front door wrenched them back from the broadcast's icy grip. A white man in a policeman's uniform, accompanied by two African *askaris* stood outside in the dark. 'Hello Mario,' we heard the man say apologetically. 'I'm really sorry, old boy, you've heard the news. We have come to get you.' Pat Davies was Inspector of Police for the Naivasha district and a friend. My father asked him in and poured him a drink before withdrawing to collect his belongings. We scuttled back to bed bewildered by the goings-on downstairs.

That night he was taken away from us and did not return for four years. Incarcerated first in the hastily erected barb wire concentration camp in Kabete near Nairobi, and then shipped to Koffifontein in the Transvaal to an abandoned diamond mine, he joined 10,000 men like himself who had lost their freedom because of a distant war that had made enemies of them. The following morning, my brother Dorian, just ten years old, was awoken before dawn by the headmaster of the Kenton College in Nairobi and informed that his country was at war with England and that he must leave school before the other boys awoke. His belongings were hastily gathered into a bundle and tied up in his bed sheet. He was set outside the school gates as if he had the plague. When Mr Crank, the headmaster, asked him who would collect him, Dorian remembered Mabs Talbot-Smith, the wife of the American consul, as the only family friend living in Nairobi who could be disturbed at that early hour. She found him looking

dazed and confused perched on top of his bundle, dressed in his school blazer and grey denim shorts, his navy school cap with its imposing insignia pulled down over his sleepy eyes. My parents never forgave the Brits for this outrageous behaviour and in some way I think this incident was the beginning of our alienation from them. We were set apart from the others. We were the enemy. As children, we were indelibly marked by this label.

We visited our father a few times in the camp at Kabete. Behind the hastily erected barb wire enclosure with sentry boxes at each corner and long lines of corrugated tin-roofed barracks. Men known and unknown to us wandered about the compound and told their silent tales of souls deprived of freedom. My father's room was bare except for a wooden chair, a camp bed and his still unopened suitcase. Bent forward his head cupped in his hands, in his familiar stress position, he sat like a broken tree. Our Garden of Eden had begun to crumble.

For the first time in her life, my mother had now to think of earning a living to keep her family alive. She exchanged her artist's smock for the khaki pants and shirt of the Kenyan farmer and turned herself into the family provider. Advised by Jack Hopcraft, her dear friend and neighbour who lived on a nearby farm, she went into pig breeding and slowly turned our African playground into a productive farm. Because of our new enemy alien status, no English schools would accept us, so we stayed on the farm in Naivasha and were taught our lessons by a Swiss governess called Miss Erica who replaced Adelina. Then in the summer of 1944 my mother heard of an American mission school about 45 miles away, set high on the eastern rim of the Rift Valley escarpment, appropriately called the Rift Valley Academy. It catered for the American missionary children in Kenya and kindly agreed to take us in. So in 1944 I went to school for the first time. I was thirteen years old and had almost never worn shoes. But I could read and write and recite poetry, and my knowledge was far ahead of the other children at school. I knew about the great Renaissance painters, and Michaelangelo and Dante and Goethe and the Panama Canal, of course. Between them, my mother and Miss Erica gave us a multifaceted unorthodox education that served us well in later life. But we hated the discipline that regular lessons imposed on our wilderness freedom. We longed for the outdoors where we learned a lot about life, about animals and human beings.

I was fourteen years old when the war ended and my father returned after four gruelling years in the Koffifontein internment camp. He was a broken man and never really got over the experience. He had lost all of his teeth and his raven-black hair had turned to snowy white. I was a tough, intensely physical

adolescent, a bit like a young wild horse snorting and kicking at the bridle. Something had to be done to rein me in, so at nineteen I was sent to be 'finished' at a smart school which catered for young ladies *de bonne famille* in Hertfordshire, called the House of Citizenship. I spent eighteen painful months there; I grew fat and ugly, and suffered from unbearable homesickness. I finally ran away to Paris in a car my father had left with me on one of his visits. This was the smartest move I ever made.

My life turned around, for it was in Paris, at my mother's suggestion, that I discovered photography. I was introduced to the great Franco-Russian fashion photographer Harry Meerson by some of my mother's cousins. I worked for him as an unpaid impassioned apprentice for two years. He taught me the rudiments of photography and lighting, but above all he taught me to see. He awoke in me an aptitude to recognise an image, a fleeting expression, a graphic shape that my mother, no doubt, had endowed me with. I never looked back. I emerged from my African chrysalis and became a butterfly. Slowly over the next five years, through trial and error, I learned the art of photography, the art of writing with light. I spent two miserable years in New York trying to be a photographer and there I met one of the Big Five in the rarified world of I was about to enter. He was a small German-Jew called Irwin Blumenfeld. He was a wonderful artist and a great human being. He said to me, 'Photographers are born, only assistants go to school. You must find out to which category you belong.'

I found out when I was thirty-six years old. After nine years of marriage and two children, I left my husband for the first time and returned to Africa. I was to photograph the tribes of Africa before they disappeared forever. The year was 1967. I realised then that I had inherited my mother's eye and that I did not belong to the assistant category. The creation of my book *Vanishing Africa*, put my name on the international publishing map. It stayed in print for over twenty years. Totally unaware of what I was doing, I had quite instinctively produced work that made its mark in the annals of photographic history, even if it did not make me rich. My life divided in two from then on – before and after *Vanishing Africa*. How many times after that have I blessed my mother for suggesting this profession. How many times it served me in moments of crisis. It allowed me to become an independent woman. I was now free to do with my life as I wished. It was a hell of a struggle, especially emotionally, but somehow I managed to keep focused, but my two little girls paid the price. For the first sixteen years of their lives, I was a single mum trying to juggle my professional and my family life.

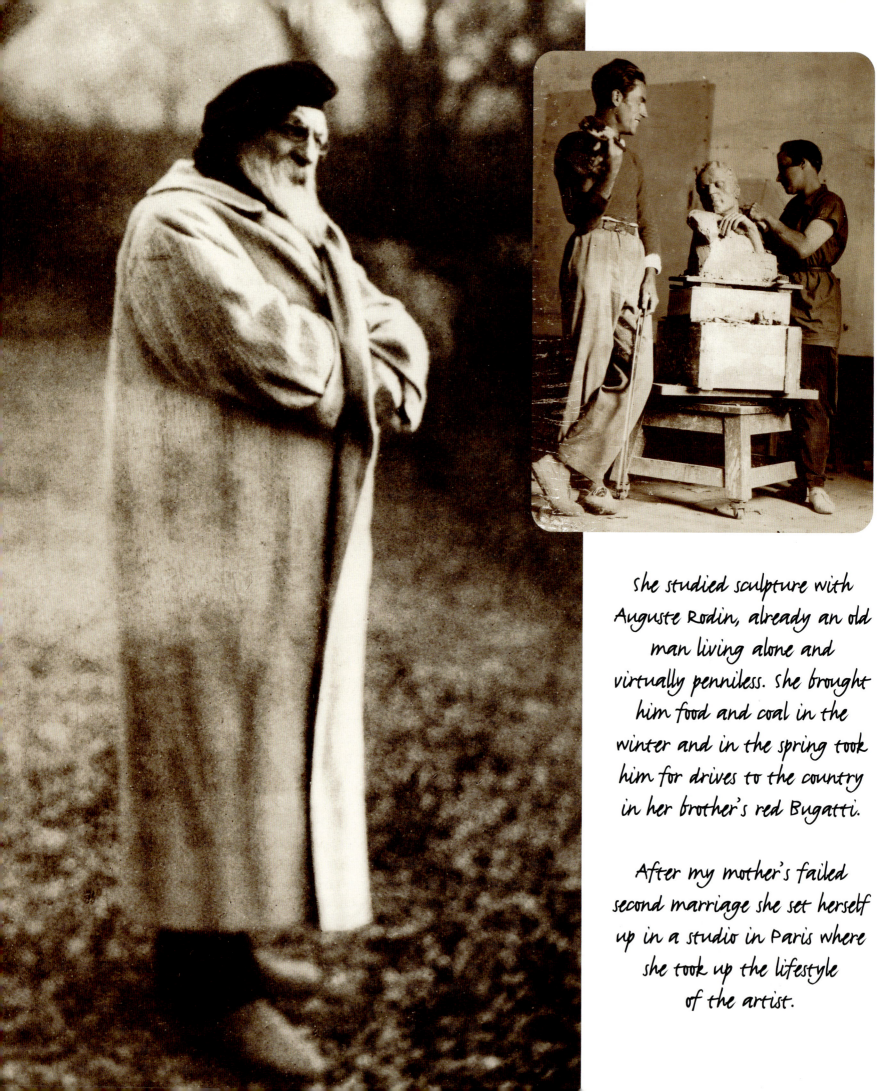

She studied sculpture with Auguste Rodin, already an old man living alone and virtually penniless. She brought him food and coal in the winter and in the spring took him for drives to the country in her brother's red Bugatti.

After my mother's failed second marriage she set herself up in a studio in Paris where she took up the lifestyle of the artist.

It was to this studio that my father, an exile from Mussolini's Italy, came for lunch. She fell irretrievably in love with him and never looked at another man for the rest of her days.

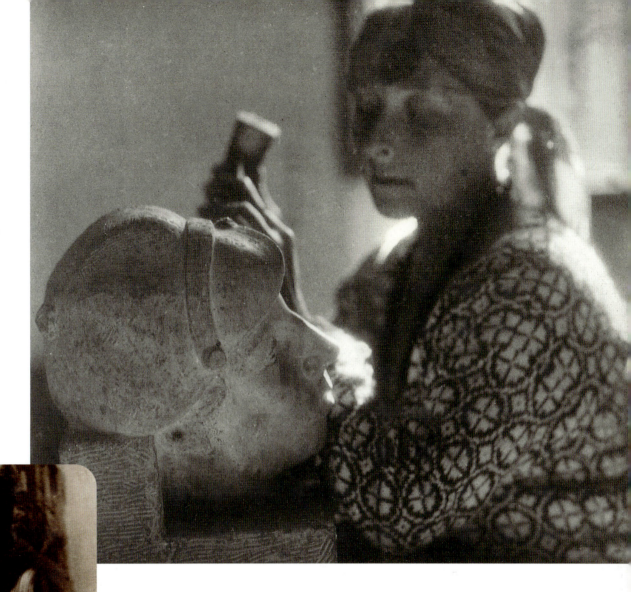

She came from a powerful and wealthy family in Paris...When she was sixteen she was permitted to attend some lectures on art at the Ecole des Beaux Arts, 'that den of iniquity where men and women posed in the nude'.

In the corner of the studio, sad and bent, sat her ever-vigilant governess.
My mother was mortified that she was the only pupil subject to this humiliating supervision.

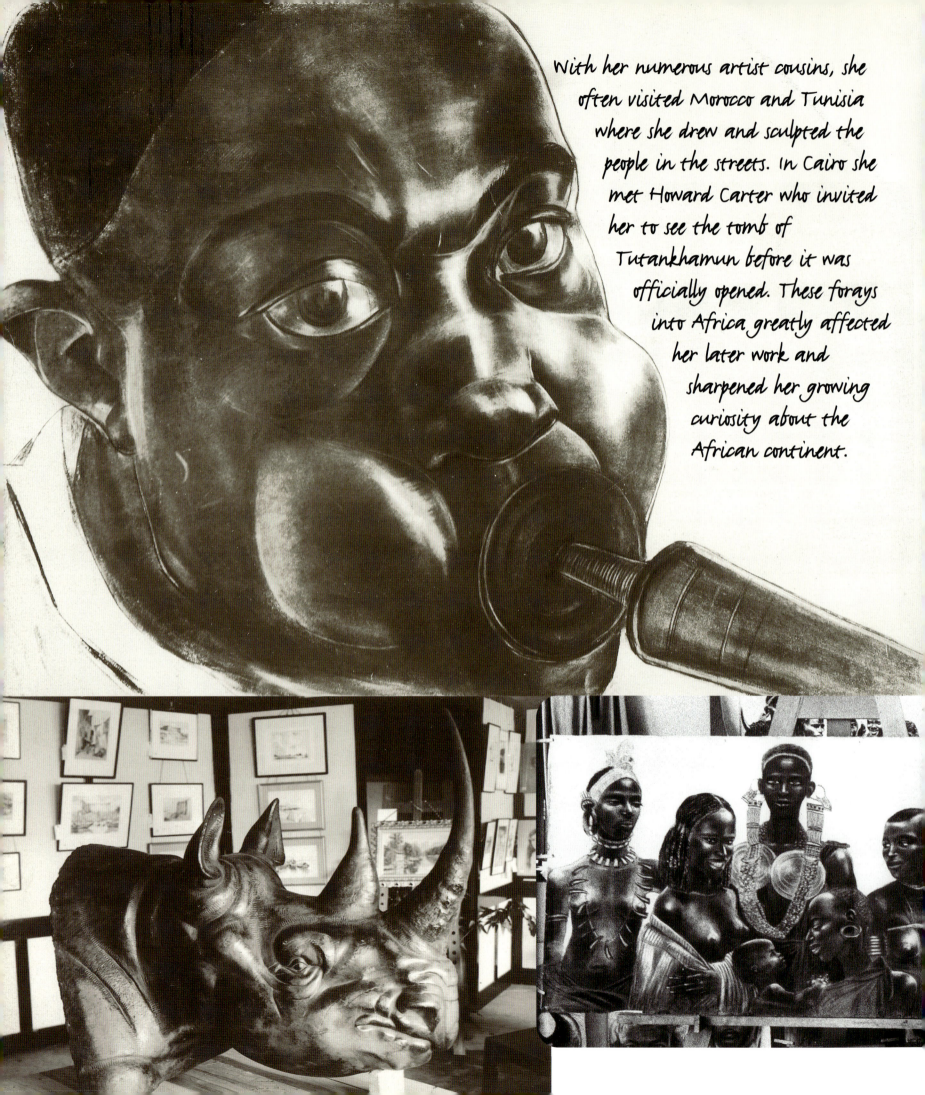

With her numerous artist cousins, she often visited Morocco and Tunisia where she drew and sculpted the people in the streets. In Cairo she met Howard Carter who invited her to see the tomb of Tutankhamun before it was officially opened. These forays into Africa greatly affected her later work and sharpened her growing curiosity about the African continent.

My mother was an independent lady with a strong mind of her own...she quickly realised that she could never conform to the norms of her society... marriage was her escape out of her asphyxiating family environment, but when that failed, she took off on a solo flight of self-discovery that unleashed her rising artistic tendencies.

In North Africa she discovered the enormous potential the continent could offer her work, but when she brought her work home to Paris she met with total incomprehension.

In her absence, her mother had thrown a lot of her work out, exclaiming that she could not understand what she saw in these 'ugly people'.

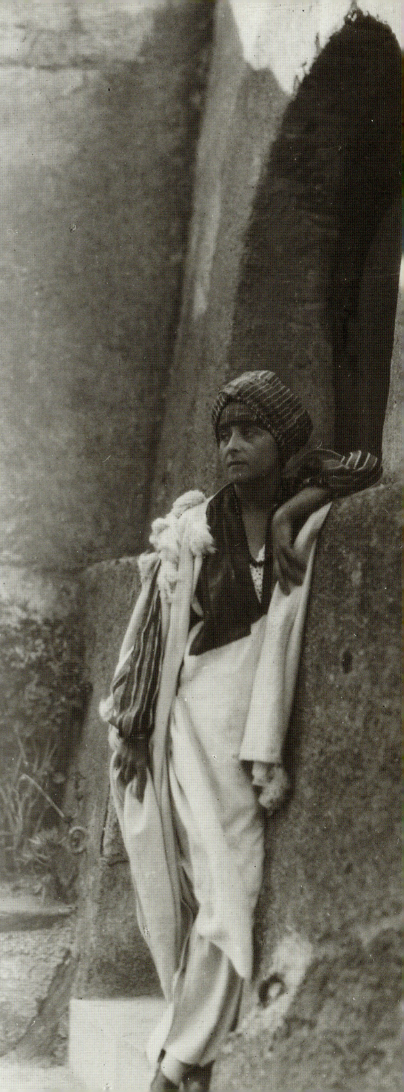

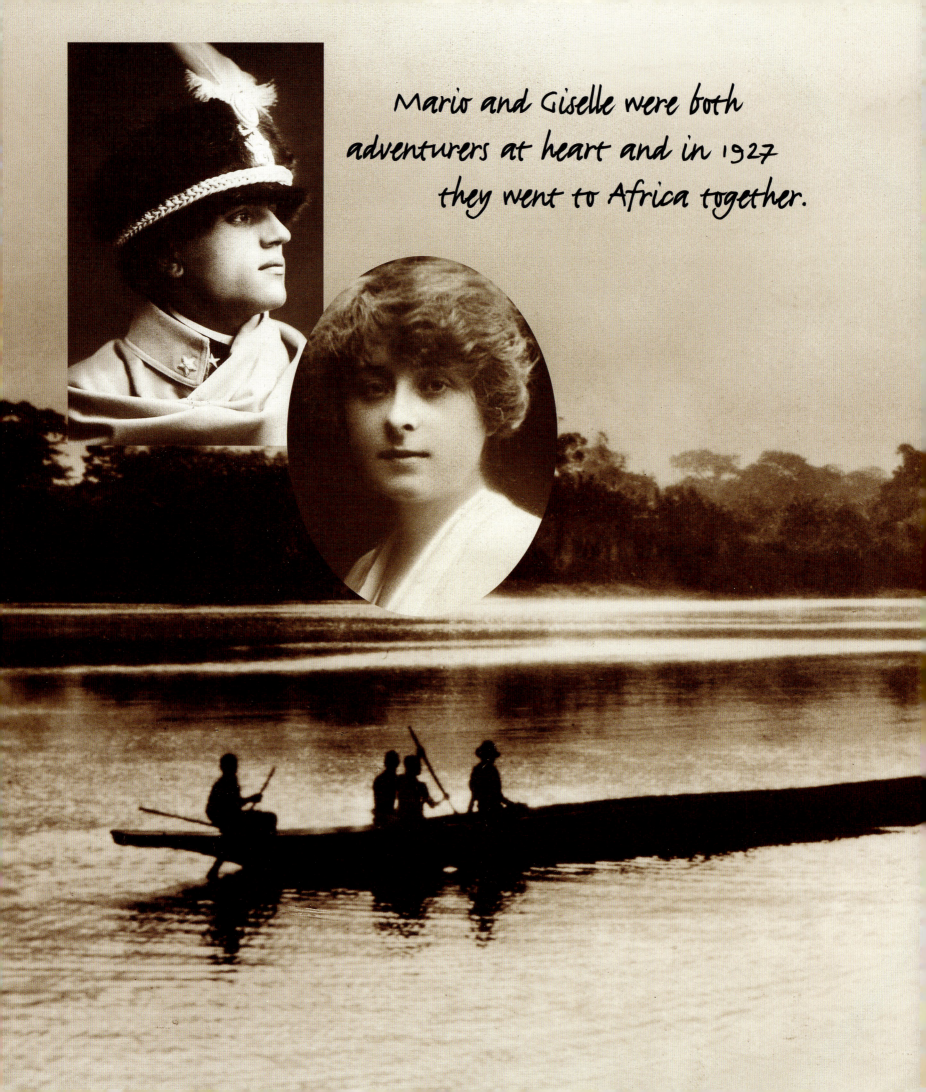

Mario and Giselle were both
adventurers at heart and in 1927
they went to Africa together.

'The crossing of Lake Tanganyika was picturesque...our black travelling companions were very curious and stood around staring at us and touching everything, with a mystified and amused running commentary...there was no landing stage at the diminutive village of Uvira and the passengers from the steamer are carried to shore on the backs of sturdy African porters.'

It was Giselle's first physical contact with black-skinned men... she did not much relish those strong black hands clasping her tender white thighs...the acrid smell of their sweating bodies brought home to her the stark reality of their adventure.

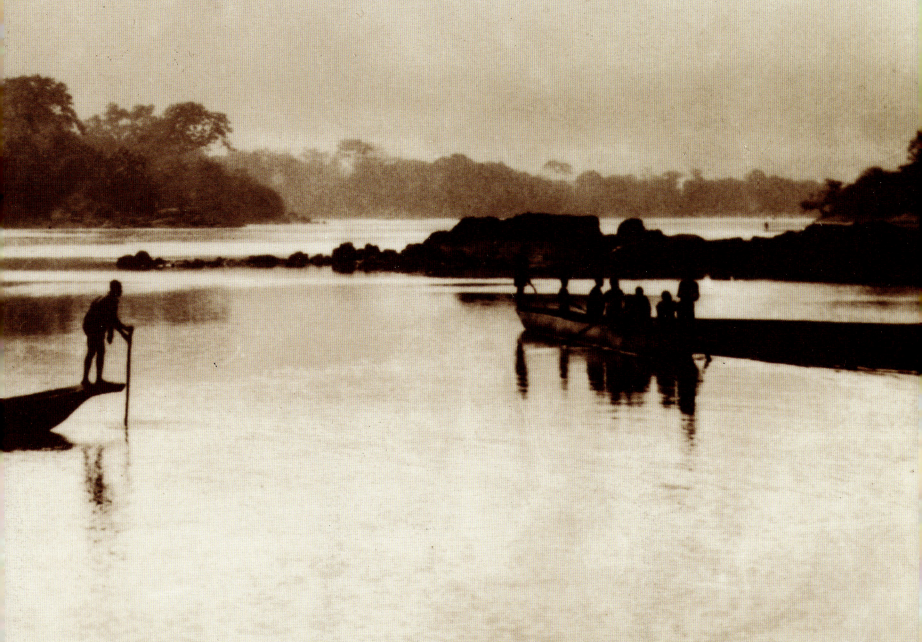

In 1927 Mario and Giselle went on a year-long foot safari through the Belgian Congo followed by sixty black porters carrying their equipment on their heads.

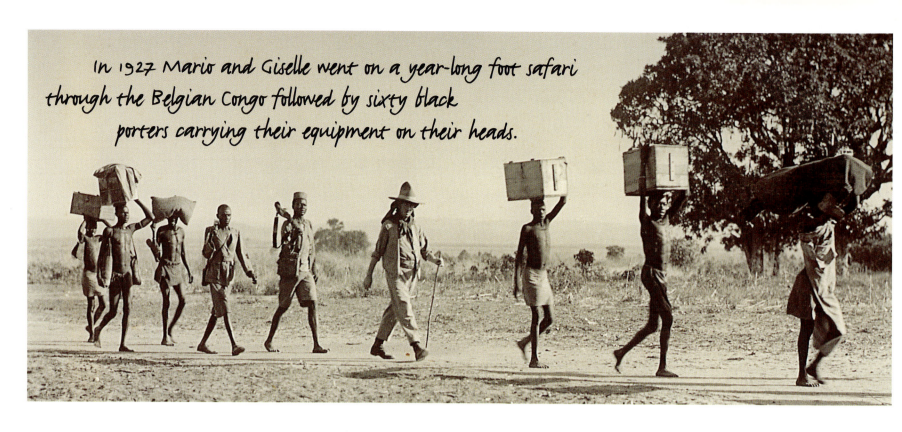

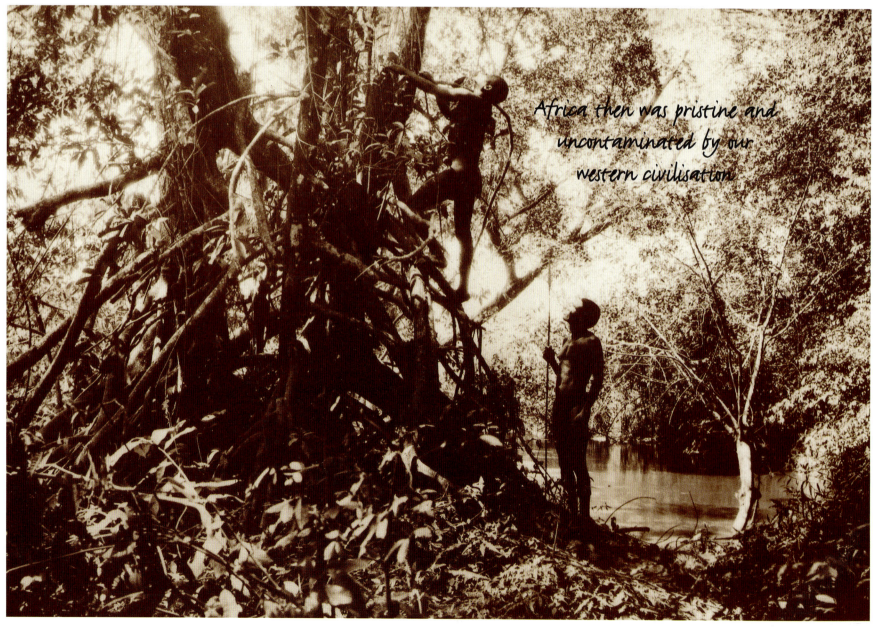

Africa then was pristine and uncontaminated by our western civilisation

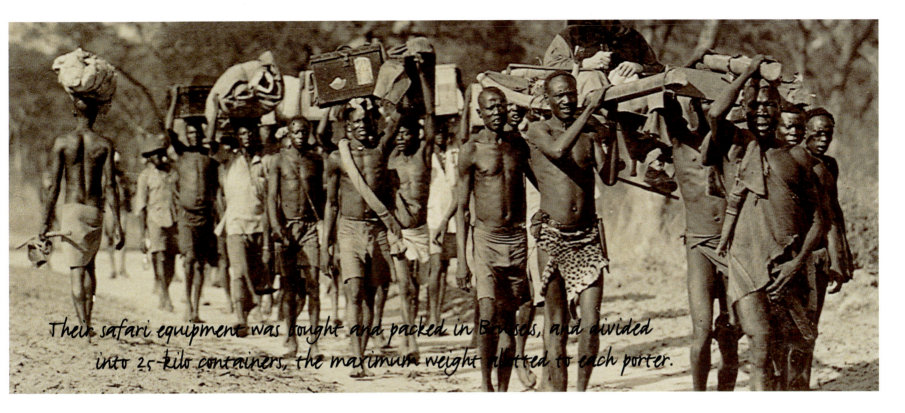

Their safari equipment was bought and packed in Brussels, and divided into 25-kilo containers, the maximum weight allotted to each porter.

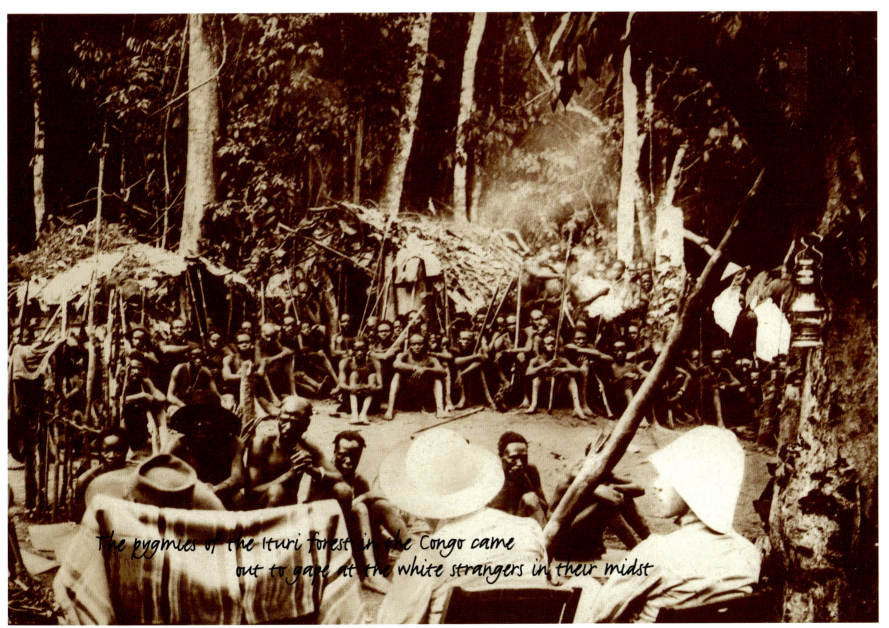

The pygmies of the Ituri forest in the Congo came out to gape at the white strangers in their midst

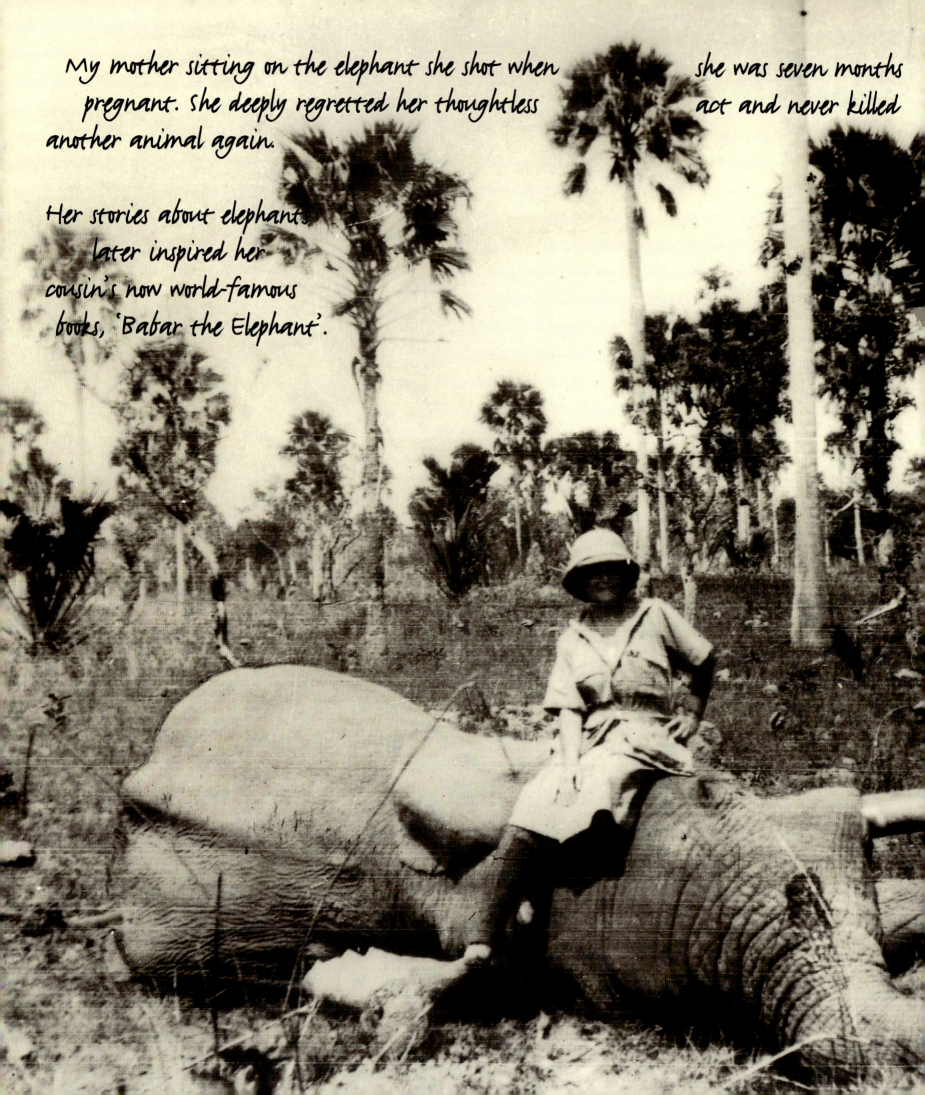

My mother sitting on the elephant she shot when she was seven months pregnant. She deeply regretted her thoughtless act and never killed another animal again.

Her stories about elephants later inspired her cousin's now world-famous books, 'Babar the Elephant'.

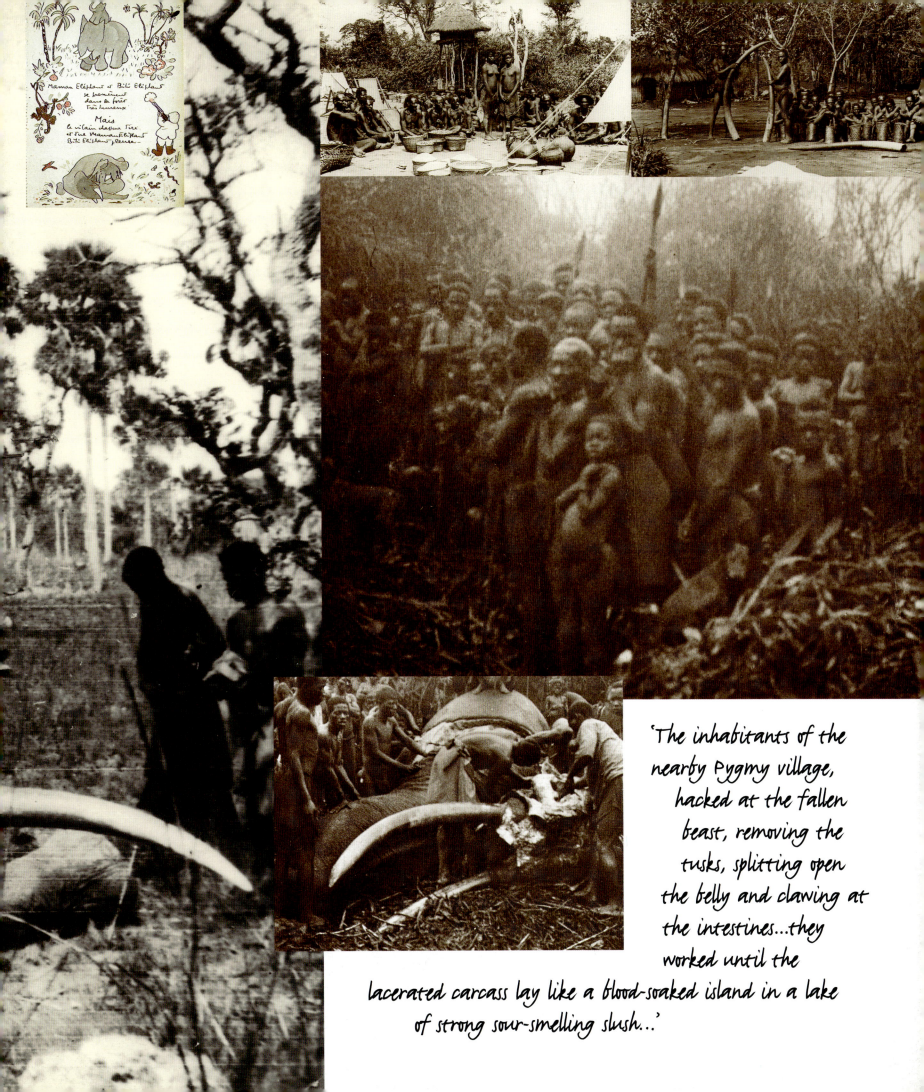

'The inhabitants of the nearby Pygmy village, hacked at the fallen beast, removing the tusks, splitting open the belly and clawing at the intestines...they worked until the lacerated carcass lay like a blood-soaked island in a lake of strong sour-smelling slush...'

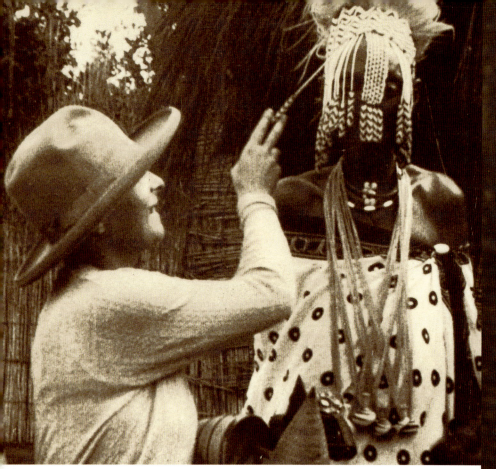

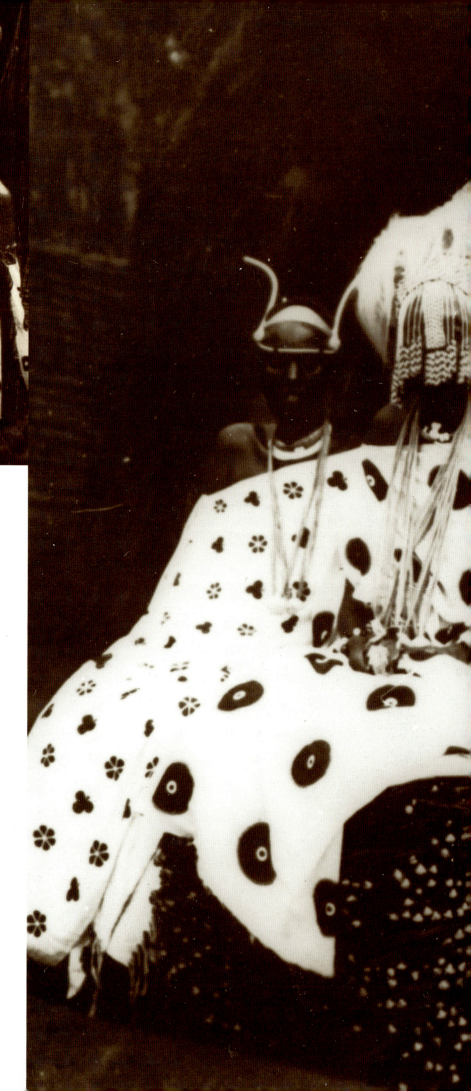

On their journey they met the
Mtusi King Musinga of Rwanda who invited
them to stay in the royal compound where he
introduced them to his family...
my mother was fascinated by their decorative
clothing and sense of style...
the picture above is a frame from the 16mm
cine film they shot in 1928...

Previous page:
The people of the forest brought manioc
and ground millet to my parents'
campsite and some of their men were
hired to carry the elephant tusks...

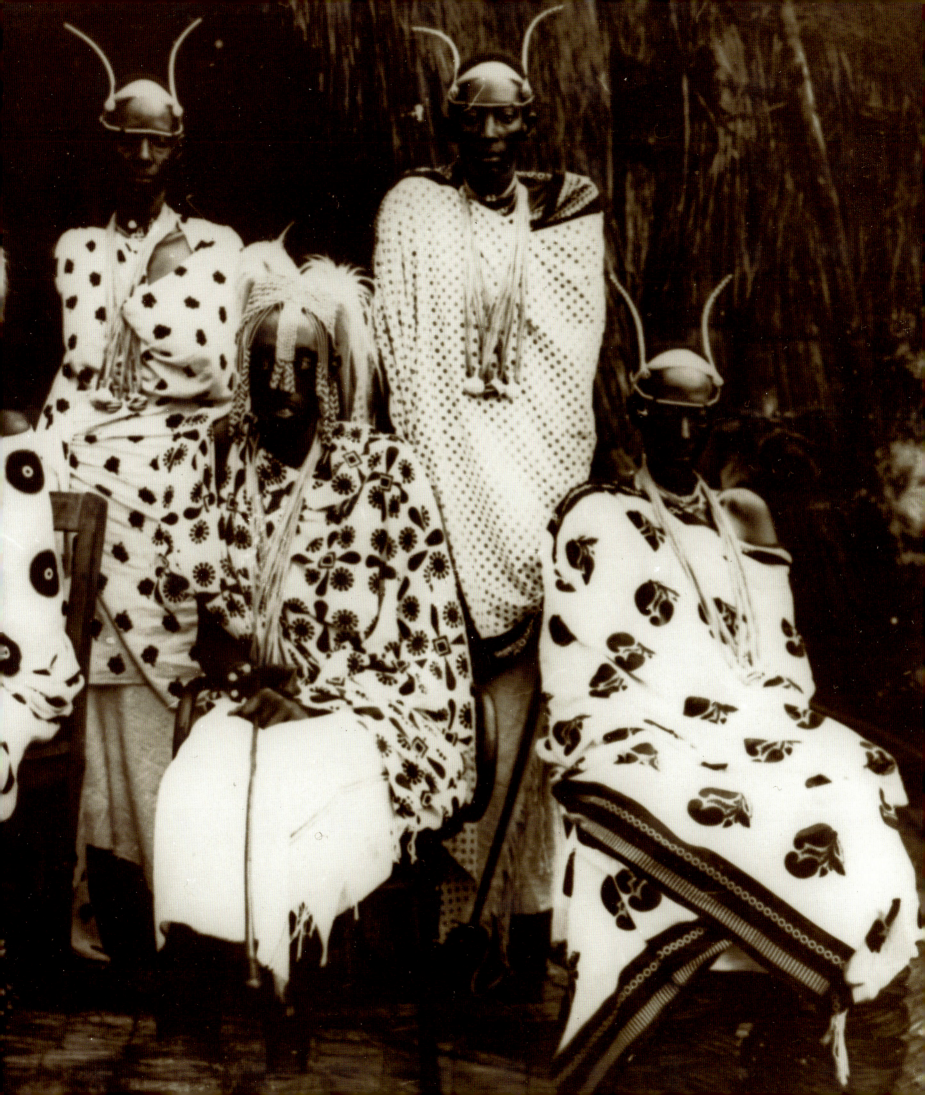

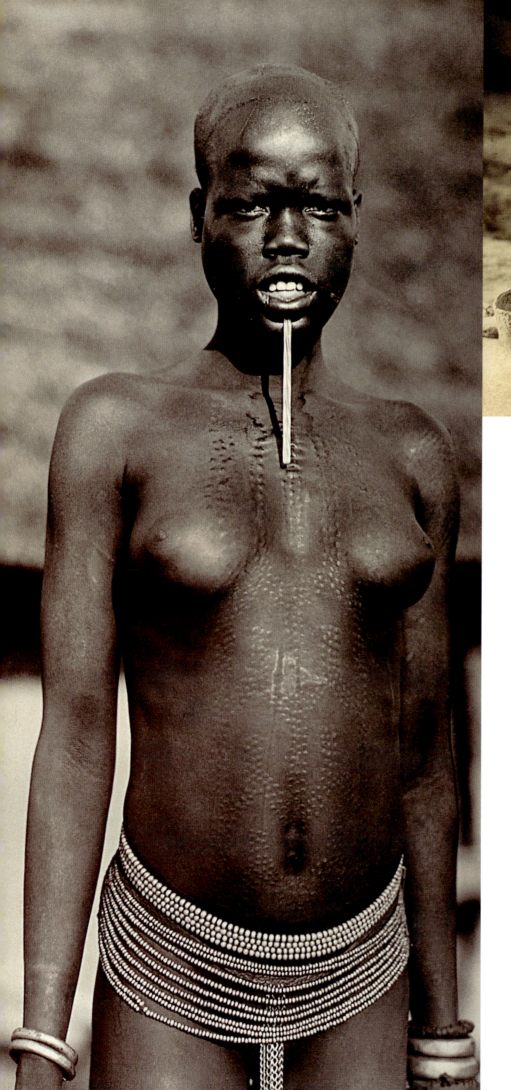

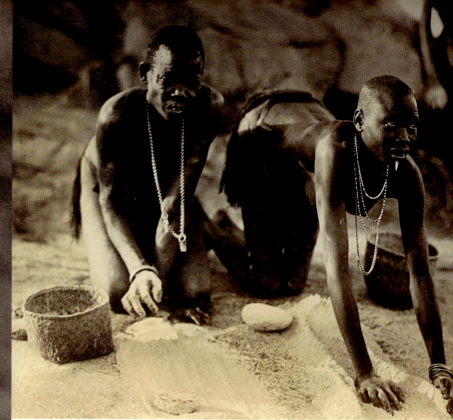

When my parents arrived in Kenya in 1930 the local tribespeople had not yet been contaminated by our Western influence and still retained their magnificent natural lifestyles, imaginative decorations and garments.

They were gentle giants, full of the pulsating force of Africa that made the invading white man look puny and defenceless.

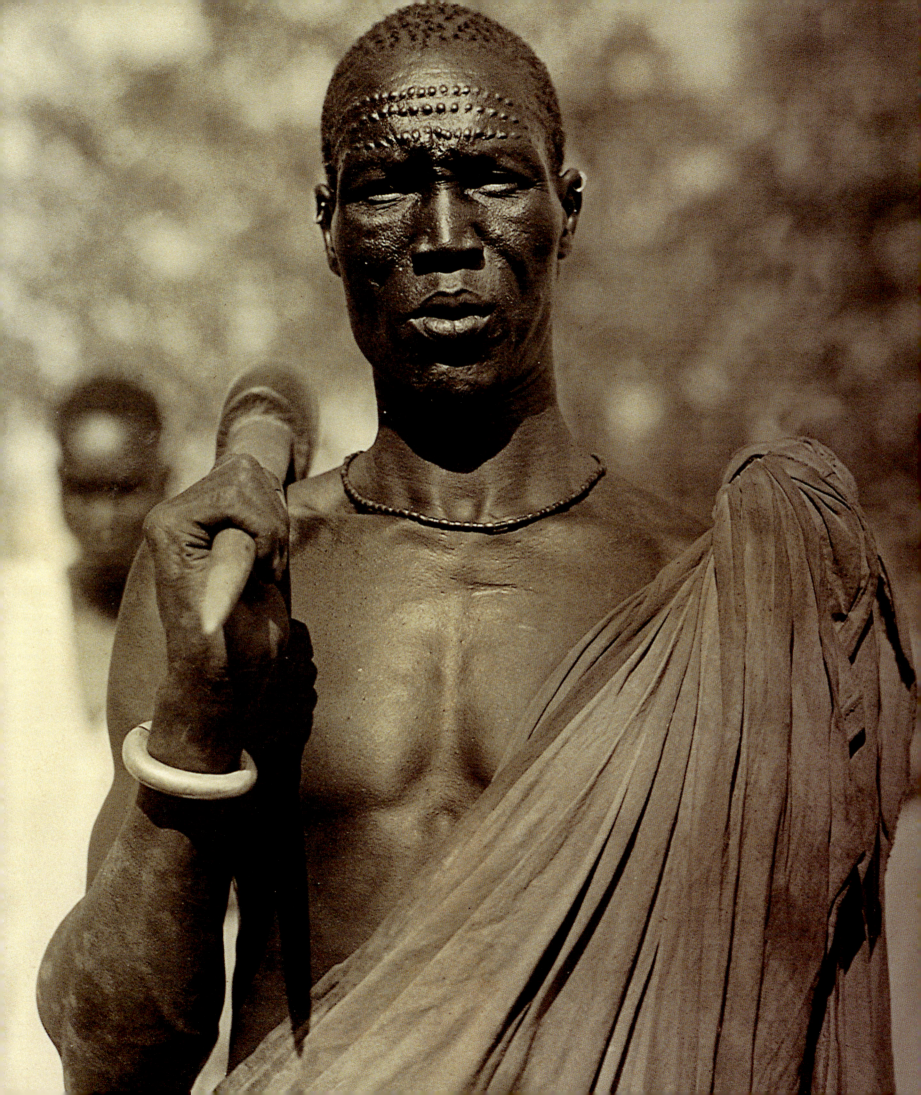

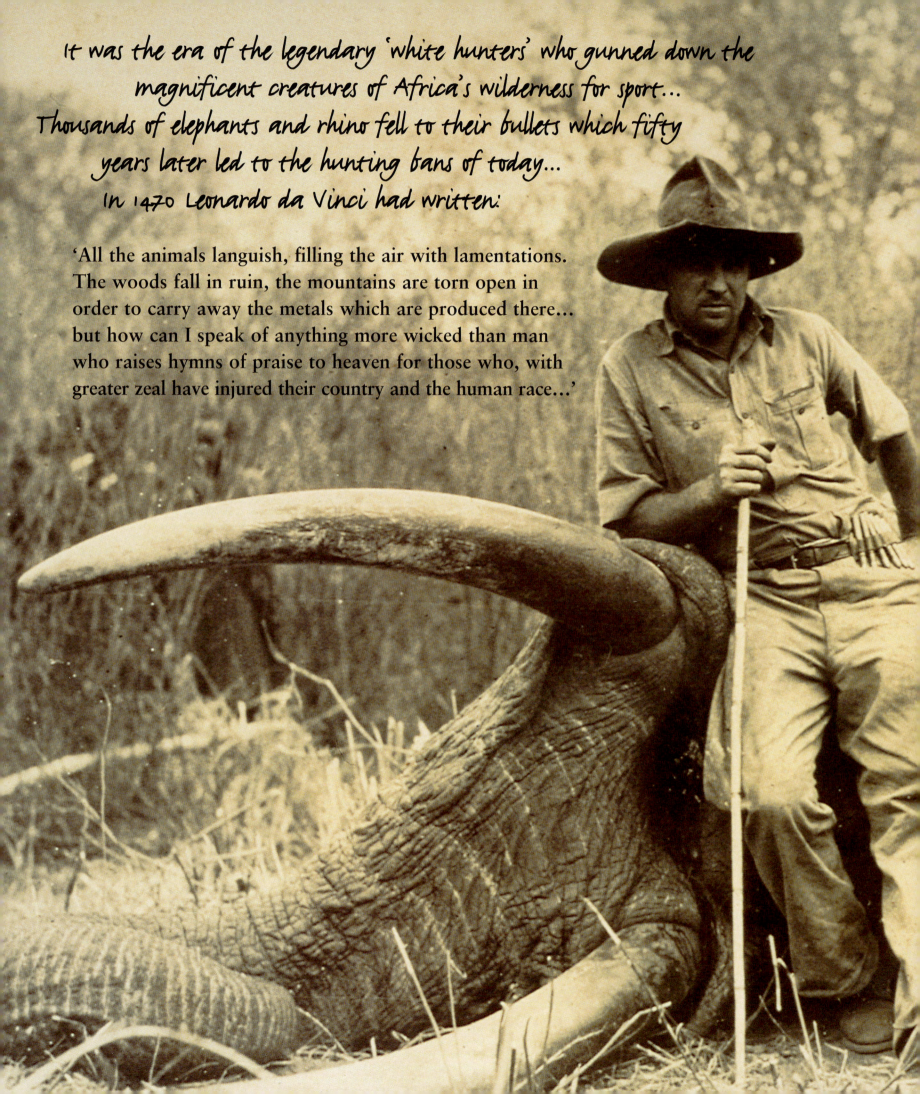

It was the era of the legendary 'white hunters' who gunned down the magnificent creatures of Africa's wilderness for sport... Thousands of elephants and rhino fell to their bullets which fifty years later led to the hunting bans of today... In 1470 Leonardo da Vinci had written:

'All the animals languish, filling the air with lamentations. The woods fall in ruin, the mountains are torn open in order to carry away the metals which are produced there... but how can I speak of anything more wicked than man who raises hymns of praise to heaven for those who, with greater zeal have injured their country and the human race...'

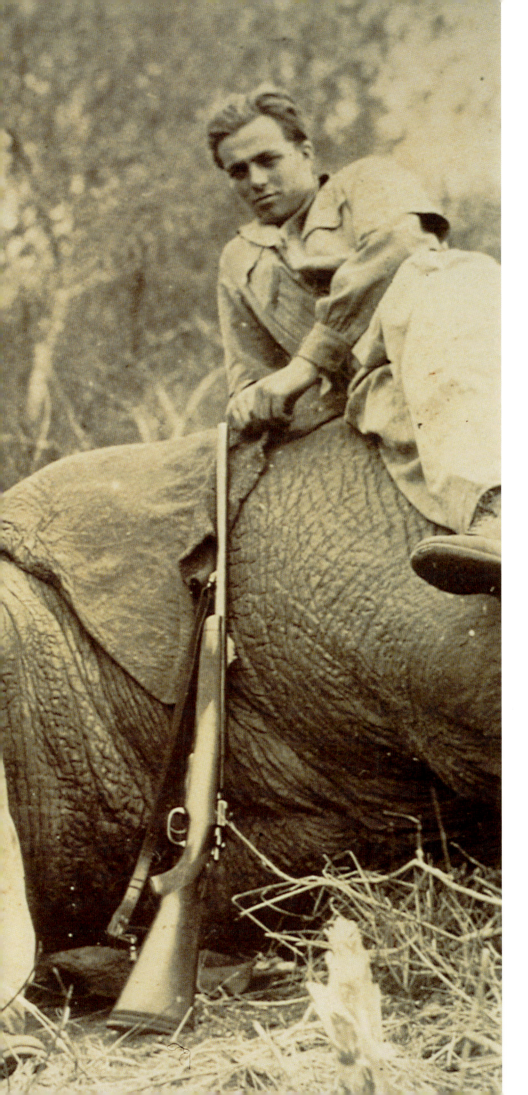
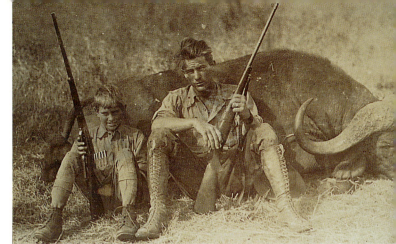
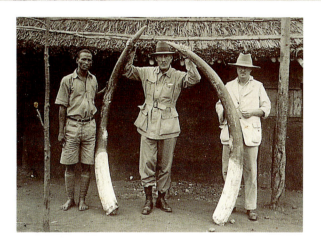
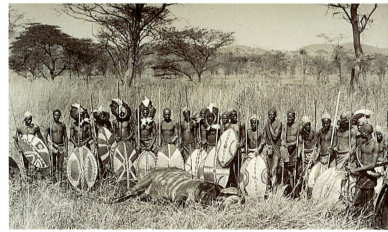

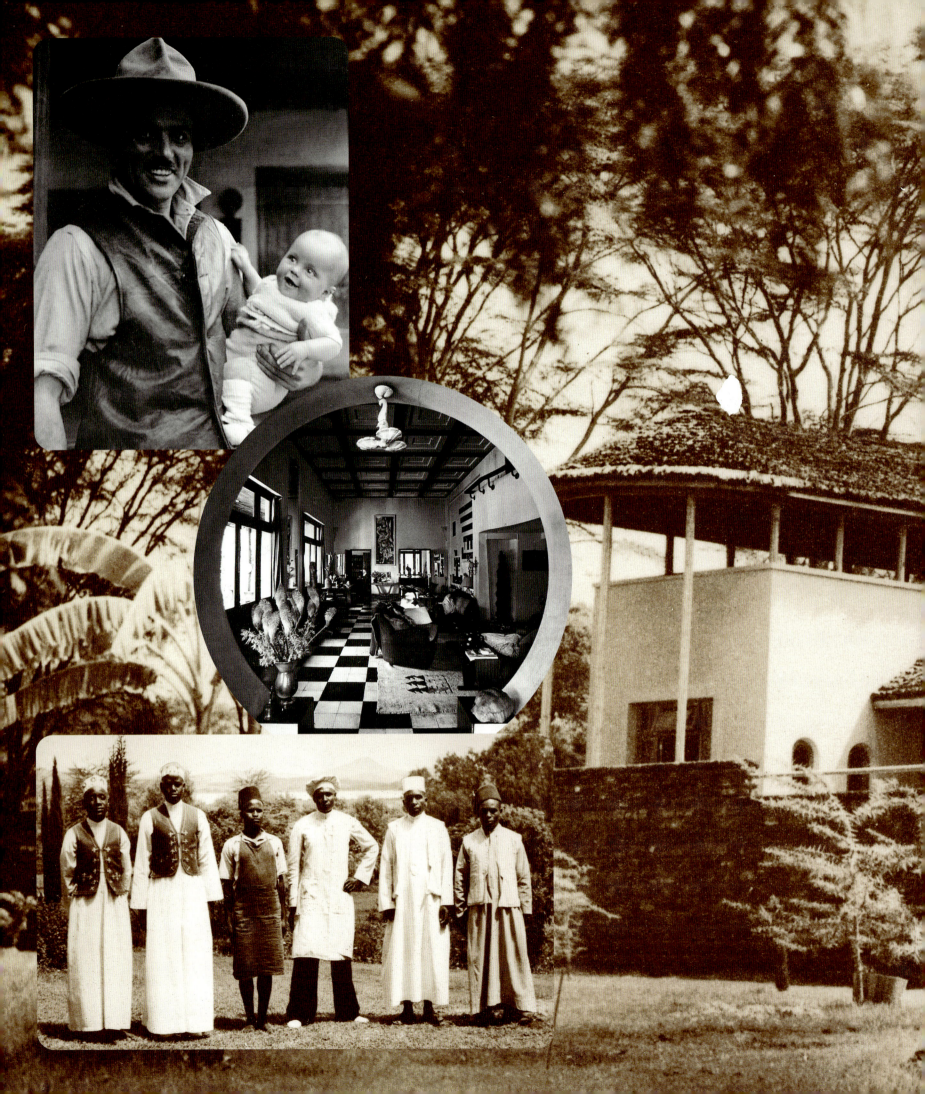

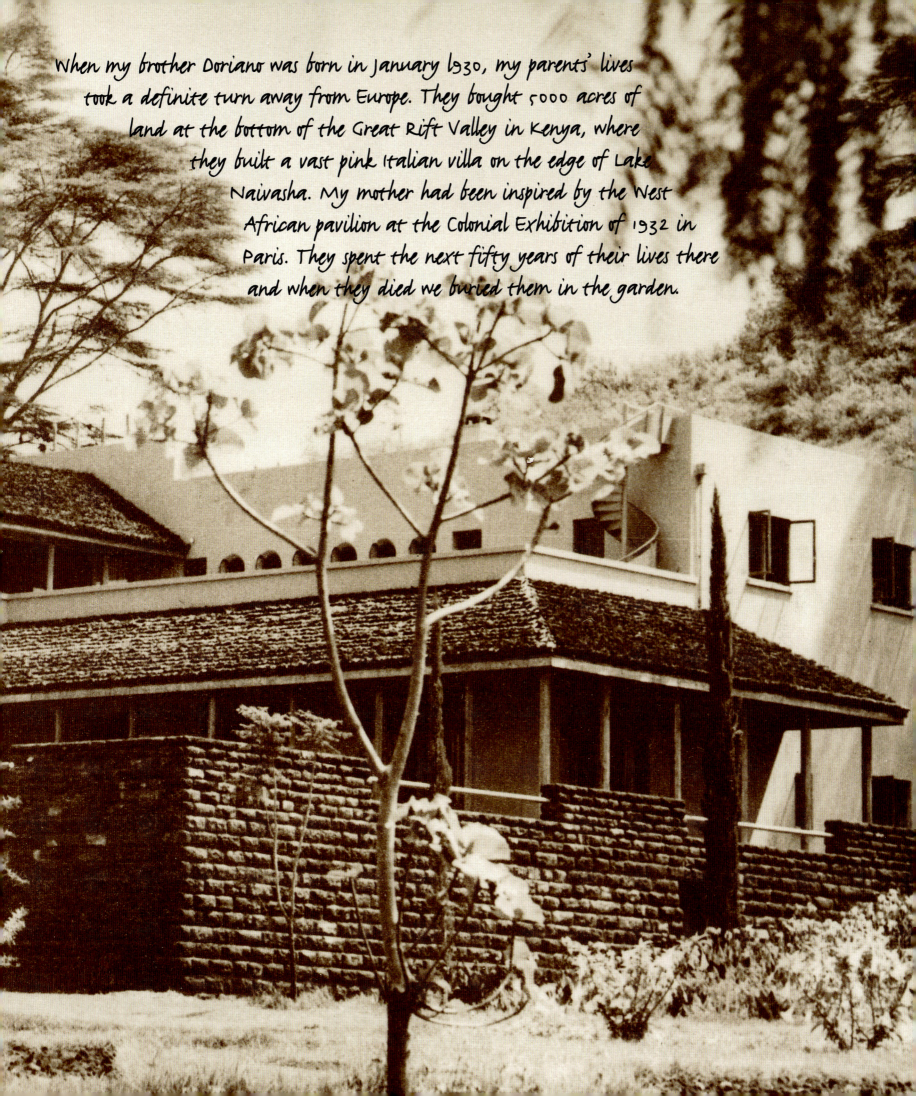

When my brother Doriano was born in January 1930, my parents' lives took a definite turn away from Europe. They bought 5000 acres of land at the bottom of the Great Rift Valley in Kenya, where they built a vast pink Italian villa on the edge of Lake Naivasha. My mother had been inspired by the West African pavilion at the Colonial Exhibition of 1932 in Paris. They spent the next fifty years of their lives there and when they died we buried them in the garden.

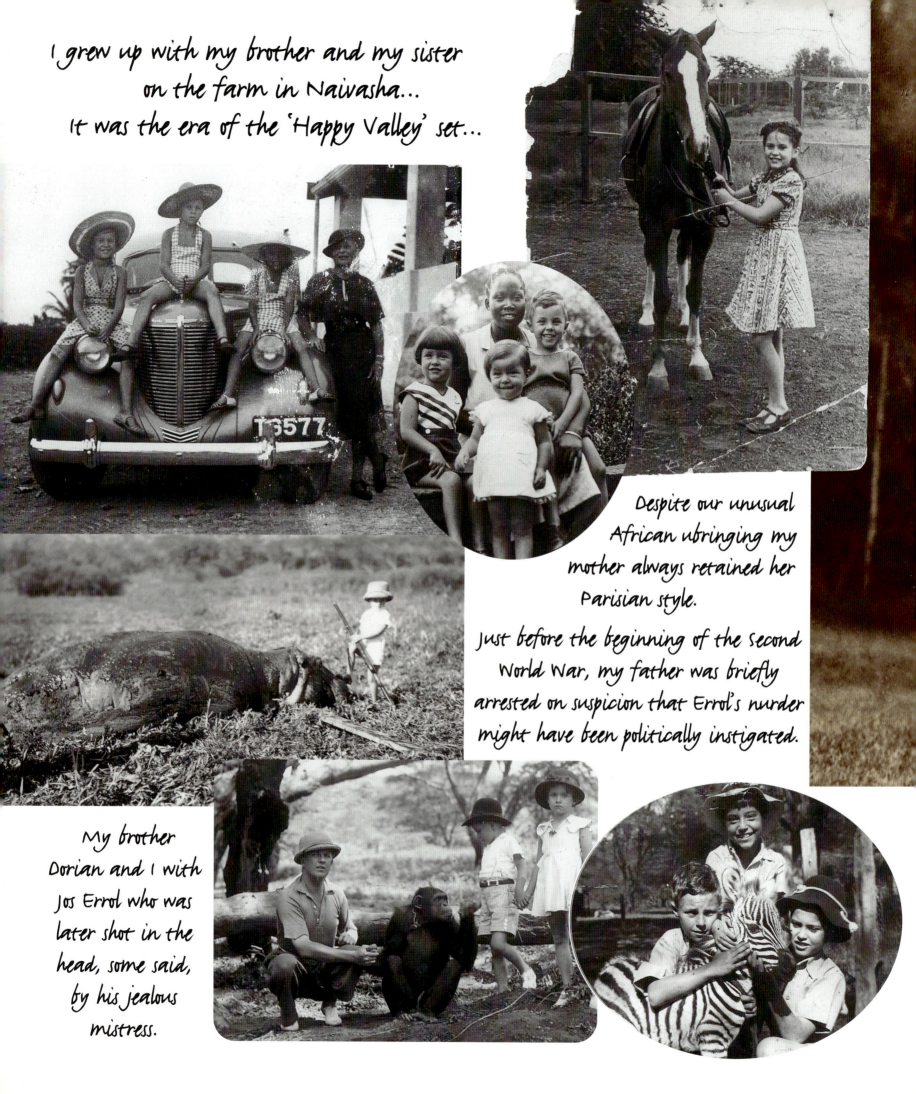

I grew up with my brother and my sister on the farm in Naivasha...
It was the era of the 'Happy Valley' set...

Despite our unusual African upbringing my mother always retained her Parisian style.

Just before the beginning of the Second World War, my father was briefly arrested on suspicion that Errol's murder might have been politically instigated.

My brother Dorian and I with Jos Errol who was later shot in the head, some said, by his jealous mistress.

We had an unusual upbringing – a mixture of sophisticated
fantasy and wilderness freedom. We played with animals instead of toys
and were looked after by a bevy of smiling Africans...
from sunrise to sunset our lives were full of freedom...
we knew no boundaries or restrictions,
but this was not white man's country....

We learned to shoot guns at an early age and went hunting on foot with our dogs and our Maasai warriors.

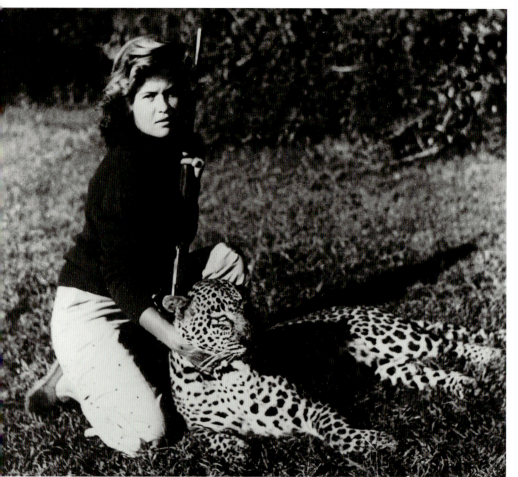

Me showing off Lorenzo's first leopard.

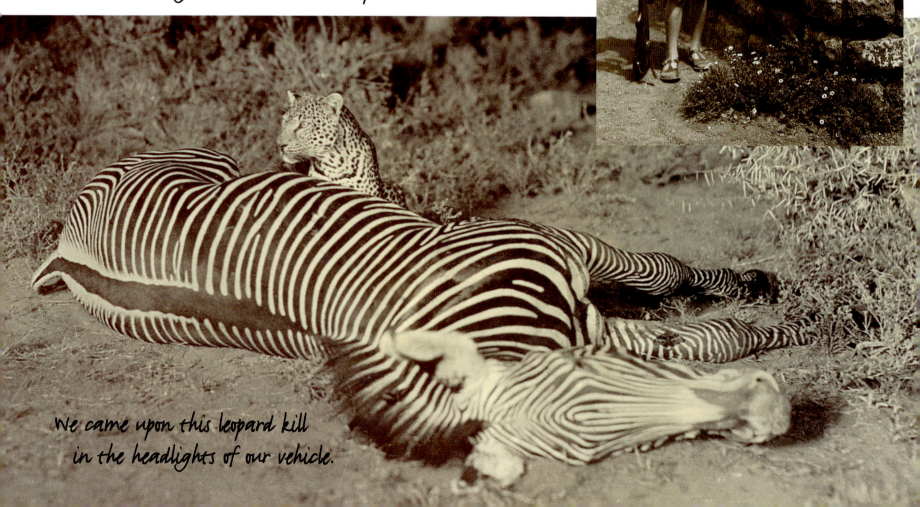

We came upon this leopard kill in the headlights of our vehicle.

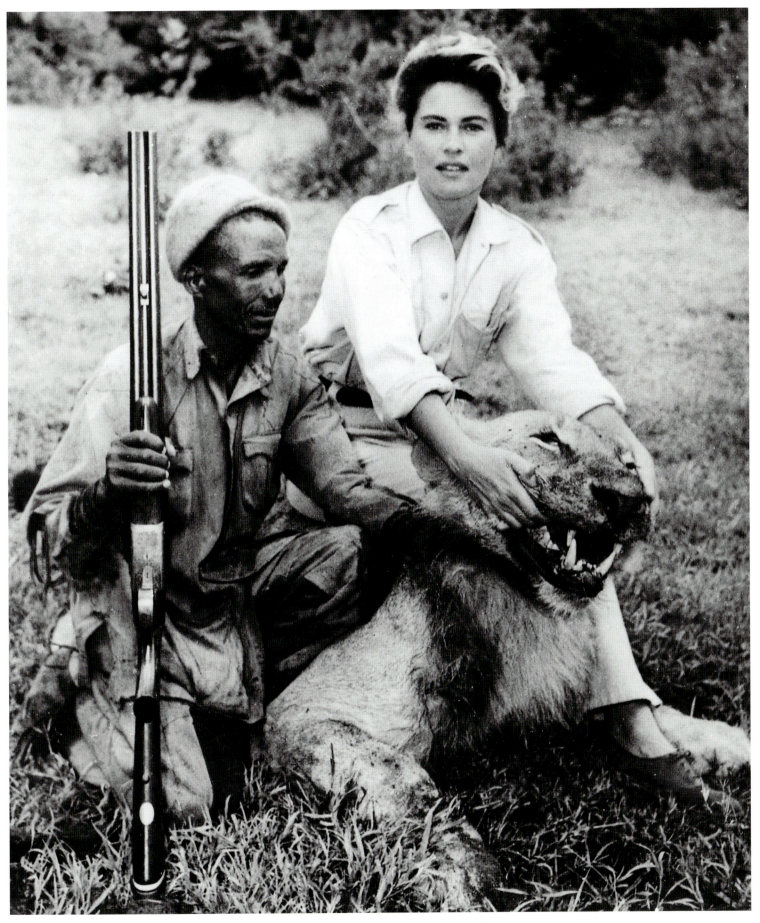

'I need a woman like you around,' Lorenzo said
when I took him on his first safari.

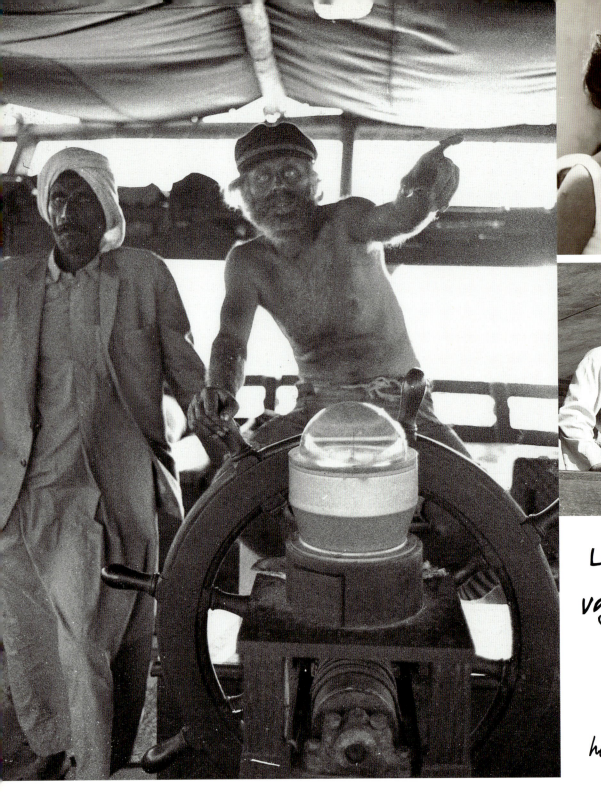

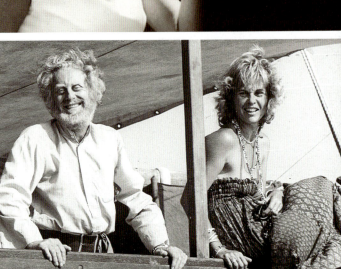

Lorenzo was a gypsy, a vagabond, a man without purpose or direction...

I met him when I was 25...
he hired me as photographer on the set
of the film he was working on and
three months later we got married...and I joined his
adventurous life.

One day I asked him to catch some fish for dinner...
he came back with an all-Africa record giant grouper

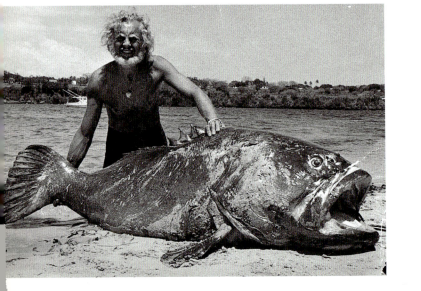

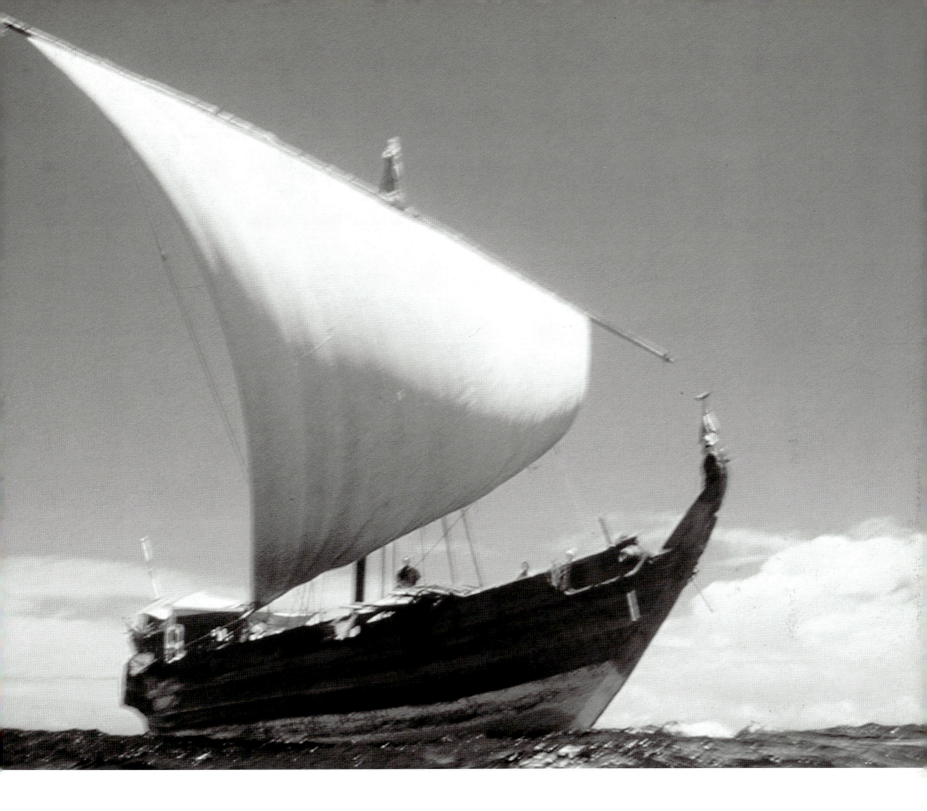

Together we sailed the Indian Ocean in the Mir-el-Lah, his Arabian dhow which he named after me. He was a dreamer who lived in a fantasy world far removed from the harsh realities of life...propelled by his charm and wit, he navigated a hazardous course through life, pulling me behind him... I followed him, powerless for forty years and then broke away.

During the Mau Mau emergency my brother Dorian
joined the colonial police force...
...the white man picked up his gun,
the black man made for the forest

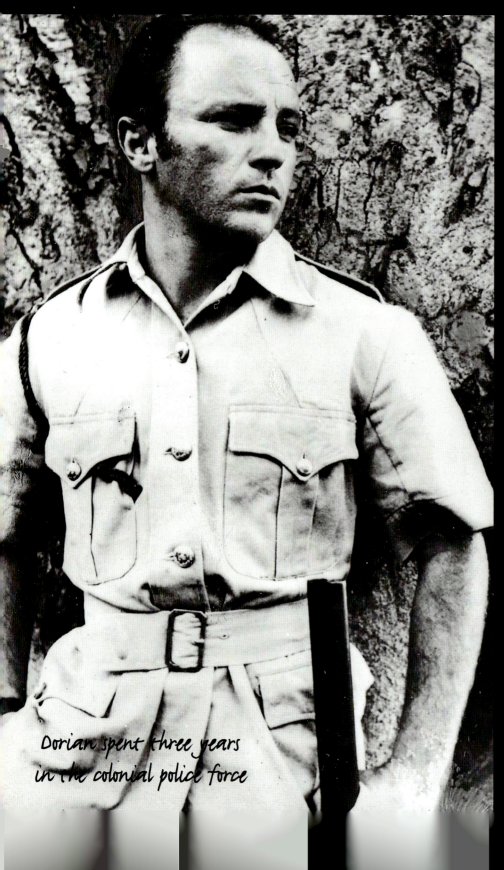

Dorian spent three years
in the colonial police force

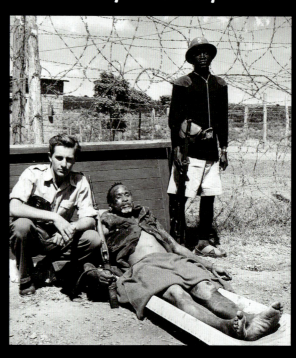

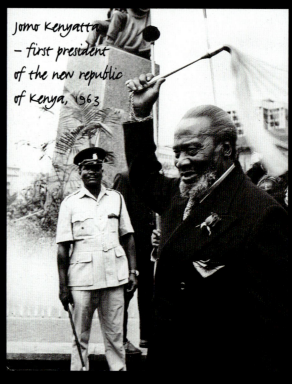

Jomo Kenyatta
– first president
of the new republic
of Kenya, 1963

Dedan Kimathi was the great resistance hero of the Mau Mau rebellion

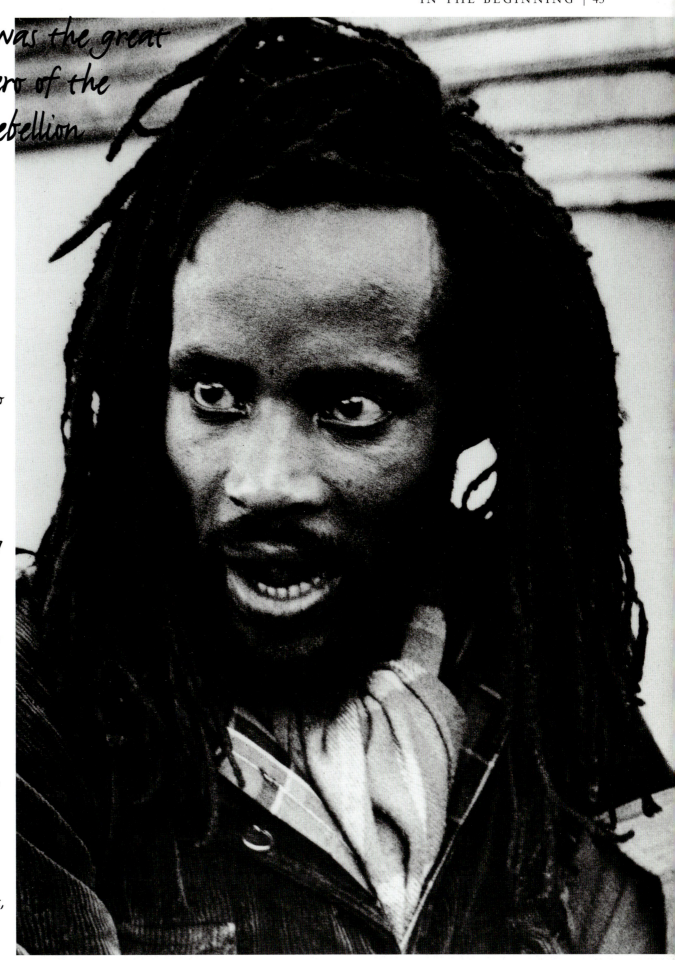

...his grandmother dipped her fingers in a goat's horn of blood, sprinkled it on his head and told him to lead his tribe...

Dedan believed that Ngai, the traditional God of the Kikuyu tribe had guided his grandmother's hand and had chosen him to lead his tribe. He began to dream. He dreamed of lands where the cows were brown, of places in the sky where rows of people sat on wooden benches, of death being like a gate which opened and shut, of rivers running up hill, of people standing before him in his sleep. He believed everything he dreamed and his descriptions of these dreams made old men and women turn their heads, for such things frightened them...

He was finally caught in the Aberdare forest and later hanged in the Kamiti jail in the outskirts of the capital Nairobi, held responsible for the death of fifty-three Europeans and the slaughter of thousands of Africans, suspected of being loyal to the whites.

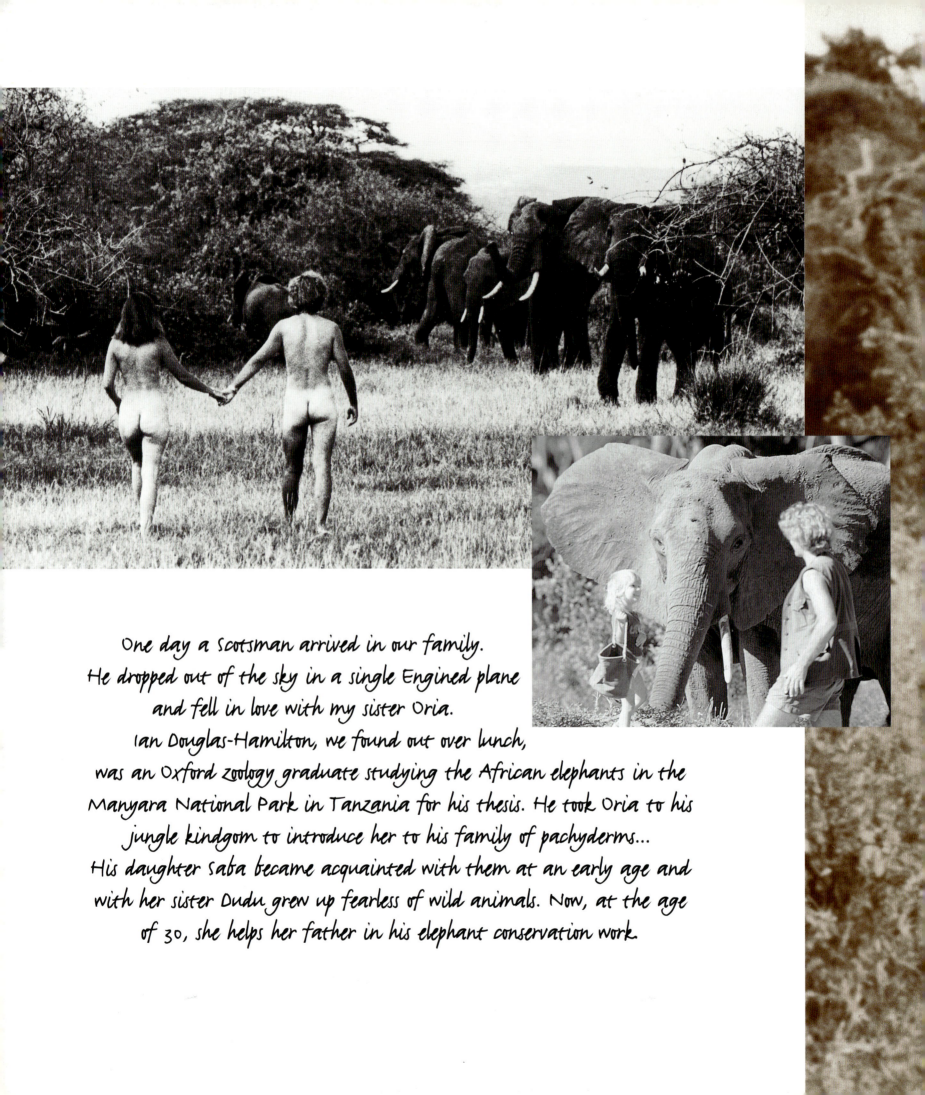

One day a Scotsman arrived in our family.
He dropped out of the sky in a single Engined plane
and fell in love with my sister Oria.
Ian Douglas-Hamilton, we found out over lunch,
was an Oxford zoology graduate studying the African elephants in the
Manyara National Park in Tanzania for his thesis. He took Oria to his
jungle kindgom to introduce her to his family of pachyderms...
His daughter Saba became acquainted with them at an early age and
with her sister Dudu grew up fearless of wild animals. Now, at the age
of 30, she helps her father in his elephant conservation work.

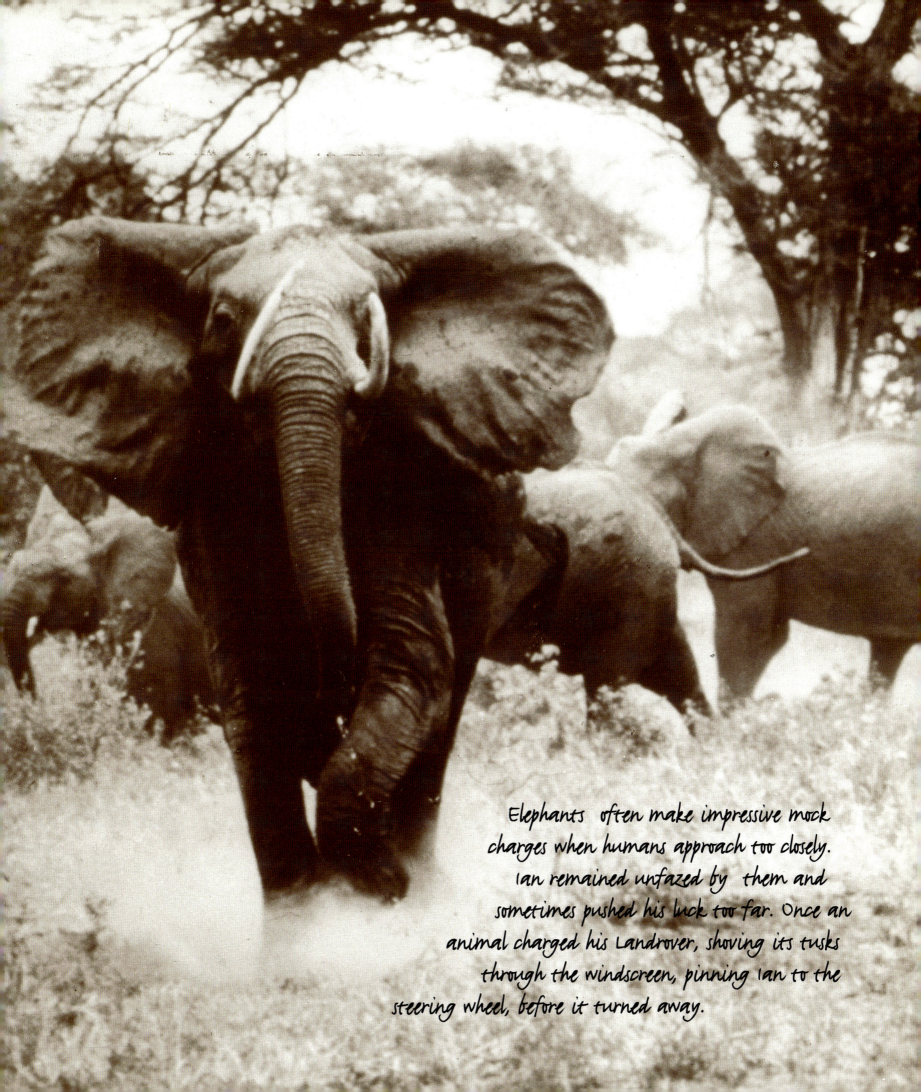

Elephants often make impressive mock charges when humans approach too closely. Ian remained unfazed by them and sometimes pushed his luck too far. Once an animal charged his Landrover, shoving its tusks through the windscreen, pinning Ian to the steering wheel, before it turned away.

My love affair with Africa

VANISHING AFRICA

WHEN VANISHING AFRICA was published I received many letters from women of all ages asking me how I had produced a book like that and also managed to have a family. The truth is that I did not manage, or rather, I only partly managed.

My family life was decomposing, my marriage was falling apart and I was in deep despair. My parents came to the rescue. I felt like a leaf blown in a storm, rising and crashing with every fresh gust of wind. Totally unprepared, I had no idea how to handle my marriage or my wayward husband, who himself was drifting down the current of his own life unable to find a firm fix for his anchor. It was a terrible time in our lives and for years I lived the debilitating existence of the drowning. Remembering those years still makes me shiver.

I finally broke away and took my first baby with me. I went to live in Paris in my mother's Left Bank *atelier*. I had completely lost sight of any direction and trudged through each day as if I was carrying an impossible burden. I was thirty-five years old and I was blowing in the wind. My African roots had been severed and I was slowly wilting. I was so enmeshed in my hopeless emotional drama that I did not bother to open a letter that had arrived for me from London for several weeks. When I did, it was an invitation from Billy Collins, an English publisher, to come to London to meet with him.

A year after we first left each other, Lorenzo and I had returned to Lake Rudolph, to a world we had almost forgotten. We camped on the shores of the huge African lake and shared the blistering days with the wild birds and the Turkana people. Lorenzo fished for giant Nile perch while I wandered around photographing the lake's inhabitants. We were so remote from our own complicated and cluttered civilised world in Europe that we shed our protective shells and for a delicious giddy period found each other again. Our second child Amina was conceived on the shores of Lake Rudolph, beneath a blanket of stars.

I returned to Paris, alone, with my pictures, pregnant again, and Amina was born seven months later. Lorenzo was not there, he was hunting in Tunisia and arrived one week later. Because she was two months' premature she weighed only one kilogram and lived in an incubator for two months; when she was ready to emerge into the big wide world I took her back to Paris with me in a wicker basket.

The letter from Billy Collins had been prompted by a mutual friend of ours in Nairobi with whom we had had dinner on our return from Lake Rudolph. I had shown him the pictures I had taken there and he suggested I send them to a publisher friend in London. That reply was another turning point in my life. I was able then to finally break the curse of obsession and possession. I emerged from my despair and my anguish and turned my back on them. I was at last able to live without the malady of doubt. There were silences in my head; periods of peace and enjoyment. There was light and hope again on my horizon. My heavy burden, the result of struggle, of many years of passionate living, was suddenly lighter. I felt finally delivered and embarked on the first, most satisfying solo flight of my life. *Vanishing Africa* was the result.

In response to the letter from Billy Collins, I arrived in London unannounced and found that he had just left for Australia and would not be back for three months. I saw his senior editor, Adrian House, instead, a charming grey-haired, very English gentleman who offered me a quarter of an hour of his time at the end of his day. When I showed him my photo layout and told him of my project – to photograph the tribal life and customs of the people of Africa before they changed forever – he pricked up his ears and the fifteen minutes spilled into several hours and ended with drinks and dinner at the Ritz. Adrian could only offer to send the photographs to Billy in Australia. I acquiesced half-heartedly and returned to Paris the next day. Forty-eight hours later an excited Adrian was on the phone reading me a cable he had just received from Australia: 'Marvellous photographs. Put her under contract. Acquire world exclusivity, give her £5000 and tell her to go' it read. Next day I was back in London and Adrian's office.

Three weeks later I landed in Nairobi with my two babies having packed my bags, let my flat in Paris and called Lorenzo in St Tropez to say goodbye. Billy Collins had given me *carte blanche*. I was free to do as I pleased; it was now entirely up to me to deliver. I felt like a painter in front of a empty canvas and I had no idea where I would put the first brush stroke; and what of my children and the condition of my soul? But God stayed with me, and for two years He kept His hand on my shoulder.

It took me three months to get organised. Having never

undertaken such a project on my own I was quite a greenhorn. I discussed my plans and my needs with my family and set up my girls on the farm with my parents and Annette, a French nanny I had flown out from Paris to look after them and teach them their lessons. I bought a Landcruiser from a friend onto which our farm mechanic welded a sturdy roofrack and two jerry can holders on the front bumper bars. I procured a tent and camping equipment from another friend who was leaving the country, borrowed my mother's cook, Kimuyu, from the house and one brisk morning drove off, heavily laden with all my goods and chattels, to start my great African adventure on my own. I was drunk with freedom, my head was light, my morale was high. I didn't know it at that point, but I was on the threshold of my new independent life.

My parents and children, the house-servants, the dogs and the cats and a handful of farm labourers all turned out to watch our final preparations, to help load the vehicle, fasten the canvases and tie the ropes. Then we all posed for a commemorative photograph. My parents, now already old, stood slightly to the side with their arms linked, looking on proudly and perhaps a little apprehensively. Everybody clapped and cheered as I revved the engine. We disappeared in a cloud of dust and began the hot slow drive to Maralal and the Samburu tribe to the north.

For the next two years as I explored Kenya with my camera, I met a multitude of different people living in the outlying districts. The tribes I visited differed greatly from one another, but they all shared the one characteristic that I had until then ignored, but was essential to the survival of the human race. They had adapted to their surrounding environments and did not yet crave or seek for things beyond their immediate needs. They seemed primitive by our standards, but their simple code of life was built on the basic laws of survival; eating, sleeping and reproducing. They solved their problems in their own ways, and law and order was kept by the elders of the clan. Women were submissive and obeyed their men and never questioned their position as perpetuators of the tribe. The children grew up naturally, according to the teachings of the elders, obeying them, and contributing at an early age to the workload of the compound. It was an ancient patriarchal system that worked and underlined the importance familial rank. I did not yet know then how threatened this way of life was and how timely my presence was among them.

After each safari I returned to the farm in Naivasha to see my girls, to service and repair my vehicle, stock up with fresh provisions, develop my film and look at my contact sheets. Naivasha was my anchor. Having such a base to return to was essential to the success of my undertaking. It provided me with immense emotional and physical security and allowed me to push my frontiers ever further. I was able thus to advance without trepidation, secure in the knowledge that my back was covered and my family was always there to close ranks behind me. It may seem a trite thing to say, but it was a crucial factor. In the two years I spent on my eight different safaris into the outback collecting my photographs, I travelled 20,000 miles, criss-crossing the country and worked in areas and under conditions so varied it was sometimes difficult to believe that I was still in the same country. From the dusty semi-desert in the north, I descended to the lush tropical environment of the coast. I froze on the slopes of Mounts Kilimanjaro and Kenya and fried on the Indian Ocean waves where the winds and salty air dried my skin to parchment. But I became tough and sinewy again and my energy could have driven a steam engine uphill. I never felt fatigued or hesitant, I barged forward like a bulldozer, circumnavigating obstacles, crushing any problems that presented themselves with my unquestioning drive and subtle conviction. I had never felt better in my life. What a rebirth it was. I had finally come into my own. I was thirty-six years old.

I also learned a great deal. For the first time I was coming into contact with the other side of the coin. Until then I had always been a white African, a product of the colonial system I had been raised in. I considered the Africans as my servants, not human beings like myself. *Vanishing Africa* was my journey of self-discovery and self-awareness. I began to use my own head and stopped living according to the dictates of my parents, my colonial friends and the rarefied environment of my status as a white woman in an African country. I don't know how or why the change came about, but I think it was prompted by the simple, open-hearted welcome and respect with which I was greeted and accepted everywhere I went.

Looking back now, almost forty years later, I can see clearly why and how the naive primitive purity of the Africans has so rapidly degenerated into the chaos and confusion of today. Their very openness was their downfall. I was then still totally unaware how close to the end they were and how very fortunate I was to still be able to catch a glimpse of them and their ways of life, let alone record it, before it was gone forever. It would be impossible to produce such a work today.

Ever since I could remember, my artist mother had pointed out to me the beauty of black people. She looked at them with the eyes of an artist and made me aware of the way they walked, the way they stood, the way they moved their hands and held their heads. I was now confronting it head on. Instinctively

I knew exactly what I was looking for, my vision had been so totally influenced by my mother's words; what I did not know at the time was why I was taking the pictures I took. Once I got back to England the reaction to my work made me realise that I had captured, for the first time, an aspect of Africa which until then had been ignored – the sheer unadulterated beauty of its people. My efforts were richly rewarded by the unanimous worldwide recognition my book received.

As I worked from dawn to dusk and well into the night, my senses were alive, and my eyes were filled with the changing lights and shapes of Africa. Time and again, as I travelled across the dusty continent, I would halt in front of immense vistas of golden grass, skies hung with billowing white clouds or streaked by thunder storms crashing from dramatic leaden skies. Each time I picked up my camera, I became aware of how much I had, until then, taken Africa's beauty and grandeur for granted. Having been born there, I was so much part of it. It was my camera that cast a new perspective over everything and started my love affair with Africa. I began to understand the obsession of those who had gone before me, those who had first come into contact with this beautiful wild continent. This was a serious affair of the heart; the sort one never gets over, for one is branded by it, scarred sometimes, but never left indifferent. But its melody is a siren song.

During my two-year walkabout collecting my photographs I shed most of my colonial inhibitions. The whole experience was a revelation and I became a more tolerant person. It was a gentle unobtrusive progression and the final straw was a chance encounter in the sea with a beautiful young man off the East African coast. A fisherman, nineteen years old, completely illiterate, but an alluring creature of Africa's wild nature.

I first saw him while I was lolling in the water one blistering midday, playing with my little girls. He appeared like a speck on the horizon, advancing in my direction. I followed his approach through half-shut eyes, without much interest. The speck grew larger until it took the shape of a tall, sturdy young man. Wearing only a diminutive faded loin cloth around his hips, he stopped a few feet from where I lay and looked down at me. The tattered straw hat was pulled low over his eyes, a worn coconut fibre basket at the end of a stick hung over one shoulder. I greeted him in Kiswahili and asked him the contents of his basket. 'Shells,' he said, dropping to his knees. As he laid them carefully in the sand beside me he looked up at me from beneath his hat. I saw the most beautiful golden-brown face set with dancing black eyes, the likes of which I had not seen before.

The coastal people are a mixture of Arabs and Bantu and are not especially renowned for their height or beauty, but this man was an exception. He told me his name was Shahibu. He was long and sinewy and when he turned his head he arched his neck in a way which made him seem aloof and inaccessible. The skin of his face was smooth and silky and slightly moist; the colour of dark chocolate, it rippled in the sunlight. I wanted to touch it. His fine straight nose and delicate nostrils, his soft, slightly slanting, eyes were not typical of his tribe. He told me he lived in the nearby Watamu village and he invited me to have tea there with his family.

I spent six weeks at the coast and saw Shahibu every day. He took us fishing and diving with him and hunted for shells with my girls. I later sailed with him and his four brothers in their dhow to the Arab town of Lamu and on to Kisingitini in the Bajun Island archipelago where I went to photograph the shy black-veiled Muslim women of the Indian Ocean coast. Shahibu had never left his village, he spoke no English and could not read or write, but he and my cook Kimuyu became a tightly knit team; without them I would never have been able to last as long as I did on this project. They relieved my solitude and the dark moods I fell into. Their gaiety and sense of adventure, their unquestioning and total loyalty, their concern for my well-being, turned the sometimes taxing undertaking into a manageable venture. I hired Shahibu initially as my assistant and then the relationship took an unexpected turn when he became my lover. He was sixteen years my junior.

My encounter with Shahibu was another particularly important turning point in my African odyssey, for it banished the taint of racial discrimination which afflicted almost every white person living in Africa then and with which I had certainly grown up. One day I caught myself looking at him, not as a black man, but simply as a man. When we realised something was happening to us, something that had never happened before to either of us, we dared not admit to it. We played and frolicked and laughed and hid behind the false pretence of casual camaraderie. It worked as long as we both remained on neutral terrain, but when I sailed with him and his four brothers on their dhow for the Bajun islands I inadvertently trespassed onto his territory.

The sea journey to Kisingitini lasted three days. My new African friends treated me with respectful courtesy and Shahibu was full of tender affections. Each night he unrolled my bedroll on the deck of the dhow and built a little overhead shelter above me with knotted *kikois* (African sarongs) which he tied to the sail ropes. His brothers slept at the other end of the boat, but he curled up on a mat at my feet. We never touched and kept our

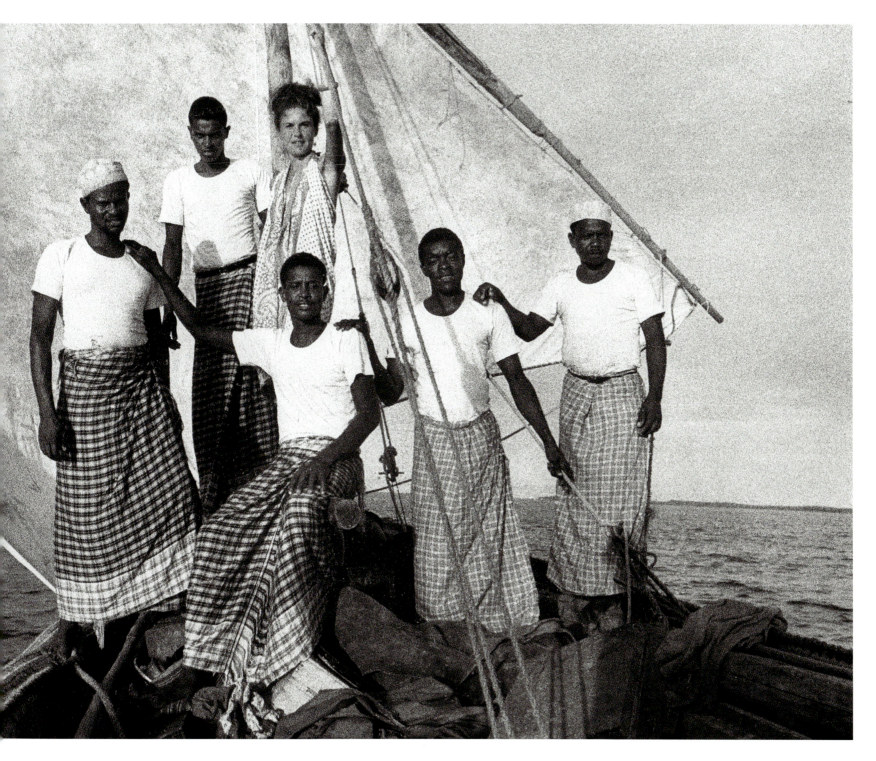

When I sailed to the Bajun Islands of the Indian Ocean with Shahibu
(on my right) and his brothers, to photograph the shy Muslim women of the
East African Coast,
I inadvertently stepped into his world.

feelings to ourselves. A few days after we set up camp on the island, I went to sea with him and his brothers in a local *ingalao*, a wooden dugout canoe. When we were out of sight of land, a brewing storm broke over us and we were drenched with icy rain. We donned our masks and flippers and dived overboard into the warm tropical sea. Under a large rock approximately ten feet beneath the surface of the water, I saw to my amazement what seemed like the tips of elephant tusks sticking out from the sand. I dived on to them and discovered a pile of tusks, a dozen or so, tucked beneath an overhang in the rock and almost completely covered in sand. When I tugged at one it came away effortlessly; it was covered in barnacles and sea crustacians and resembled some ancient Greek relic lying at the bottom of the sea. We pulled it on board to examine it further and photograph it, but when I told my crew I wanted to take it back to shore, they exclaimed in alarm that in so doing I risked landing all of us in jail, since possession of ivory was highly illegal. After much argument they finally persuaded me to return it to the sea bed.

When we went back the next day with the necessary permission from the local chief to collect them, the tusks were gone, no longer there, presumably lifted that night and hidden elsewhere. We never found out who had deposited them or in what circumstances, but presumed they had been thrown overboard from a passing dhow in danger of being intercepted by the Wildlife Protection Services on the coast. The current around us was very strong and I quickly drifted away from the boat. When Shaibu noticed how far away I was, he swam towards me and grabbed hold of my wrist, pulling me alongside him. He slipped his arm around my waist and pushed me gently underwater beneath him. I looked up at him through my goggles and saw him stretched out dark and powerful in a blaze of bright bubbles, hovering above me like a bird of prey. He smiled down at me and then I resurfaced on the other side of him. With this gesture he inadvertently removed the first brick in the wall that separated us. He was the man, he took the first step. Together we swam back to the boat.

That night in the tent we talked for the first time about the relationship between a man and a woman of different colour. I was very nervous but Shahibu remained calm. The glow from the hurricane lamp played on his face and naked chest and threw our shadows on the canvas above us. We sat on the floor and listened to the sea and the hot wind in the palm trees. A pink crab scuttled from beneath the tarpaulin trailing white sand grains in its wake. The jasmine blooms the women in the village had given us that evening lay scattered on the floor and filled the tent with their heady perfume.

I thought of Lorenzo and how I had been brainwashed by my parents for so long. I remember wondering if black men made love the same way as white men did. I had never had these thoughts before. Excitement and confusion made me shiver as if I had a fever. That night I embarked on the most exciting love adventure of my life. It was to last for two years and was so natural, I wondered what all the fuss had been about. But Kimuyu sulked for days. He went listlessly about his chores and refused to talk to or cook for Shahibu. He disapproved and made his feelings known in no uncertain fashion as he stared moodily into the fire. He was in shock. Kimuyu had been to a Protestant mission school and read his Bible each night before retiring. In his view black girls and white men were just about acceptable, but he had never had to deal with the opposite and that was definitely not on. Whenever we addressed him, he dropped his eyes in confusion.

When it was time to head home I explained to Shahibu what it was like in my white world; the hostility, the resentment and the prejudice he might have to face. I spelled it out ruthlessly to him, for it was important he should understand. If we wanted to continue together it was not possible for him to share my life as I had his. But he did not listen, perhaps he did not understand, certainly he did not care, and insisted I take him with me. Young, impulsive and in love he only wanted to be with me wherever I went, regardless of the consequences.

When we reached Naivasha he faced the first acid test when I entered my home through the front door and he went in with Kimuyu by the kitchen door. I sat in the drawing room with my parents, he sat in the servants' quarters with the house servants. The situation made me cringe, but there was nothing I could do about it. These were the conditions, I had explained to him, if we wanted to avoid instant banishment, for if my father had found out he would have shot Shahibu and probably me and then himself. In Naples, where he came from, crimes of passion and betrayal were a code of life. Wives and daughters are treated like the Madonna, to be revered but never touched, and certainly not by a black man. I had not forgotten how my father had chased Lorenzo out of the house before we were married, brandishing his duelling sword, because one afternoon he had caught him sitting on my bed reading a magazine with the door wide open. He was evicted for a week after a flamboyant Latino confrontation.

The time I spent with Shahibu taught me many things. From him I learned the fundamental truths and values of life. Like the lion, the giraffe, the fever tree and the ochre warrior, Shahibu belonged to Africa. At one with him, I was at one with Africa,

an experience which never repeated itself in sheer physical intensity. Making love to him, I felt, was making love to Africa. This was my love affair with Africa. What did Karen Blixen know about this, I wondered.

And then one day many years later, long after we had gone our separate ways, I heard he had contracted Aids. He had abandoned his Muslim teachings and turned to drink after I left him to return to England for the publication of my book. He had hooked up with many white tourist women after me in an attempt to maintain the lifestyle I had introduced him to; he was unable to return to his simple life as a fisherman. He had been contaminated by my life, much like the white man had contaminated Africa. He never recovered and finally died of Aids in his village. He was thirty-five years old.

Vanishing Africa was published in 1971 with a bang and the acclaim it received in the world at large was truly surprising. I had no idea what I had unknowingly unleashed. An exhibition in London at the Time-Life building was opened by Princess Anne, who was extraordinarily gracious towards me and all the family members who had gathered around to celebrate with me. Lorenzo and his father flew from Italy and all my friends pitched in to help me hang the exhibition. It was a truly great moment for me to see the large black and white prints of the images I had captured so far away and with so much passion, looking down at me, stark and elegant, so vividly portraying what until then had been virtually ignored, the exquisite grace and beauty of the African people. My mother would have been proud of me. I had rewarded her for her insight and proved to her that I was indeed a chip off her block.

This life-changing experience made my camera an extension of my eyes, a tool of my expression. Whatever I looked at from now on was framed in a 35mm surround. My children, my home, my friends, the scenery, the trees and clouds and sky and everything I looked at became potential targets for my lens. It had turned into an obsession.

Some years later, having hooked up with Lorenzo again, I travelled with him to the Arabian Gulf on his dhow that he proudly named the *Mir-eh-Lah* after me. We sailed together for six months down to the East African coast, sharing yet another memorable adventure, capturing the sights and fleeting moments of another fast-vanishing world, that of the Arabian sands. It was just before the oil boom, the discovery of Black Gold, that threw such chaos and destruction into this enchanted world. I am not a natural sailor like Lorenzo and feared I would not be able to cope with the demands of endless days on the sea, but life on an Arab dhow is totally different from that on any other sailing

vessel. Because of its size, the inconvenience of compressed space is eliminated and the open-plan deck living was compatible with my inborn claustrophobia.

Life on board was made quite bearable by the three-man Arab crew we assembled in Khorramshar at the nothern-most tip of the Gulf and in Dubai. They joined our two faithful fellows from Kenya – Matheka, the skipper, and Kimuyu, my *Vanishing Africa* cook. Between them they kept the mood jovial with their jokes, their caustic remarks and their endless good humour. Lorenzo was in his element, I had never seen him look better or behave with such command. He is truly a man of the sea and is at his best in this environment. With his wild blue eyes and unruly long blond curls kept in place by an Arab turban, his sun-baked leathery skin, his long lean body taut and twitching with every movement of the vessel as it rode the heavy sea, he looked very much the salty seaman behind the great wooden steering wheel. I was nervous at first as we crossed and overtook other dhows and incoming tankers in the Gulf; he seemed so at ease, it terrified me. But then I realised he really knew what he was doing and my apprehensions were put aside.

The five-month journey was filled with magical moments. We pulled up onto sandy beaches in hidden coves with steep mountain ridges dropping into the sea, so clean and transparent we could see the fish swimming around the boat like in an aquarium. Becalmed on a motionless sea we watched the dolphins dive and swoop like swallows beneath its surface and then burst through the calm waters, shining acrobats of the deep, plunging in unison by the prow of the boat when the wind was blowing, as if leading us to some unknown aquatic destination. The desert storms that crossed the ocean covered us in sand, obliterating the horizon so that it seemed like we were floating in space. Spectacular sunsets and dawns swept great swathes of colour across the sky, giving us our daily weather reports; and everywhere we went, smiling people in bright-coloured clothes and turbaned heads would come running down to the waters' edge to welcome us and guide us to safe anchorage.

With their dark eyes and strong angular features they resembled characters from the *Arabian Nights*; shouting and laughing and waving their slender arms in the air, they used sign language to communicate with us. Black-veiled women took me by the hand to visit the villages tucked among the date palm trees and allowed me to photograph them without much ado. Slender girls with gold earrings and dark black curls, children with rounded cheeks and golden skin looked straight into my lens with liquid brown eyes rimmed by long black lashes, while the turbaned men, in long white *jellabas* with silver daggers

fastened to leather belts, looked on in inquisitive amusement.

Before we left Dubai we went hunting the Arabian Habara bird in the desert with Sheikh Mohammed al Maktoum, the son of the ruler of Dubai, and his falcons. I took one of my favourite pictures of all time on that occasion. We had pulled in to Muscat harbour at twilight, the sun had almost set, there were still some tinges of pink in the sky and all the lights in the mosque on the quayside were turned on. The hills in the back were covered in mist or smoke and the sea was like a dark purple sheet of glass that reflected the winking lights, the night air was hot and gave the place a dream-like quality.

Aquatic birds followed us and sometimes landed on the deck or perched on the mast ropes to rest, gulls and fairy terns and water hawks, fellow-travellers on a long sea journey to some distant land. They brightened up our days and were our living link to the restless nature of the sea, providing endless entertainment and distractions to our often uneventful days.

At night we stretched out on the deck and looked up at the sky, picking out the constellations and watched shooting stars streak the heavens as Arab sailors sang mournful dirges or knelt in evening prayer facing to the east towards Mecca. Great tankers with bright headlights passed us by like denizens of the night, displacing great sheets of water in their wake, making us bob like corks; because of our infinitely small size, the code of the sea demanded we give them right of way and we had to remain vigilant throughout the night to avoid collision. Guided by the Southern Cross, navigation was simple and we took turns at the wheel. Kimuyu cooked us delicious simple meals of fish and rice on the little paraffin burners housed in a tin trunk, and when we encountered the Greek shrimpers we pulled up alongside them and feasted on king prawns that came on board in bucket-loads, part of the solidarity of the sea.

These were enchanted moments, indeed, in the often turbulent life that we had chosen to live together. Each time, I have to admit, it was my photographic quests that gave purpose and direction to these adventures. Without my camera there was far less reason to be there. Lorenzo was often the instigator of such adventures; his restless nature and insatiable need for travel kept him continually scouting for new horizons to explore. It was during these times that we recognised the bond that united us and somehow, for better or for worse, because we shared this common spirit of adventure and discovery, we have stuck together for almost forty-five years.

I did not, however, depend entirely on Lorenzo to set myself in motion. I sometimes took off on my own, either on assignment or propelled by my own insatiable wanderlust. On one of these occasions I joined a friend living in Khartoum and went on a two-month walkabout in the Sudan. Travelling on a local bus, I went to Cassala. I can't remember the reason why, probably something someone had mentioned to me. I holed up in a little local hotel in the noisy diminutive desert town and spent the days picking out timeless images with my camera.

The place was ringed on one side by a line of high rock formations that looked like a giant cardboard cut-out silhouetted against the sky. The smooth sheer face of the rocks provided a perfect backdrop to the life of the people living in their shadows; I was able to create my images almost like a painter would with his brushes. I visited the market place and browsed among the curious vendors selling exotic spicy food and bolts of multicoloured cotton cloth, and drank hot sweet coffee laced with exotic-tasting cardomom seeds at the local café. The people were always friendly and respectful and surprisingly amenable to my camera. I had learned to move gently and unobtrusively among them so they did not feel threatened. I was thus able to snatch exquisite moments and expressions and the uninhibited poses of a people still pure and uncontaminated by our Western civilisation.

One day I watched a camel herder returning home at dusk. He was comfortably perched between the humps of his beast, leading his herd. It gave him an elevated view of his surroundings. He was humming a song as he swayed backwards and forwards in rhythm to the soft, padded gait of his animals. I remember being impressed, as I raised my camera, by the nonchalance of the slow, rhythmic pace, covering the ground as effectively and rapidly as any vehicle in the same circumstances.

On one of my trips to West Africa, I discovered Djenne, a mud-walled desert town in Mali. After many hours crammed into an overpacked taxi-*brousse*, in the heat and dust of midday, the great adobe mosque appeared ahead of us, the colour of burnished sand, rising proudly from the desert floor and dominating the area. It was market day and all around it, in billowing waves of colour, the people moved about their business, draped in flowing robes, the men crowned with large straw shade hats, the woman sequinned with the glint of pure gold from the great rings fastened to their ears.

People in Africa are acutely in tune with their environment and are unperturbed by nature's sudden mood changes. A solitary man fleeing a dust storm in the desert of Mali offered me an indelible image, as did an early morning in a Maasai *manyatta* (village) when I caught the sun pouring through the branches of a fever tree, bathing the sleepy inhabitants going about their morning chores in an iridescence that removed them temporarily

from reality. And again, a group of scantily clad Maasai children sitting around a fire, arms outstretched over the flames, warming their hands as the smoke enveloped them in a veil of transparent white.

One afternoon on a rough road along the Nile, between Bor and Juba in southern Sudan, I came across a Dinka cattle camp set up along the muddy banks of the river. The water was low and almost immobile. The whole camp was shrouded in smoke and evening mist. The people and their huts and cattle were silhouetted against the blue haze and reflected in a mirror image in the still water beneath them. For a brief moment I gazed at the scene in wonder, almost afraid it would fade before my eyes, and then reached for my camera. A strong wind was blowing across the desert pulling a rainstorm in its wake. Suddenly the scene changed as the angry winds swept down, chasing great black clouds across the sky, swirling the smoke and momentarily obliterating everything from sight. The tall naked Dinka glided unperturbed about the compound, tying down the cow-hide roofs of their huts with leather thongs. The heavy downpour of rain that followed sent the people scuttling for cover and one old man with two small children who looked like twins, pulled a cow hide over their heads and huddled beneath his primitive umbrella until the squall had passed. There was something ageless in their movements. I could smell the advancing rain, that rain sacred to all Africans, especially to the nomad, since from it springs their livelihood. Nomadic people are more in touch with nature and when they are not interfered with, the rhythm of their lives is guided by the environment in which they live.

The Africans do not, for instance, dance merely for amusement; dance is the expression of a communal spirit. In Africa everyone dances; they dance as they live, inserting dance almost casually into everyday gestures and it is perhaps because of this that they guide the music rather than be guided by it. They can dance to any sound even if that sound is only confined to their heads. The monotonous chanting, the sharing of grief and joy are all part of this same communal spirit, and from it the Africans draw the strength and continuity that binds them to their basic instincts.

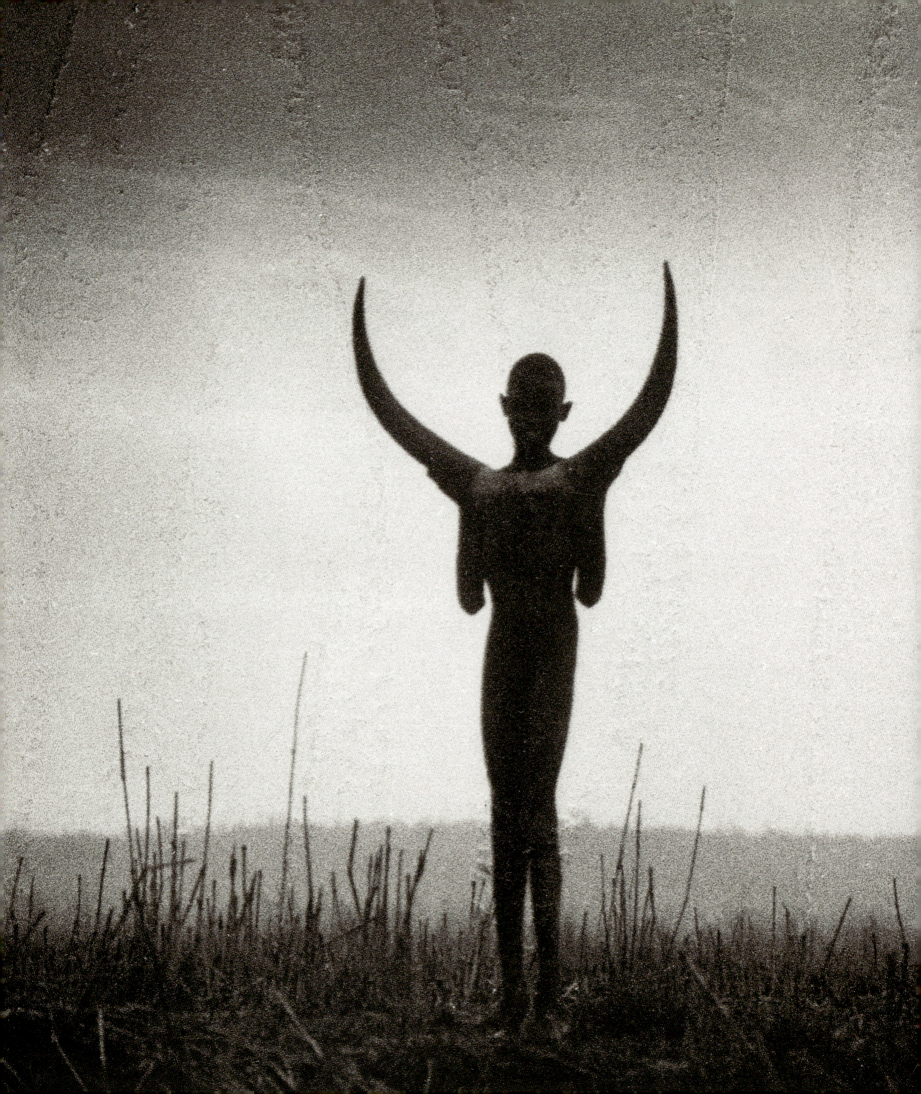

I felt like a painter in front of an empty canvas and had no
idea where to put the first brush stroke.
 Africa lay around me in all her magnificence...
 I seemed so small and insignificant in my task
 of capturing her magic.

In the hot dusty environment of Kenya's northern frontier
where the pastoral Rendille tribe survived under impossibly harsh and barren
conditons, I would sometimes sit under a thorn tree in the midday sun

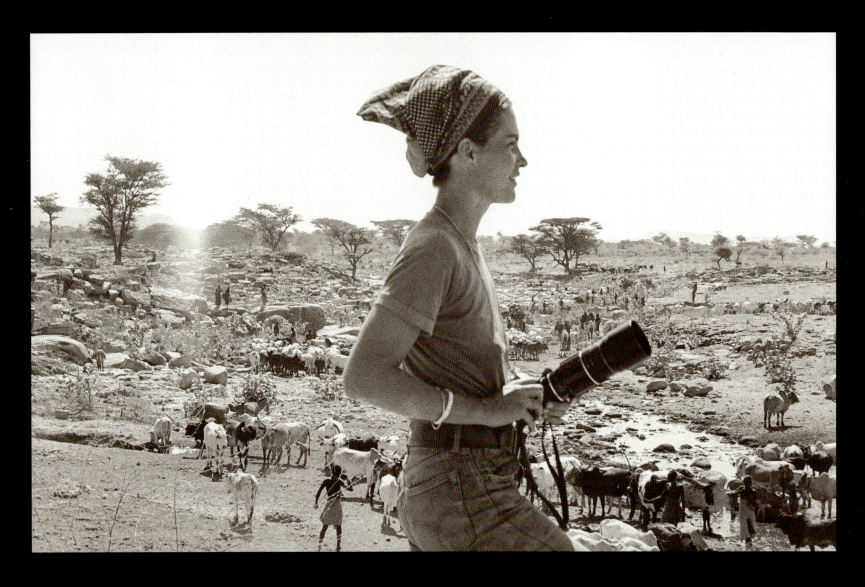

and wait for the cattle to come to the watering holes.
I foresaw this image as the two large horned cows moved behind each other
and was able to take just one shot before they moved on
and the image changed.

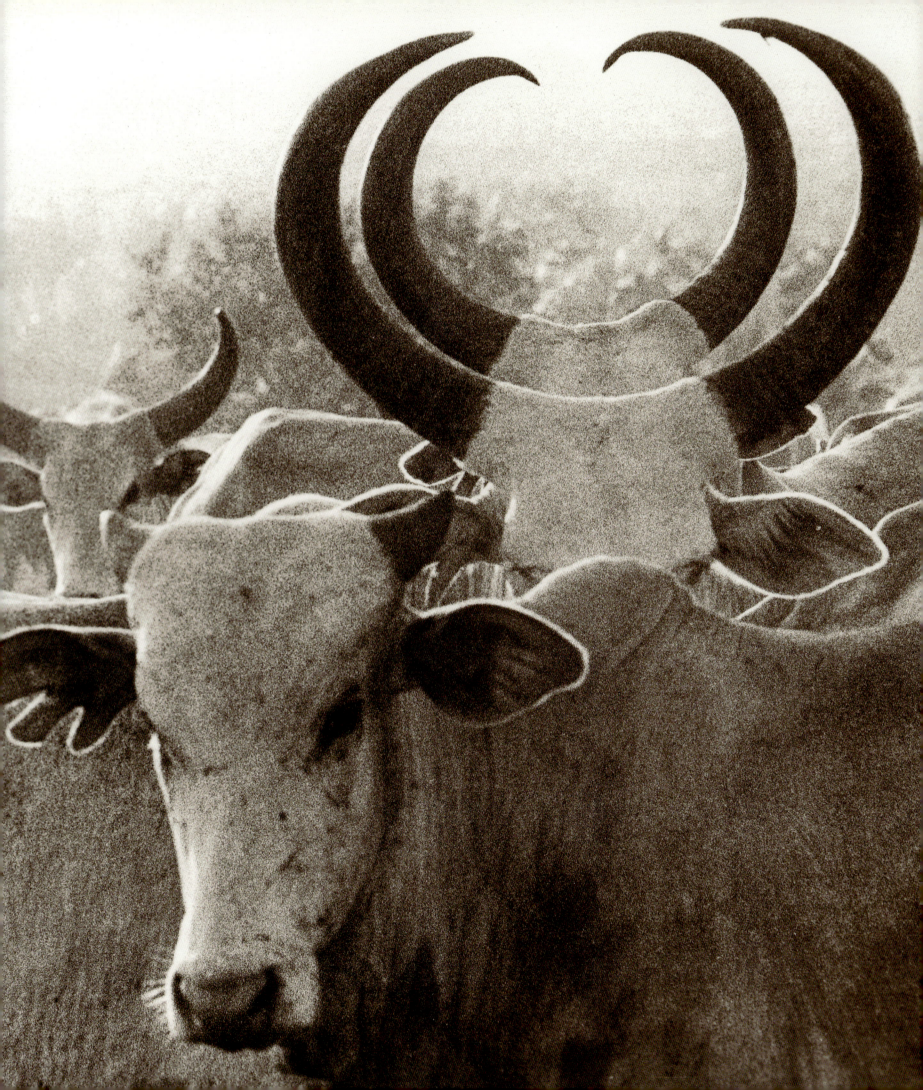

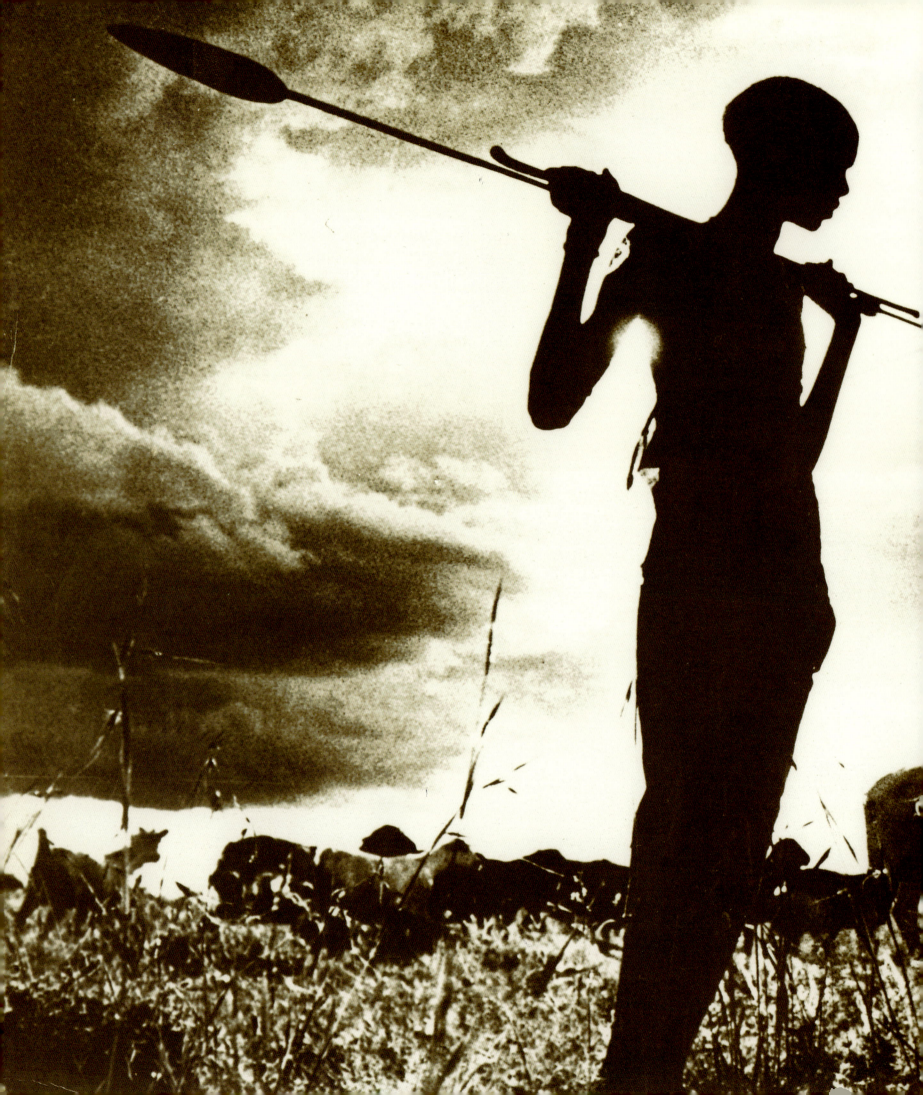

As I travelled across the dusty landscape, wonderful images of Africa appeared. The tall samburu youth herding his cattle remained immobile against the stormy sky as if he was posing for my camera.

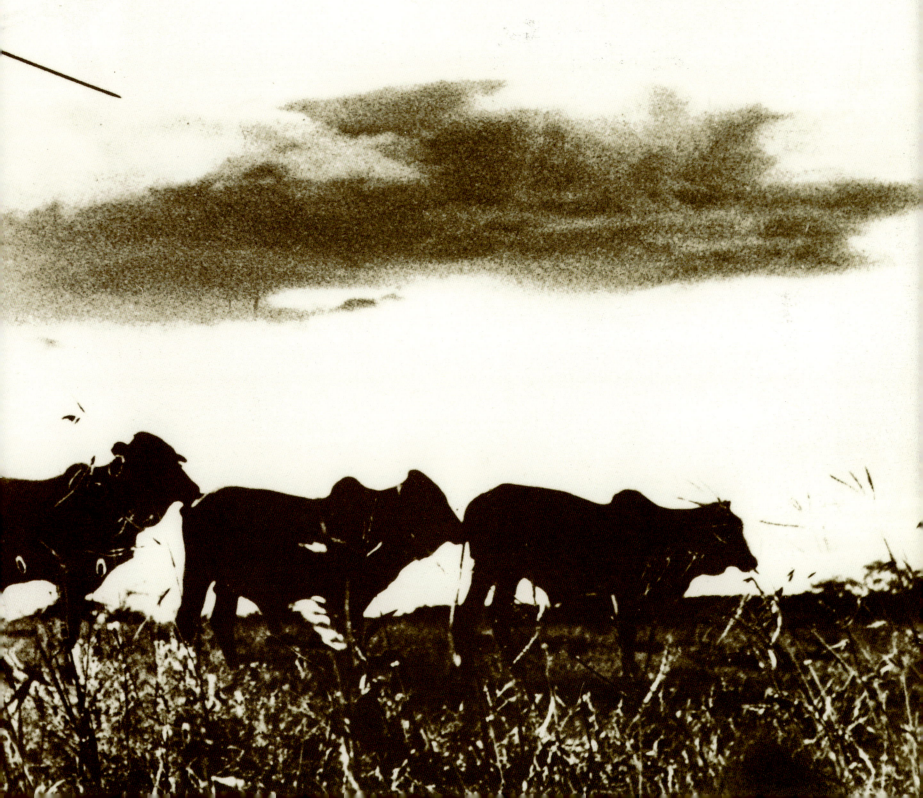

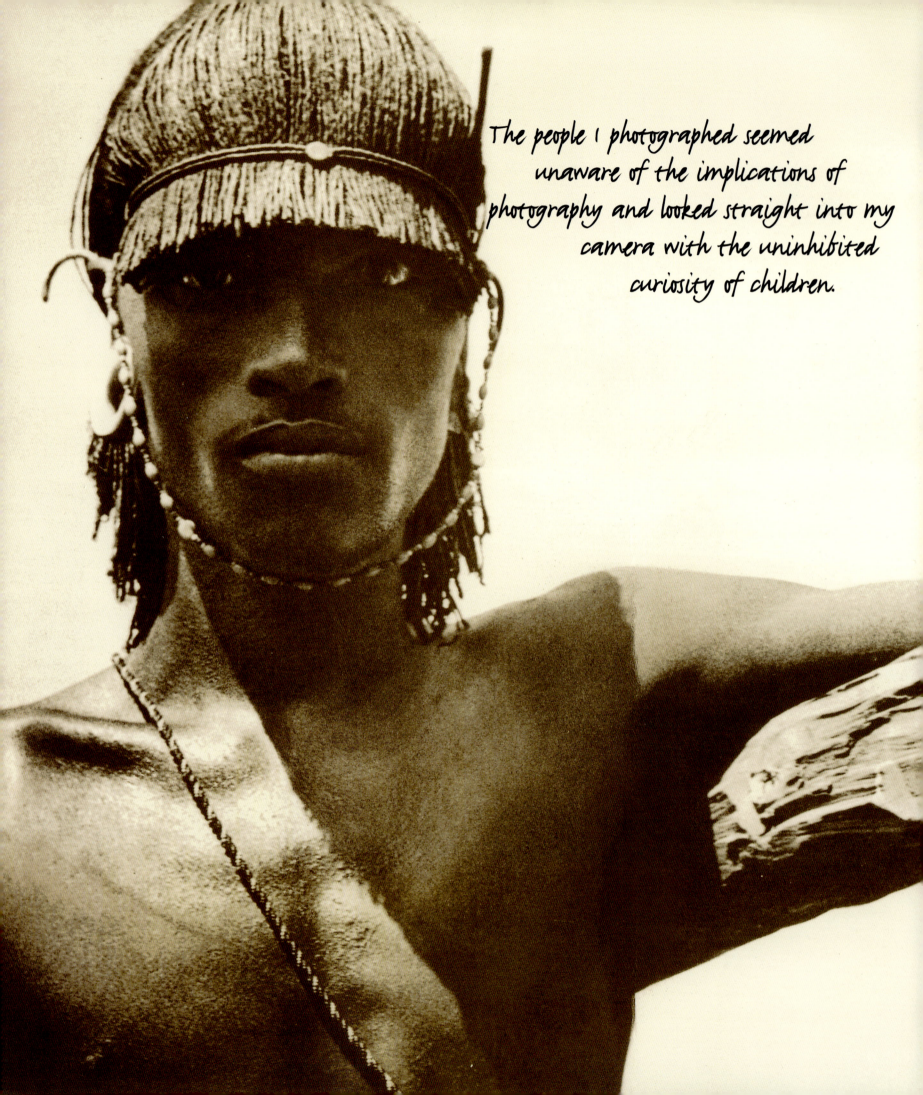

The people I photographed seemed unaware of the implications of photography and looked straight into my camera with the uninhibited curiosity of children.

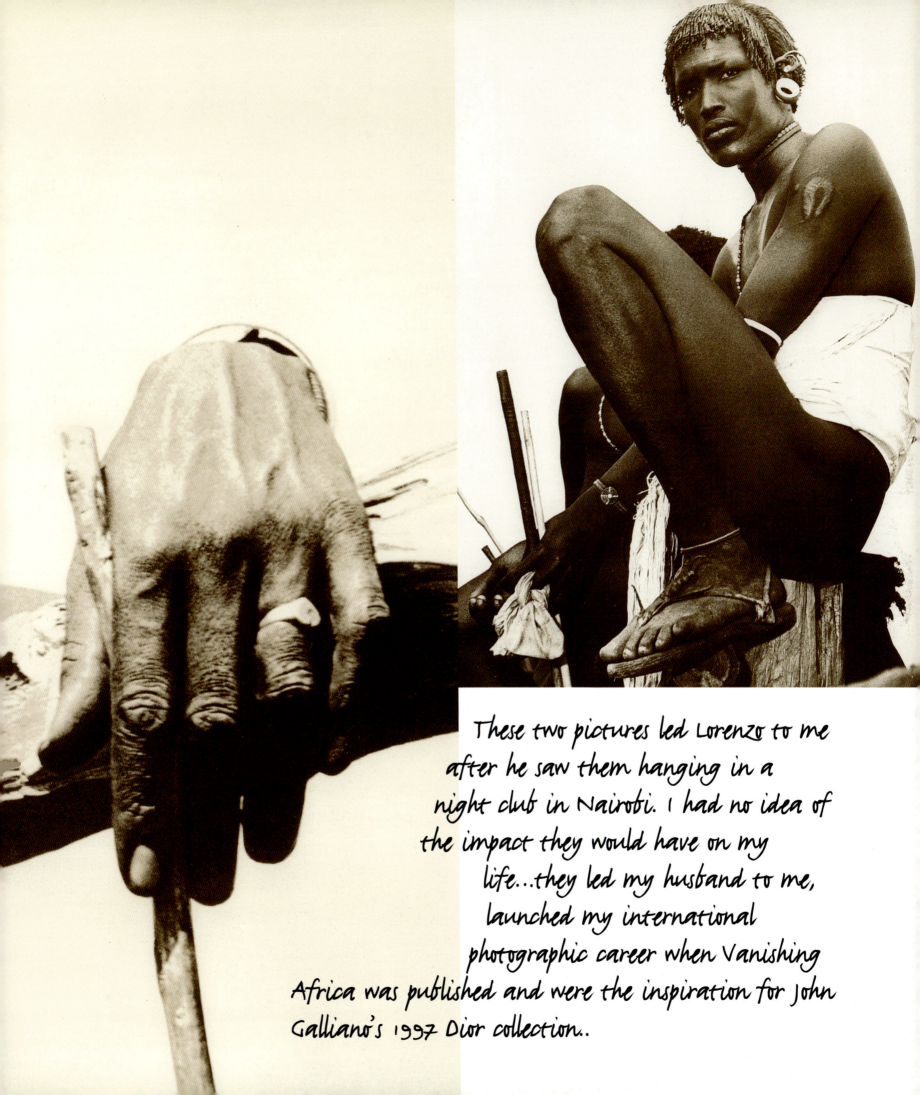

These two pictures led Lorenzo to me after he saw them hanging in a night club in Nairobi. I had no idea of the impact they would have on my life...they led my husband to me, launched my international photographic career when Vanishing Africa was published and were the inspiration for John Galliano's 1997 Dior collection..

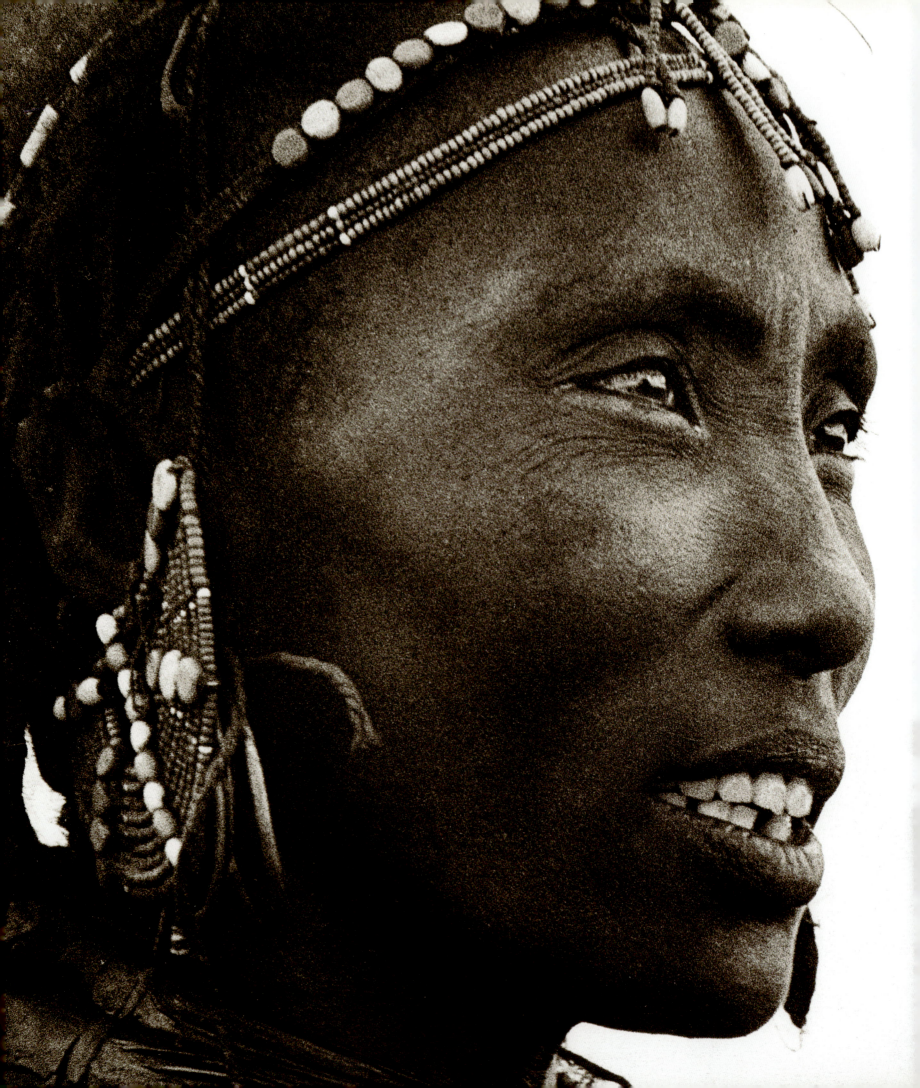

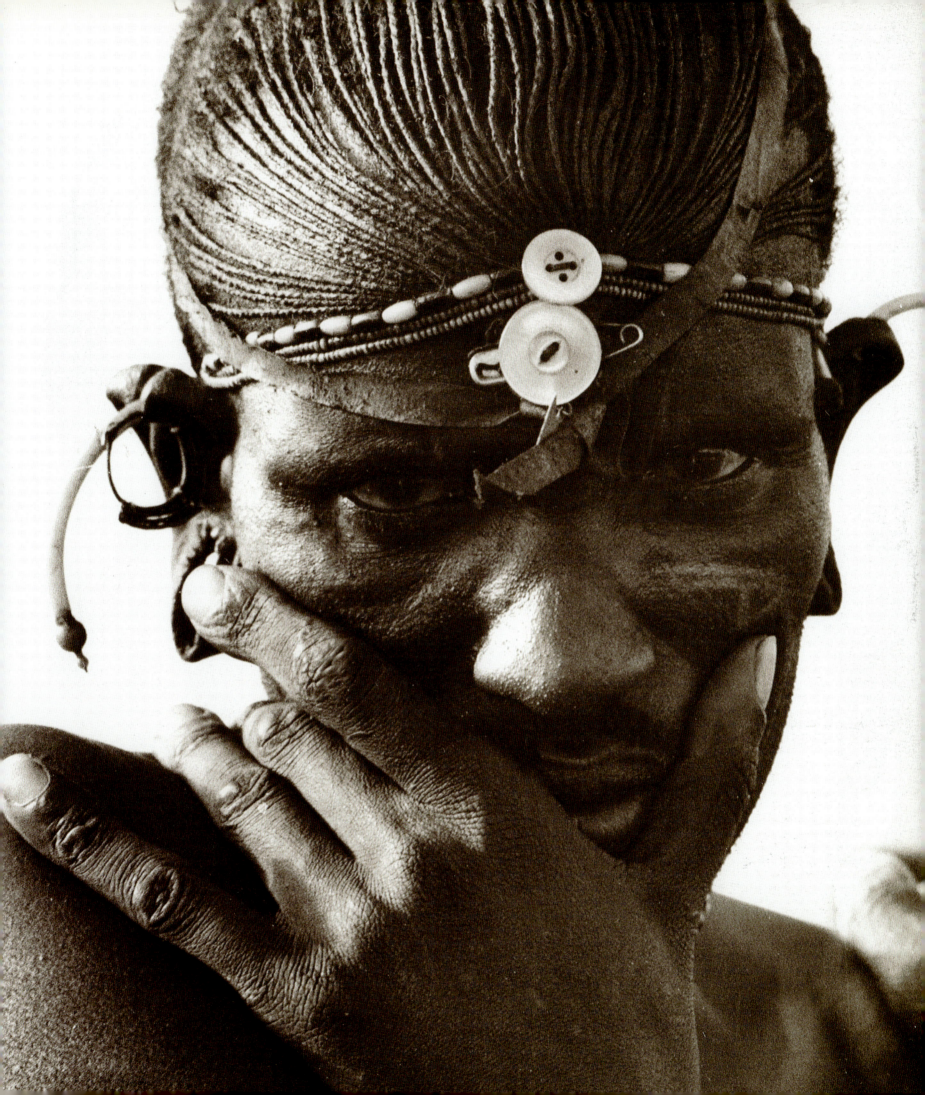

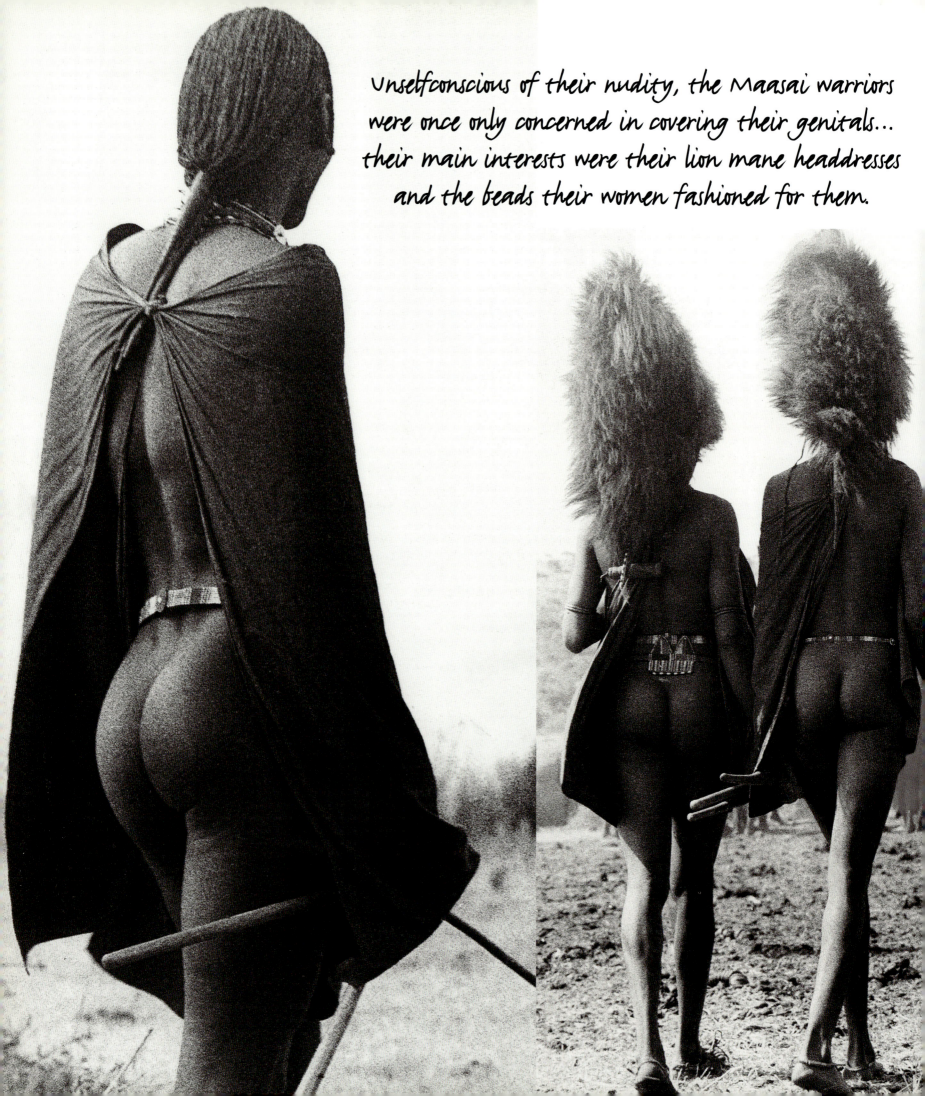

Unselfconscious of their nudity, the Maasai warriors were once only concerned in covering their genitals... their main interests were their lion mane headdresses and the beads their women fashioned for them.

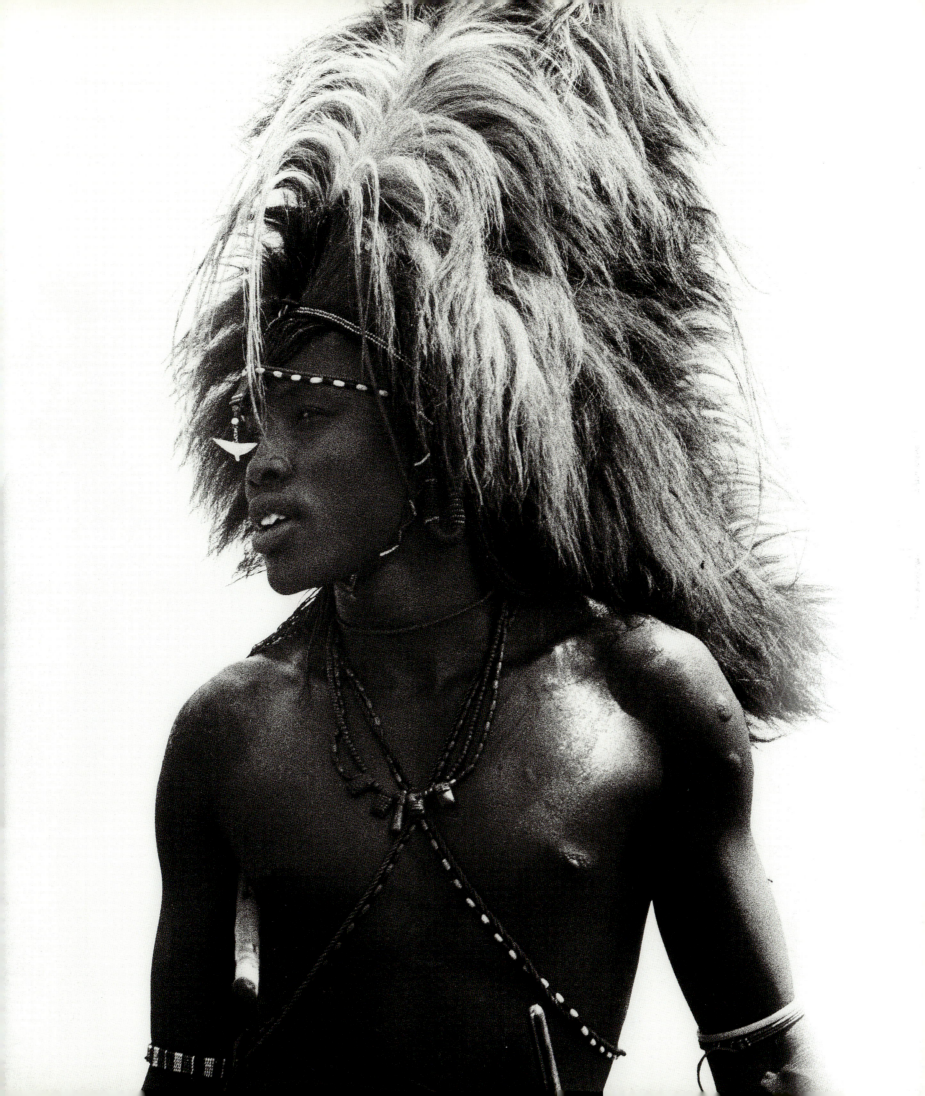

Naked warriors at the coming-of-age Eunoto ceremony are kept
in control by the village elders...wrapped in ochre-coloured blankets,
they carry long whips with
which to beat the warriors
if they get too rowdy...

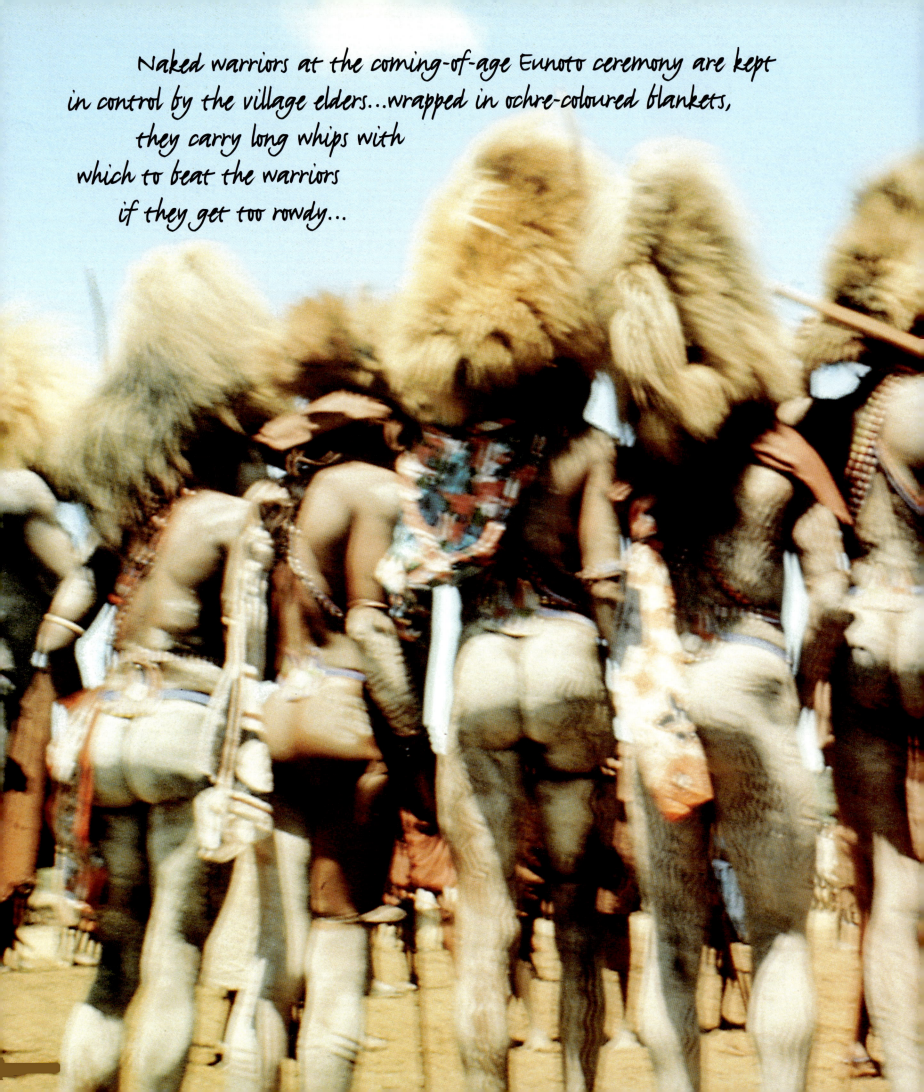

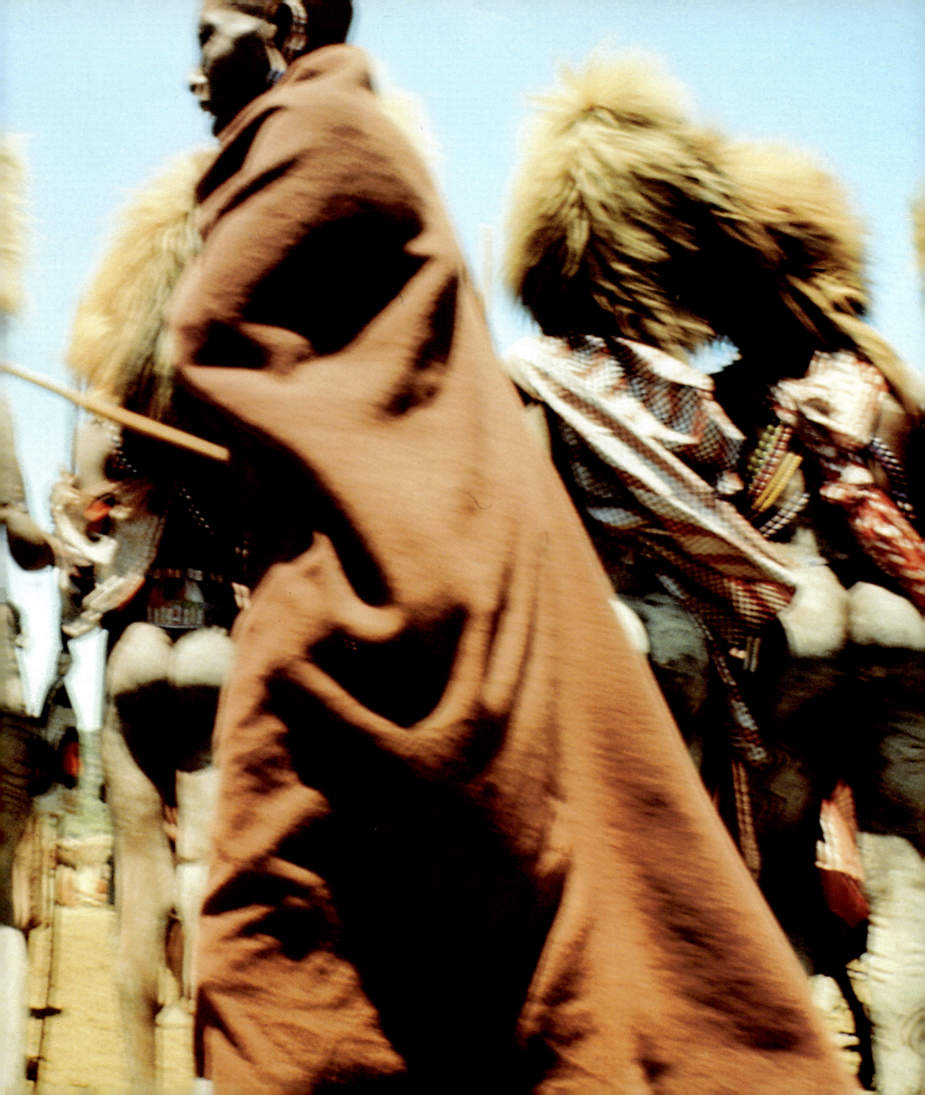

Eunoto ceremony – Loita Hills, 1968

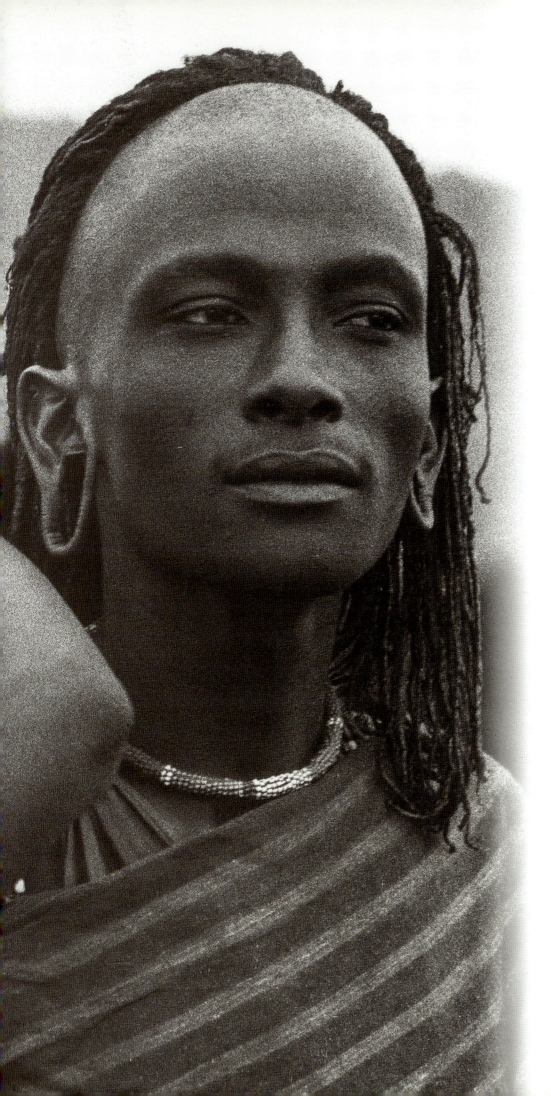

Ever since I can remember, the beauty of the African people was pointed out to me by my mother...

The Maasai, who are of Nilotic descent, still retain the features of their origins, but sadly these are being more and more dissipated as they intermarry with other tribes and abandon their spartan diets and ways of life.

I had, however, never seen a man quite as beautiful as this young warrior with his nubile damsel.

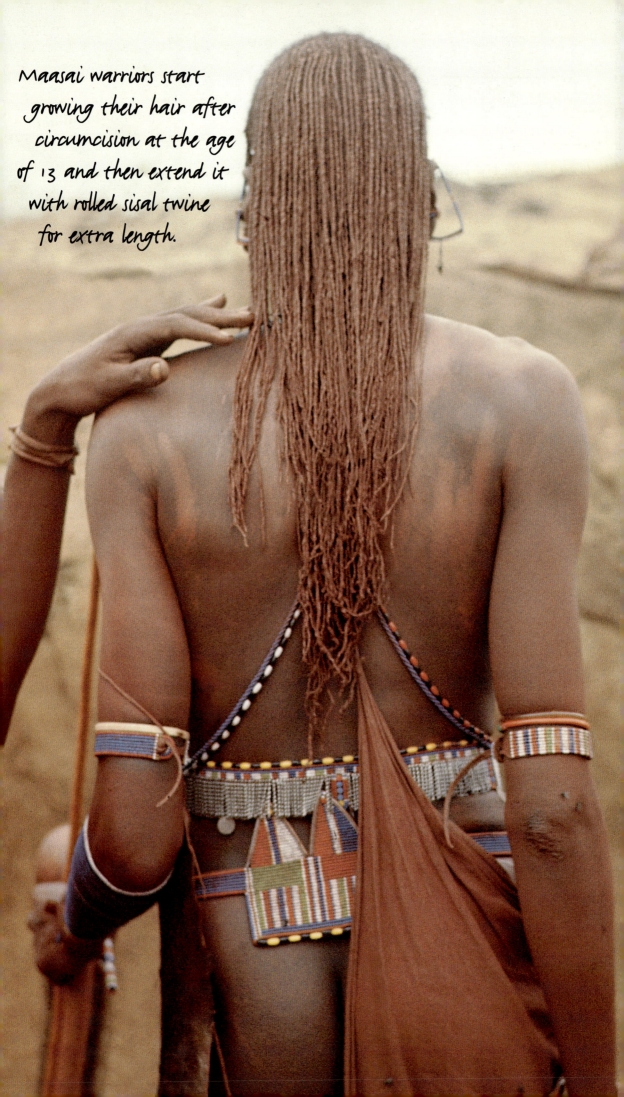

Maasai warriors start growing their hair after circumcision at the age of 13 and then extend it with rolled sisal twine for extra length.

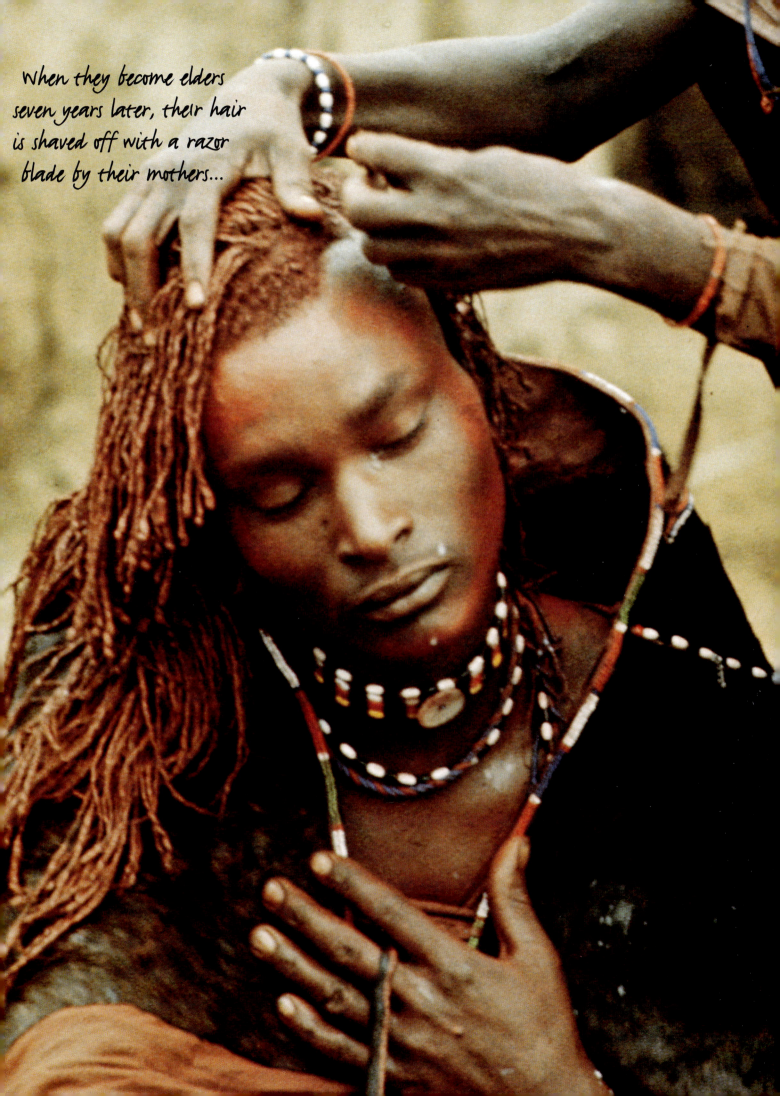

When they become elders
seven years later, their hair
is shaved off with a razor
blade by their mothers...

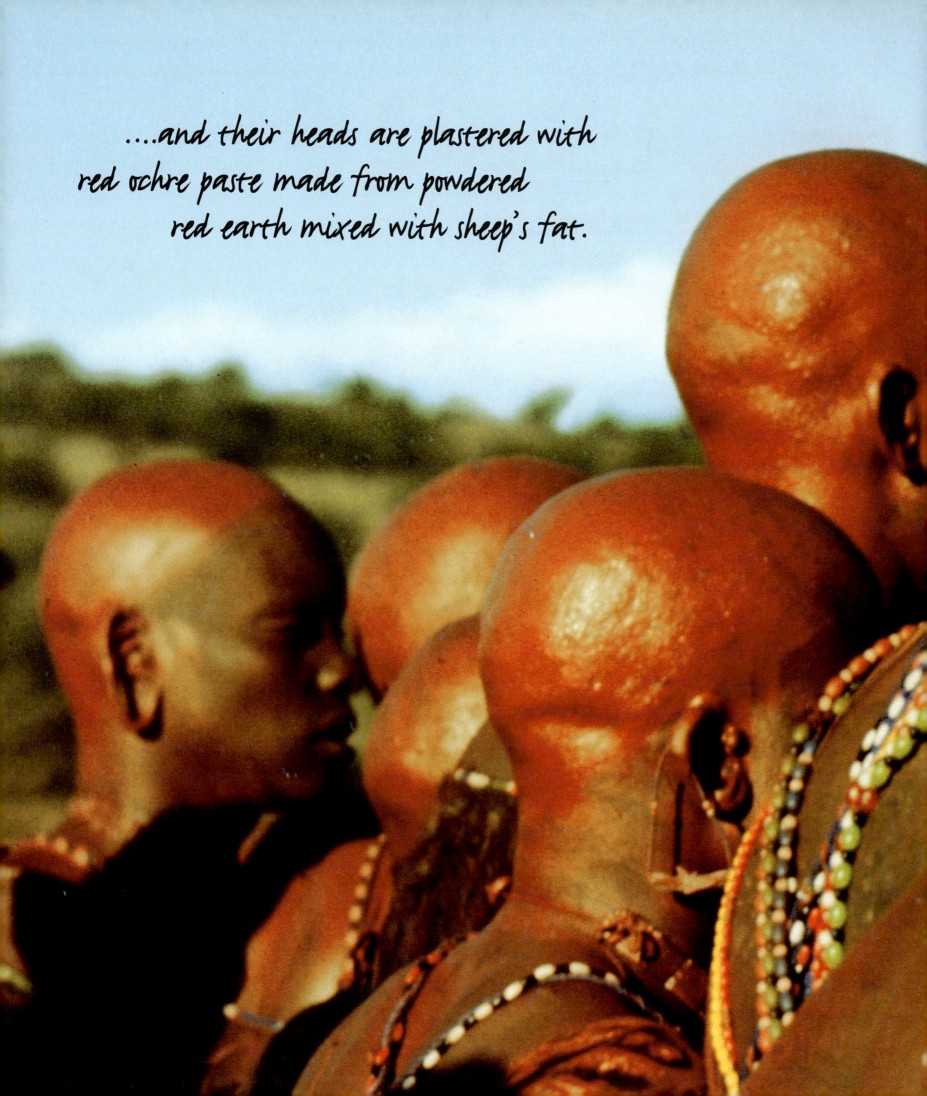

....and their heads are plastered with red ochre paste made from powdered red earth mixed with sheep's fat.

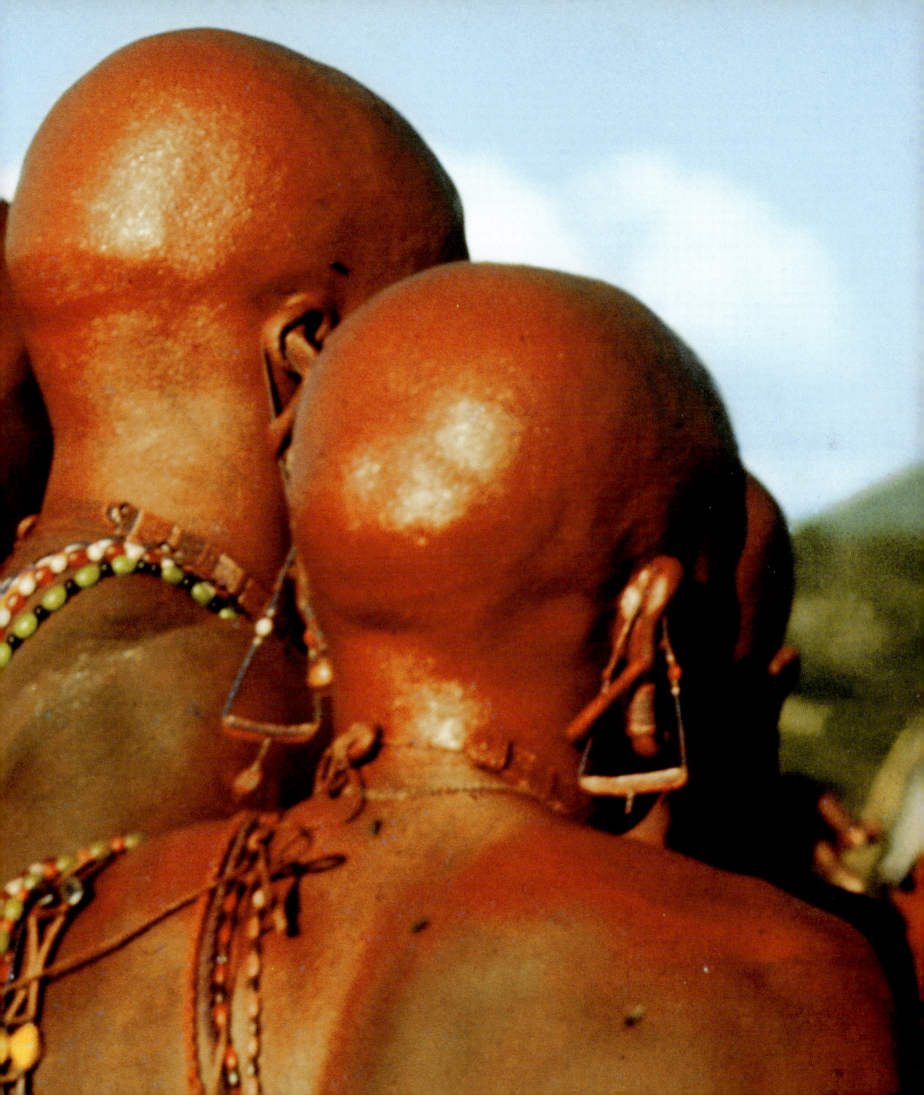

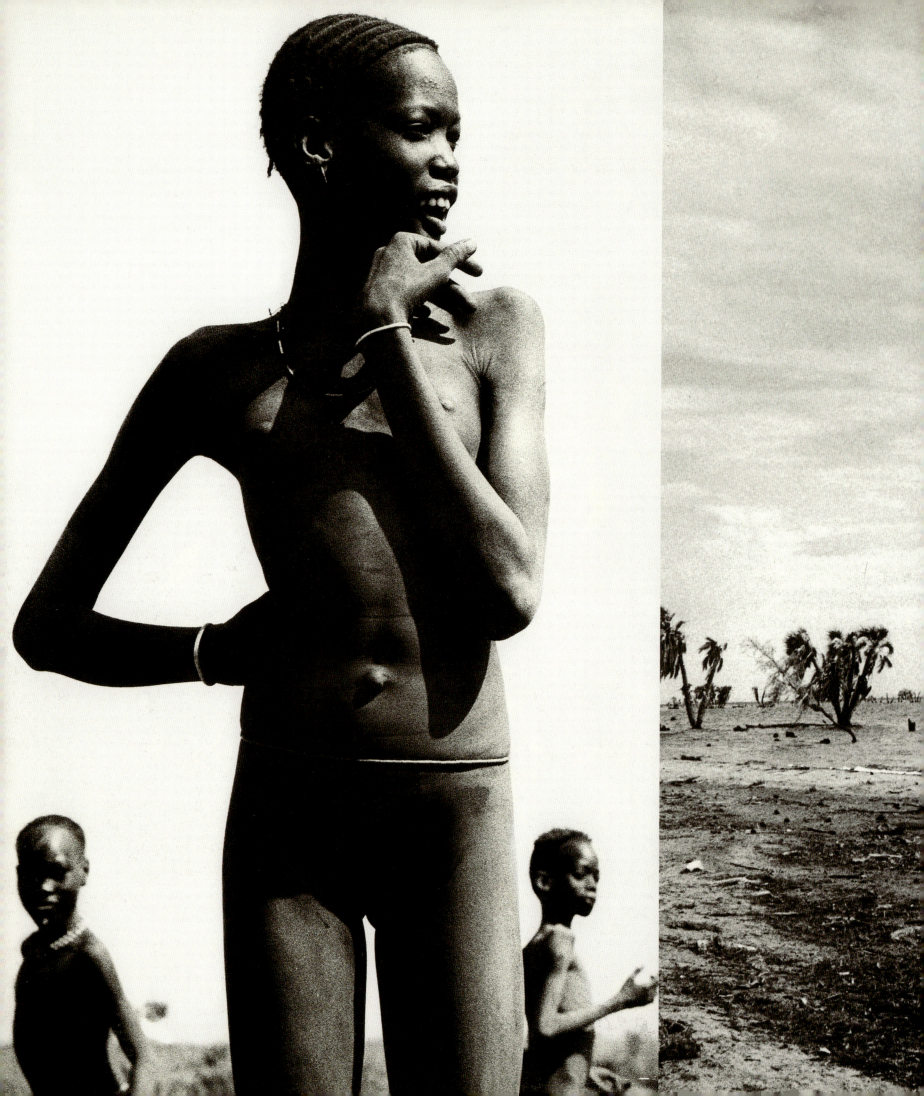

As I ventured forward capturing these timeless images
I stepped into a world where the essence
 of Africa was still intact...
But I did not then know for how long.

Lake Turkana, Northern Kenya, 1968

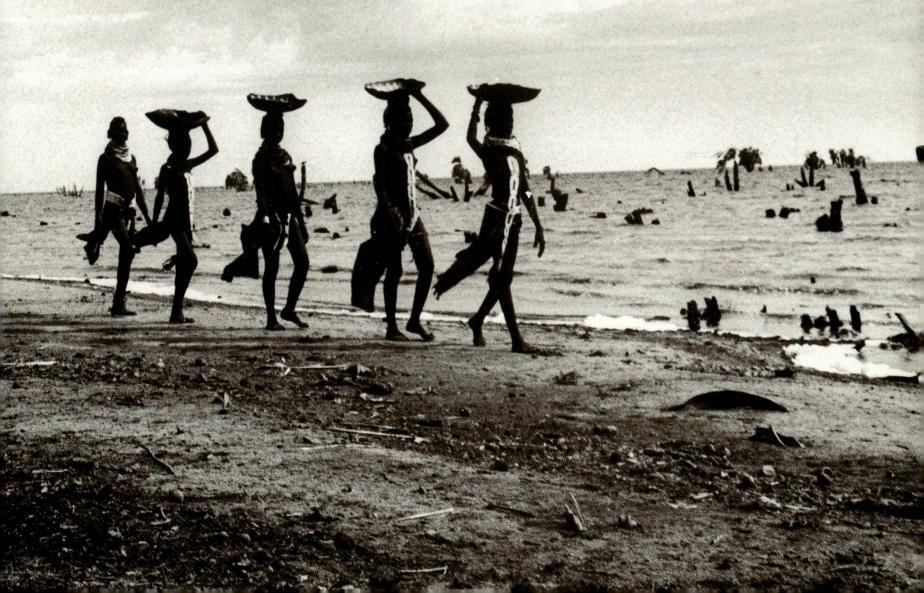

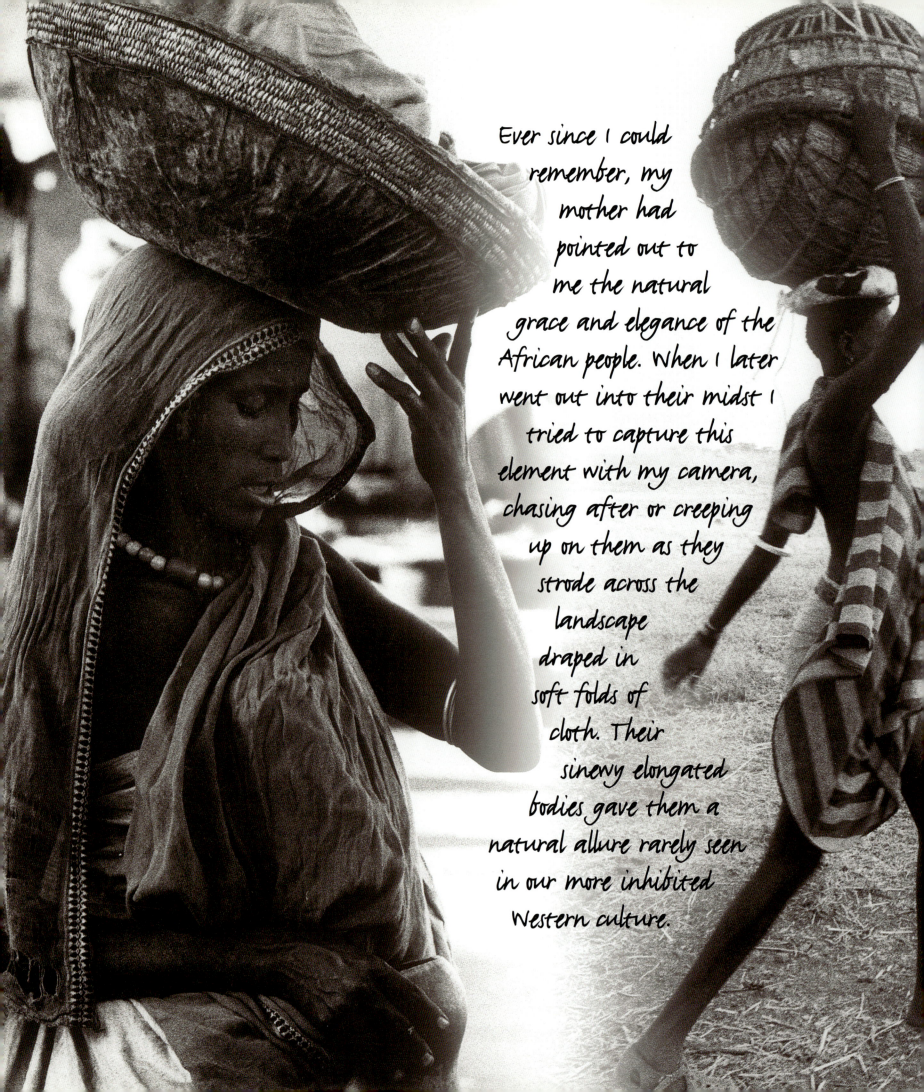

Ever since I could remember, my mother had pointed out to me the natural grace and elegance of the African people. When I later went out into their midst I tried to capture this element with my camera, chasing after or creeping up on them as they strode across the landscape draped in soft folds of cloth. Their sinewy elongated bodies gave them a natural allure rarely seen in our more inhibited Western culture.

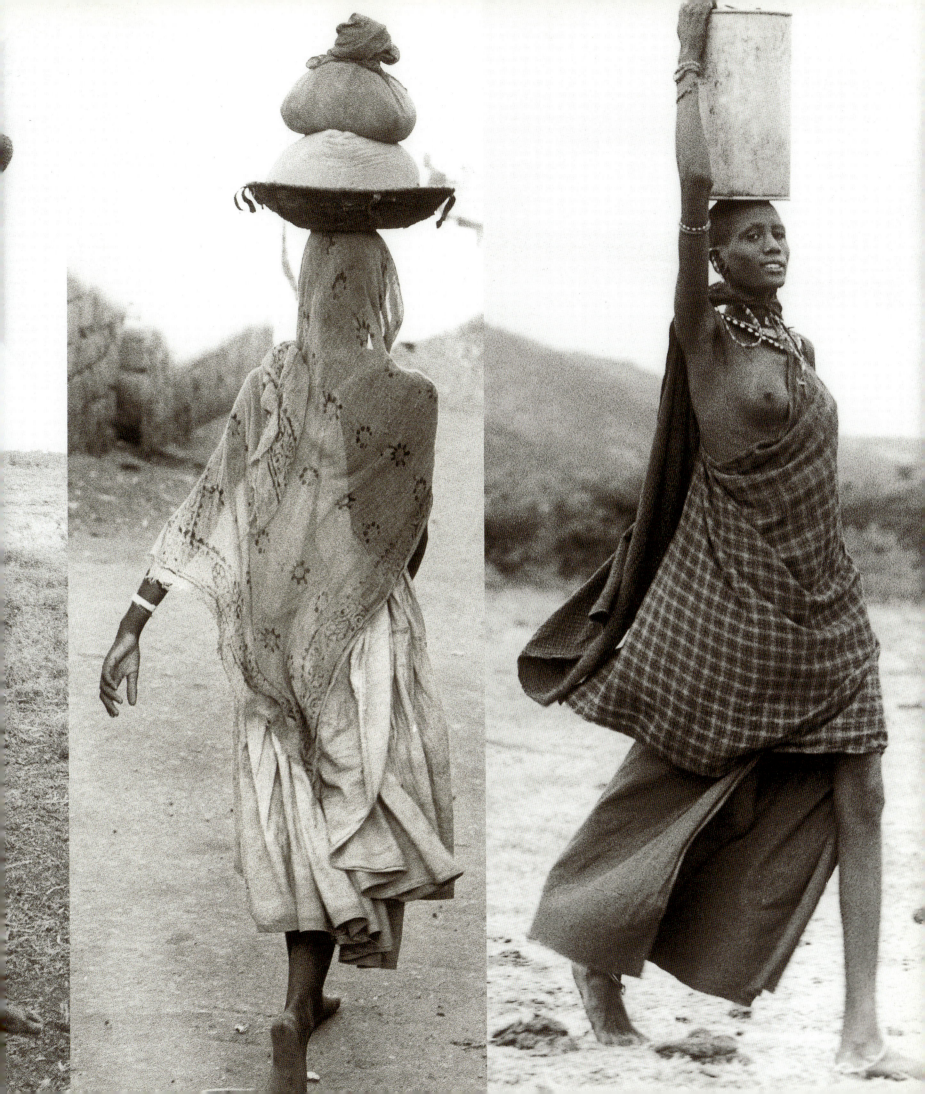

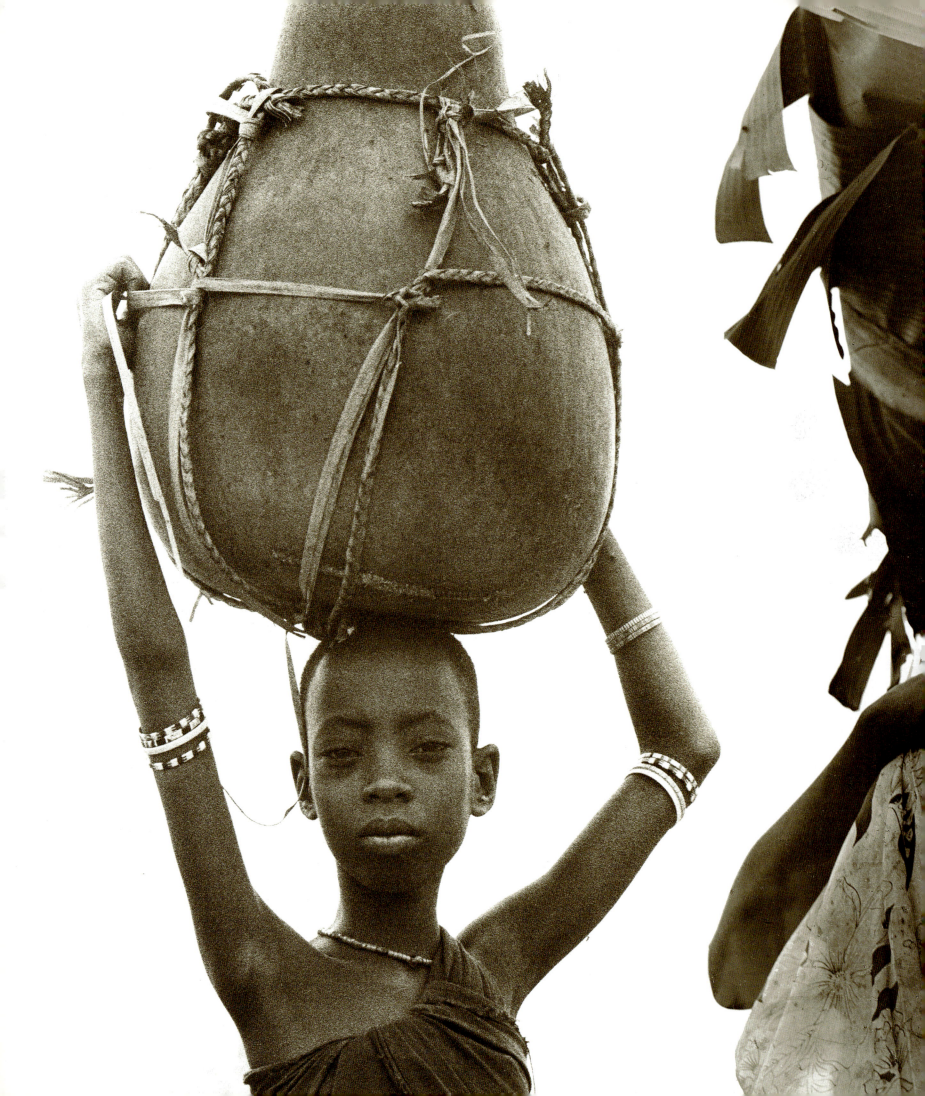

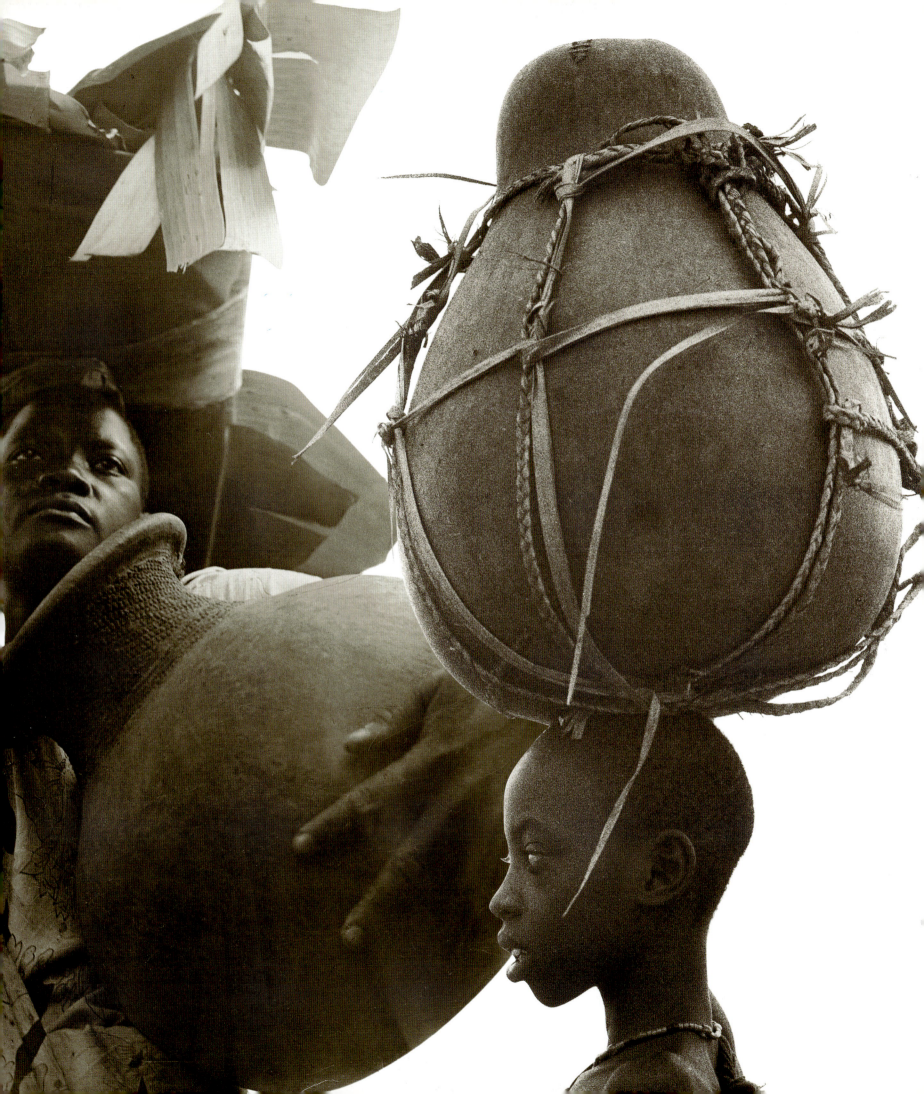

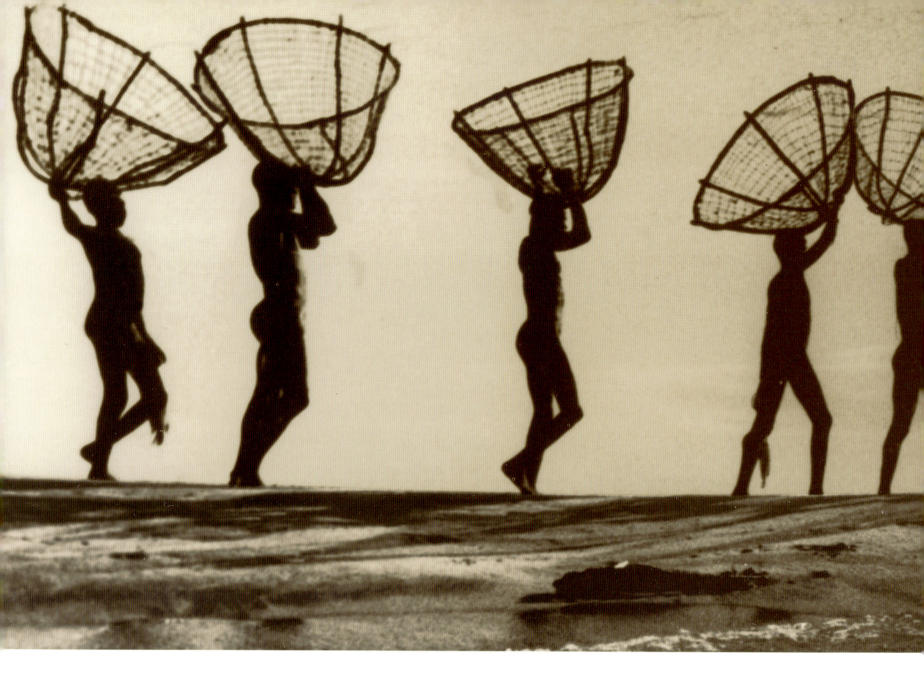

LAKE TURKANA IS an extraordinary phenomenon of nature. Set in some of the most inhospitable desert areas of East Africa, it is 185 miles long and 37 miles wide and rarely receives more than twelve to fourteen inches of rainfall a year. The water in the lake is so saline it is undrinkable and makes cultivating crops near the water impossible. The only vegetation which seems to thrive is a long spiky grass with woody stems and hardy desert doom palm. The Turkana dig holes as far as possible from the water's edge from which they draw the water for themselves and their herds of goats and camels.

The doum palm is put to every possible use: fishing rafts, punting poles and paddles are made from its light spongy wood, stems and leaves are used for making frames of fishing baskets, and thin strips of bark are turned into string. Leaves are used for thatching and the roots eaten as a vegetable although they have little nutritional value. The original mode of fishing was to stand waist-deep in the water to spear passing fish. Another, slightly haphazard, method is to form a large semi-circle of people, who plunge the cone-shaped baskets into the water moving towards the centre. Any trapped fish are then extricated by hand from an opening inside the cone. But now the government of Kenya is providing large Japanese nets that pull in much heavier catches which are then sundried and sent into the interior of the country. The tilapia and giant Nile perch which weigh up to 170 pounds each are of high nutritional value. Crocodiles are frequently found entangled in the nets and are also a source of food in these arid surroundings. Fishermen are often maimed or killed by them. In recent years long Cesse canoes with outboard motors have been introduced to the lake and are slowly robbing the lake of much of its magic and the primitive beauty which had existed while the people solved their problems by means offered to them by nature.

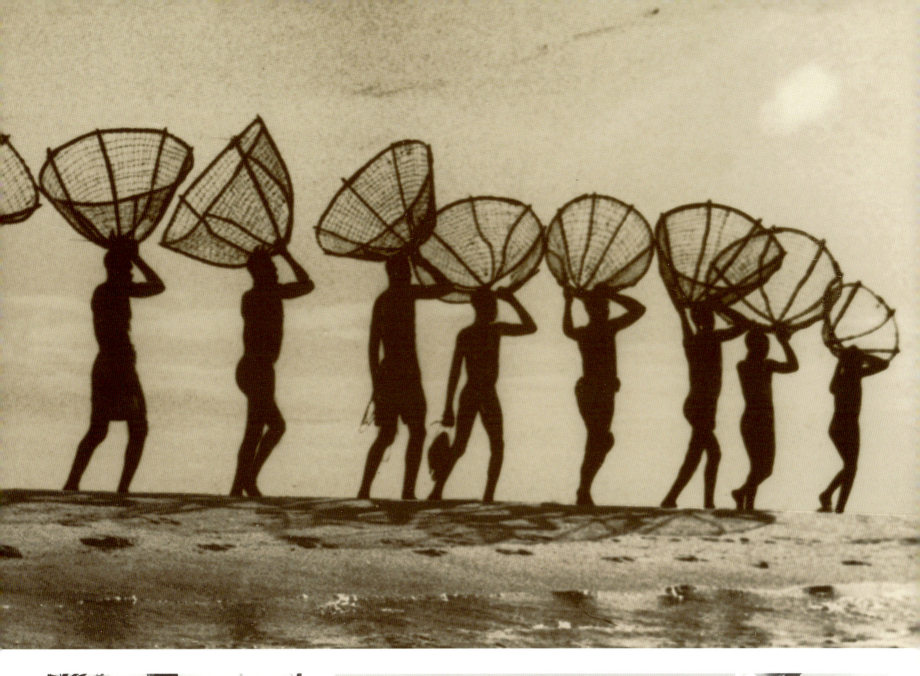

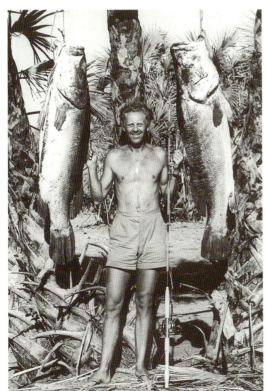

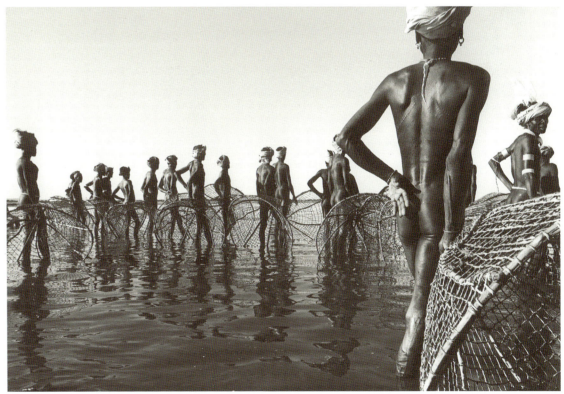

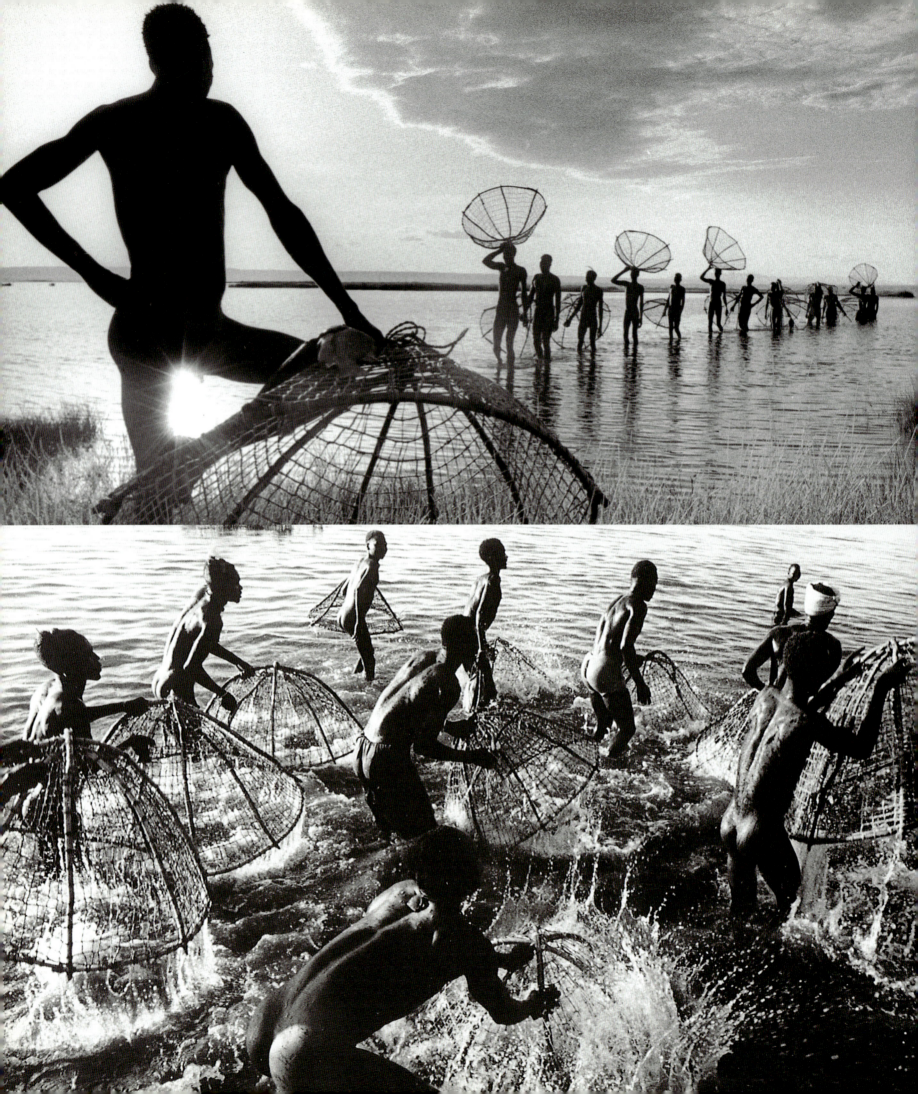

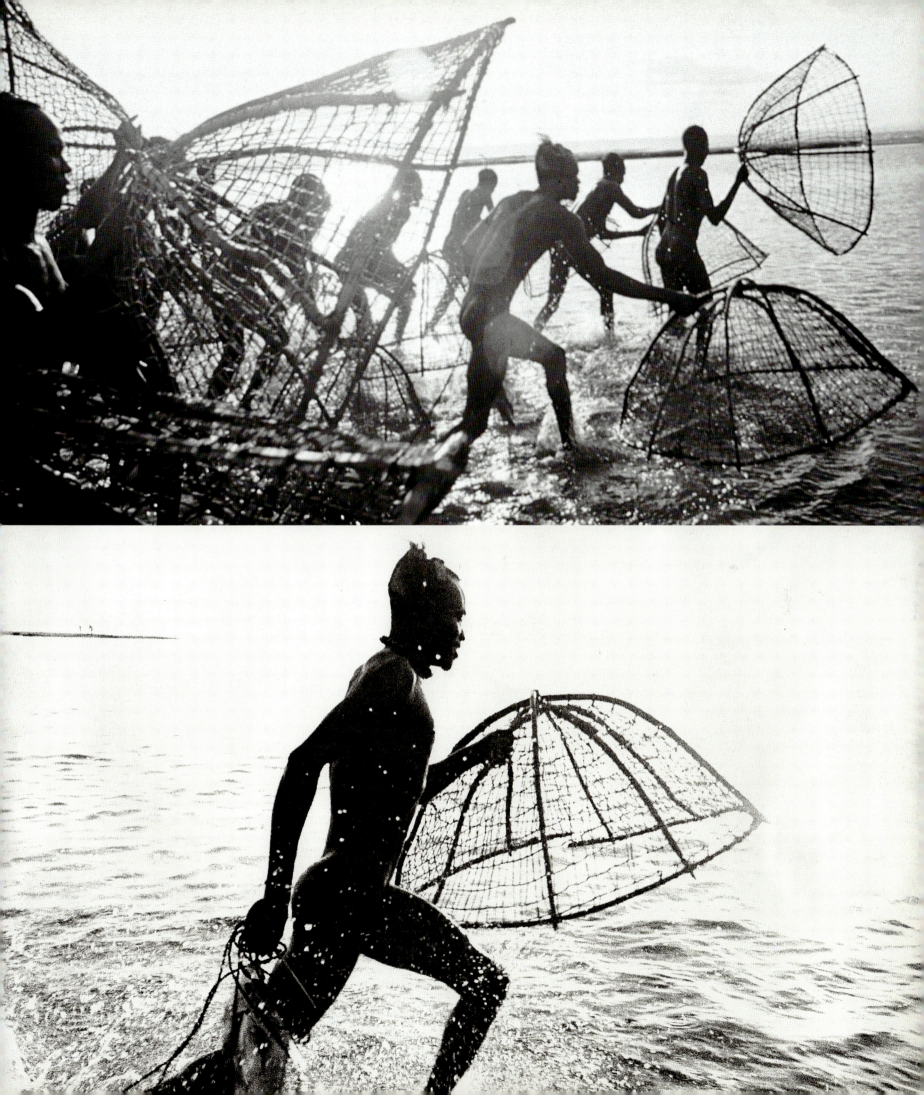

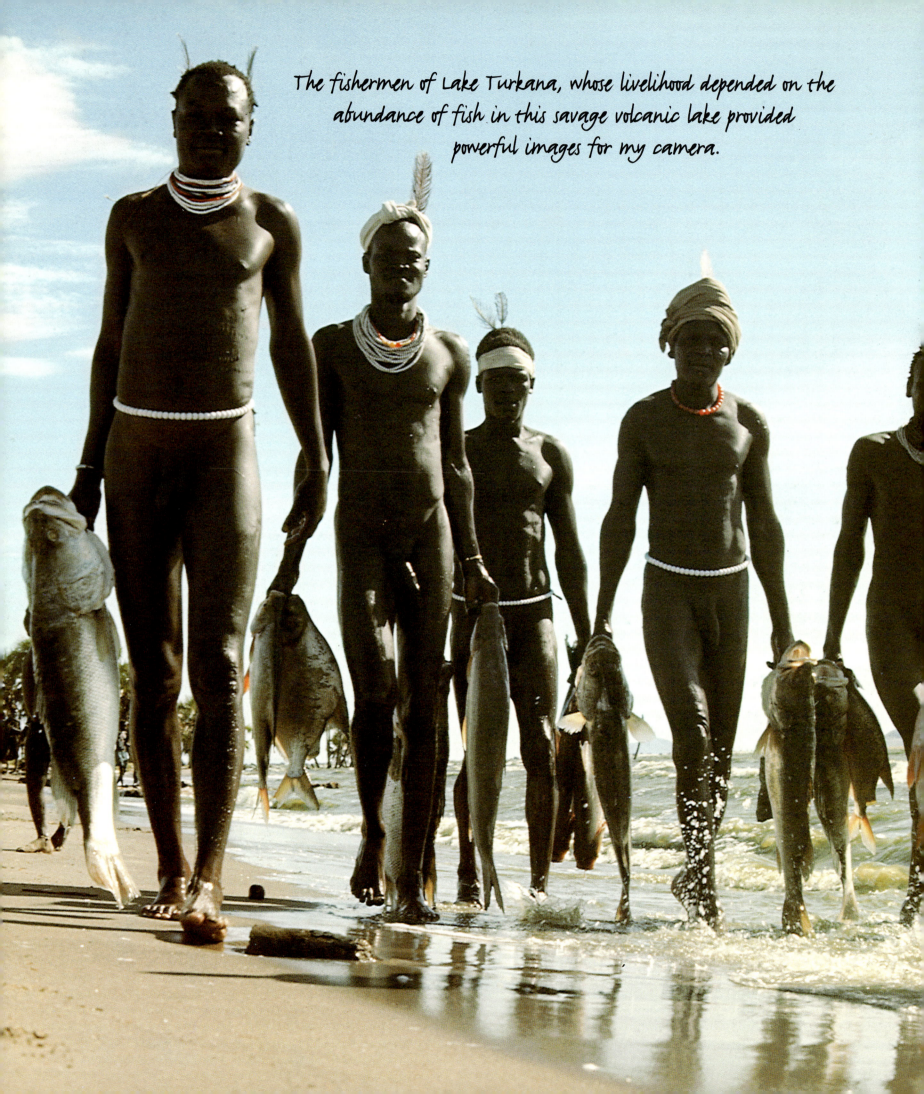

The fishermen of Lake Turkana, whose livelihood depended on the abundance of fish in this savage volcanic lake provided powerful images for my camera.

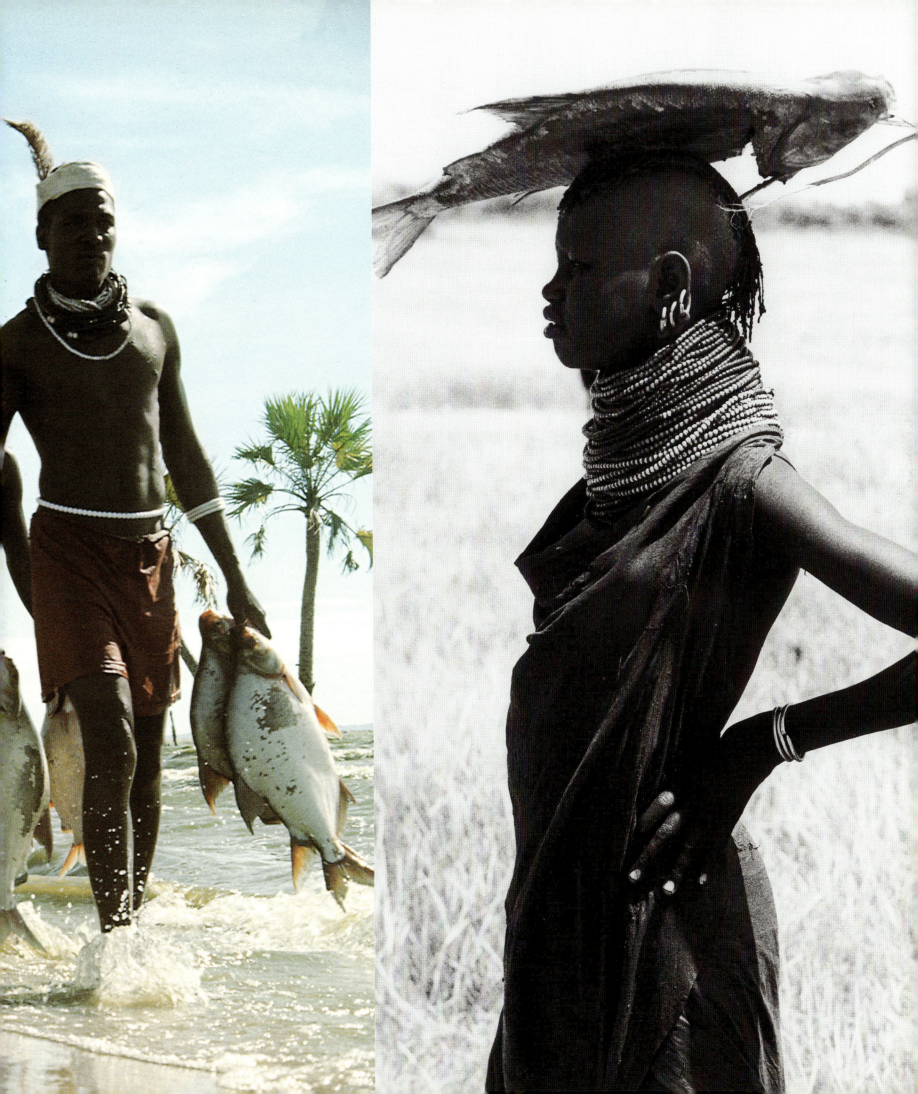

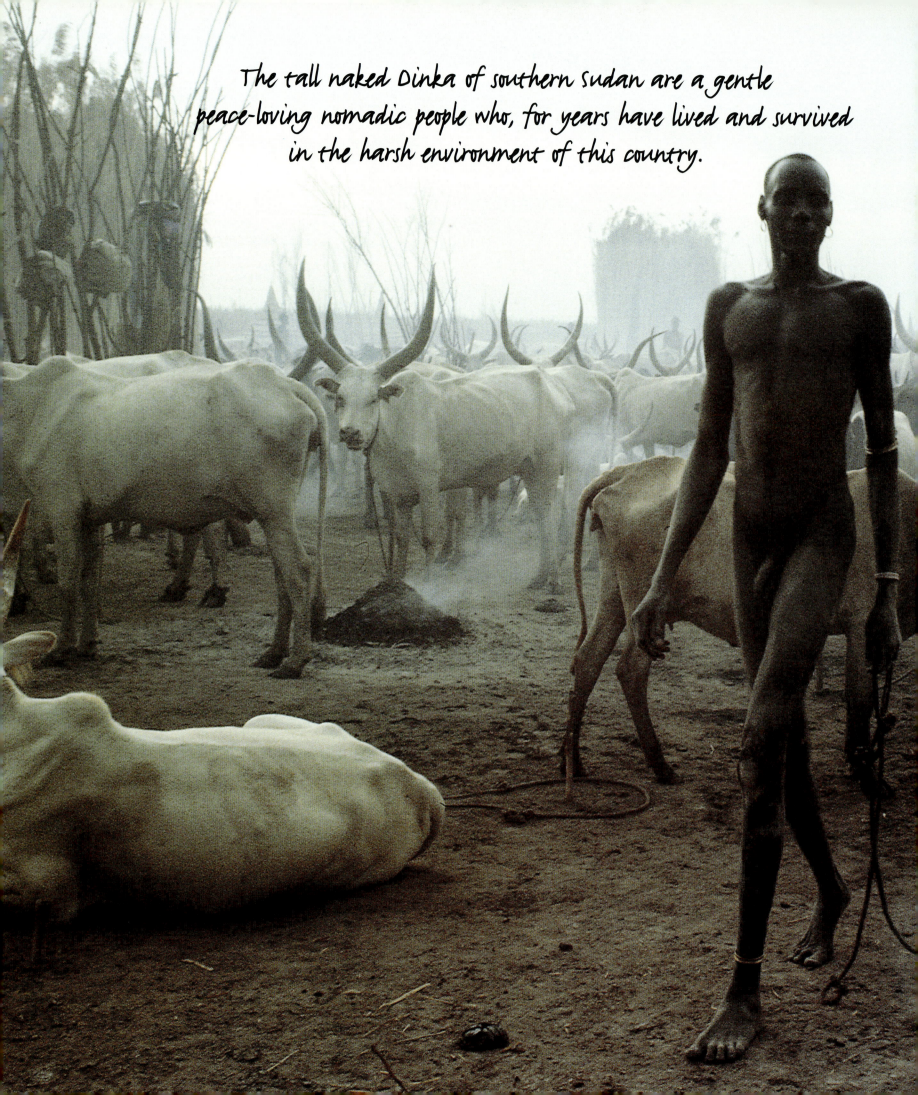

The tall naked Dinka of southern Sudan are a gentle
peace-loving nomadic people who, for years have lived and survived
in the harsh environment of this country.

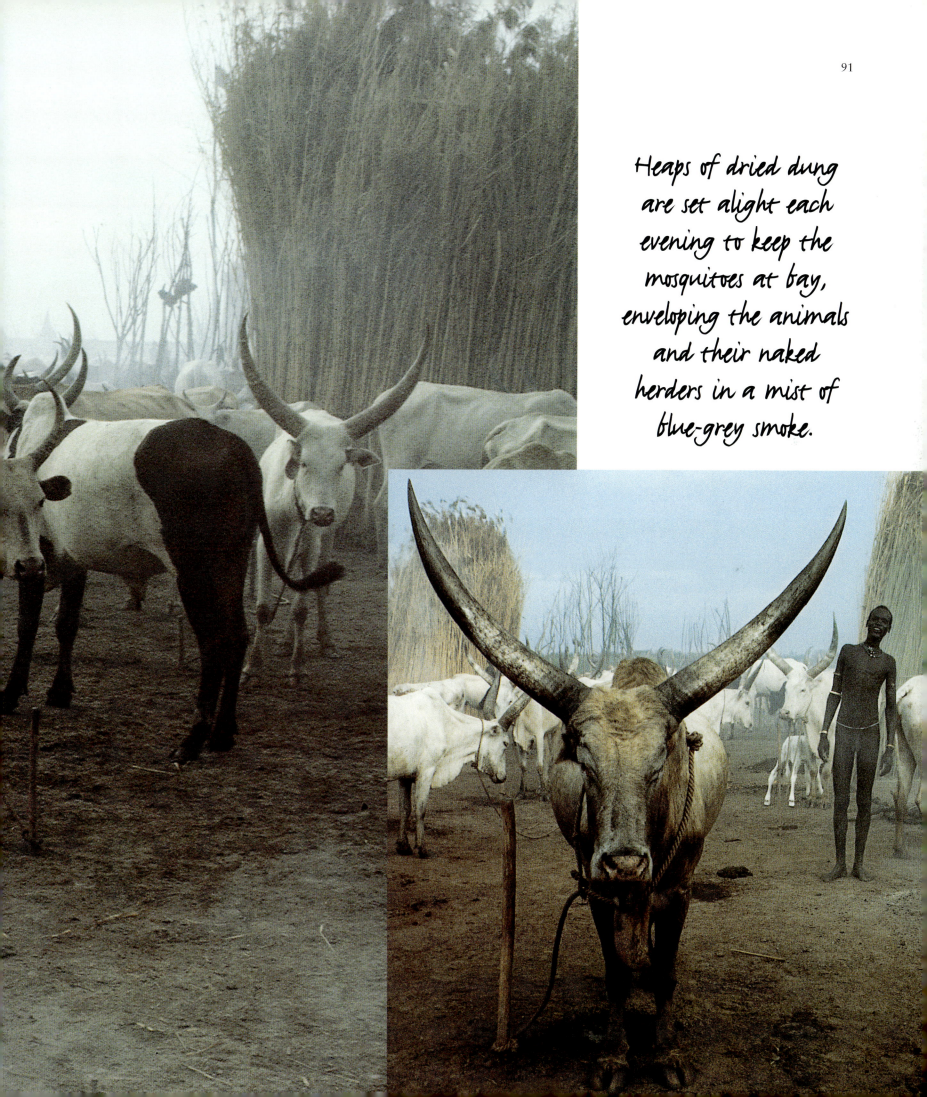

Heaps of dried dung
are set alight each
evening to keep the
mosquitoes at bay,
enveloping the animals
and their naked
herders in a mist of
blue-grey smoke.

In semi-arid northern Kenya, water
is hard to find...when it rains it
rushes in great torrents down the
dry riverbeds, carrying everything
in its wake. In the dry season the
water disappears beneath the sand and
must be dug out by hand,
sometimes 10 feet down, in
order to water the camels and
goats...watering scenes take on an
almost biblical feeling.

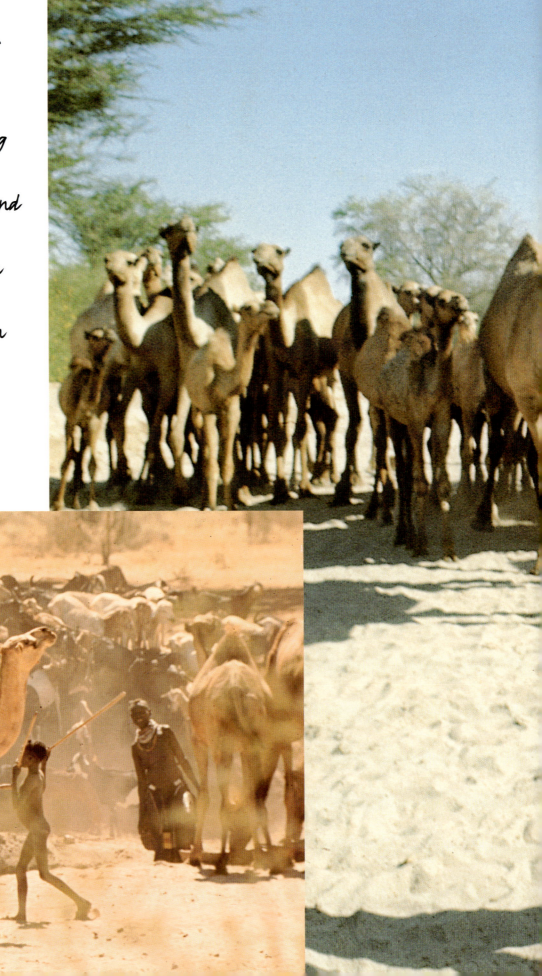

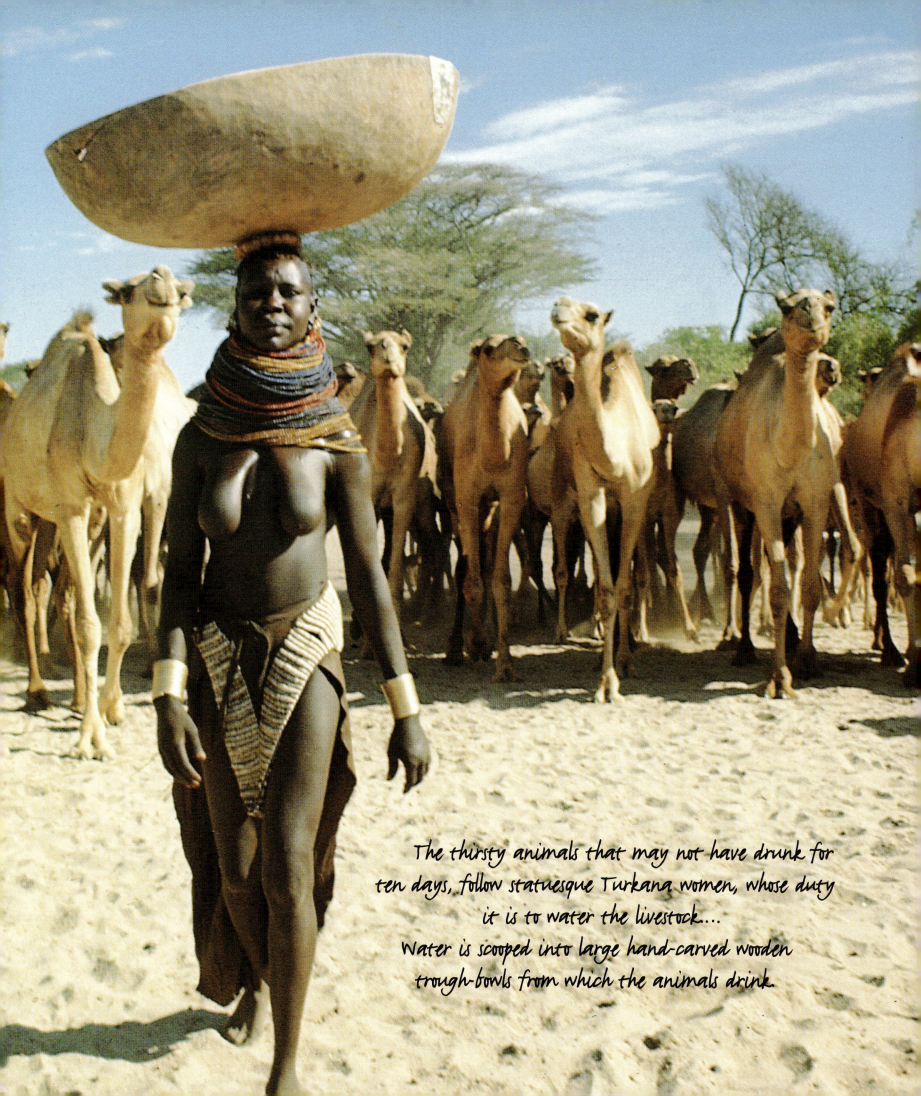

The thirsty animals that may not have drunk for
ten days, follow statuesque Turkana women, whose duty
it is to water the livestock....
Water is scooped into large hand-carved wooden
trough-bowls from which the animals drink.

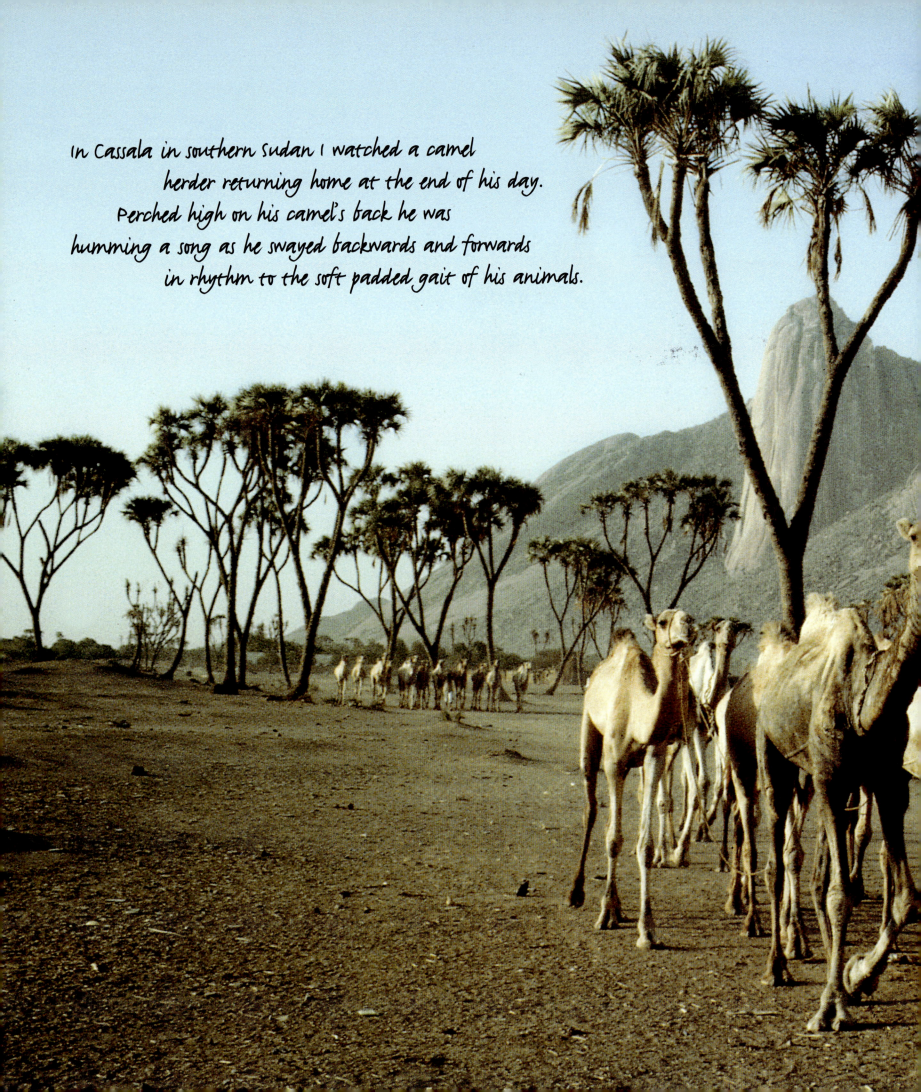

In Cassala in southern Sudan I watched a camel
herder returning home at the end of his day.
Perched high on his camel's back he was
humming a song as he swayed backwards and forwards
in rhythm to the soft padded gait of his animals.

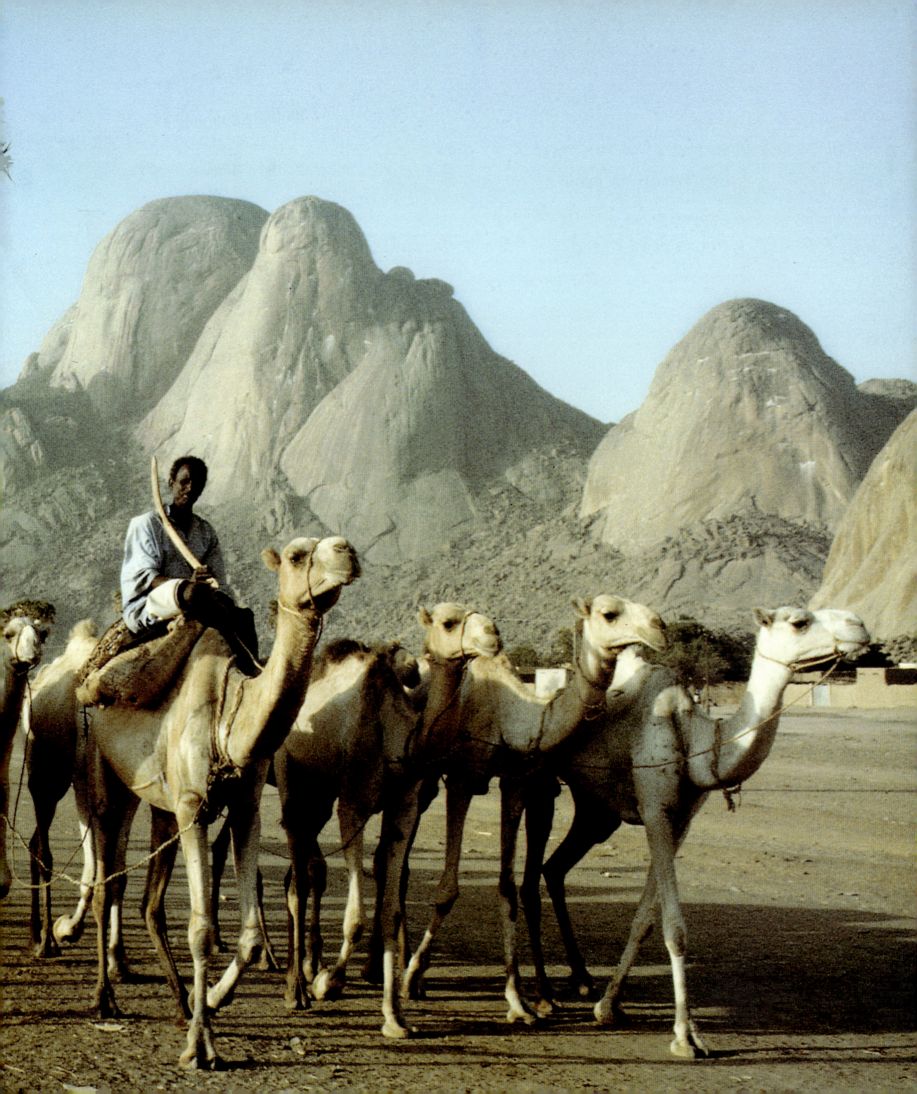

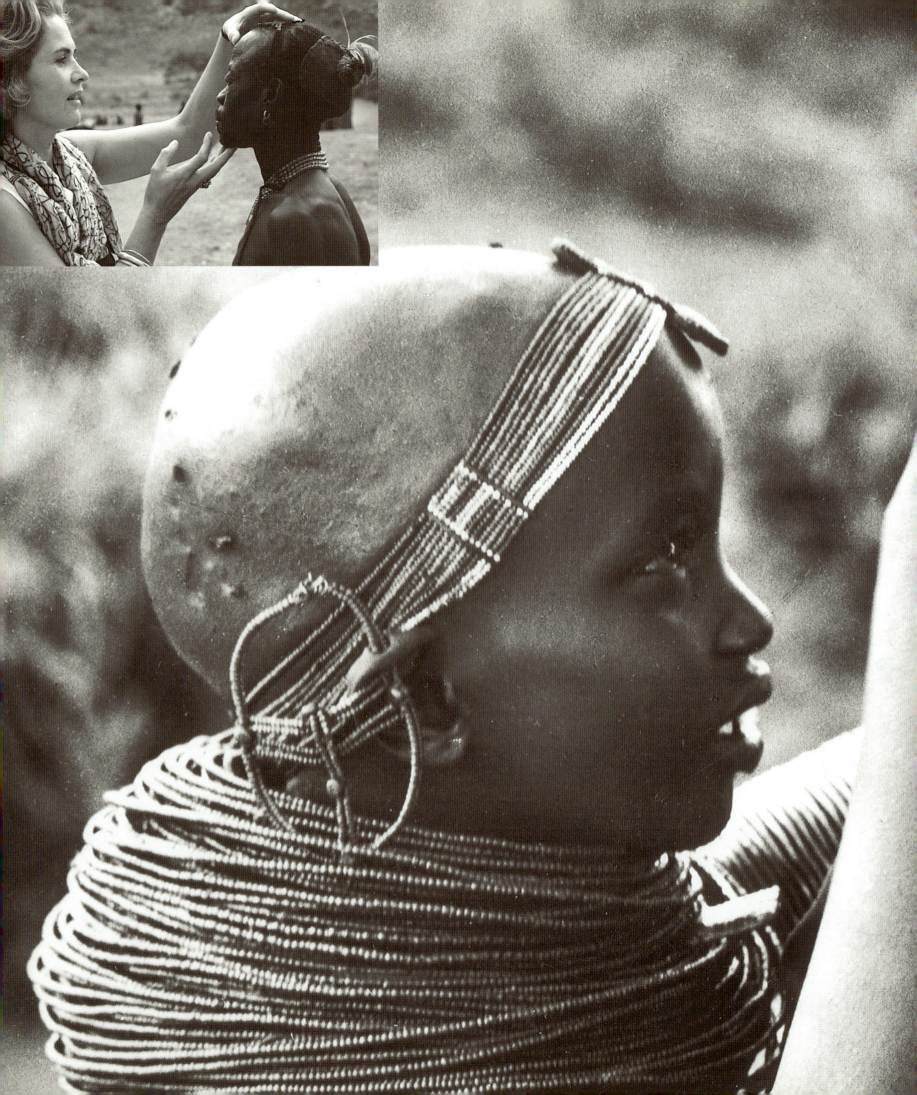

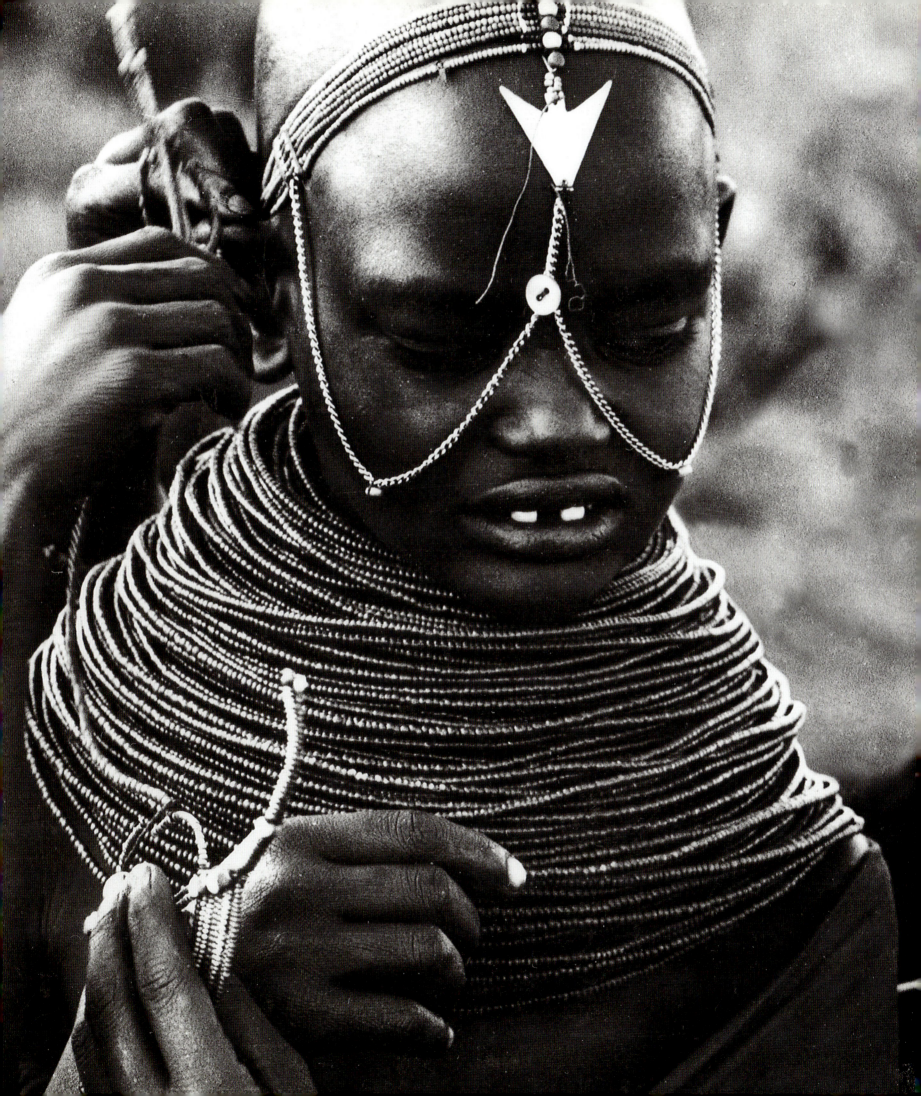

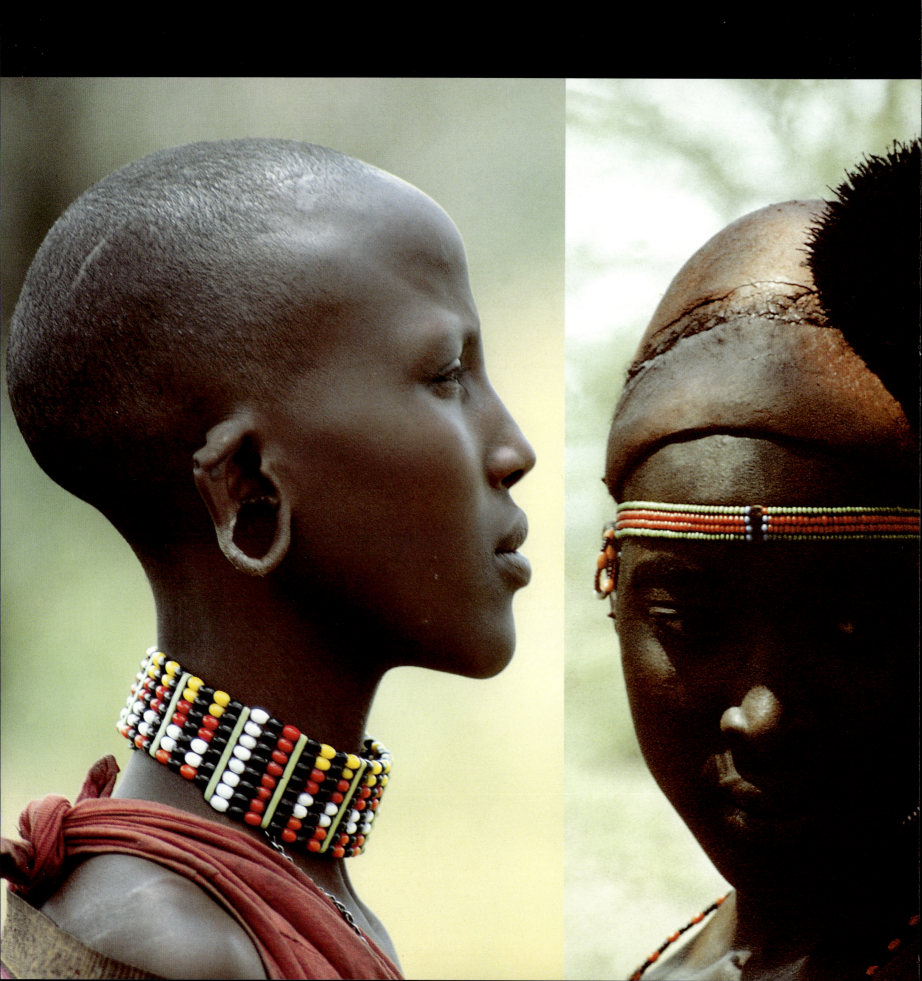

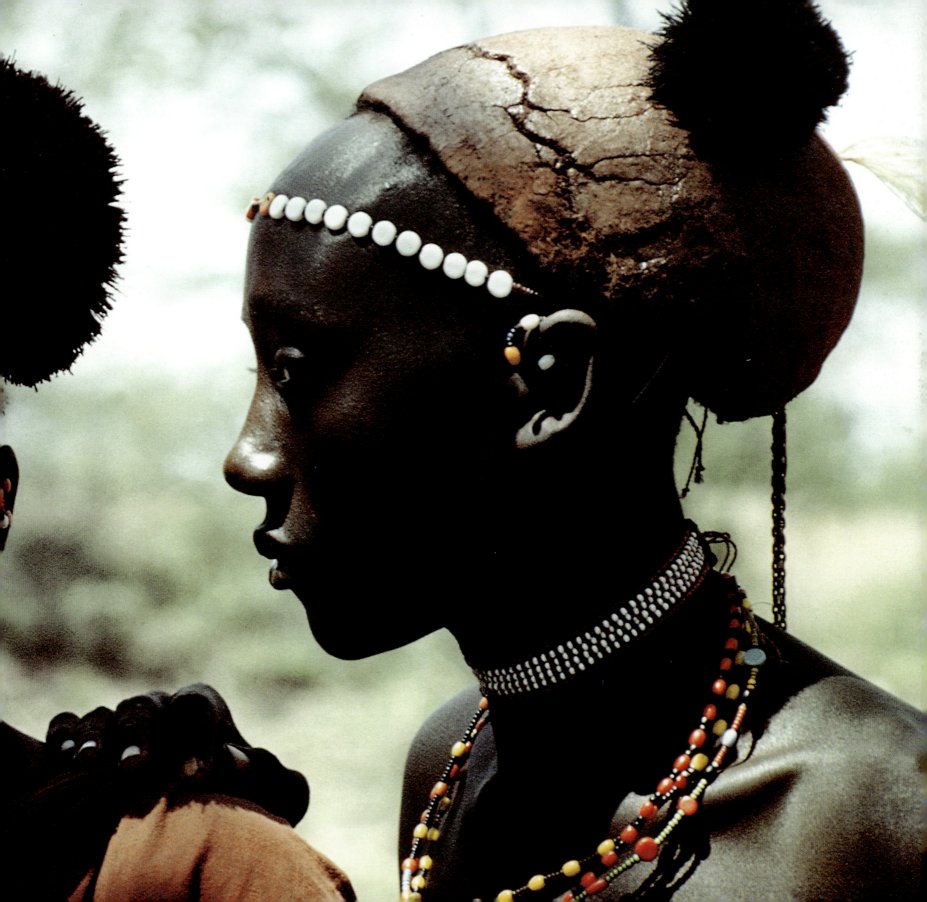

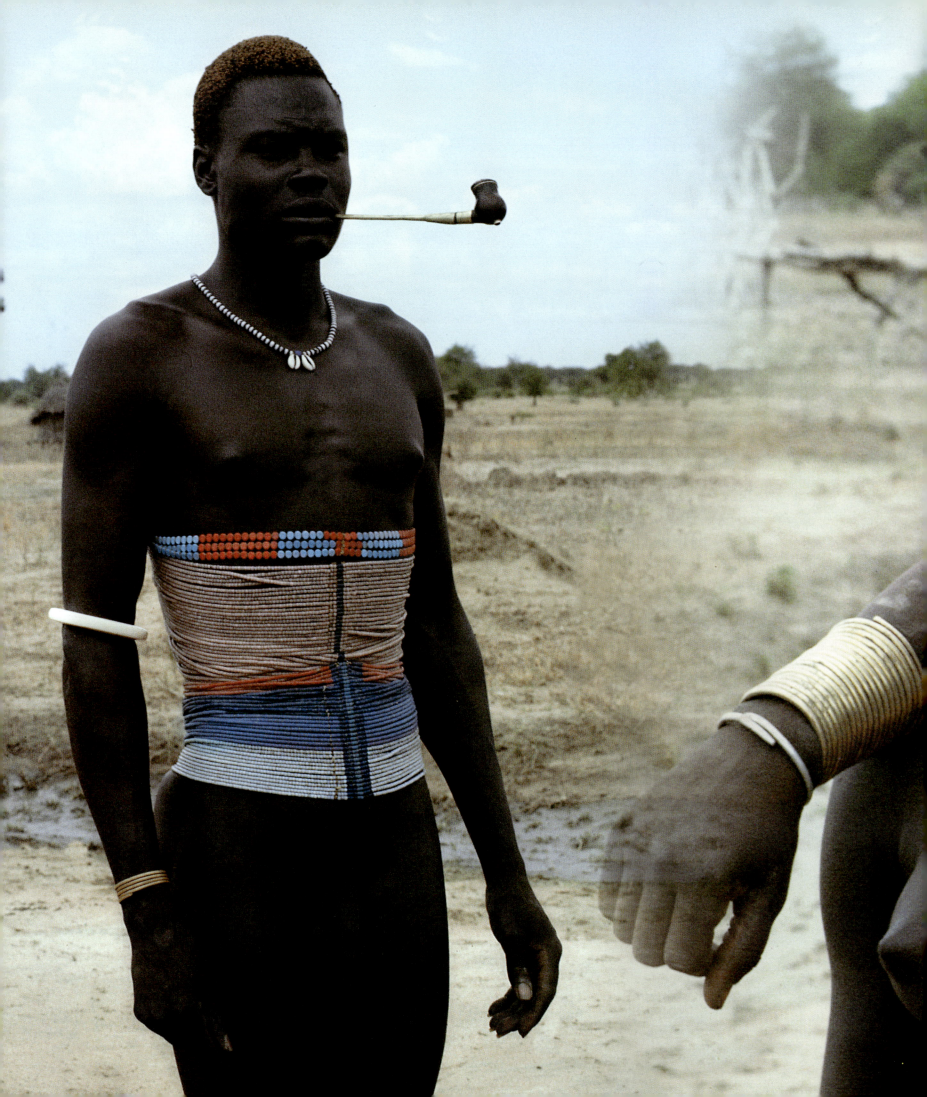

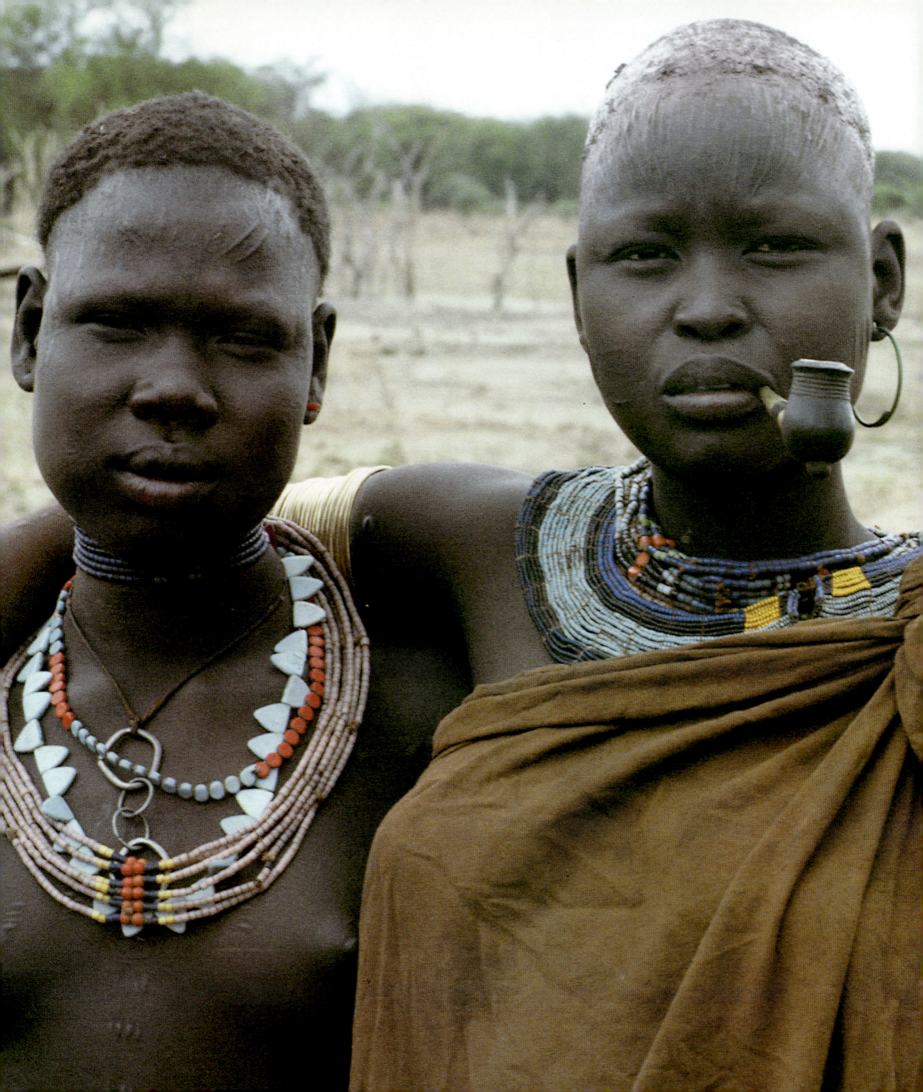

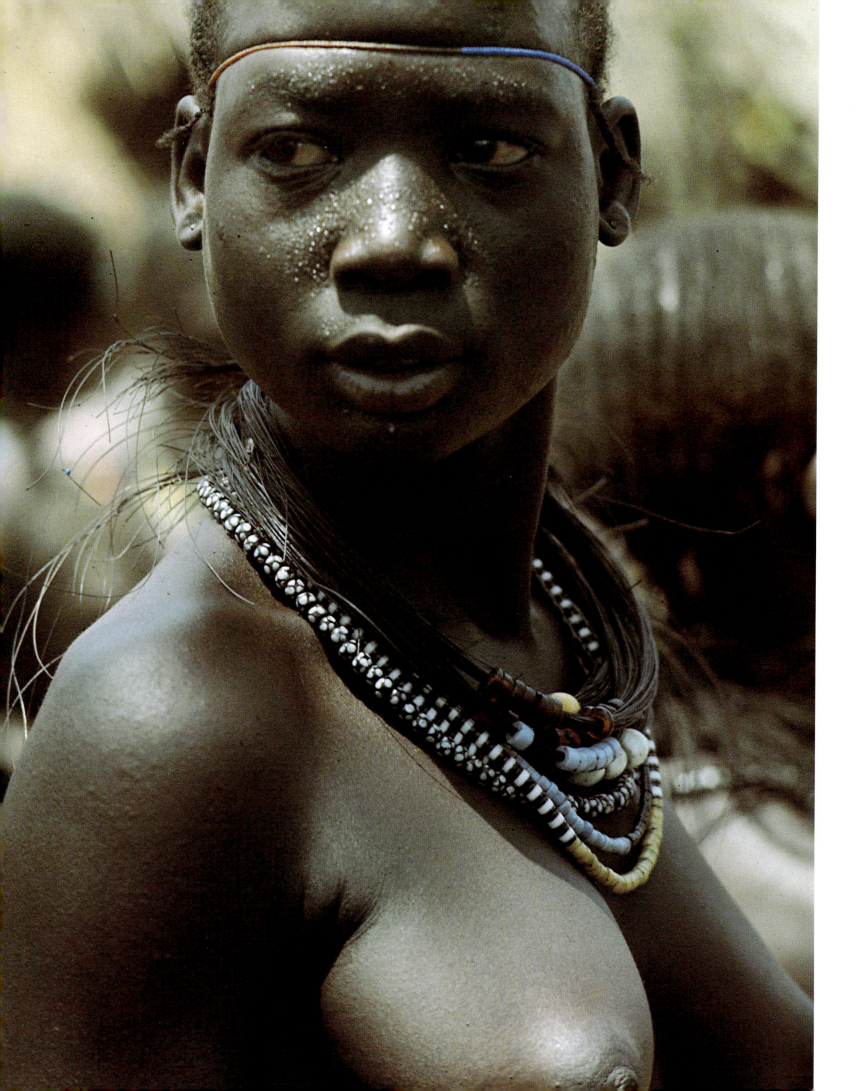

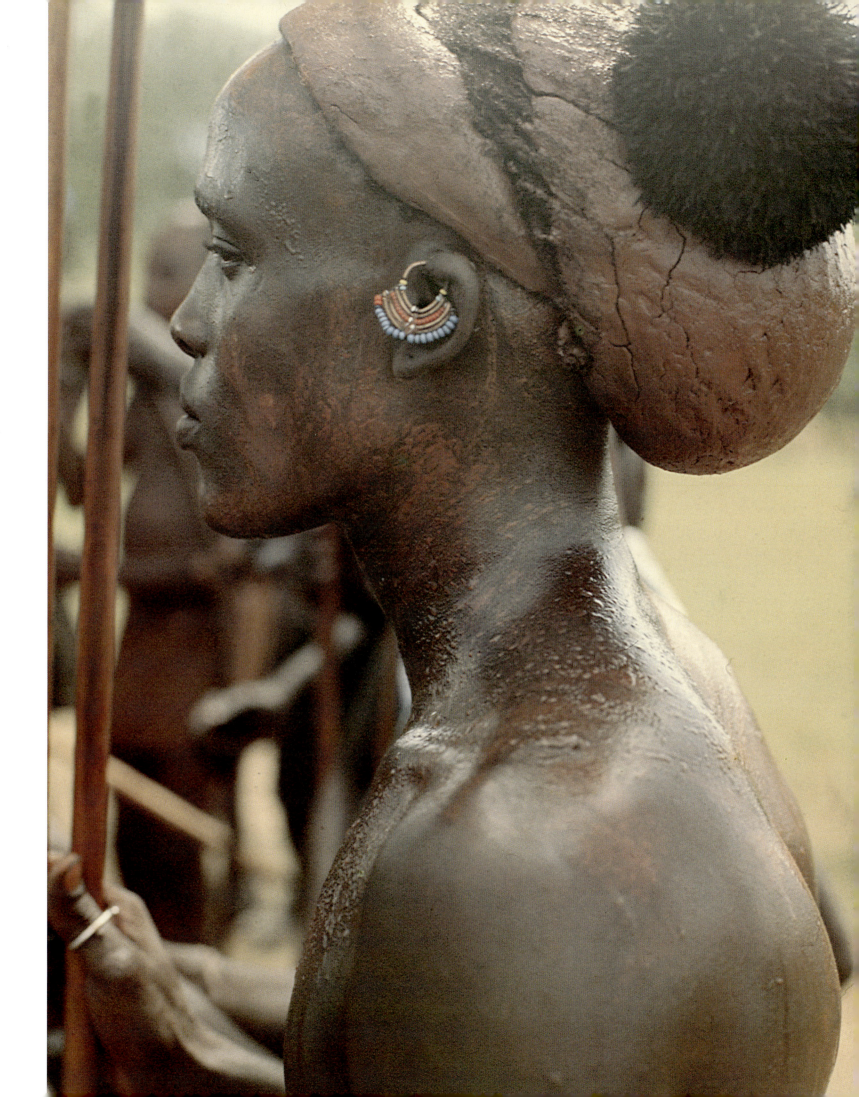

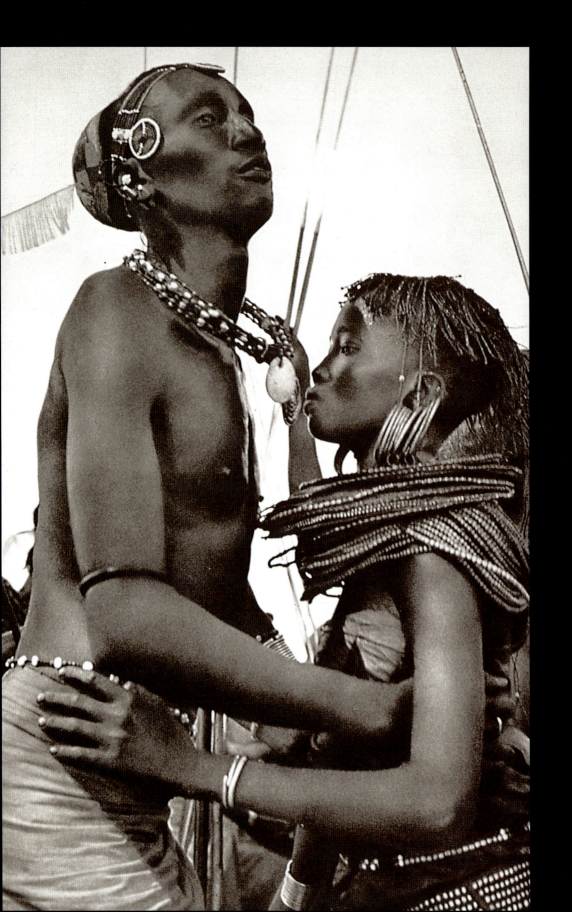

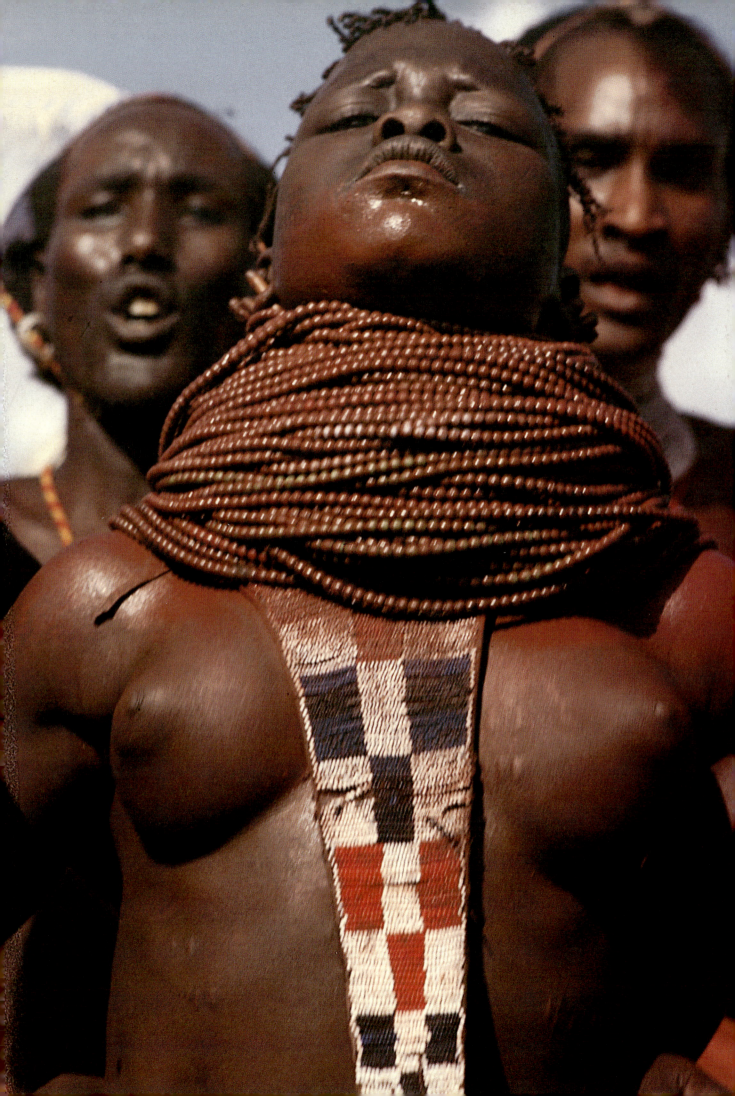

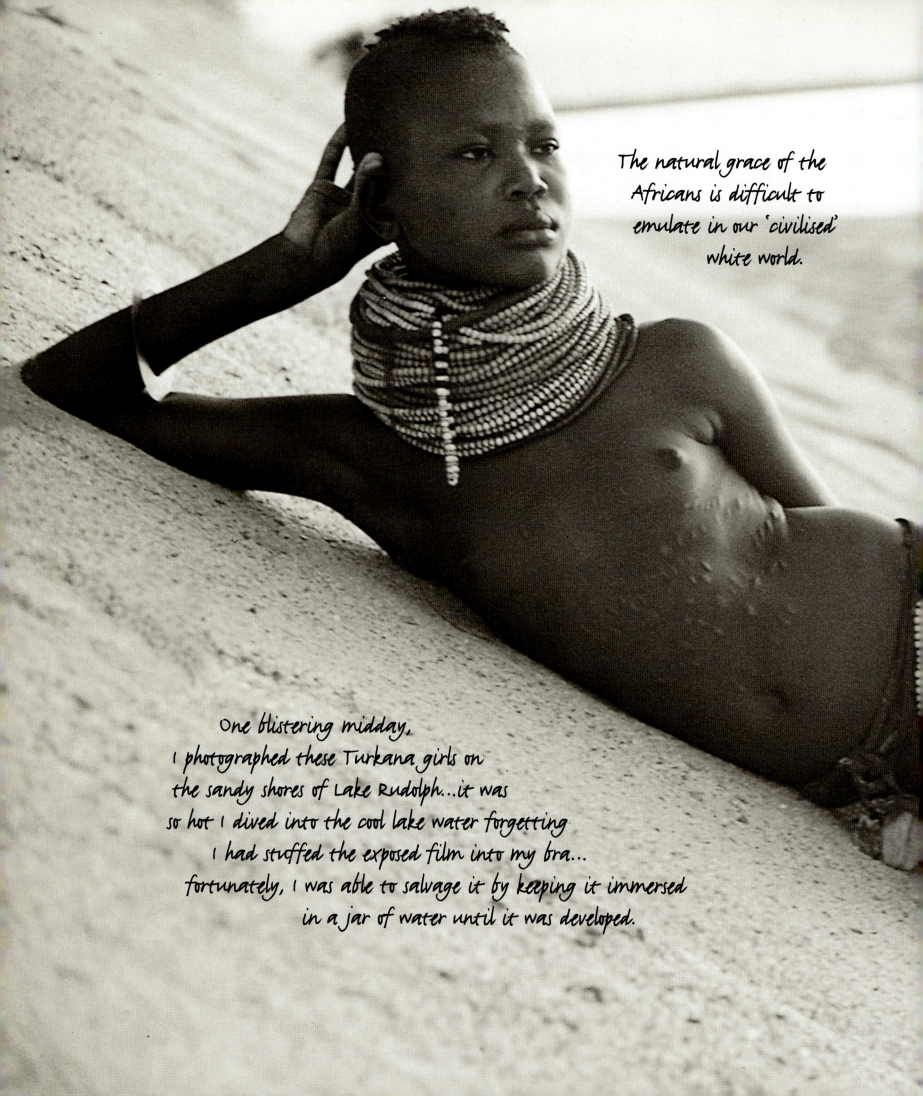

The natural grace of the
Africans is difficult to
emulate in our 'civilised'
white world.

One blistering midday,
I photographed these Turkana girls on
the sandy shores of Lake Rudolph...it was
so hot I dived into the cool lake water forgetting
I had stuffed the exposed film into my bra...
fortunately, I was able to salvage it by keeping it immersed
in a jar of water until it was developed.

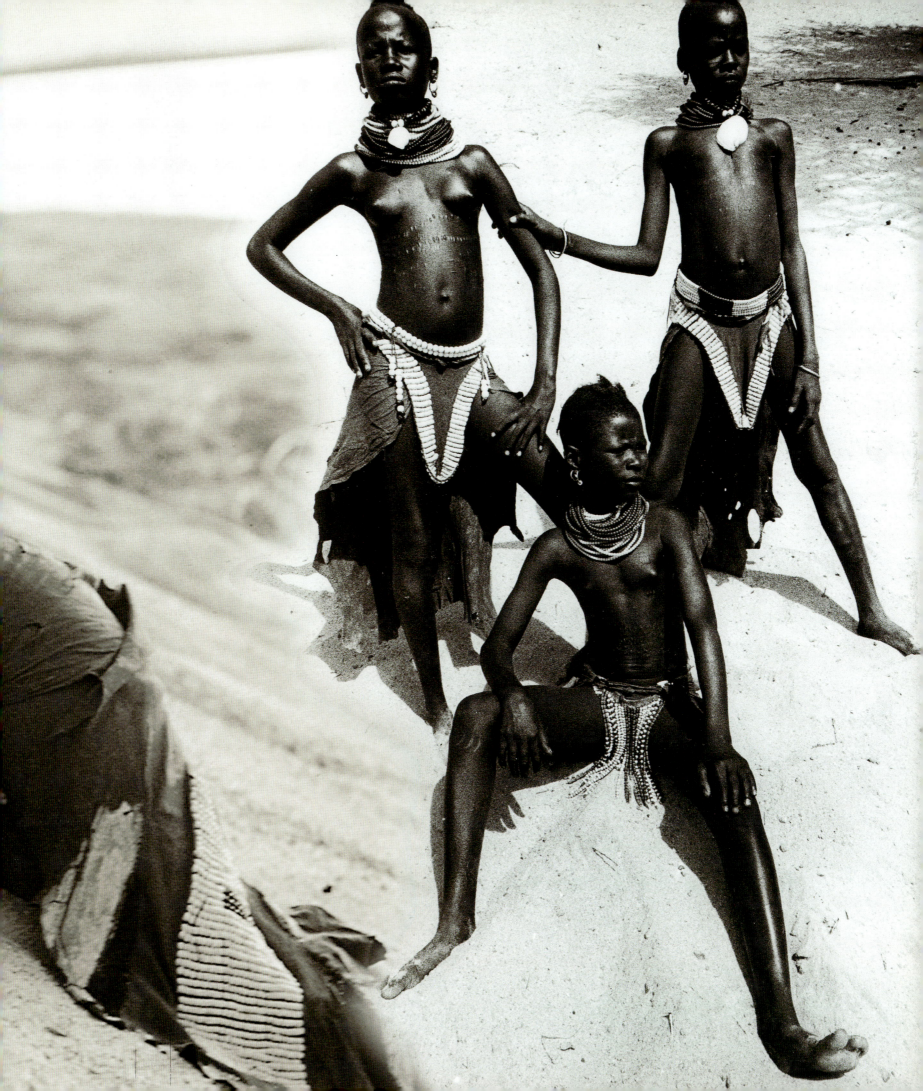

'Do you remember when the first white people arrived?' I asked.

For a while they did not speak.
'They were so white, with pale blue eyes and long straight hair that looked like sisal fibre and they turned red in the sun....'

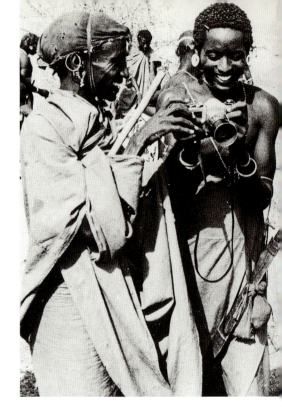

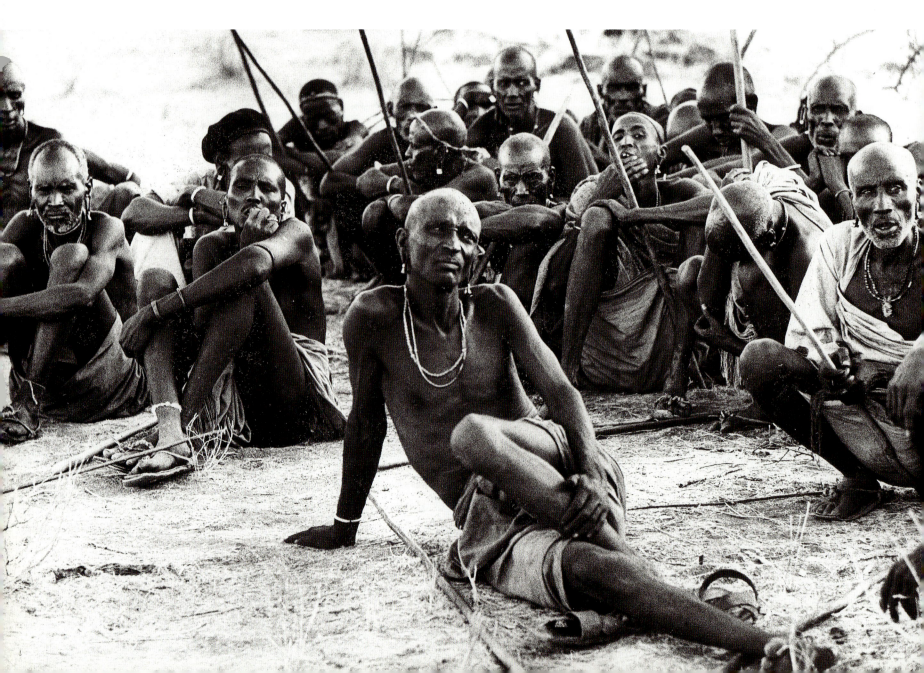

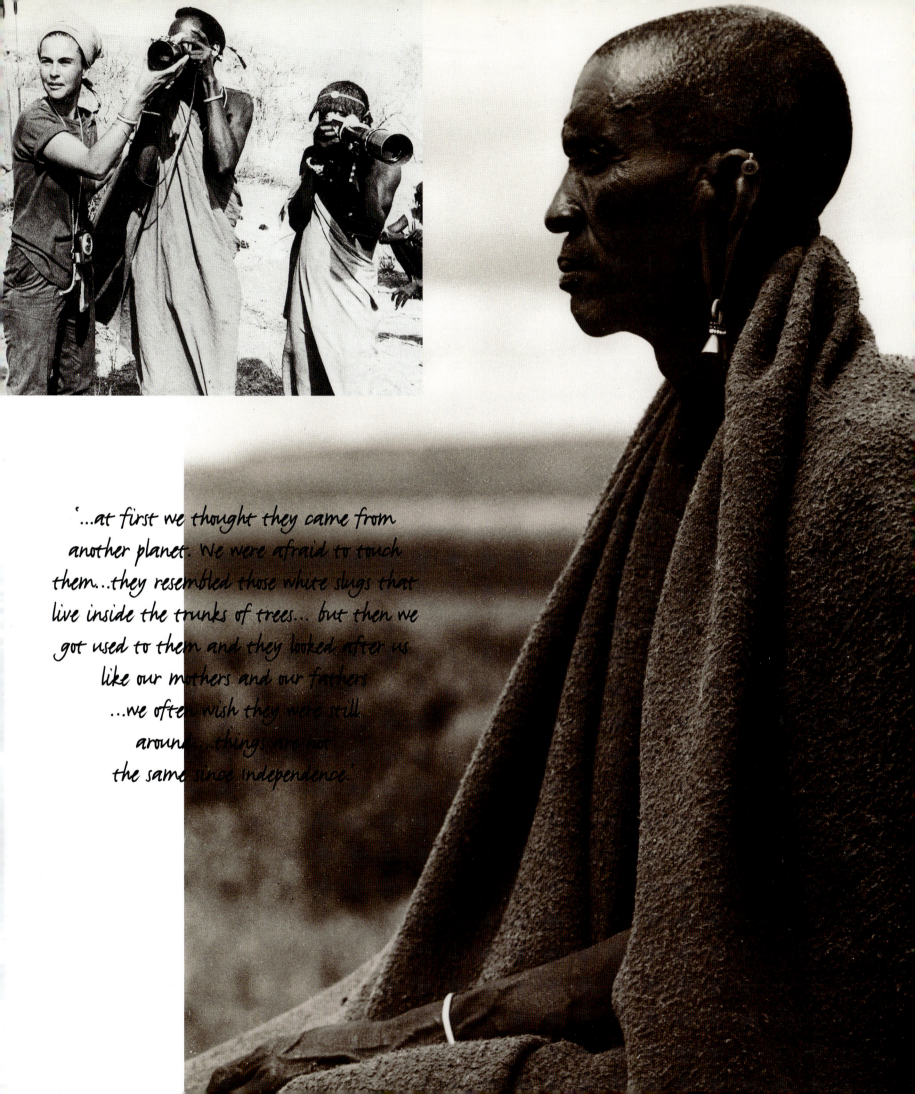

'...at first we thought they came from another planet. We were afraid to touch them...they resembled those white slugs that live inside the trunks of trees... but then we got used to them and they looked after us like our mothers and our fathers ...we often wish they were still around...things are not the same since independence.

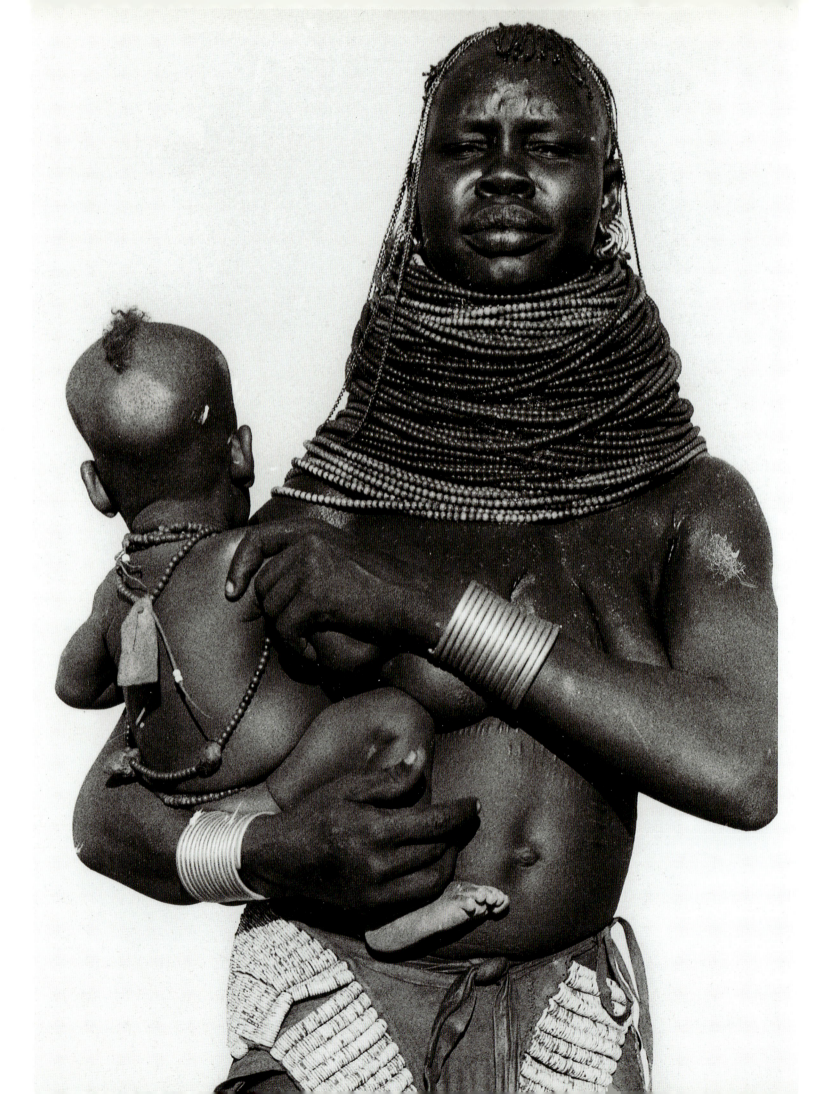

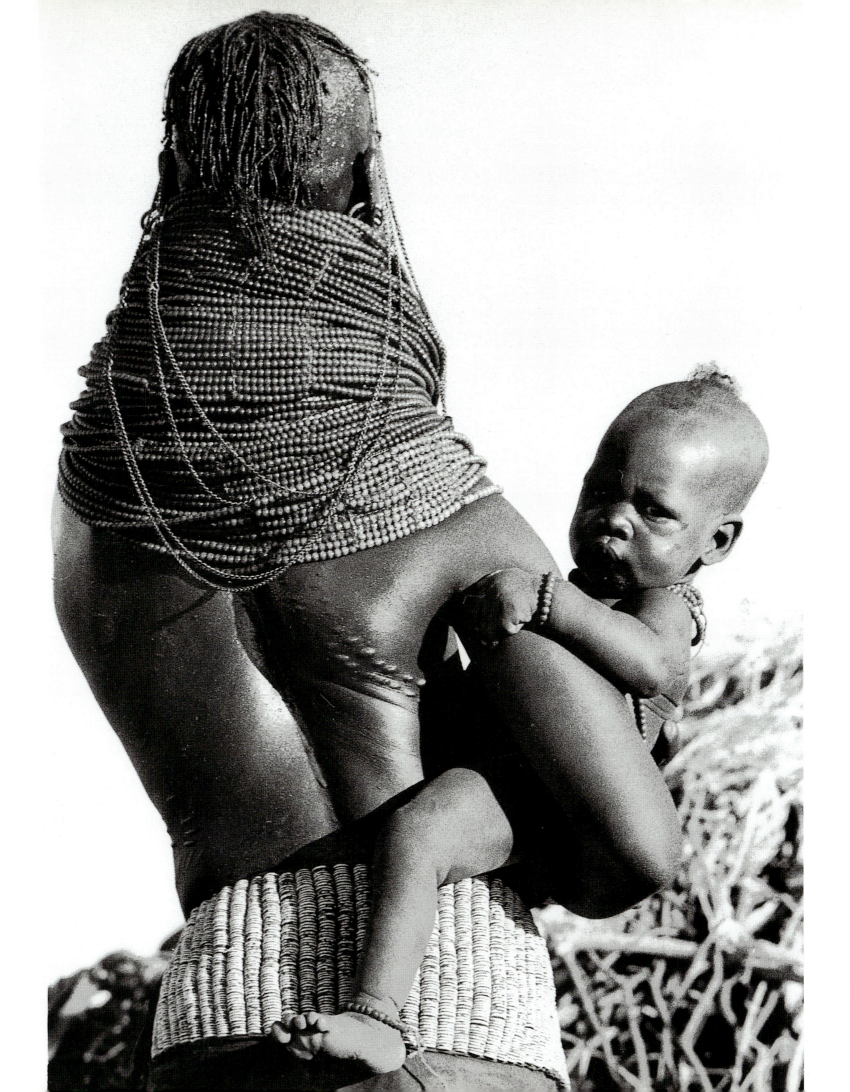

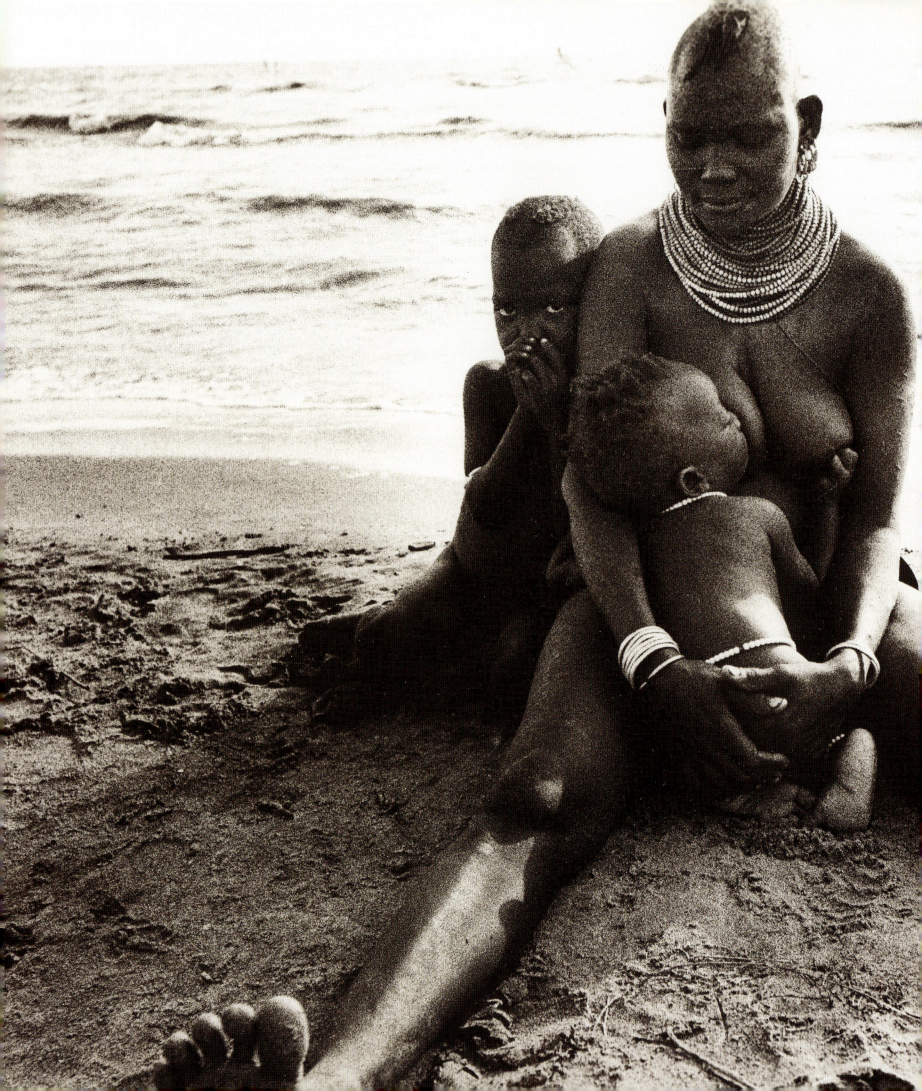

I learned from the women I met, the importance
of the tactile reassurance African women give their children,
who, for the first nine months of their lives, are in constant
contact with their mothers' bodies...it made me realise
how far removed we in the Western world are from
this natural habit...

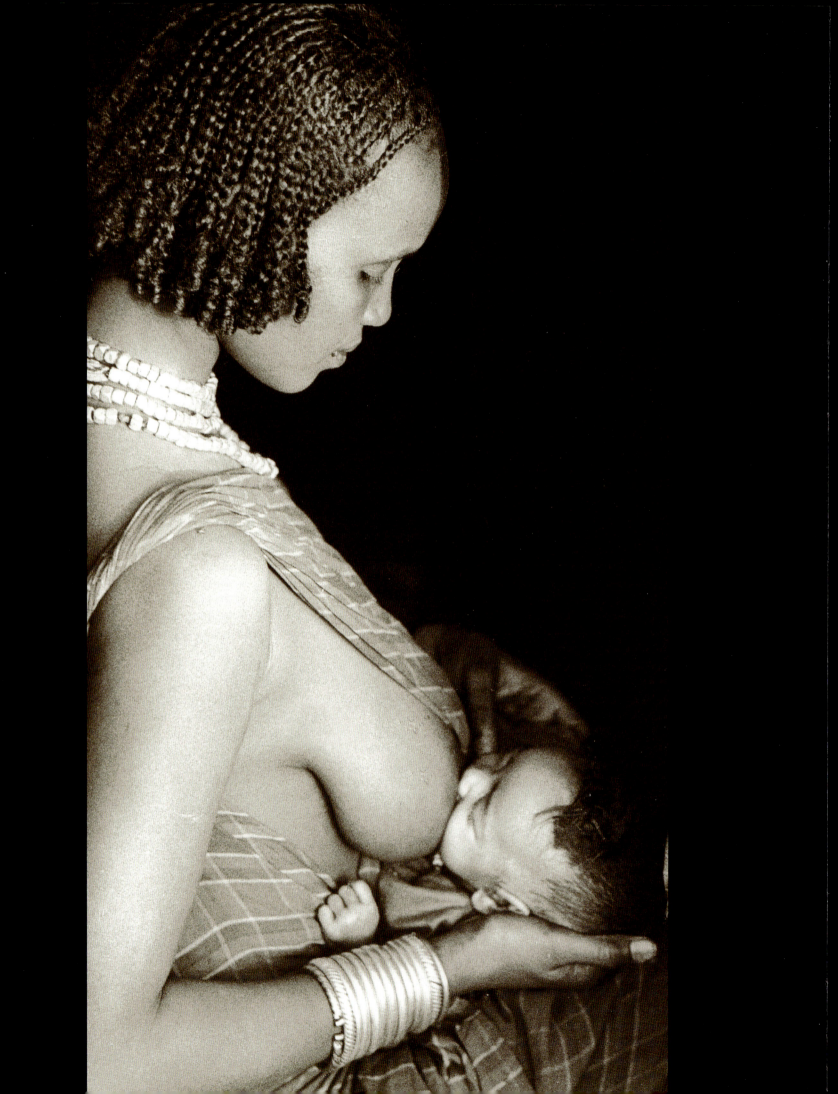

My only knowledge of motherhood
came from African women,
who produce children with
the ease and insouciance they
apply to their daily lives.
Pregnancies and births do not
interfere with the chores they
carry out, and children
grow up to the rhythm of the
village. The older care for the
younger while the mothers
are at work...

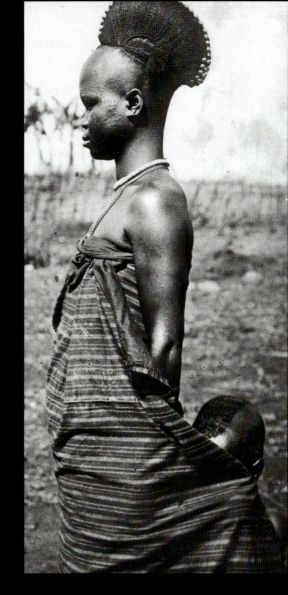

I did not yet know how
different it was in our world and
when my children
were born it was difficult for us
to adapt...

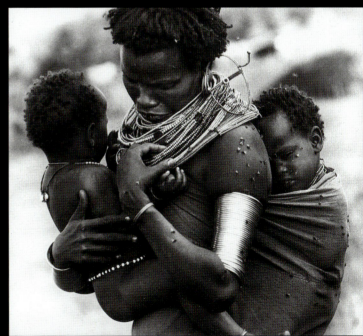

Africans possess the secret of joy...

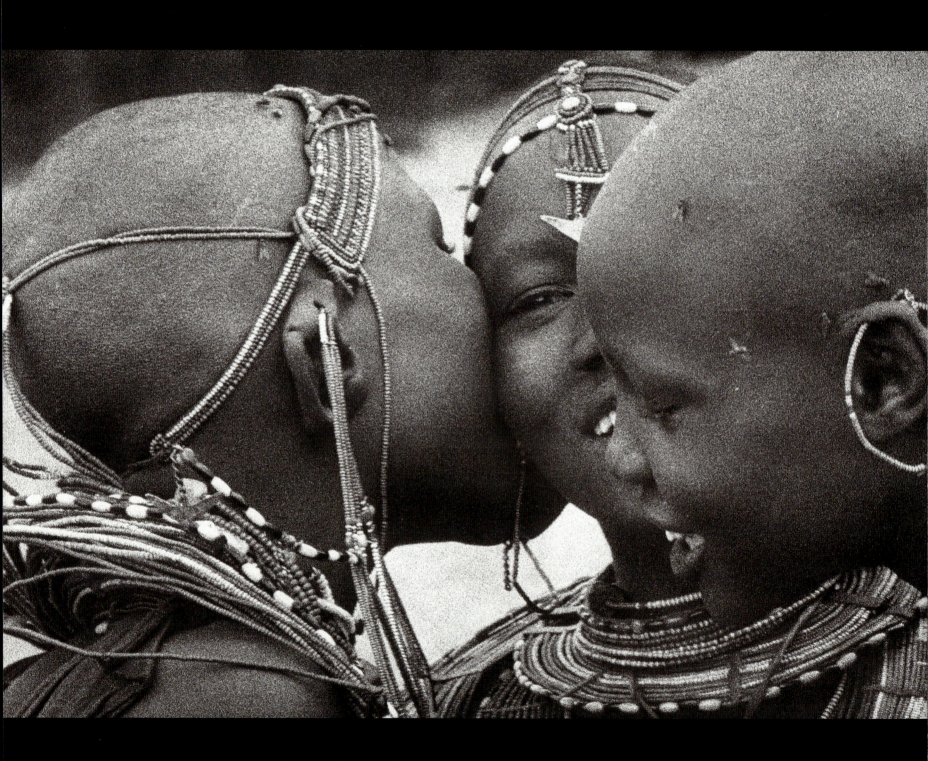

... it gives them the strength they need to confront
the hardships of survival and the humiliations
imposed upon them by the whites...

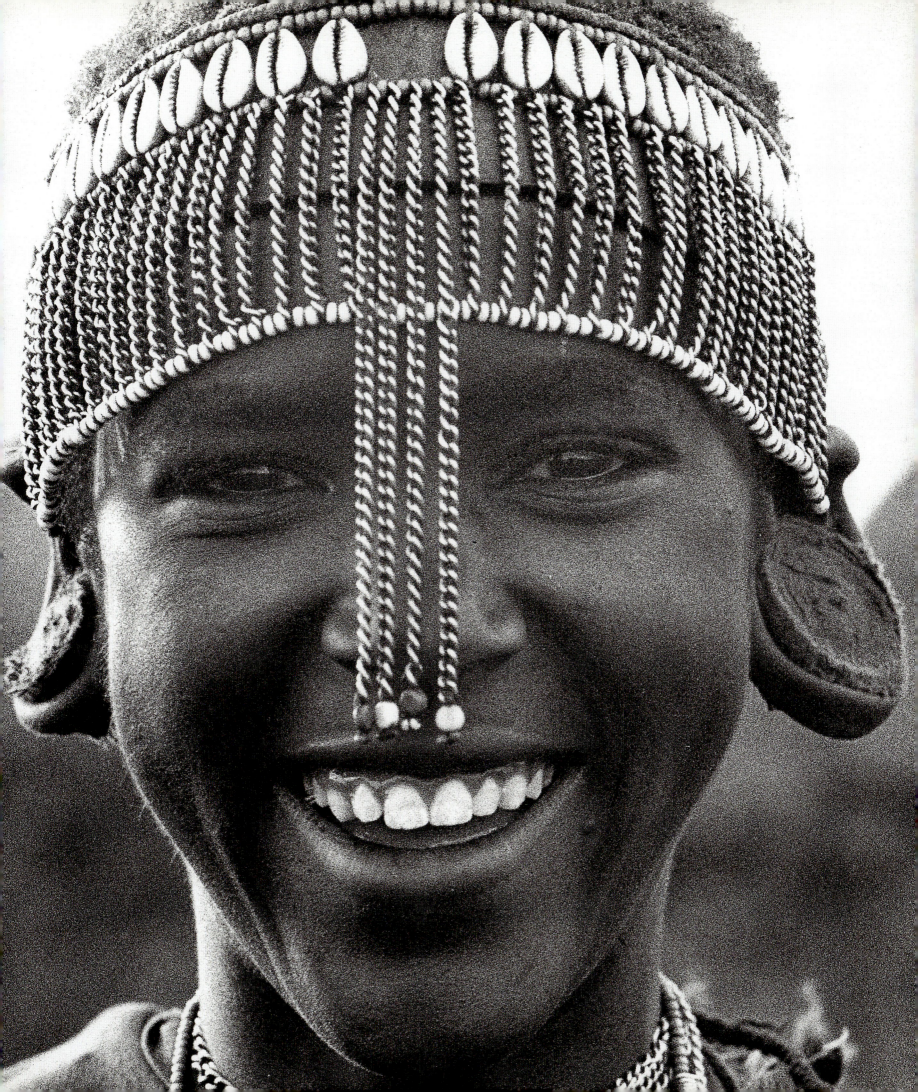

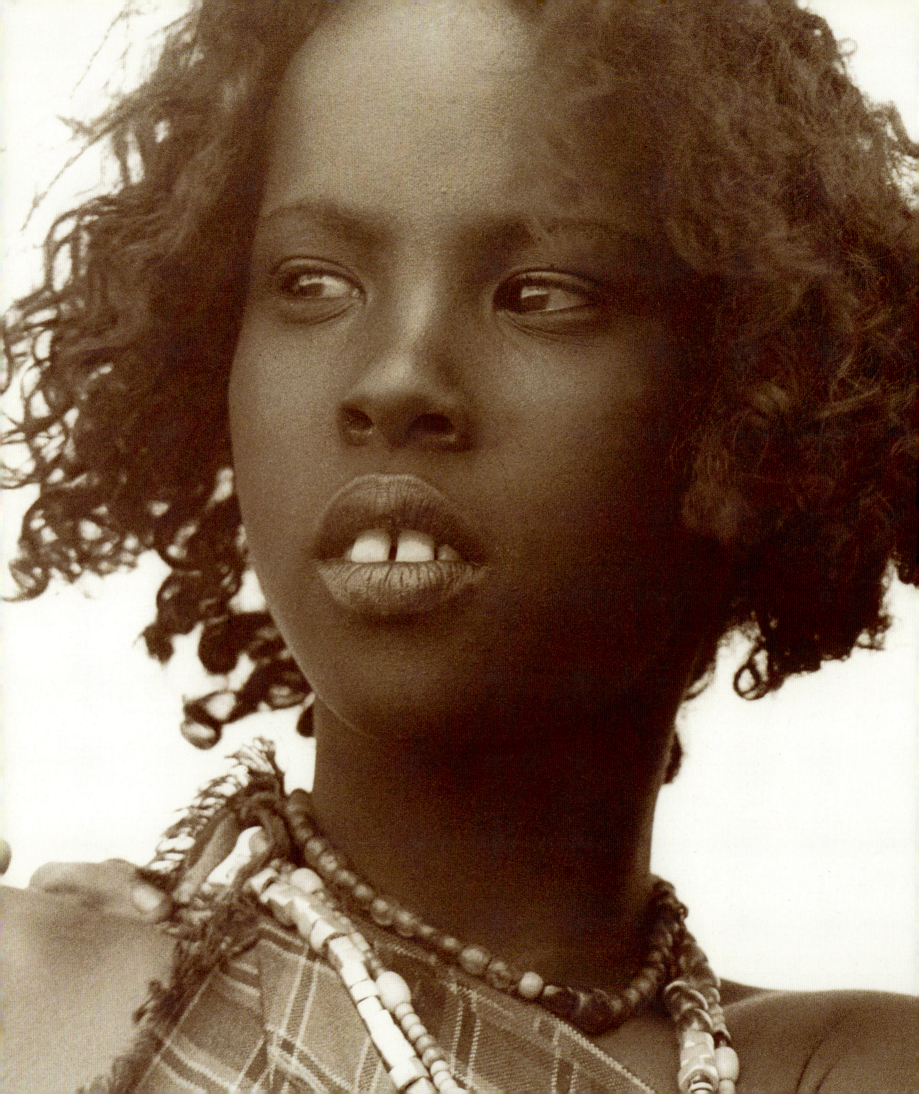

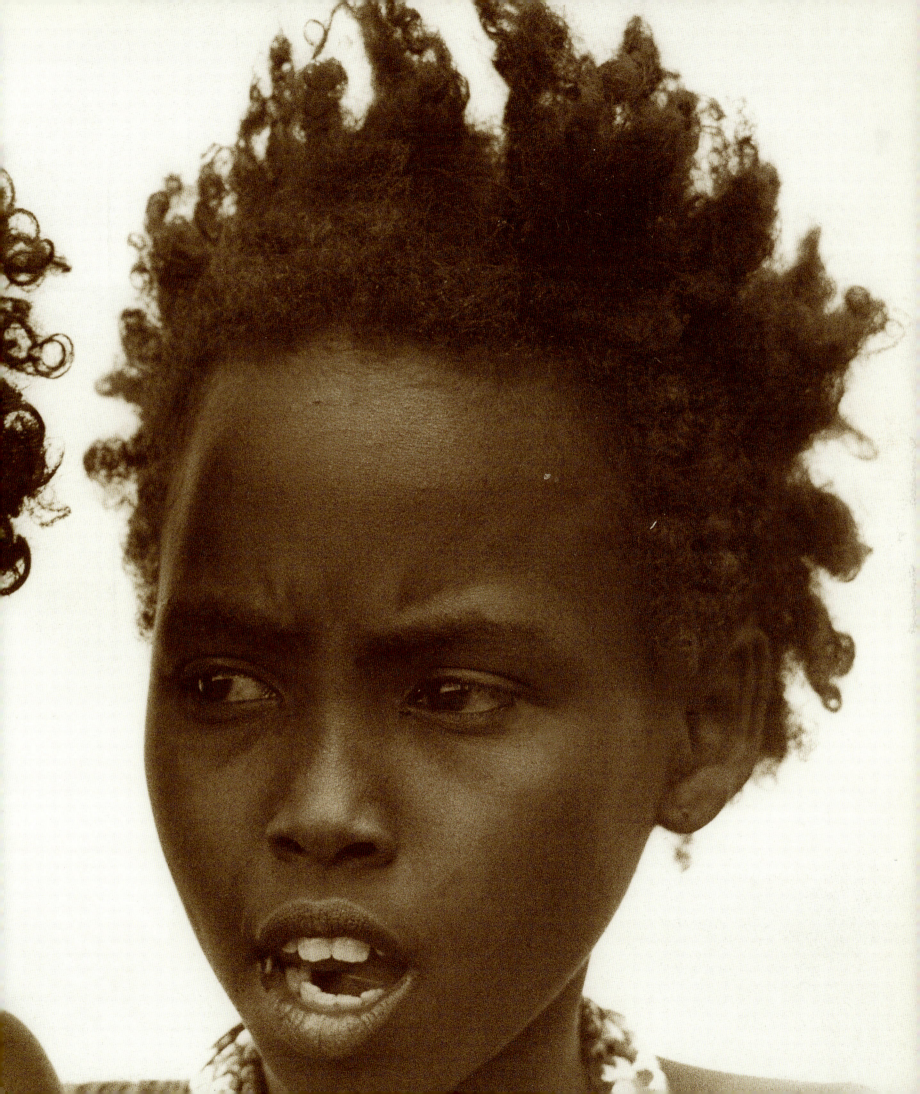

In the bosom of my family

WHEN I RETURNED home from my forays into the interior to rest and repair, I indulged in the softer, more poetic side of my life, that of my home and my family. These were moments of grace and reflection that charged my batteries and prepared me for another sortie. After the harsh realities of the Sudan, Eritrea and Zaire, I focused my camera on my own children and their cousins, who, like I had done, were growing up in wilderness freedom, on my ageing parents and on the gentle smiling staff who looked after us, that silent resilient workforce that allowed us to luxuriate in the absurd commodity of servants. It banished the boring mundane daily domestic chores of survival and allowed me time to be creative. During these moments I was able to catch fleeting glimpses into the miracle of childhood, into the desolation of old age. I kept my camera cocked and ready by my side and fired at them remorselessly, capturing the magic of their growing up, the sadness of their growing old. There were tears and laughter, joy and sorrow rimmed in sunlight, hidden in shadow, a tender pantomime in the bosom of my family. Little by little I put together an unusual and telling set of images that keep me company and my memories alive and vivid. This is one of the pluses of photography and as I now compile my diary, I sift through the boxes and envelopes and files I have stored away for so many years and am able to reconstruct my life like a jigsaw puzzle. It is a strange emotional journey filled with bittersweet memories of a life gone by. I can remember vividly the circumstances of each image, the vagaries of time give them depth and distance, the yellowed paper, the crumpled surface, the torn corners; but the light, the textures, the story they tell remain as clear as if they had been taken yesterday. Quite unwittingly I had captured the moments I will never want to forget.

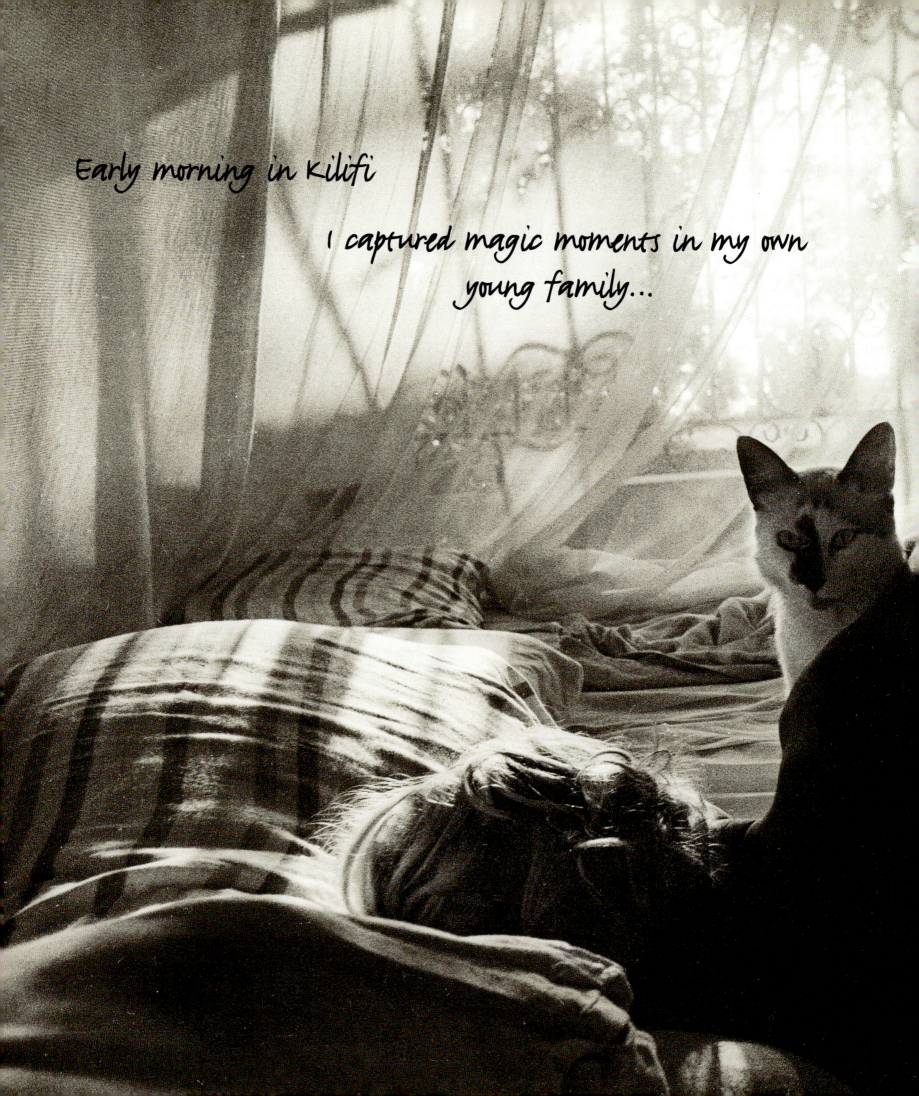

Early morning in Kilifi

I captured magic moments in my own
young family...

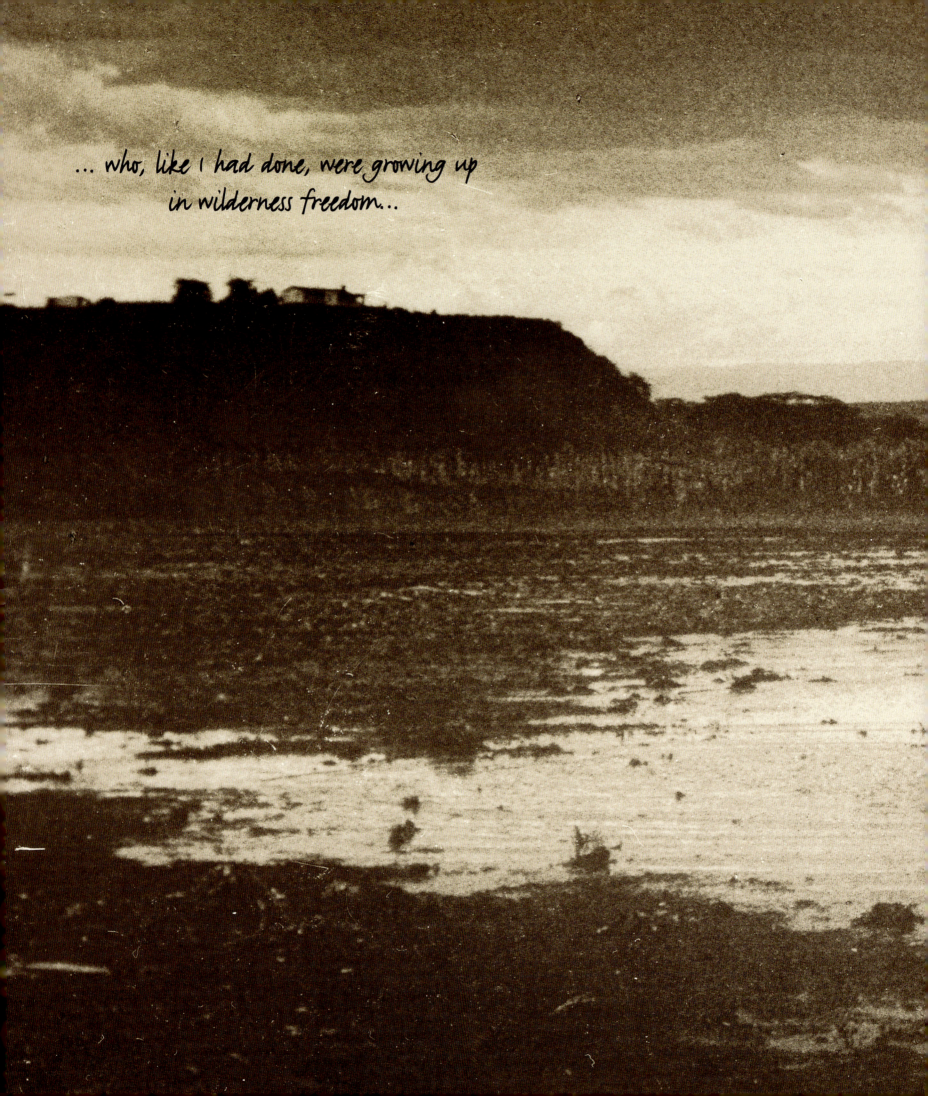

... who, like I had done, were growing up
in wilderness freedom...

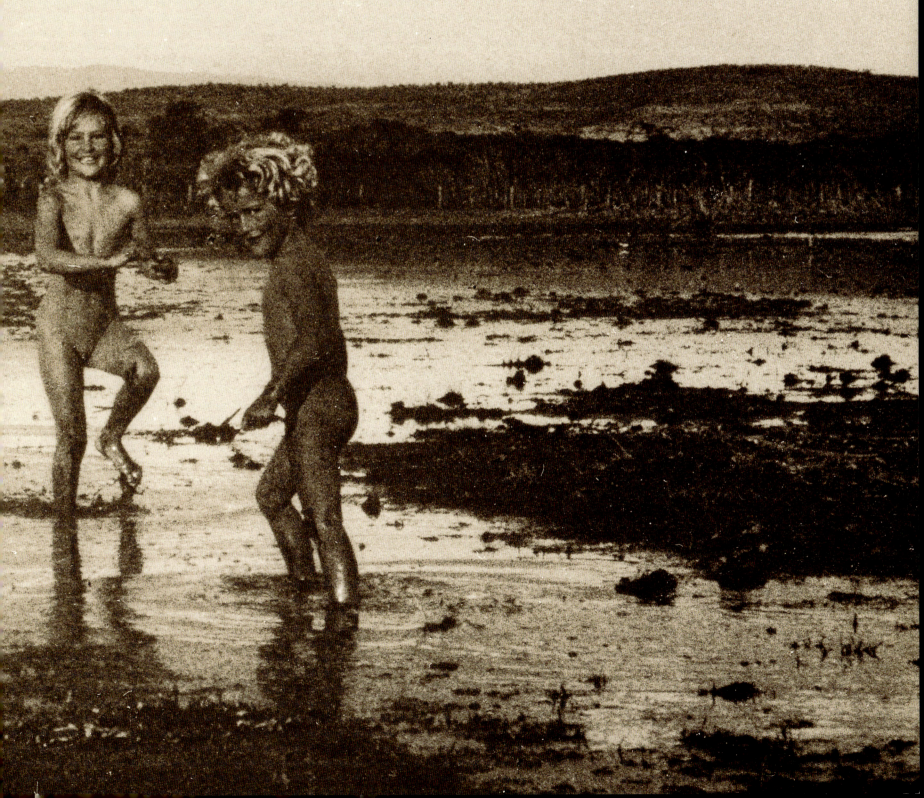

...across the years I put together an unusual and telling
set of images that now keep me company
and keep my memories vivid and alive.

saba and Dudu in Lake Naivasha, 1975

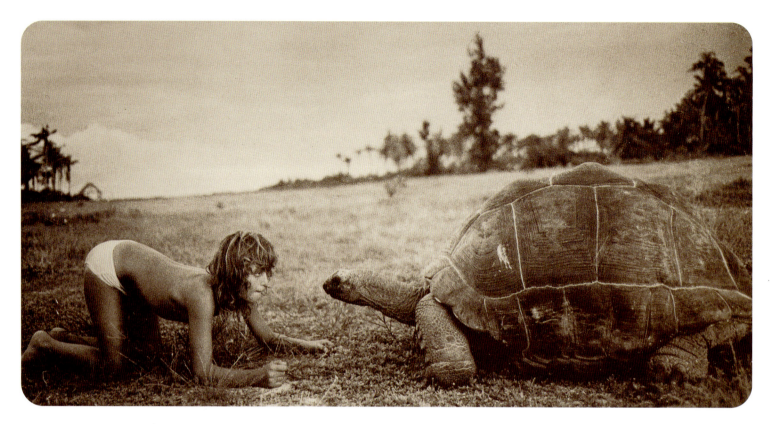

Our children grew up unafraid of animals...

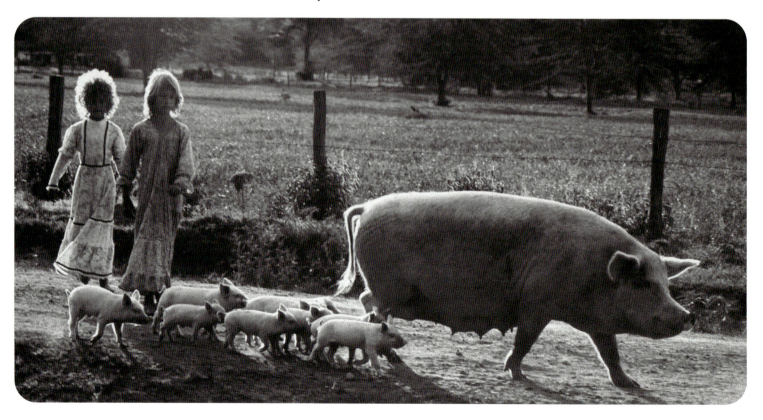

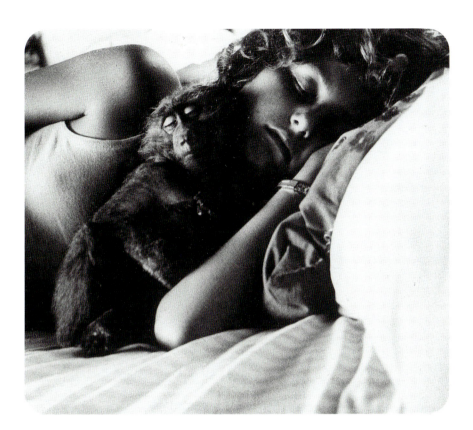

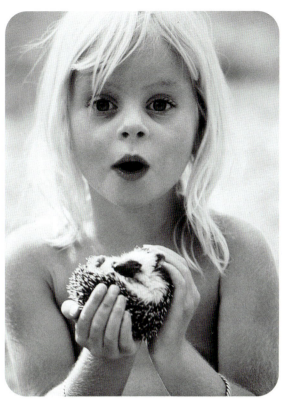

...and like we had done, played with them instead of toys.

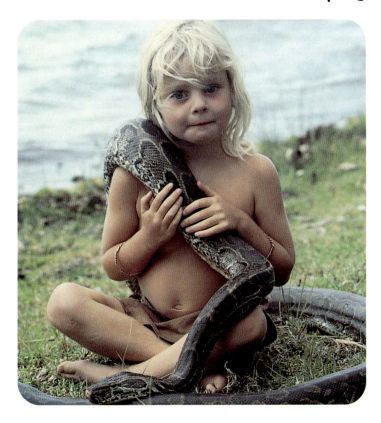

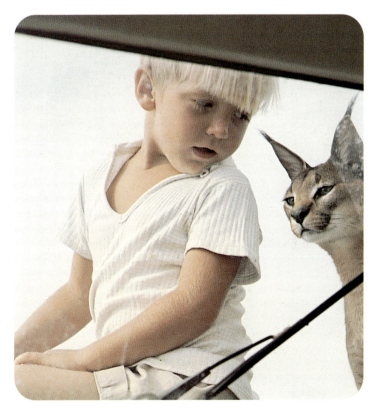

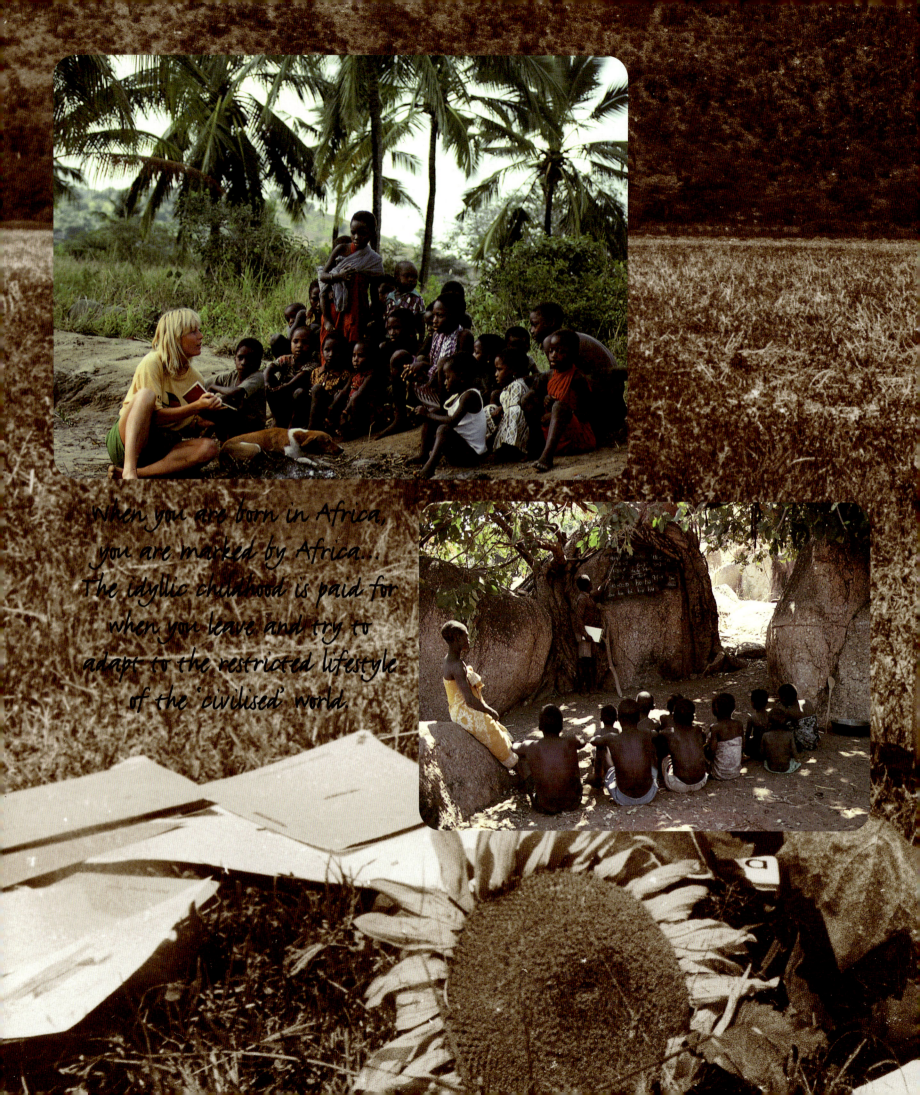

When you are born in Africa,
you are marked by Africa...
The idyllic childhood is paid for
when you leave and try to
adapt to the restricted lifestyle
of the "civilised" world.

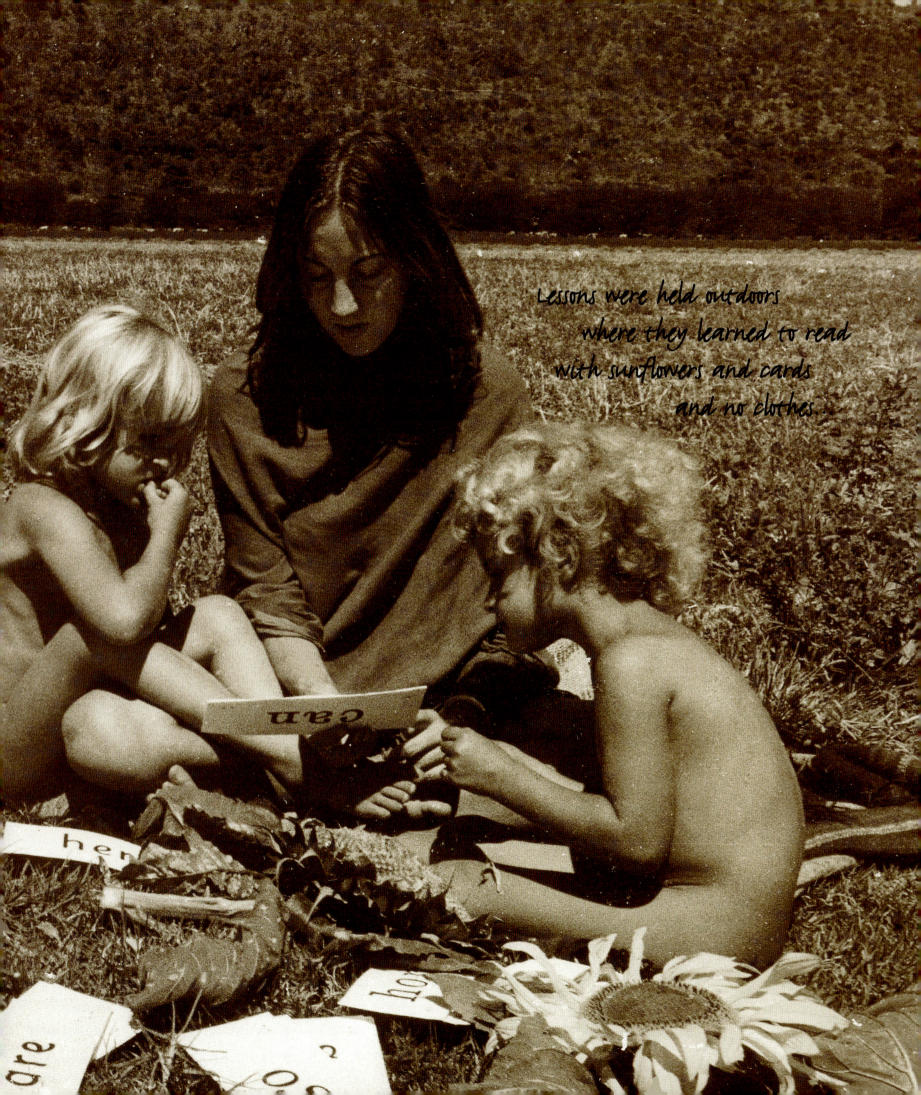

Lessons were held outdoors
where they learned to read
with sunflowers and cards
and no clothes.

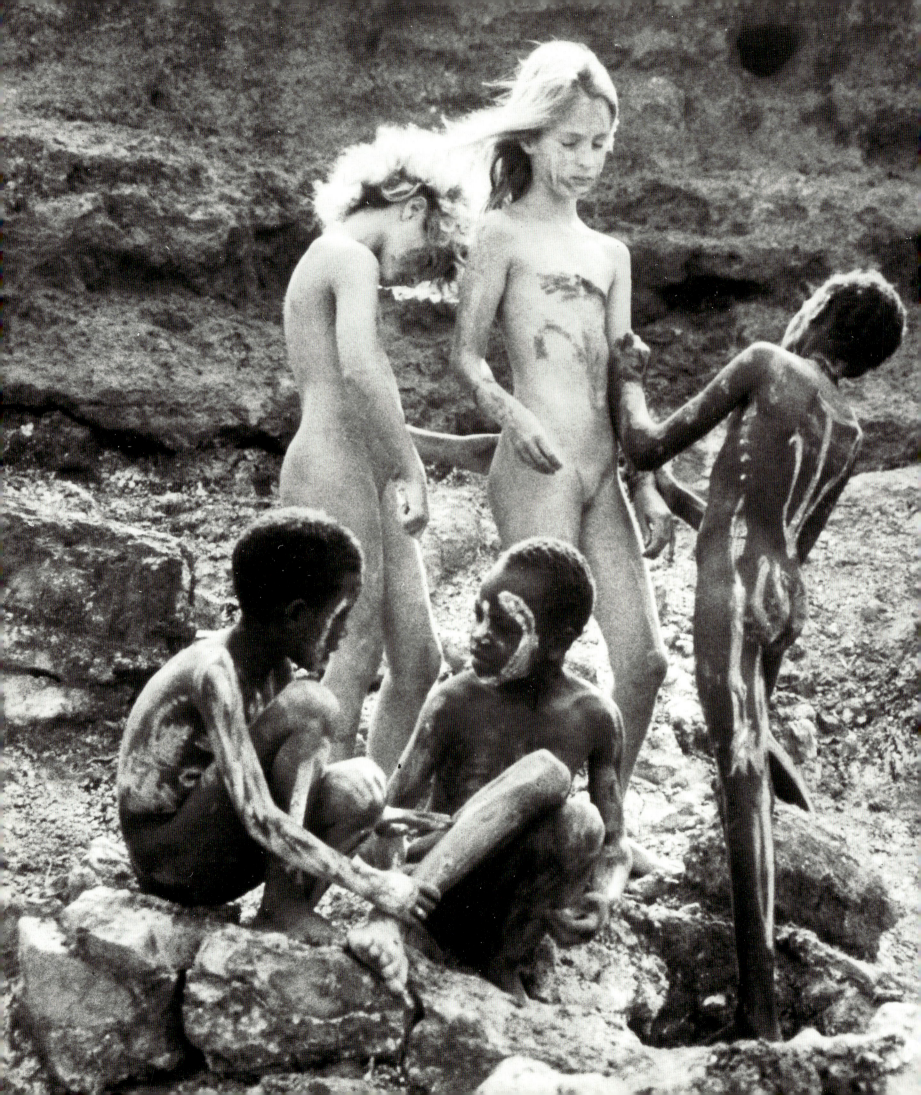

Children born in Africa
 have no inhibitions...

As the generations moved on our relationship with
 the Africans changed.

we were kept strictly segregated from them and
 considered them as servants,
 not as friends...we rarely played with them,
 and certainly not in the nude.

never in my own childhood would such a
 photograph ever have been taken.

Now as I sift through the boxes,
 the envelopes and the files I have stored away
for so many years, the complex pattern
 of my life appears as in a jigsaw puzzle and
I can still remember vividly the
 circumstances of each image...

 the vagaries of time bestow them with a
depth and meaning that distances them
 from me, as if they belonged to someone else...

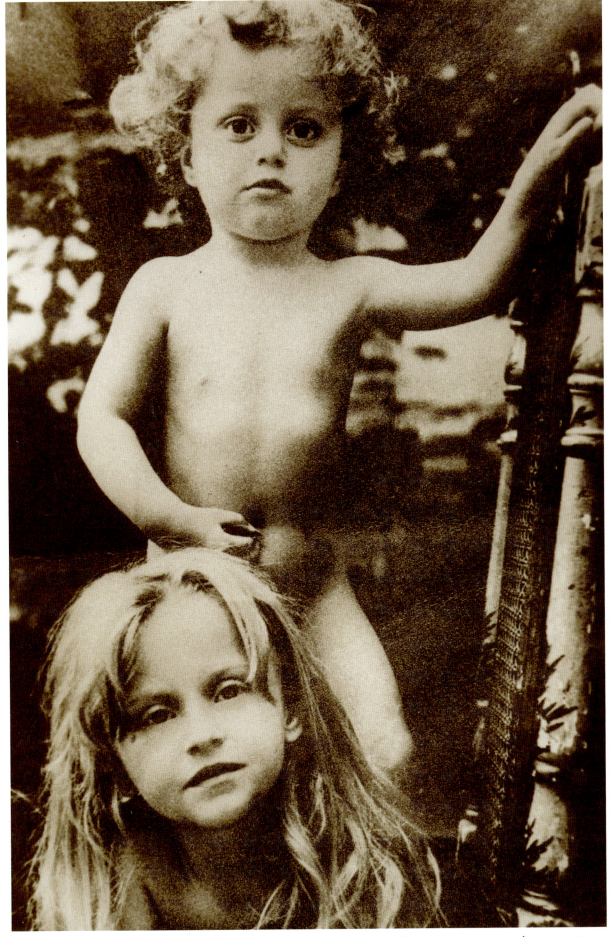

They became the most photographed children in the world

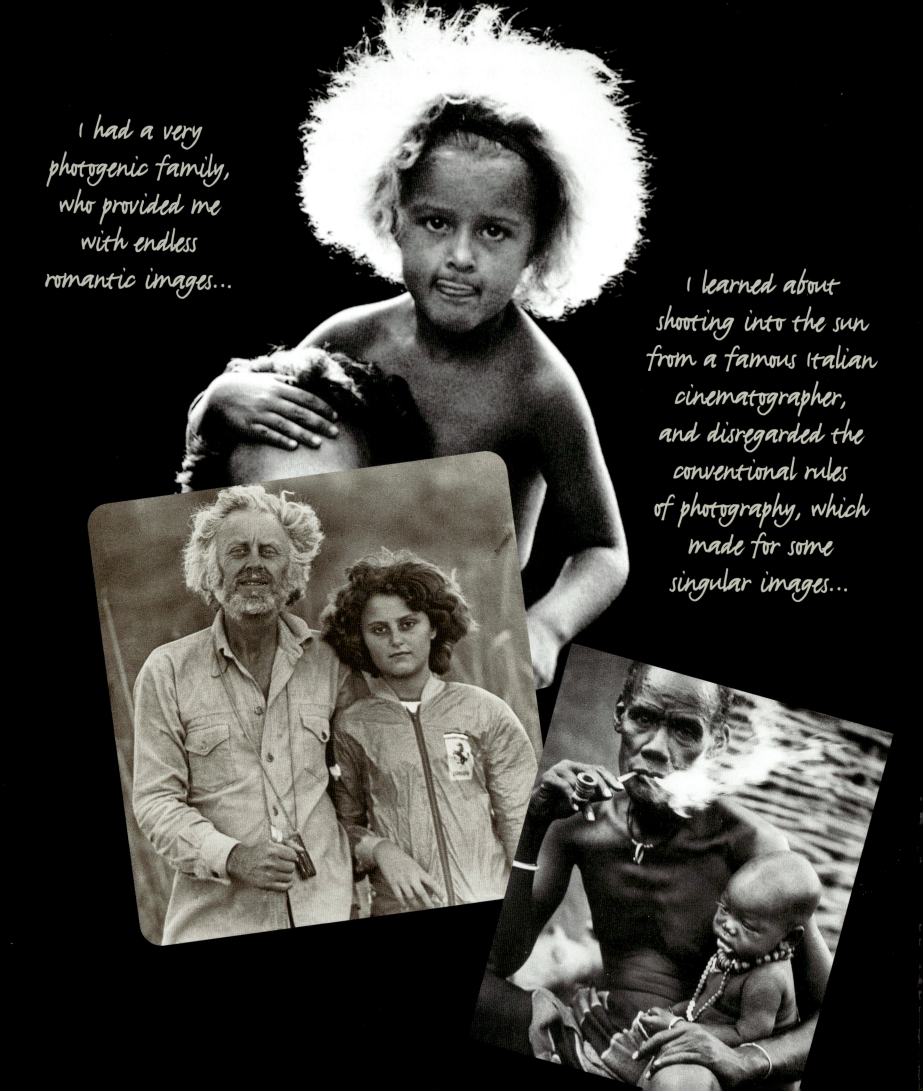

I had a very photogenic family, who provided me with endless romantic images...

I learned about shooting into the sun from a famous Italian cinematographer, and disregarded the conventional rules of photography, which made for some singular images...

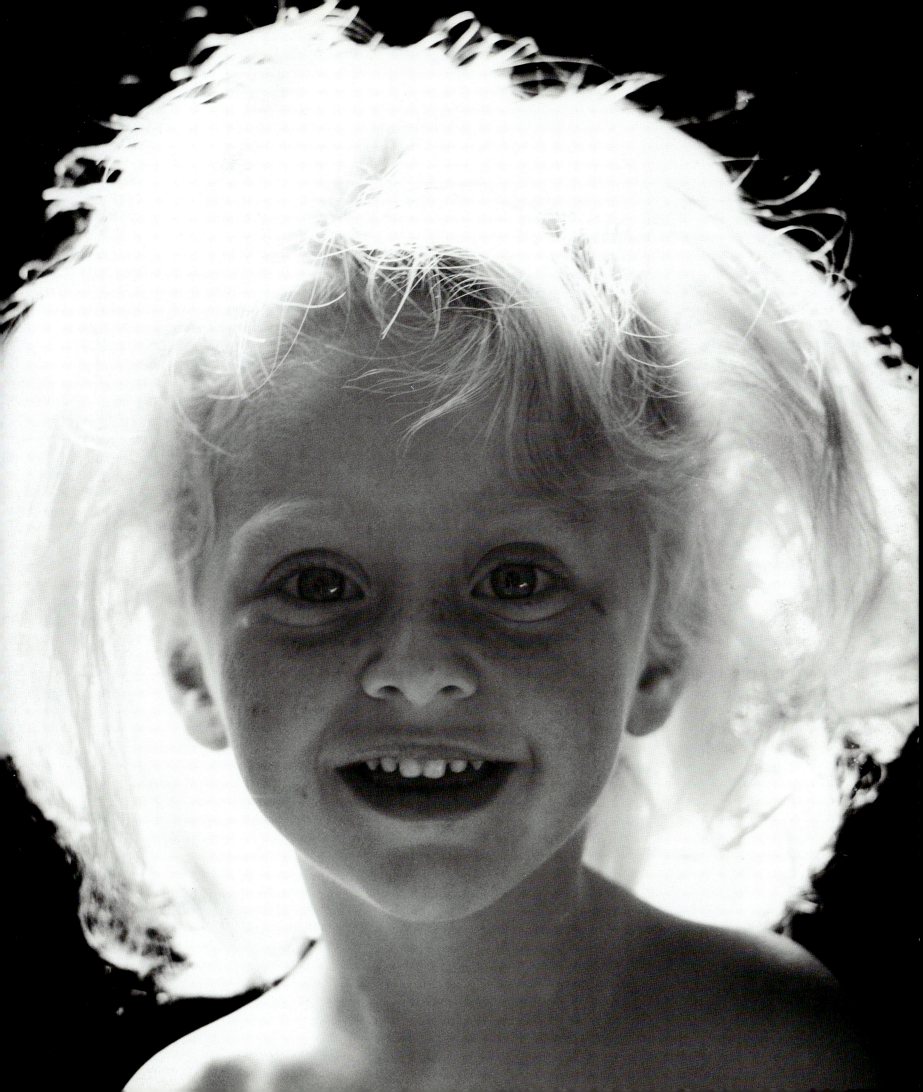

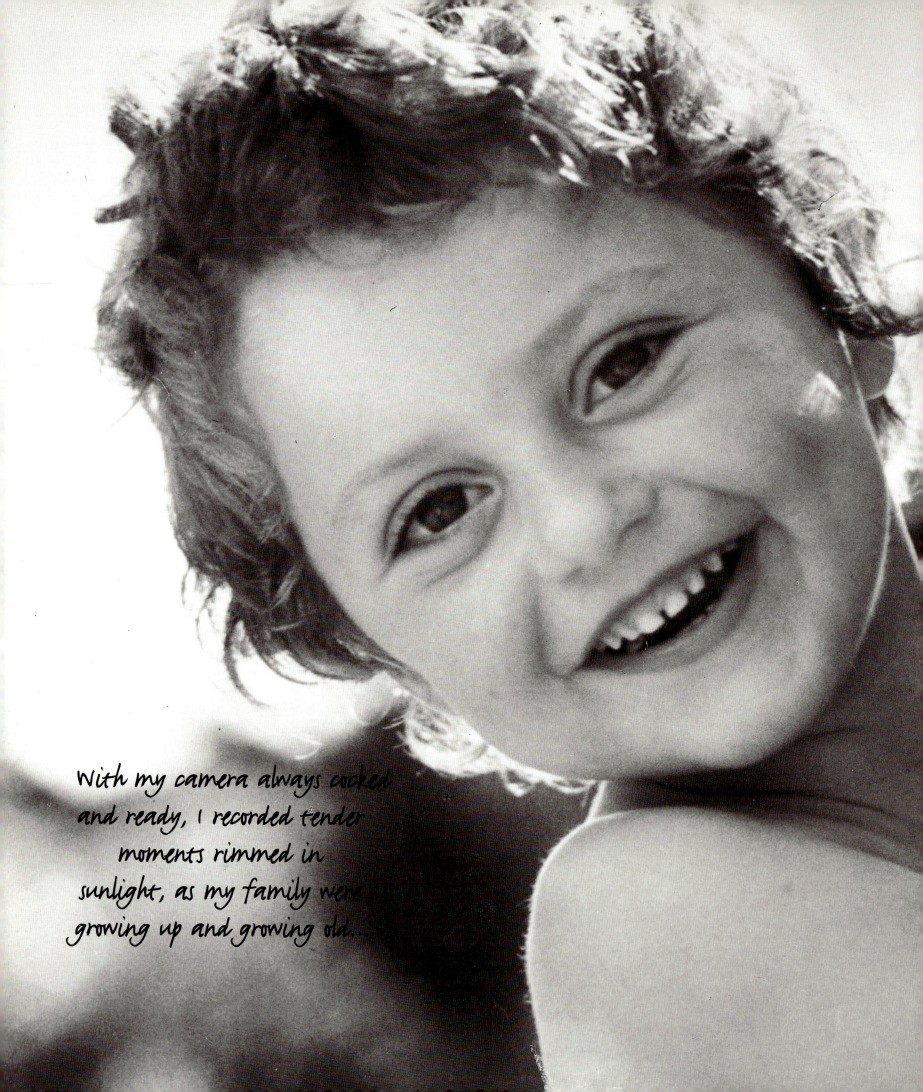

With my camera always cocked
and ready, I recorded tender
moments rimmed in
sunlight, as my family were
growing up and growing old...

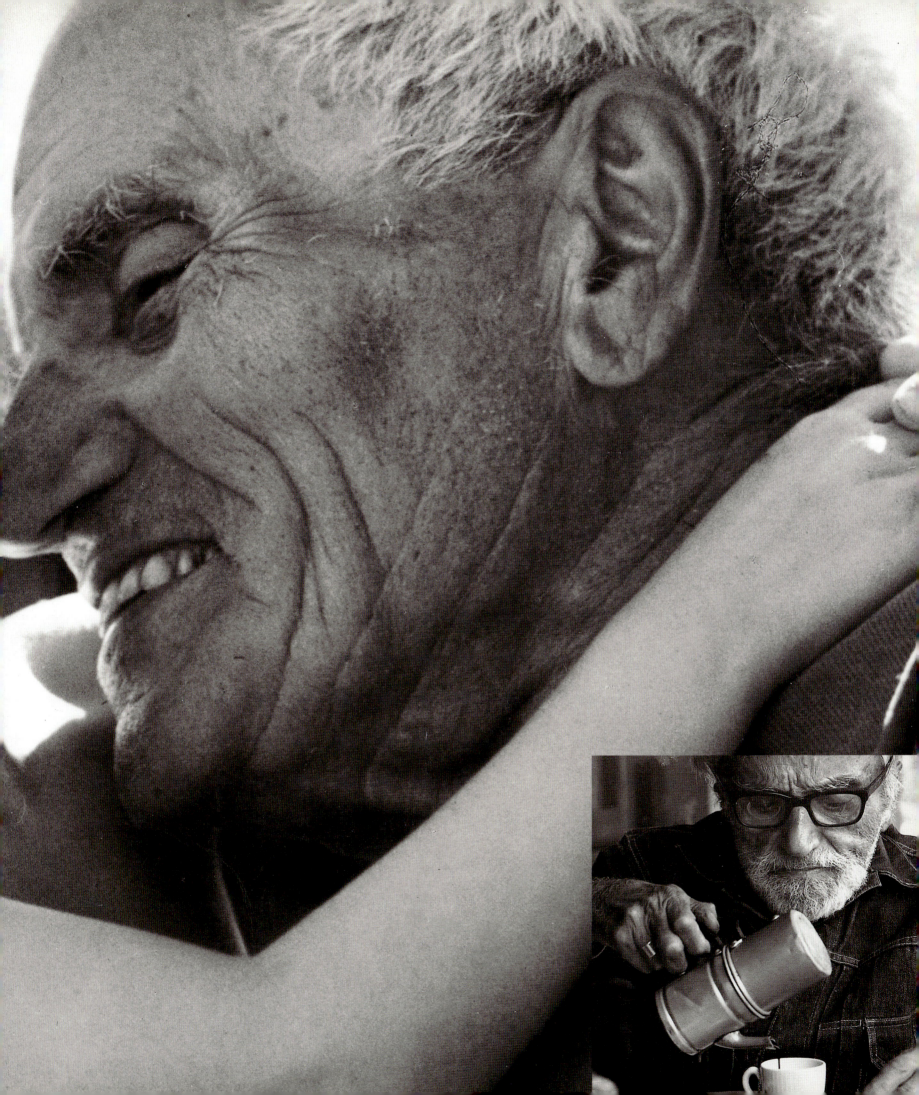

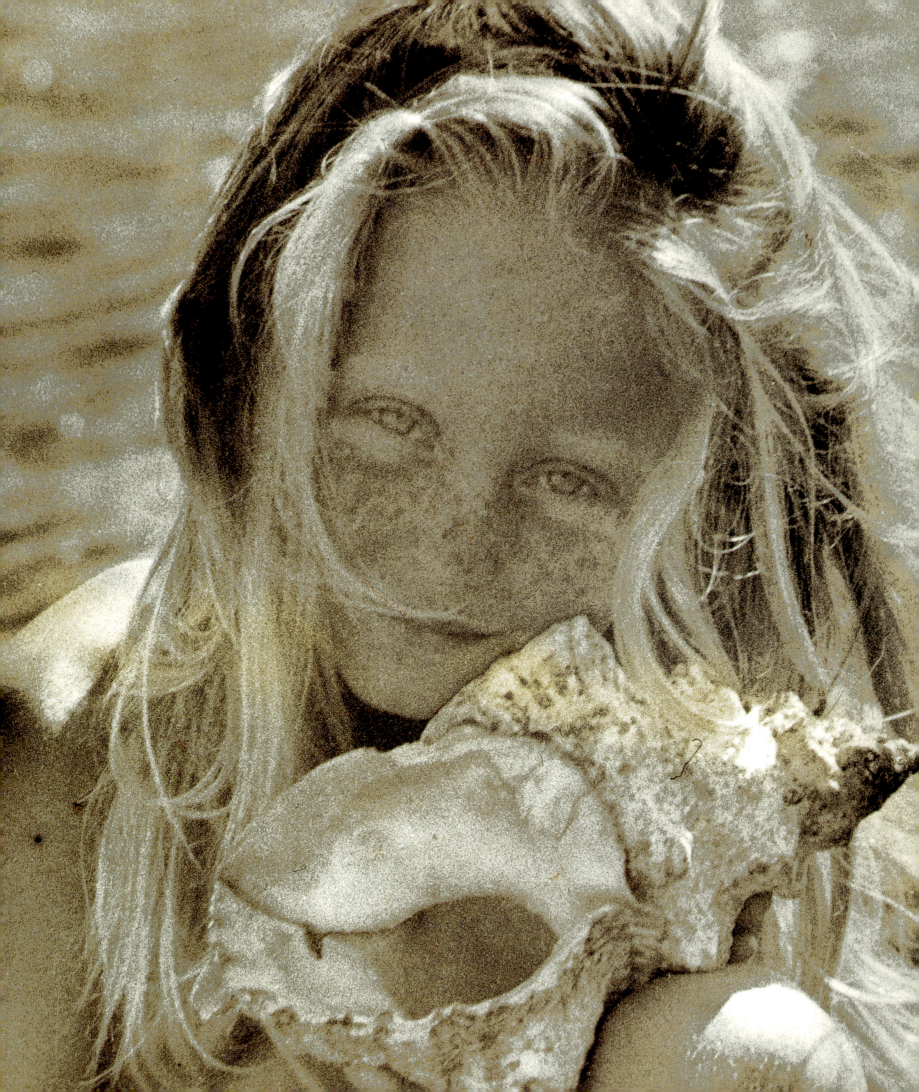

I lost my daughter Marina to cancer...
she was 36 years old...
now all I have left of her are the photographs
I took as she was growing up. This tragedy in my life
underlines what I am doing now.

'capture the moments you never want to
forget, before they are gone forever'

has become my motto.

Marina wanted to return to her home in Kilifi,
'to die in Africa,' she said, but she
never made it....
We buried her ashes in the garden of our
home overlooking the Indian Ocean where
we had dived for fish together.

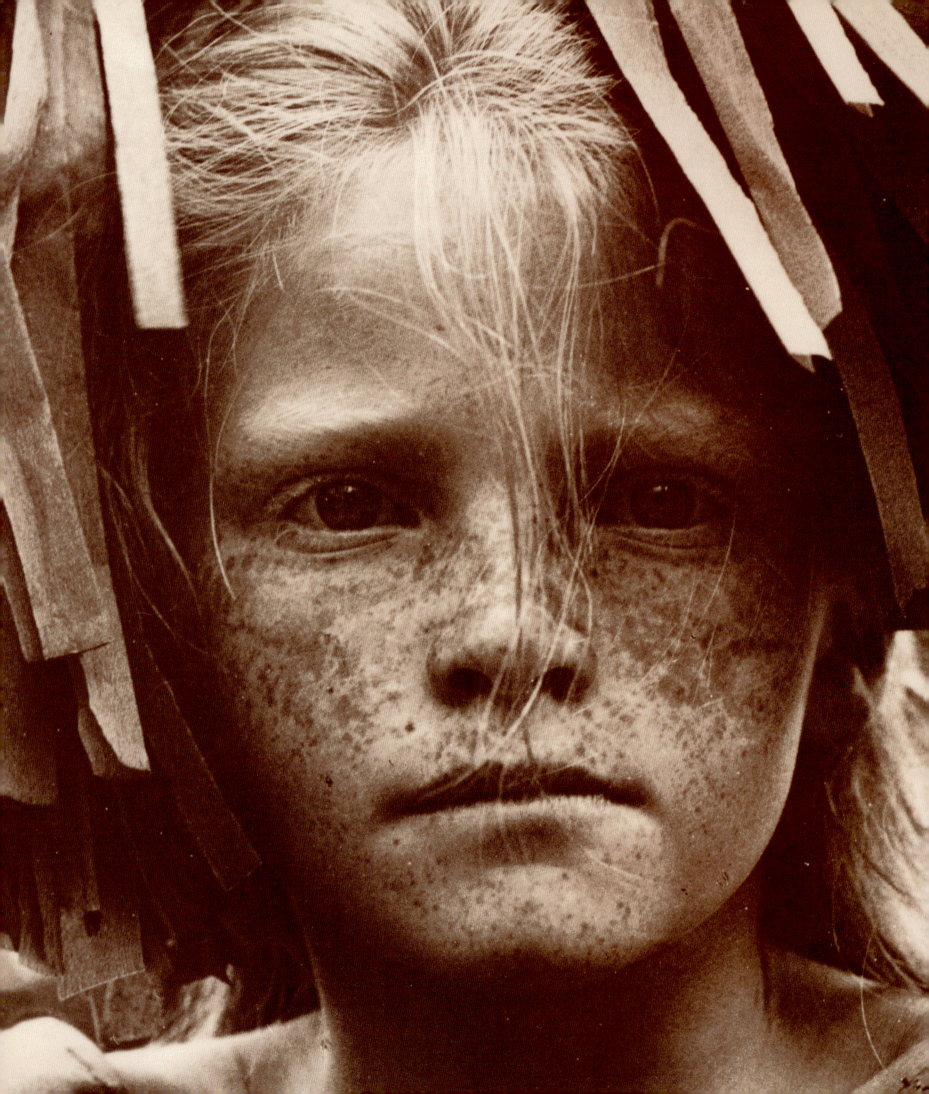

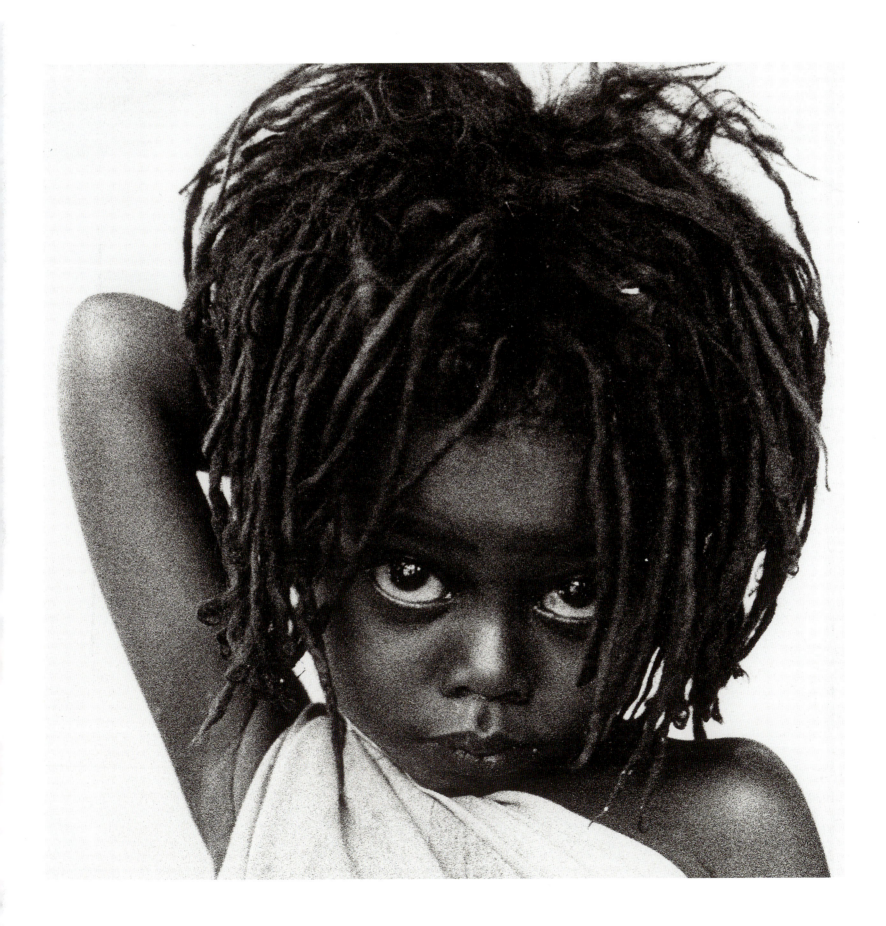

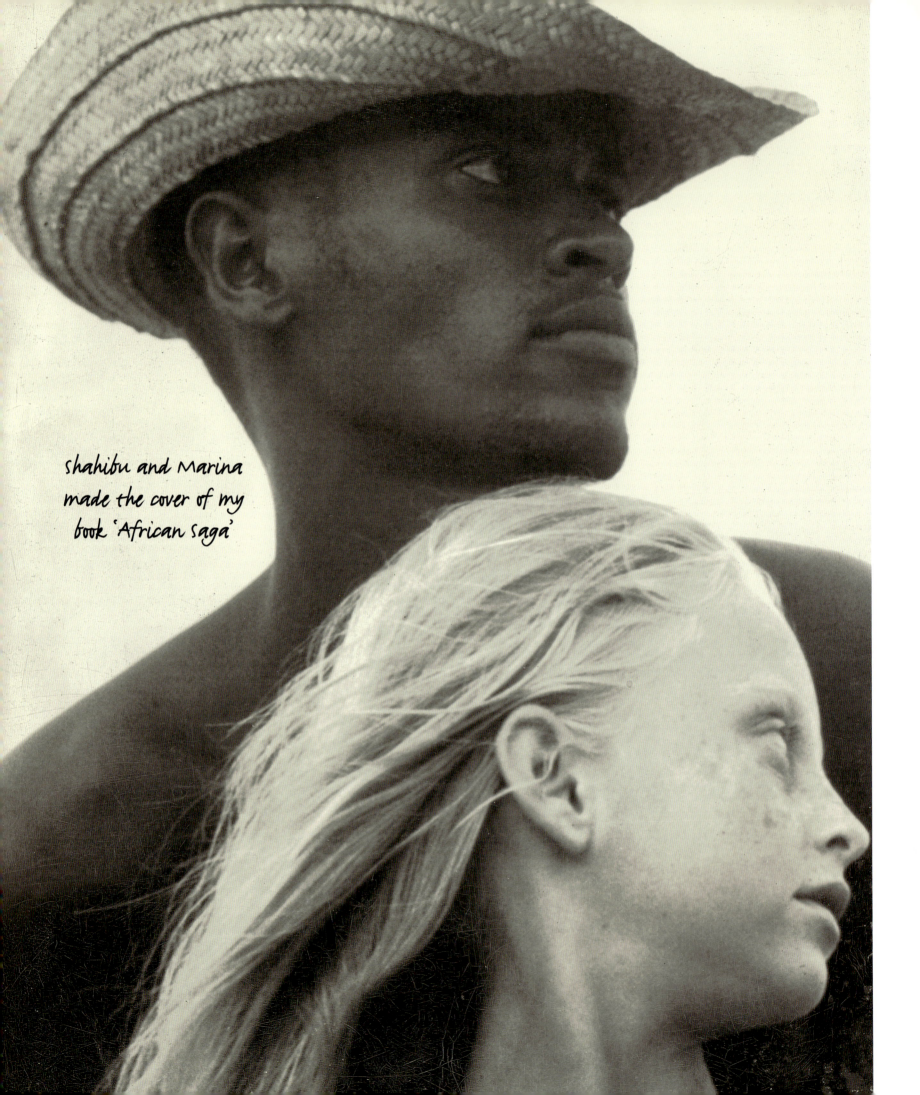

Shahibu and Marina
made the cover of my
book 'African Saga'

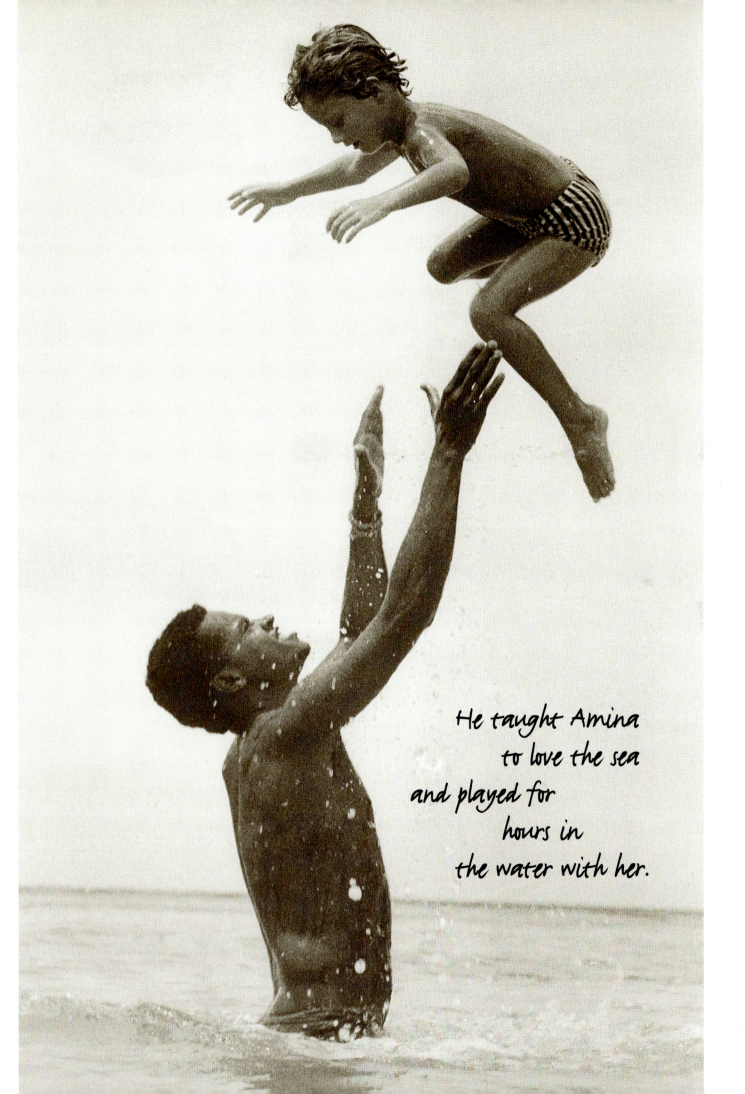

He taught Amina
to love the sea
and played for
hours in
the water with her.

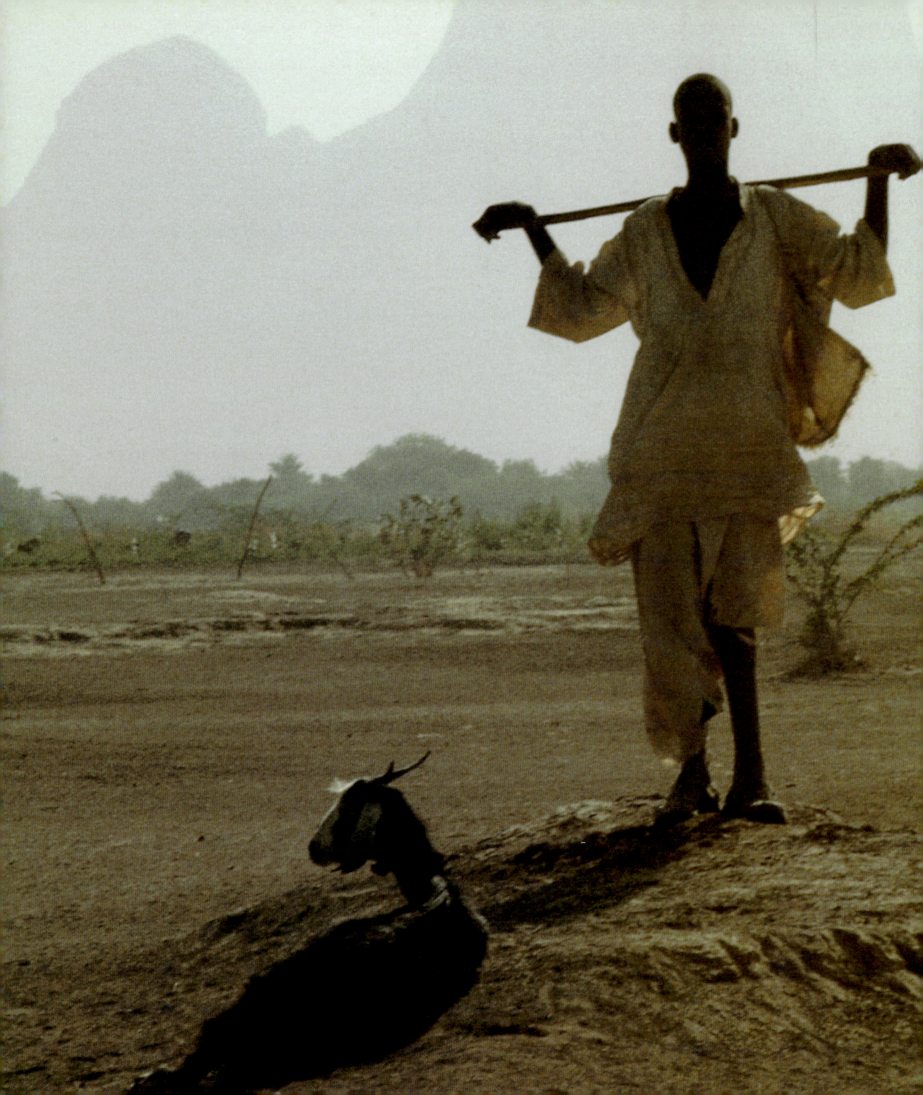

'In Africa...
everywhere you looked was made for greatness'

KAREN BLIXEN

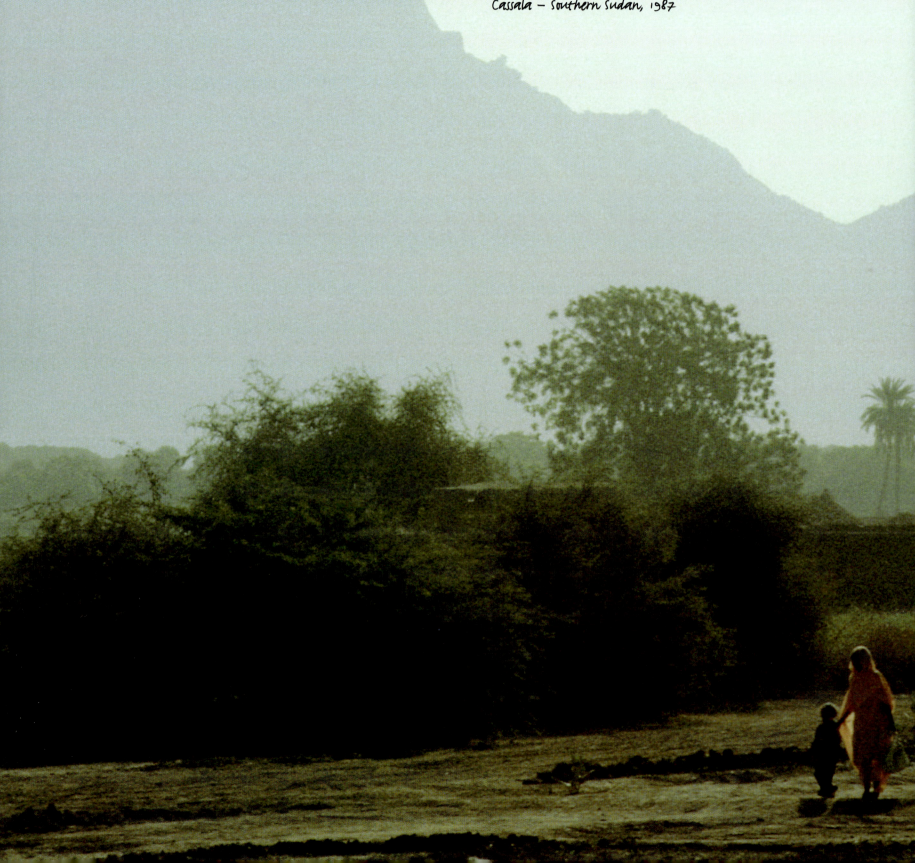

I realised here in the Sudan that
God and the Devil are indeed one....

Cassala — Southern Sudan, 1987

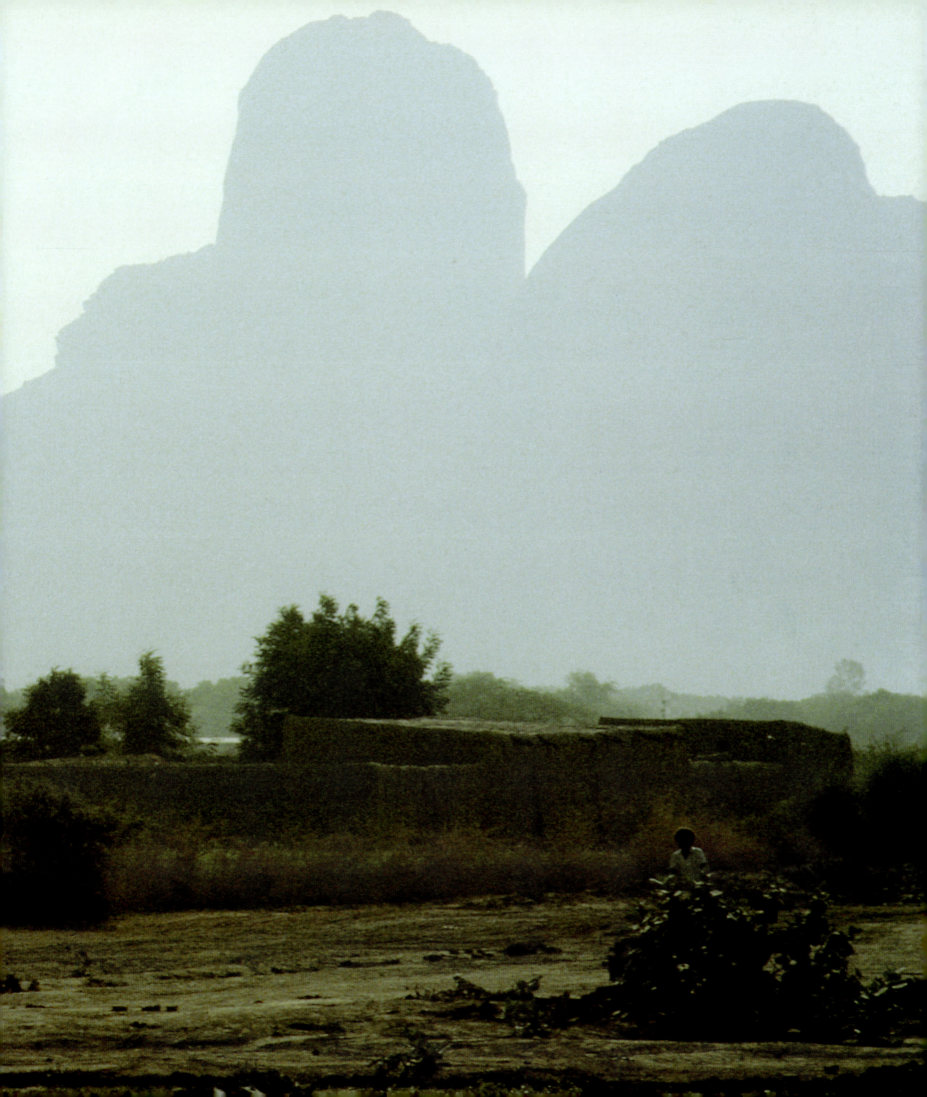

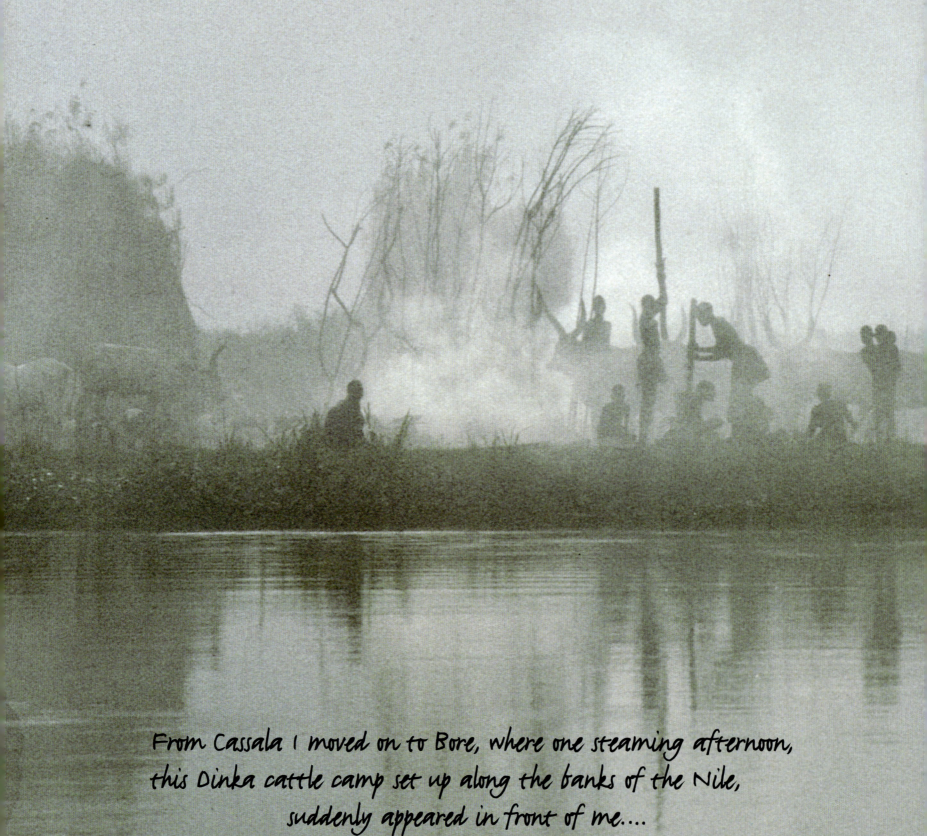

From Cassala I moved on to Bore, where one steaming afternoon,
this Dinka cattle camp set up along the banks of the Nile,
suddenly appeared in front of me....

....a storm was gathering and soon the place
was enveloped in a veil of rain
that obliterated it from sight.

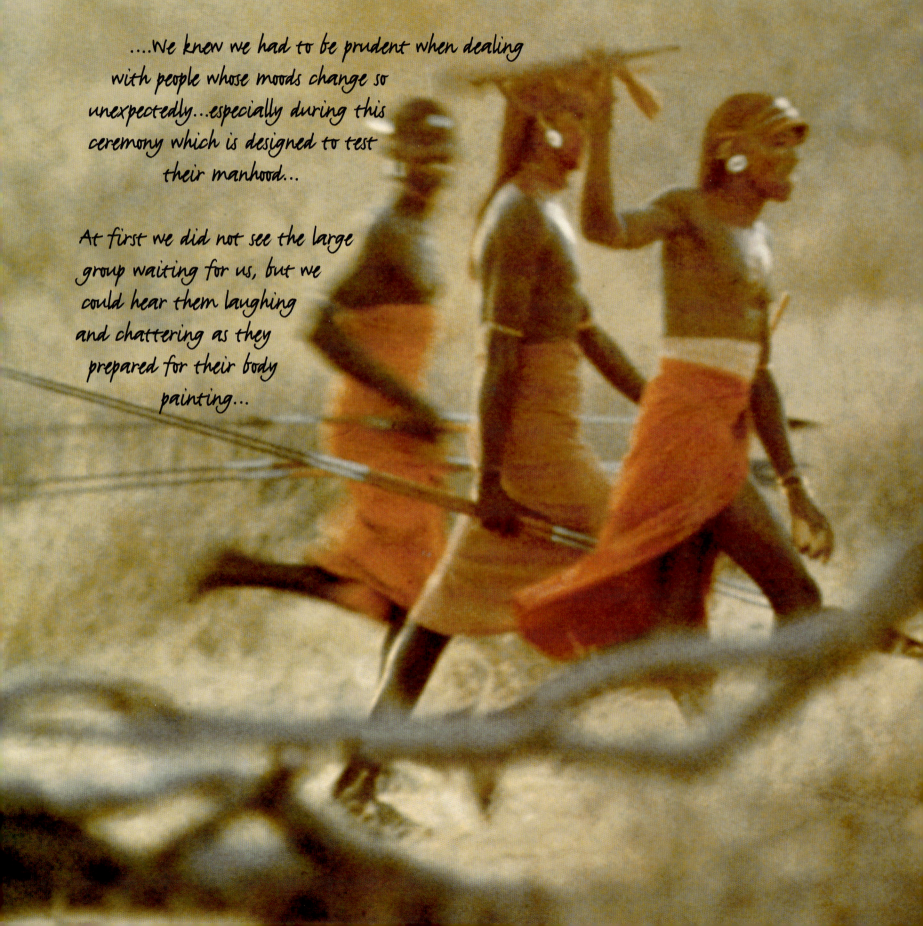

On the first day of the Eunoto coming-of-age ceremony, I followed some of the murran (warriors)...suddenly they broke step and rushed towards the forest... I followed them through the bushes for some seven miles along a small game track made by elephants and cattle...

....We knew we had to be prudent when dealing with people whose moods change so unexpectedly...especially during this ceremony which is designed to test their manhood...

At first we did not see the large group waiting for us, but we could hear them laughing and chattering as they prepared for their body painting...

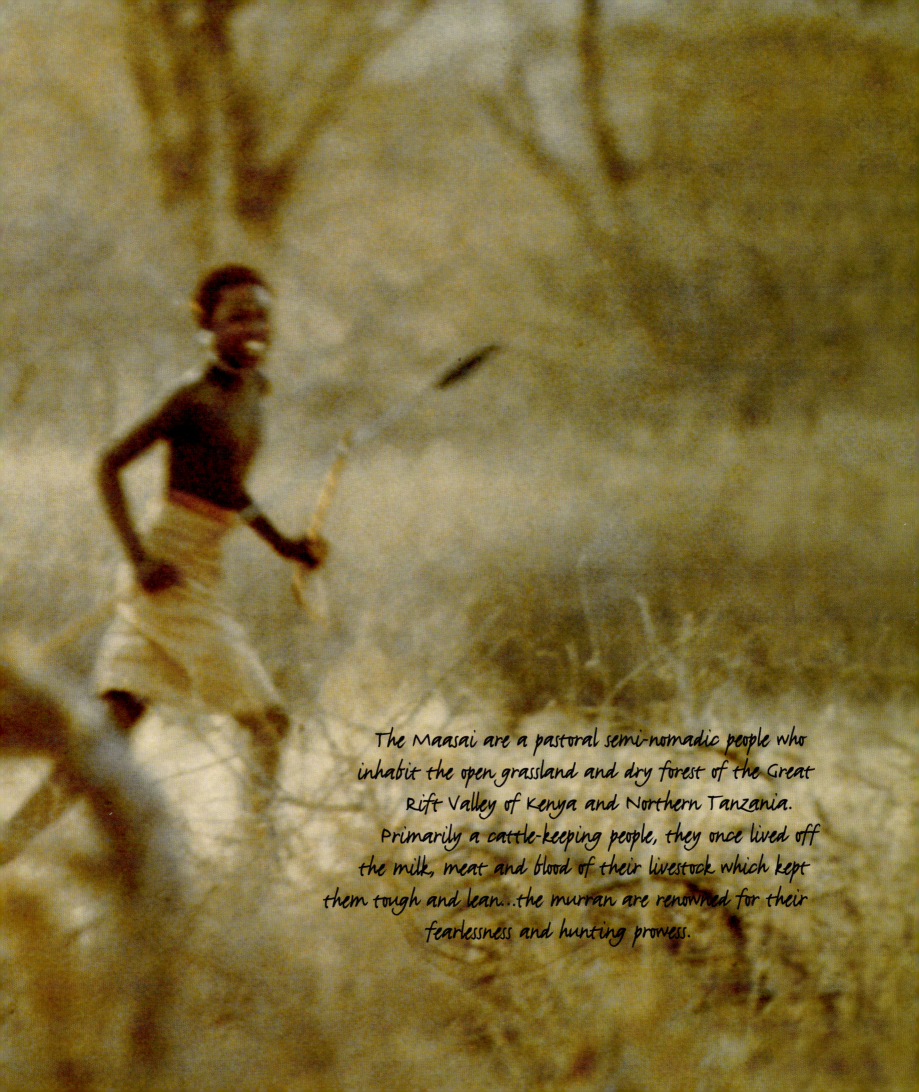

The Maasai are a pastoral semi-nomadic people who inhabit the open grassland and dry forest of the Great Rift Valley of Kenya and Northern Tanzania. Primarily a cattle-keeping people, they once lived off the milk, meat and blood of their livestock which kept them tough and lean...the murran are renowned for their fearlessness and hunting prowess.

One early morning in a Maasai manyatta I caught the sun pouring
through the branches of a fever tree, bathing the sleepy inhabitants
going about their morning chores in an
iridescence that removed them
momentarily from reality....

It was images like this that gave
birth to my love affair with Africa.

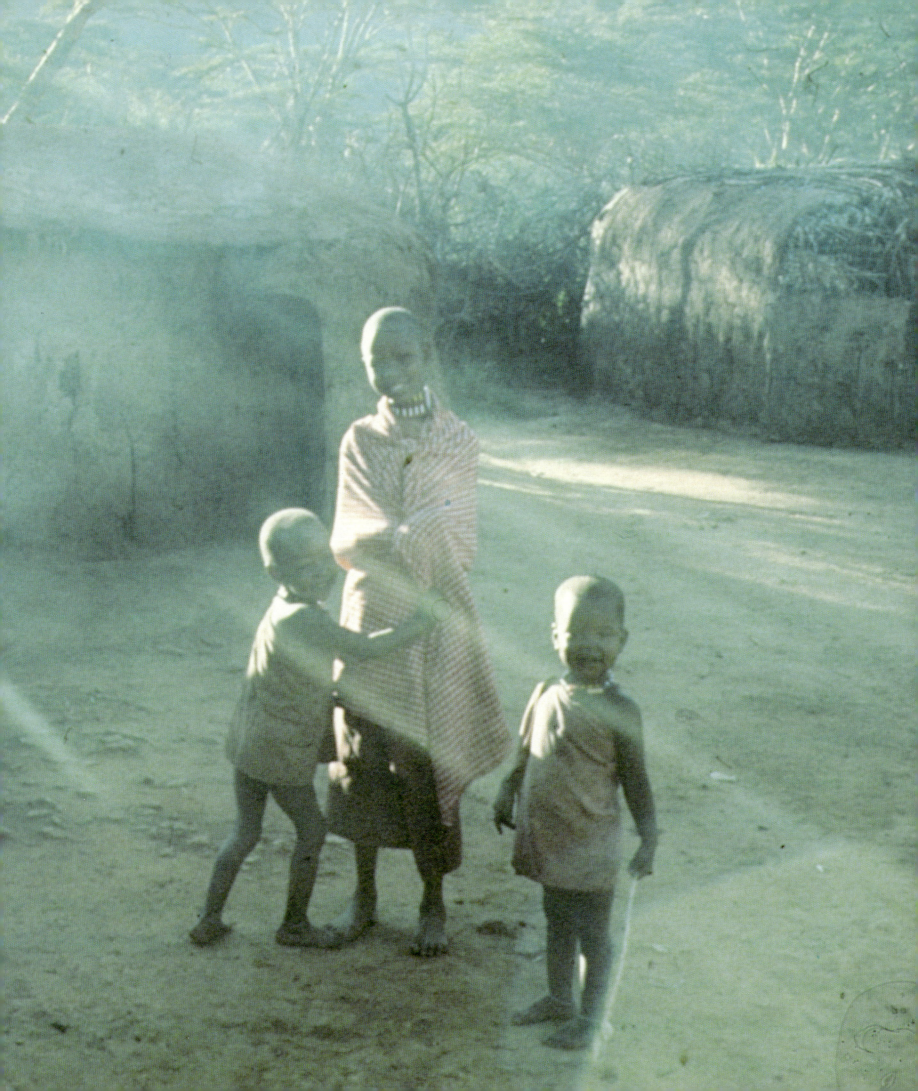

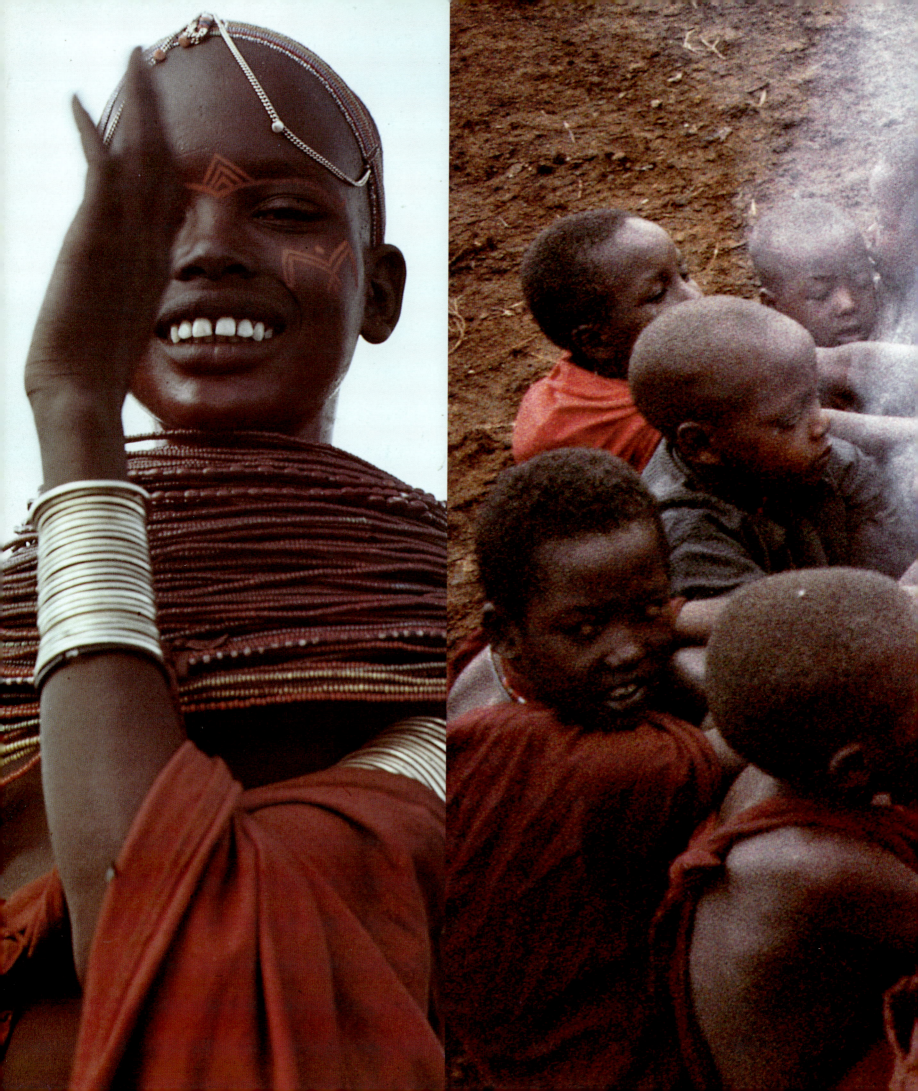

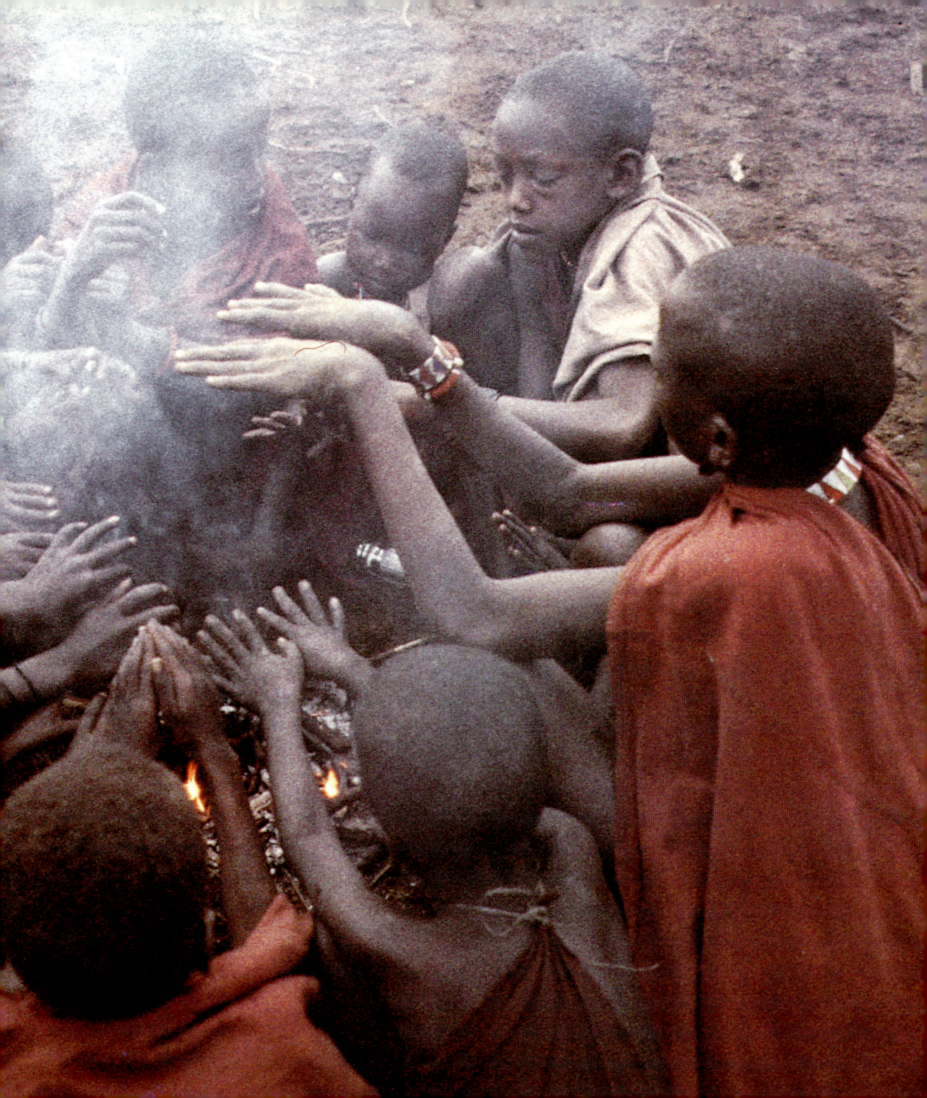

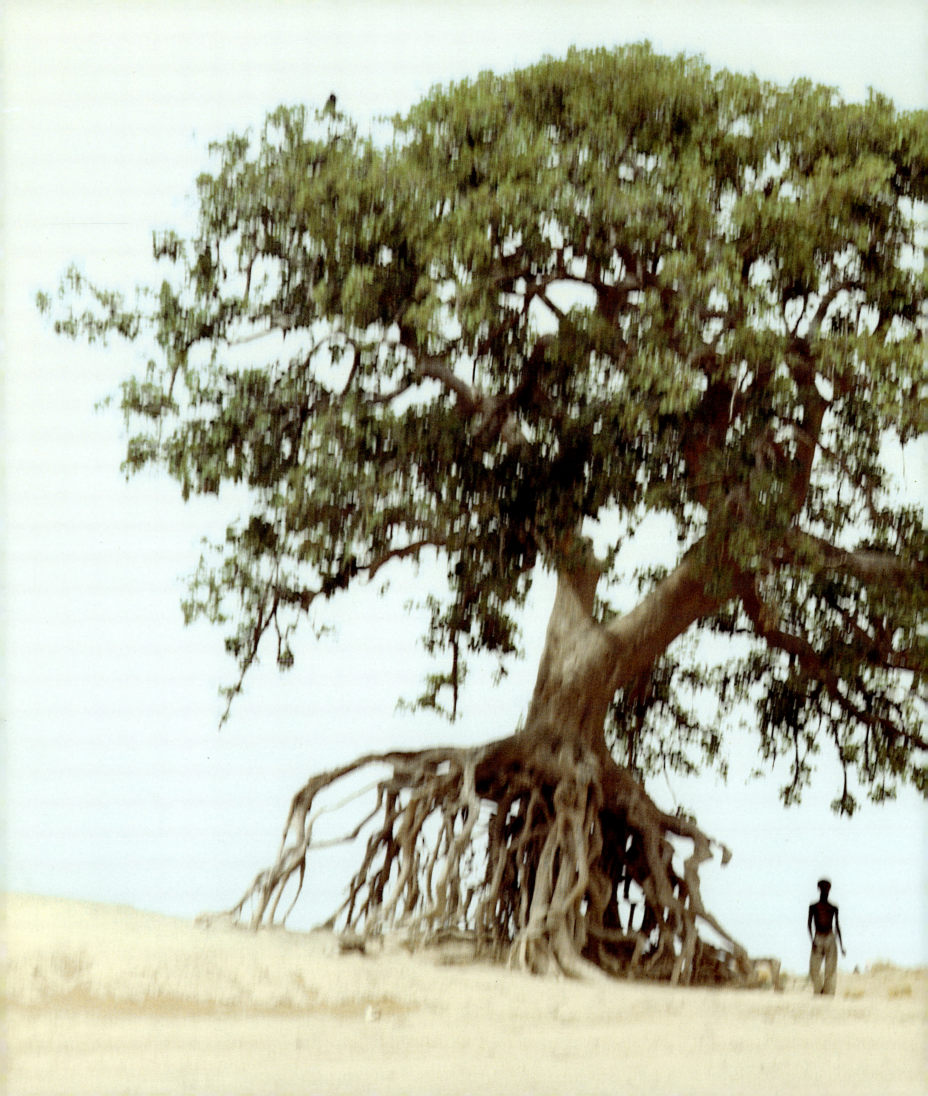

Travelling in a 'taxi brousse' from Mopti
to Djenne in Mali I came upon this tree, shimmering
in the heat waves of the open desert...

I reached for my camera and shot just one frame
through the windscreen
of the vehicle before the figure moved
and the image changed...

It was in moments like these
that I became aware of how much
I was part of Africa.

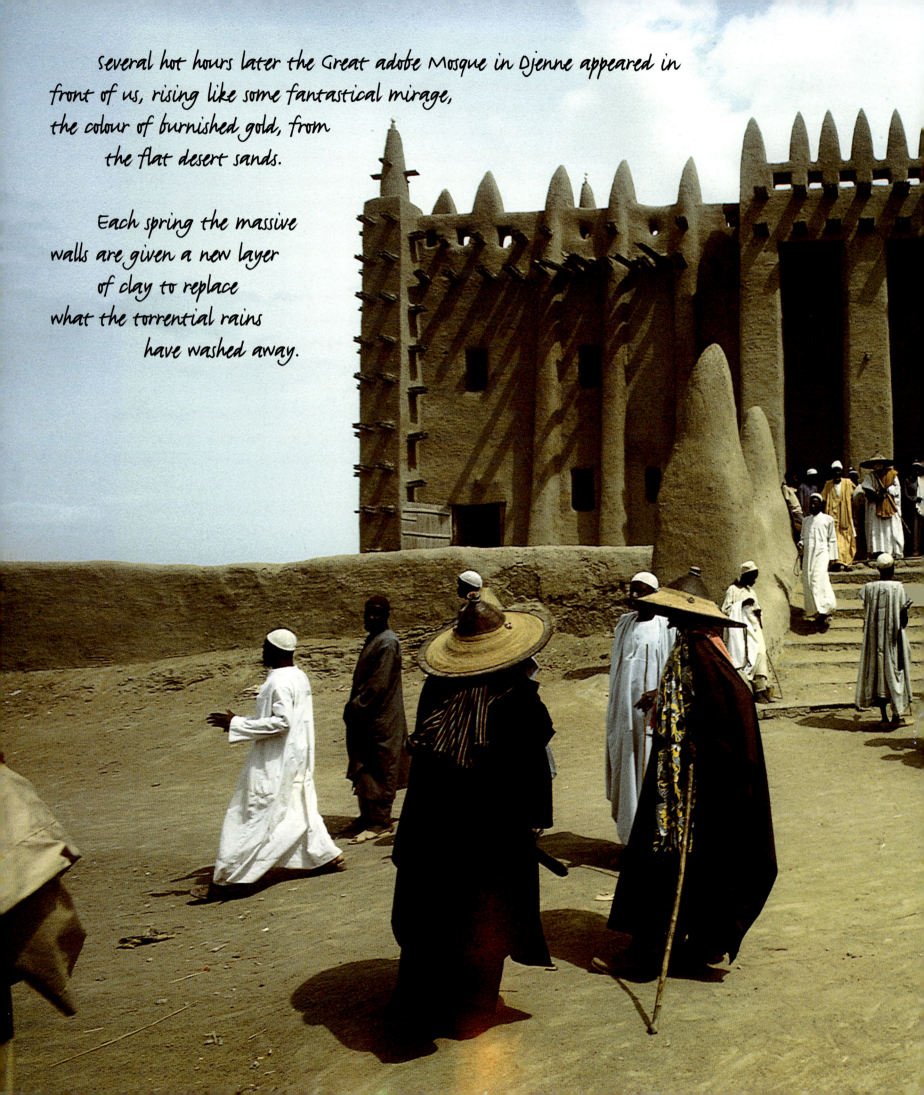

Several hot hours later the Great adobe Mosque in Djenne appeared in
front of us, rising like some fantastical mirage,
the colour of burnished gold, from
 the flat desert sands.

 Each spring the massive
walls are given a new layer
 of clay to replace
what the torrential rains
 have washed away.

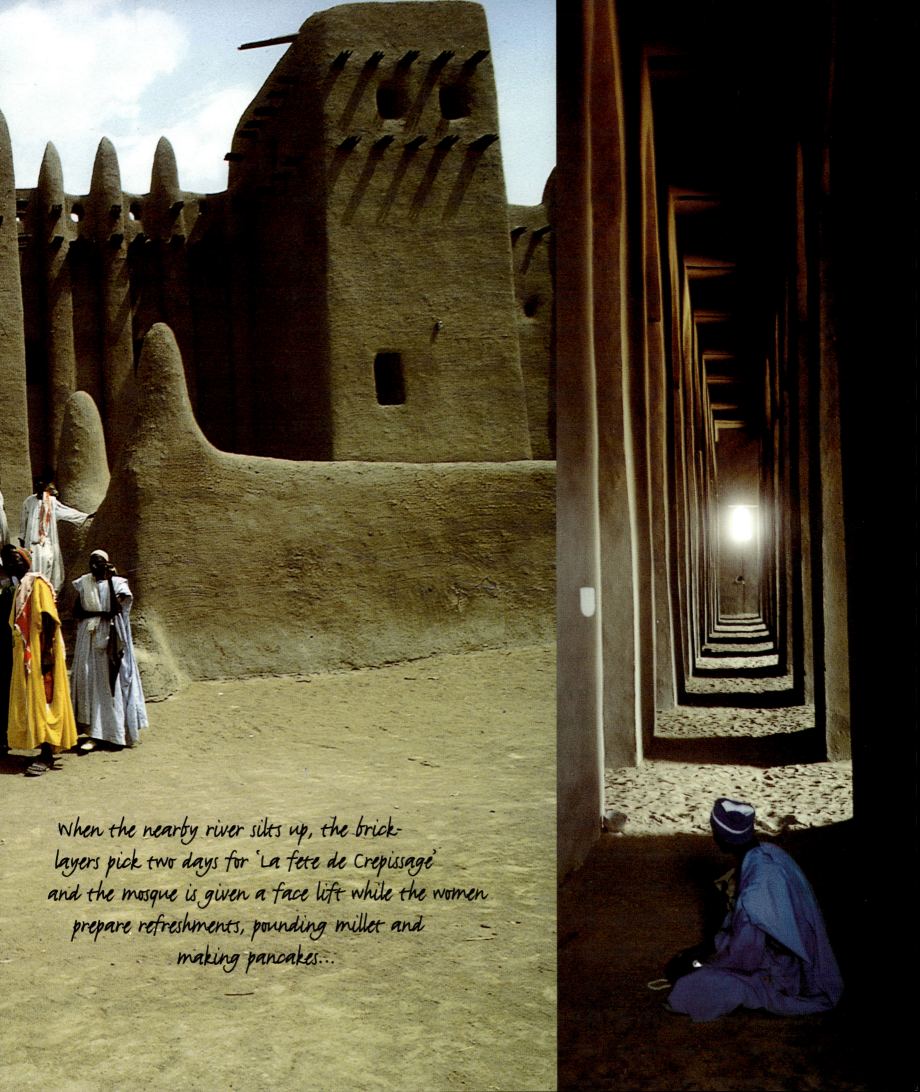

When the nearby river silts up, the brick-
layers pick two days for 'La fete de Crepissage'
and the mosque is given a face lift while the women
prepare refreshments, pounding millet and
making pancakes...

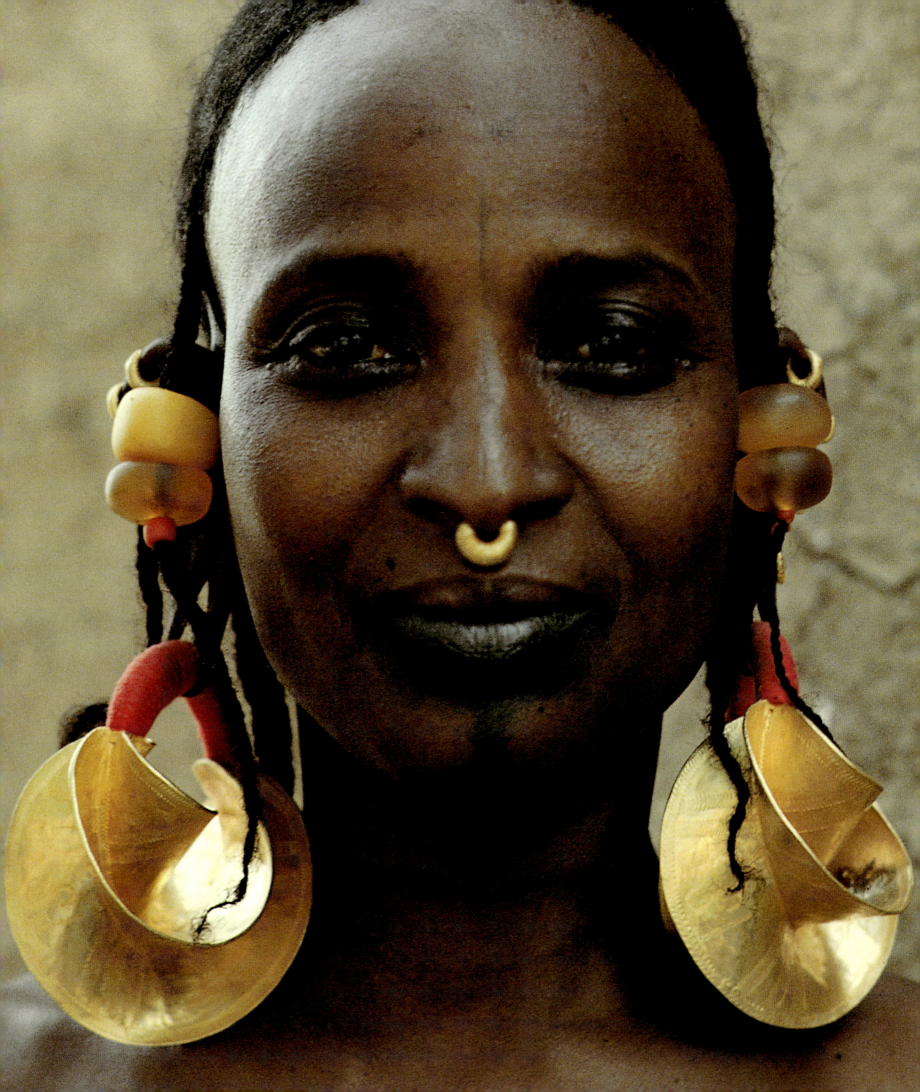

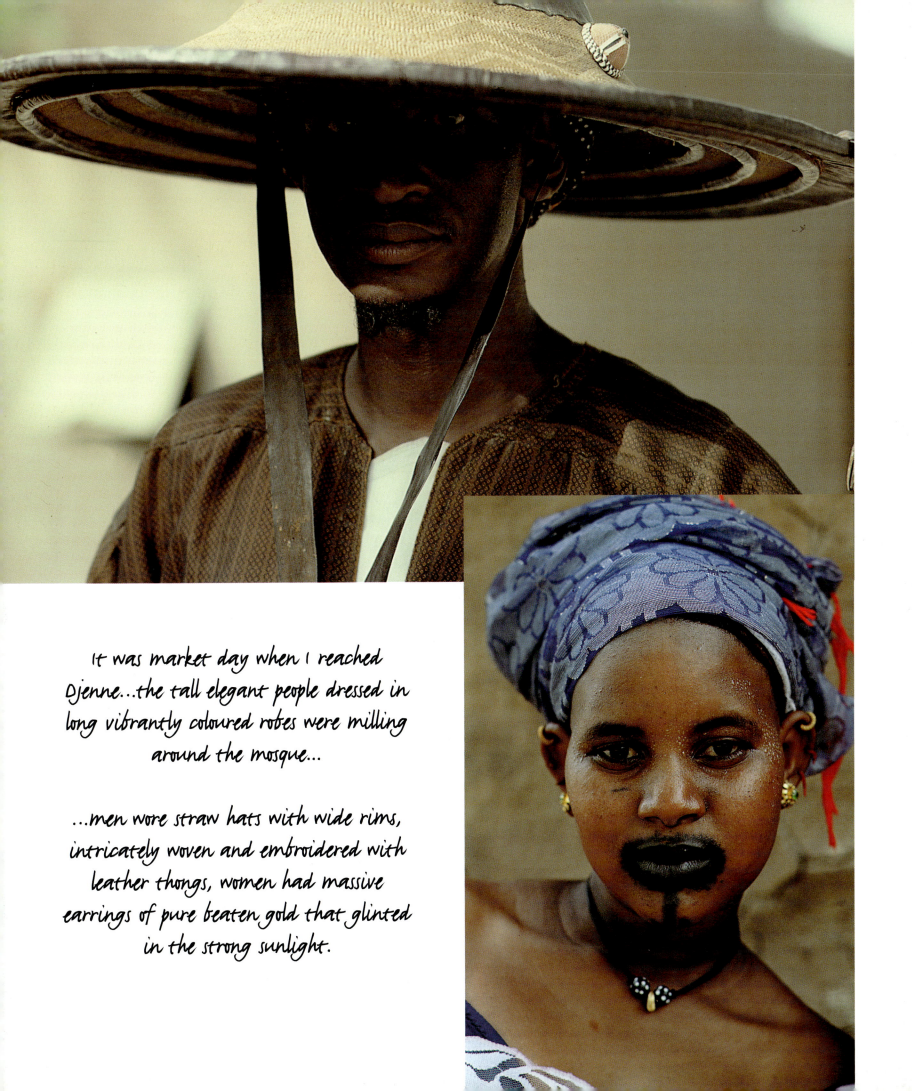

It was market day when I reached Djenne...the tall elegant people dressed in long vibrantly coloured robes were milling around the mosque...

...men wore straw hats with wide rims, intricately woven and embroidered with leather thongs, women had massive earrings of pure beaten gold that glinted in the strong sunlight.

For the Arabs who travelled
from the desert lands of
sand and mountains
of Arabia, Africa and the
fertility of the East
African coast, in
particular, appeared like in
a dream; for these men,
whose religion and severe
traditions had been
adapted to their natural
waterless environment, their
penetration into the continent
and the subsequent colonisation
of the coastal area was
ruthless and dearly paid
for by the African
coastal people, who fled
from them offering
little resistance.

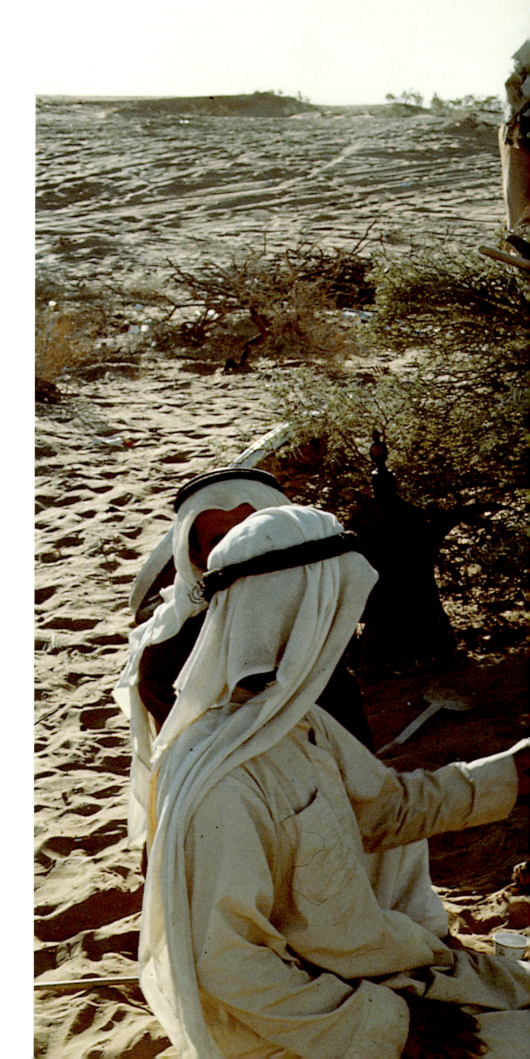

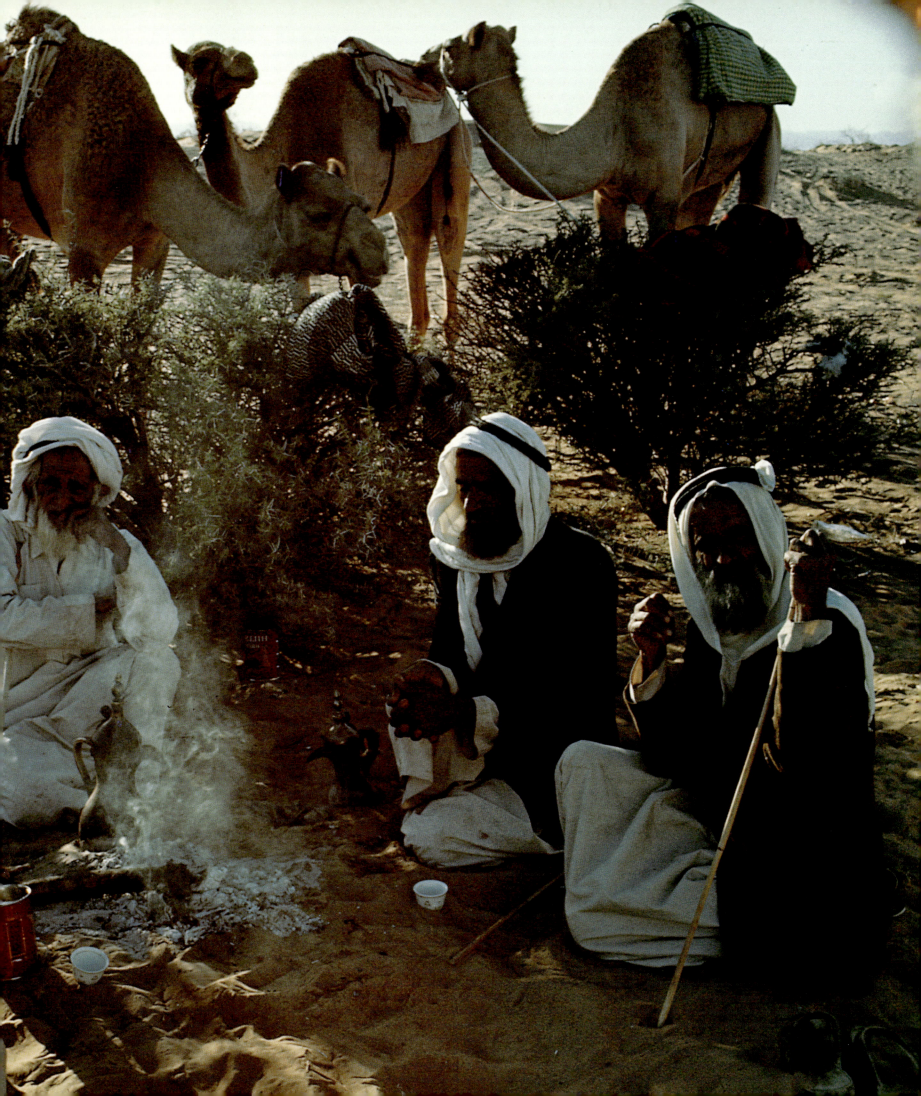

Pushed by the monsoon winds that blow each year for six
months from north to south and then from south
to north, the Arabs found in Africa an
immense and apparently inexhaustible oasis where they could reap without
sowing...making use of these regular winds they came and went
without ever abandoning their country of origin...

On our own journey southwards from the Persian Gulf to
East Africa in Lorenzo's dhow we were accompanied by sea
birds...gulls and fairy terns and sea hawks would land to rest on the mast ropes,
fellow travellers on a long sea journey to some distant land.

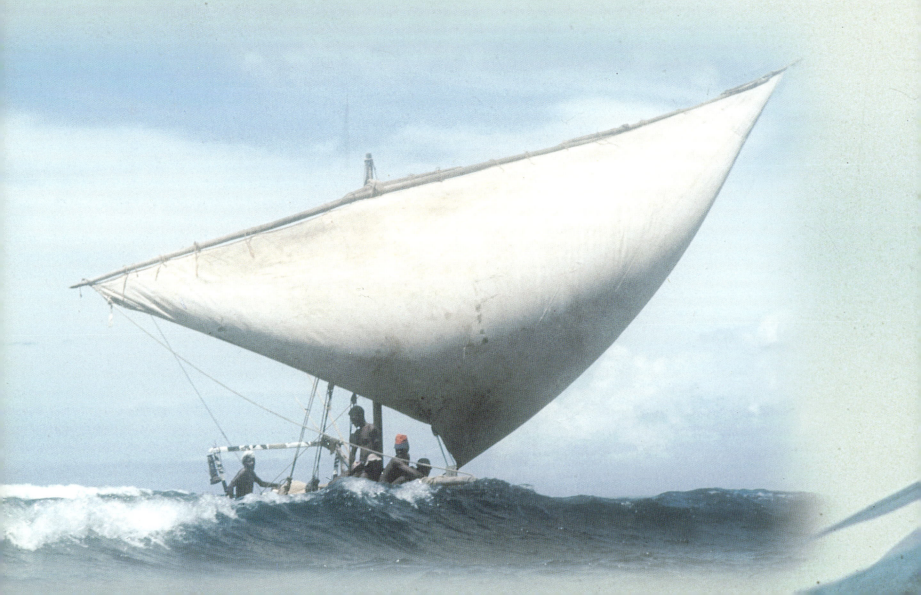

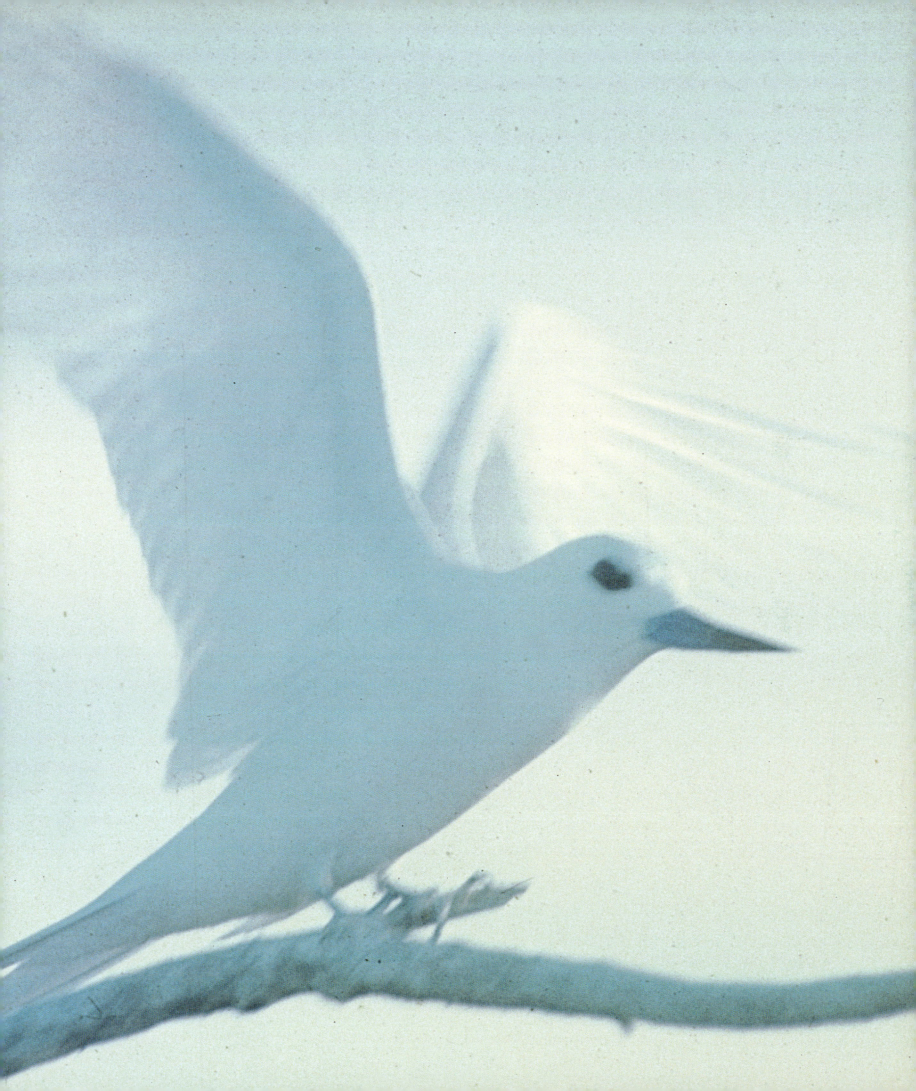

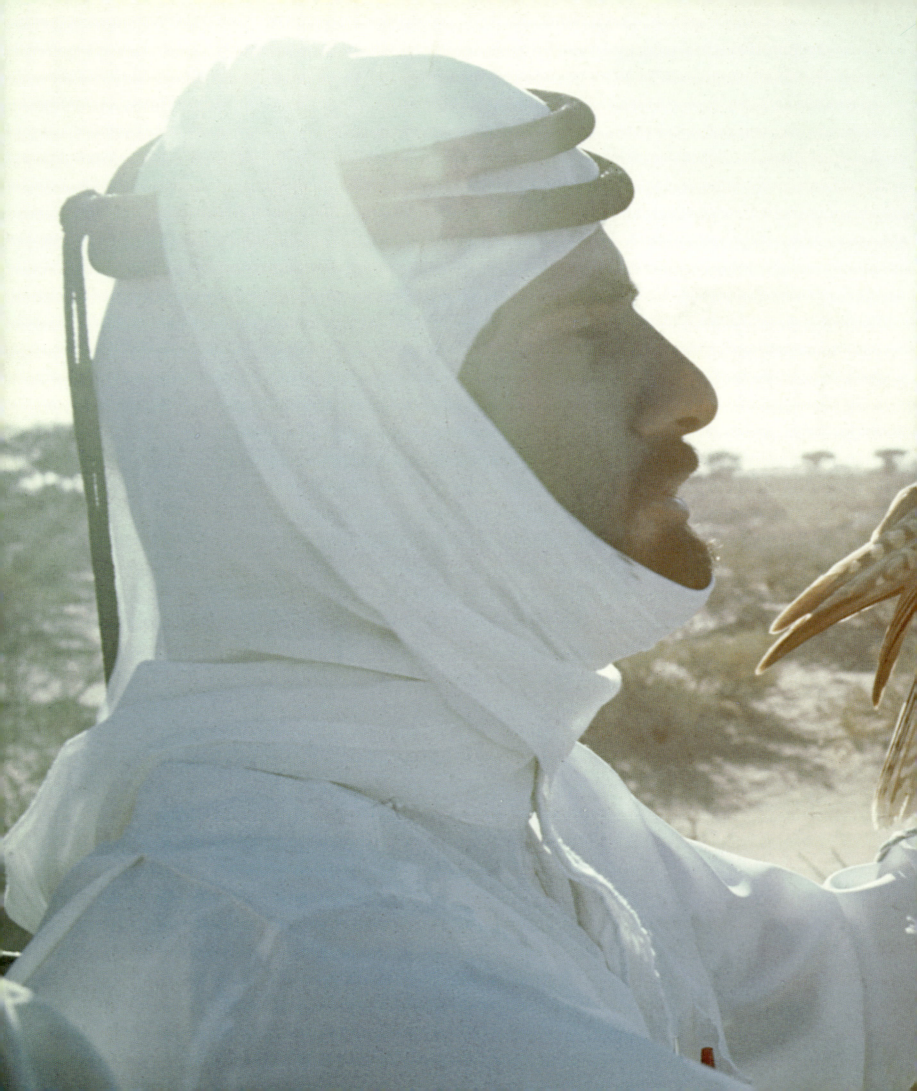

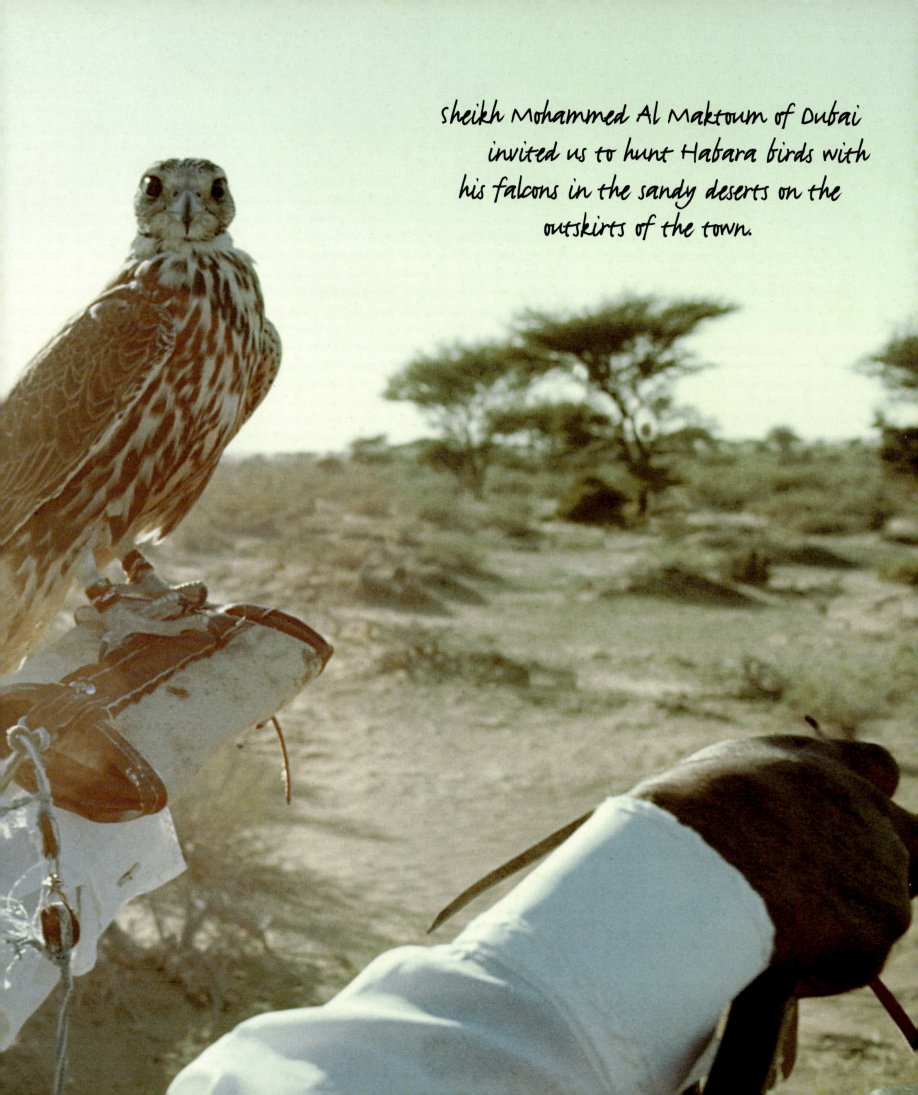

Sheikh Mohammed Al Maktoum of Dubai invited us to hunt Habara birds with his falcons in the sandy deserts on the outskirts of the town.

... I approached this lion on the back of my elephant... he stood motionless in the long golden grass with the wild African backdrop, smelling man but seeing only elephants.....

'Human over-population is the greatest problem of the world today. It makes one very despondent about the future of wildlife because there is absolutely nothing which can withstand human pressure...'
GEORGE ADAMSON – 1985

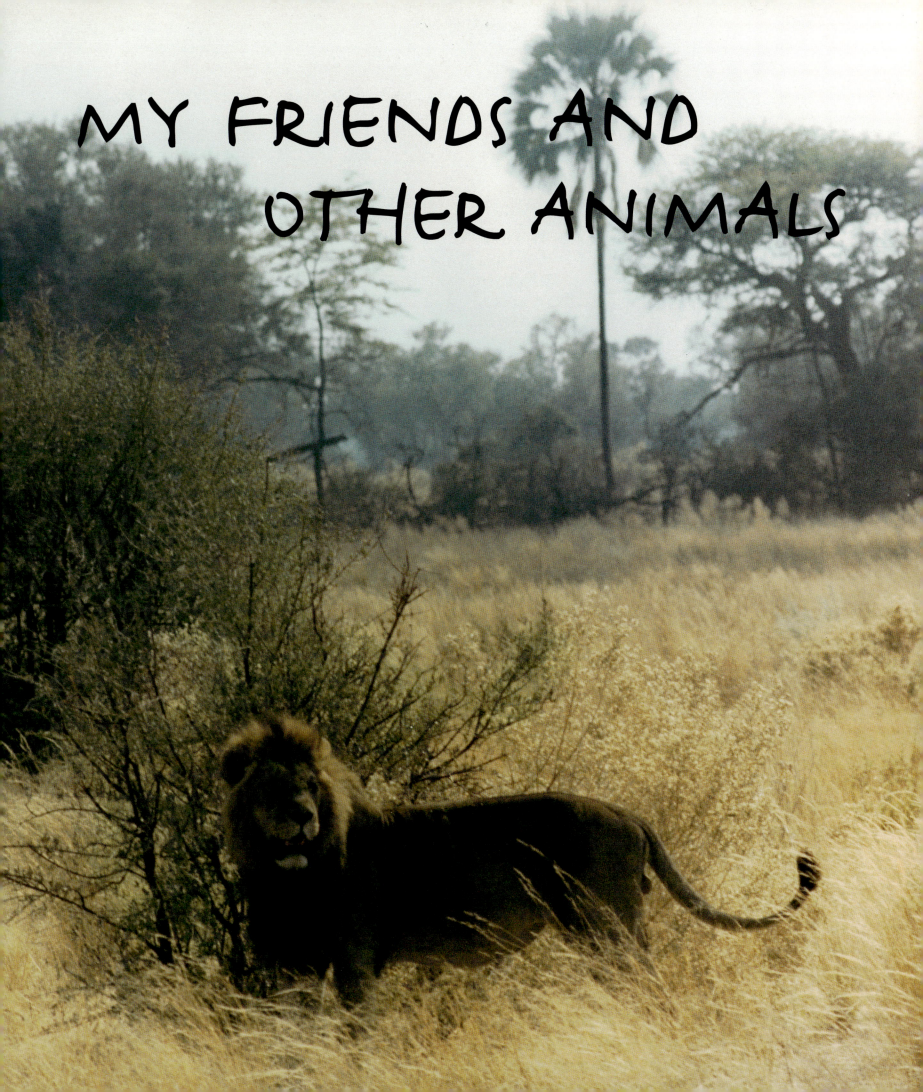

MY FRIENDS AND OTHER ANIMALS

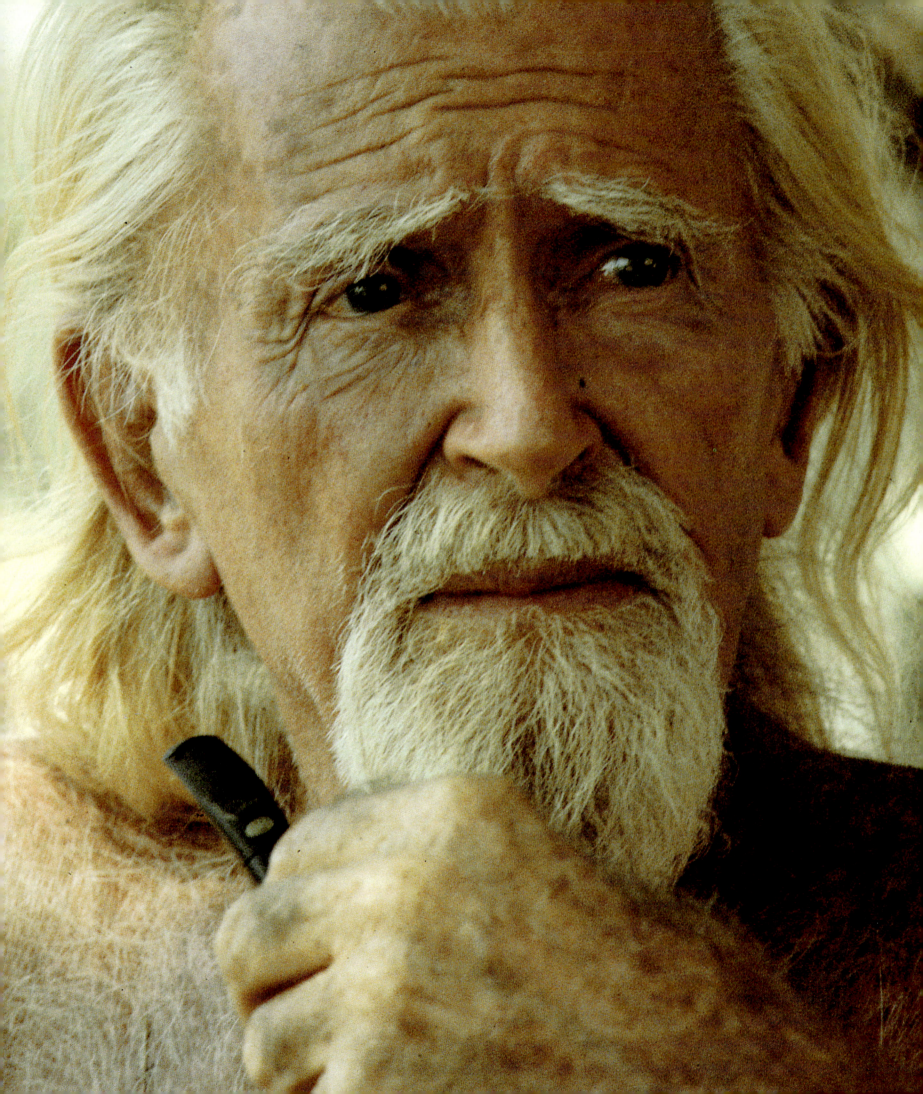

Walking with lions

GEORGE ADAMSON WAS one of my more memorable encounters. I first met him when I was shooting *Vanishing Africa*. He invited me to Kora, up north near the Somali border where he lived with his pride of tamed lions he had returned to the wild. He resembled a mystical man from another age with his mane of white hair and his carefully clipped goatee. He rarely wore anything more than a faded pair of green shorts and a pair of Petamba Koda sandals. His skin was weathered by years of exposure to the sun. With his brother Terence, who lived with him, these eighty-year-olds could not have better depicted two characters from the finest African fables. George was a quiet, gentle soul whose experience and wisdom emanated from his bright blue eyes with an infectious warmth that instantly drew you to him. Terence was a more silent, sultry replica of his brother; together they complimented each other. I stayed with them for several weeks, sharing their simple, no-nonsense lifestyle in the thorny bush country they had chosen to live in, far from the hustle and bustle of civilisation. It was a peaceful time which allowed for reflection and contemplation and brought into stark relief the value of man's close harmony with nature.

'Overpopulation,' he said one day, drawing on his pipe, 'is the greatest problem of the world today. It makes one very despondent about the future of wildlife, because there is absolutely nothing that can withstand human pressure. People have to realise that they have got to control their fertility, their population growth, because if they don't, I'm absolutely convinced that nature will find a way of doing it, and it will be very unpleasant; you can already see the symptoms now in the world, everywhere you look there is strife and that is a symptom of overpopulation.' George was savagely gunned down a year later by Somali bandits who wanted him out of the land he spent his life trying to preserve. His last wish was to be buried beside his lion family in Kora in the dramatic wilderness he so loved.

The two brothers spent their last ten years together in Kora, where they shared the simple spartan life of true bush people. George (left), Terence (right).

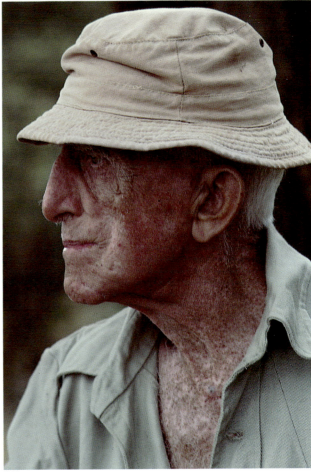

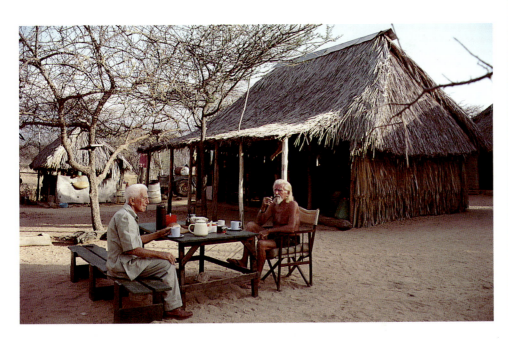

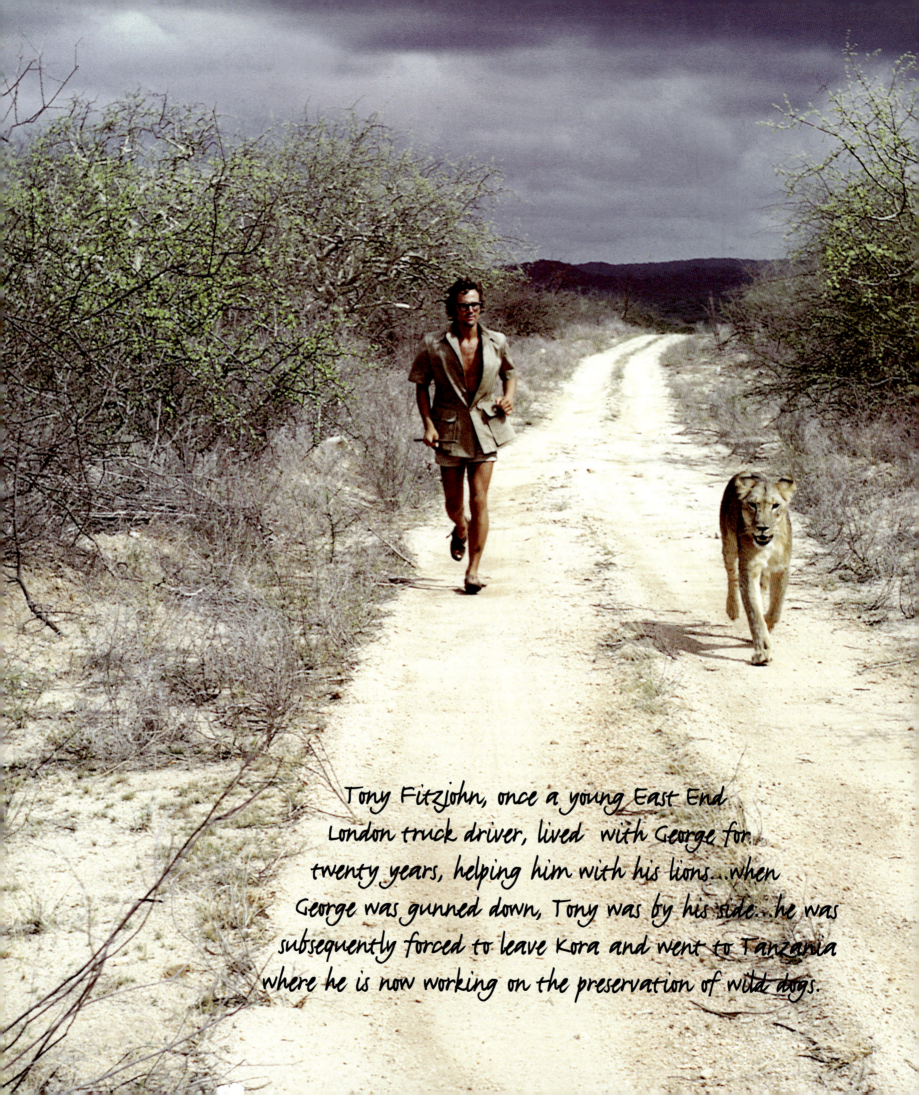

Tony Fitzjohn, once a young East End
London truck driver, lived with George for
twenty years, helping him with his lions...when
George was gunned down, Tony was by his side...he was
subsequently forced to leave Kora and went to Tanzania
where he is now working on the preservation of wild dogs.

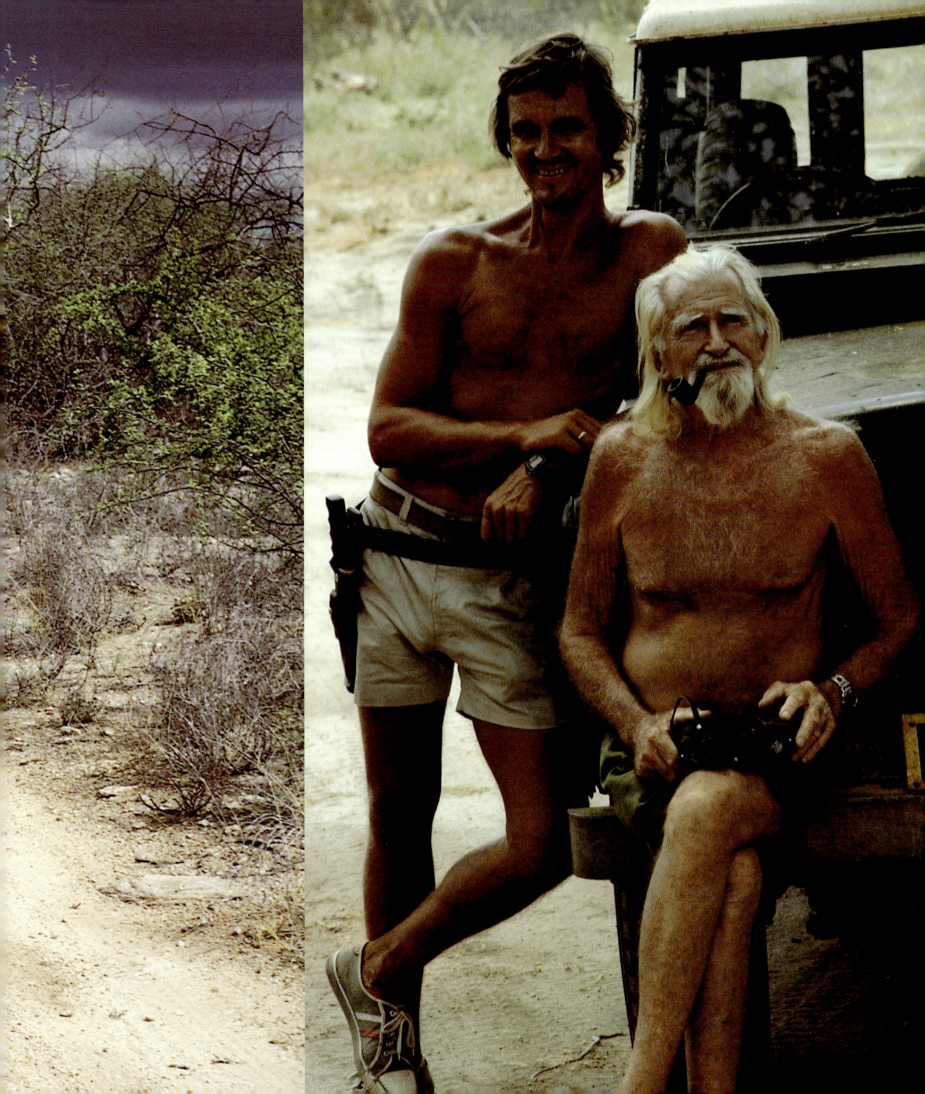

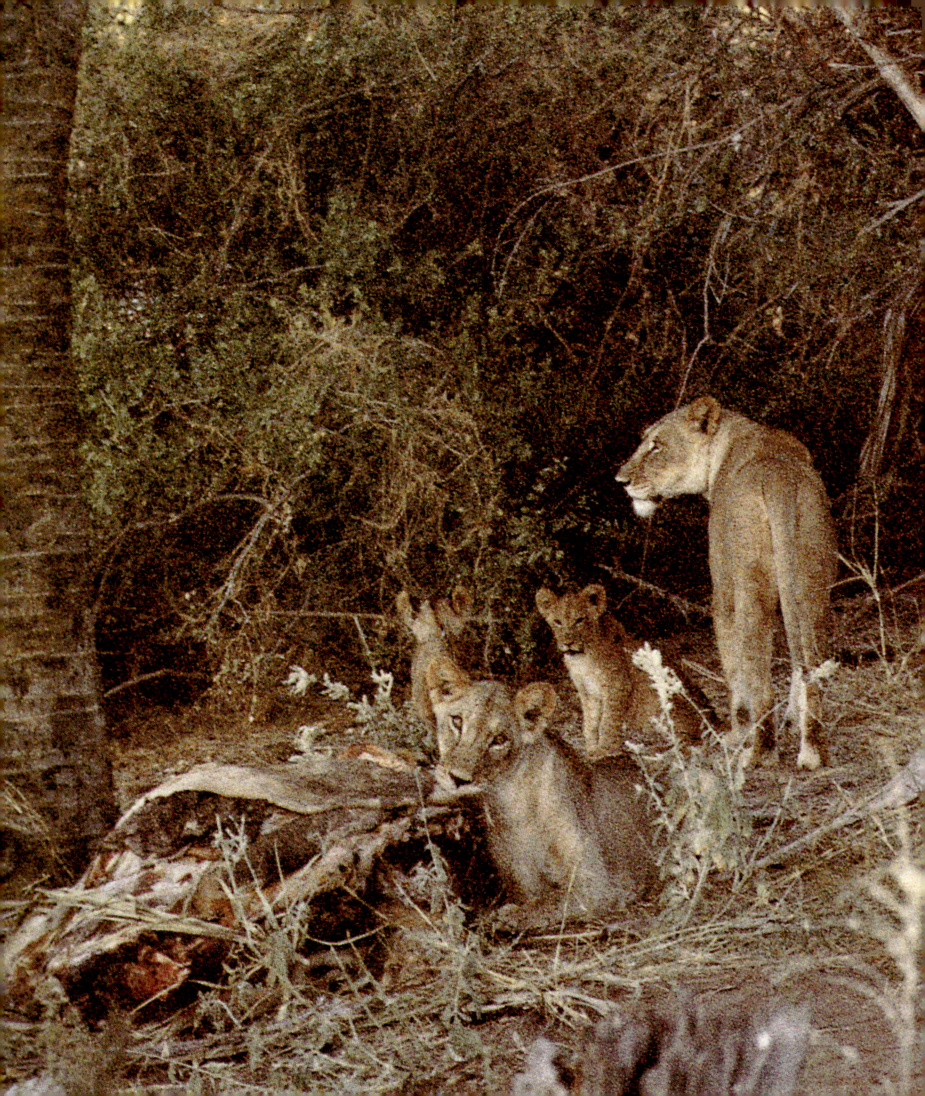

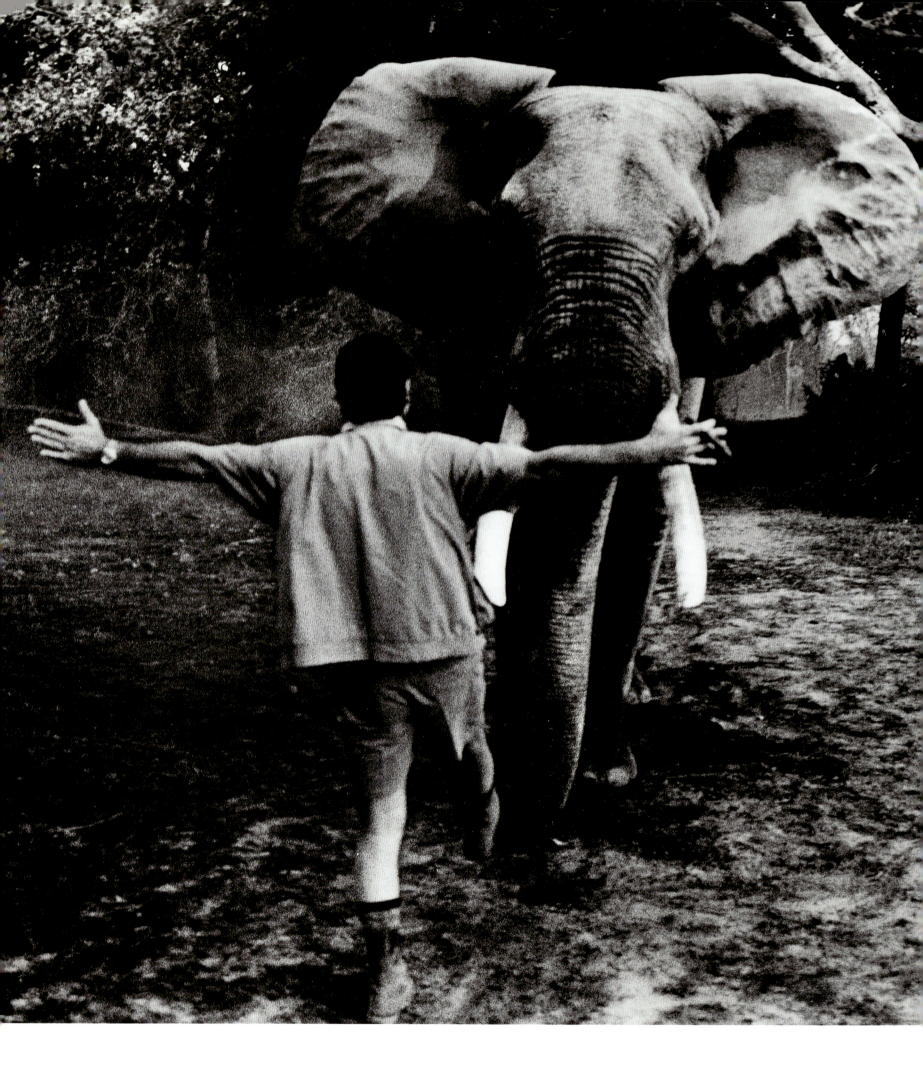

Abu Elephant Camp

MY ECCENTRIC FRIEND Randall Moore invited me to his Elephant Safari Camp in Botswana. There are few places left on earth where one can still experience true nature. Abu Camp, Randall's half-a-million-acre concession on the edge of the Okavango swamp in Botswana is one of them. It is here that Randall turned his dream of returning African elephants back to the land of their origin into reality. The idea of elephants providing the ultimate photographic safari had long been in his mind. 'There is no better way to move through the bush or to approach game,' he said to me. 'Elephants are silent and produce no petrol fumes.' Drawing on his experience of training elephants for circuses and films, he knew that he could also train them to take people on their backs.

This was a totally new experience for me and the sensation I felt as I heaved myself onto Abu's back, the five-ton, ten-foot tall leader of the pack who had lowered himself to ground level with such docile command so that I could climb into the saddle, was unforgettable. He then rose again, swaying heavily from one side to the other as he uncoiled his legs and moved forward slowly, followed by fifteen of his teamsters. From my ten-foot vantage point I looked out over the open swamp. Around us Africa spread, shining in the early morning light. Pink and white and mauve water lilies framed in flat dark green leaves, had opened with the rising sun and bobbed like butterflies as the massive feet moved over them, swishing on through the reeds.

One behind the other we roamed into Africa against a primeval backdrop of ancient doum palms and mahogany trees bathed in morning mist. The vision was surreal. I felt drunk with pleasure. This eccentric mode of travel gave us a taste of the miraculous wildlife that lived in the swamp. White egrets and Egyptian geese rose from the water and circled around us, tinged by the morning sun; we approached zebra and buffalo and kudu as I had never done before. They looked at us bewildered, smelling man but seeing elephants. When we dismounted and walked beside our gentle giants, I quickly realised how deceptive was the speed we were travelling at; I had to jog to keep up with their seemingly lazy gait.

Because I was doing a travel article for the *Tatler* magazine in London, I took Natasha, an aspiring professional huntress I had met around Peter Beard's camp fire in Nairobi. She rode ahead with Randall. Dressed in her smart Holland and Holland clothes, with her long blond hair streaked by the sun, she resembled a character in a novel I had just read on early

African exploration. I persuaded her one day to cast off her smart clothes, strip down to her knickers for a mud bath roll with Abu in a slippery depression by the swamp. After much hesitiation to her credit, she complied with my request and I had a field day with my camera.

On this trip I suddenly realised how much the elephant had been present in my family. One of the early childhood stories I remember was of my mother's elephant hunt in the Congo which gave birth to *Babar*, the internationally acclaimed children's book, written by one of her cousins, Jean de Brunoff. Killing an elephant filled her with so much remorse, she never again picked up a rifle. My sister brought elephants into our family once again when she married Douglas-Hamilton; at the time he was studying elephant behaviour in Tanzania's Manvara National Park for his Oxford thesis. I had gone with Peter Beard on his wildlife fashion shoots and photographed him with the elephants of Amboseli which he approached on foot to get his own extraordinary pictures.

On one of these occasions we photographed the Somali fashion model Iman, whom I had discovered and he had made famous, with one of the lions from *Out of Africa*. The lion jumped on its trainer, but Iman never lost her professional composure. Now here was I, perched high on this magnificent beast, falling irretrievably in love with them, bringing full circle my family's affinity to these archaic creatures.

Drawing on his experience of training African elephants for circuses and films, Randall Moore knew he could also train them to take people on their backs.

From his half-a-million-acre concession on the edge of the Okavango
swamp in Botswana we roamed on the backs of elephants,
against a primeval backdrop of ancient doum palms and
mahogany trees, steeped in morning mist.

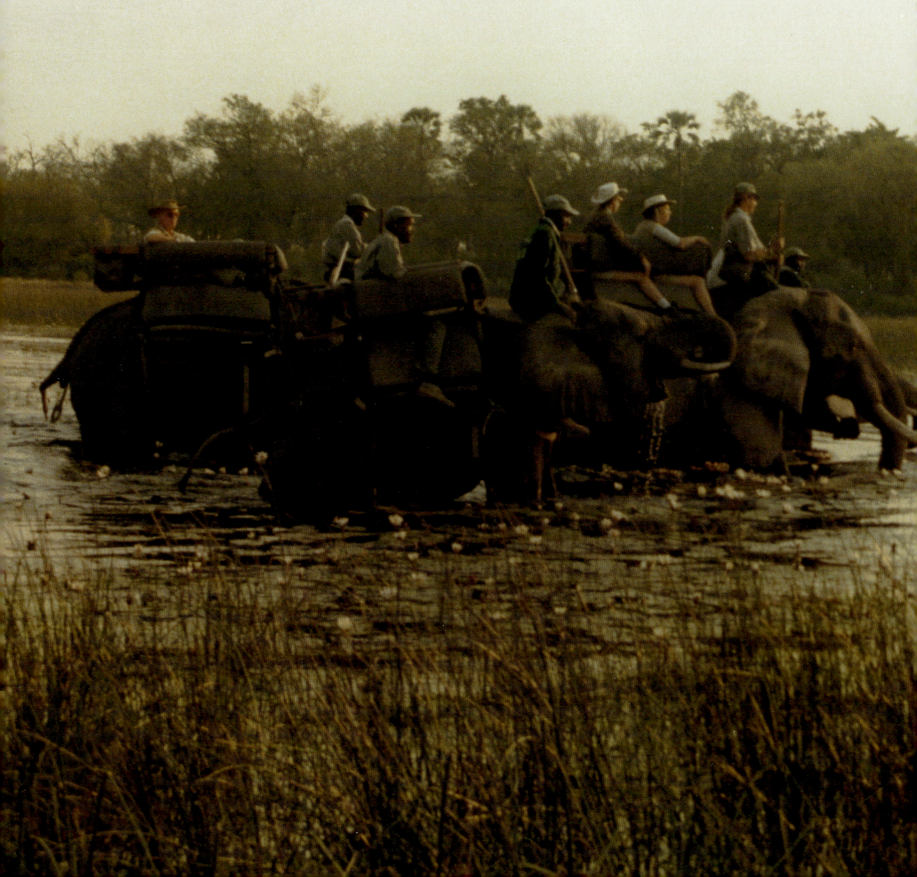

His eccentric mode of travel gave us a taste of the miraculous wildlife living
in the swamp; zebra, antelope, buffalo and kudu looked at us fearless
and bewildered, smelling man but seeing elephants...
white egrets and Egyptian geese rose from the water
tinged by the morning sun.

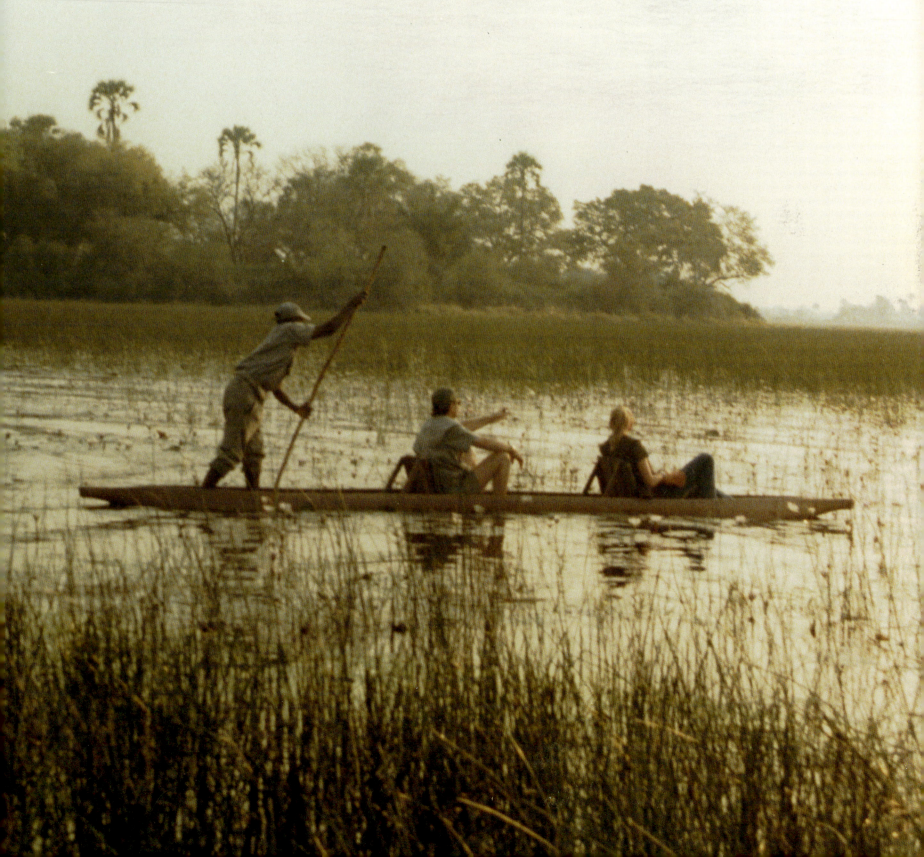

Around us Africa spread, shimmering
in the early morning light...

...soft-coloured water lilies, opened by the rising sun, bobbed like butterflies
beneath the massive feet as the elephants swished through the reeds spraying
the air in front of them with water.

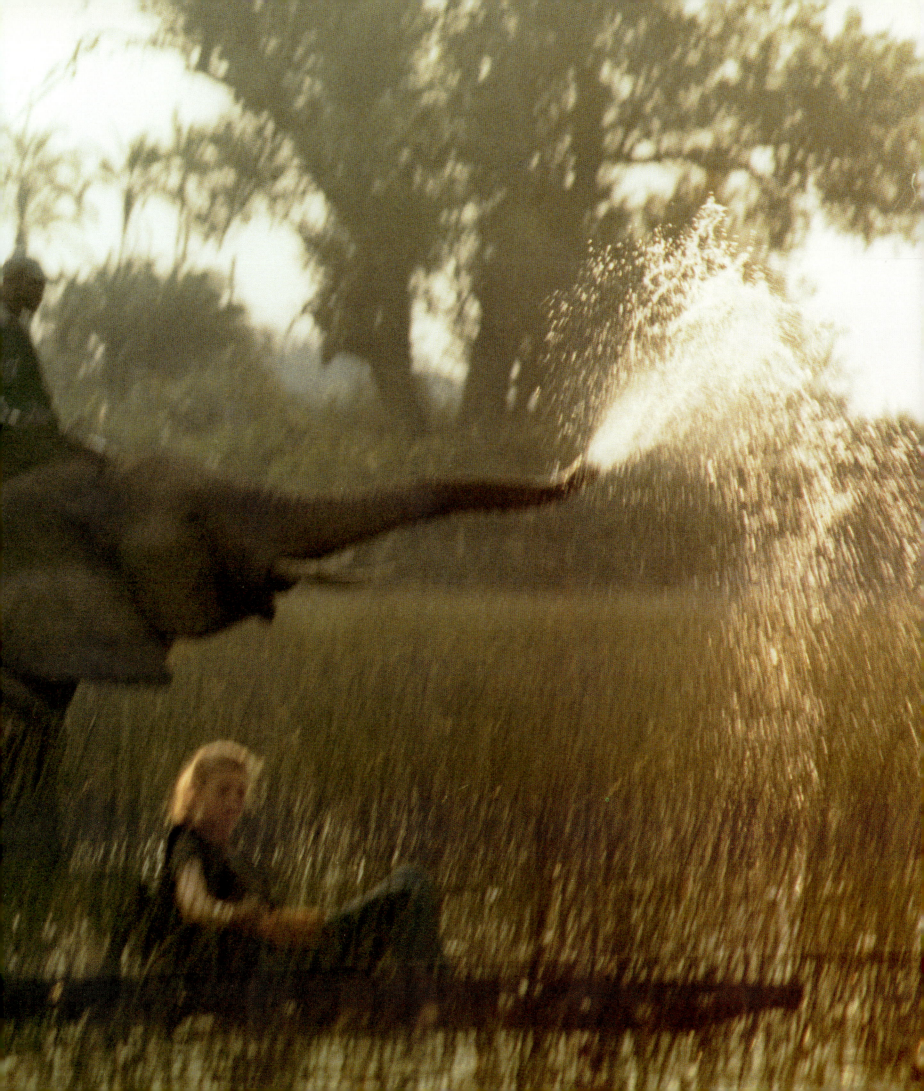

The idea of elephants providing
the ultimate photographic safari
had long taken root
in Randall's mind

'There is no better way to
move through the bush,' he said
'elephants are silent and produce no
petrol fumes.'

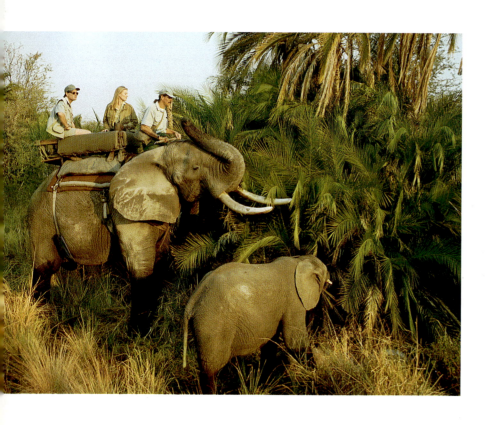

I took Natasha, an aspiring professional huntress I had met around Peter
Beard's camp fire, as my model for the article I was doing... she was nervous
about getting too close to elephants...

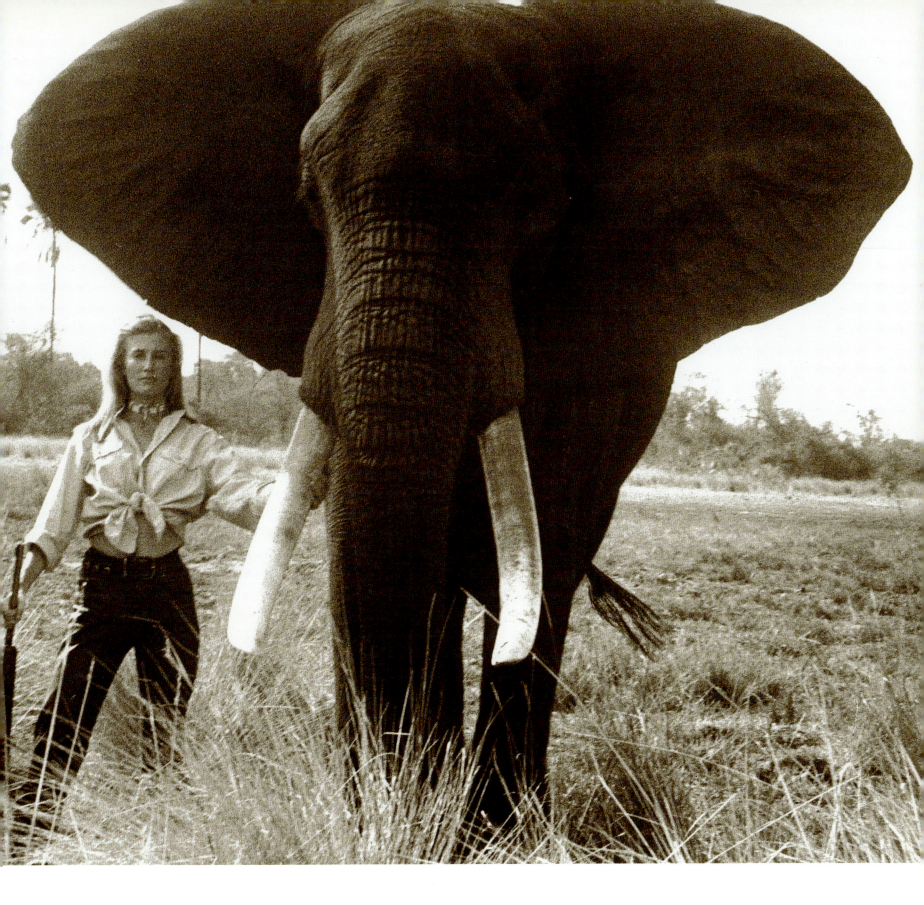

Abu was taken to America from Africa when he was just a baby...he grew up in
an American circus from which Randall rescued him and returned him to
Africa as an adult. He is docile and obedient and spreads his ears on command.

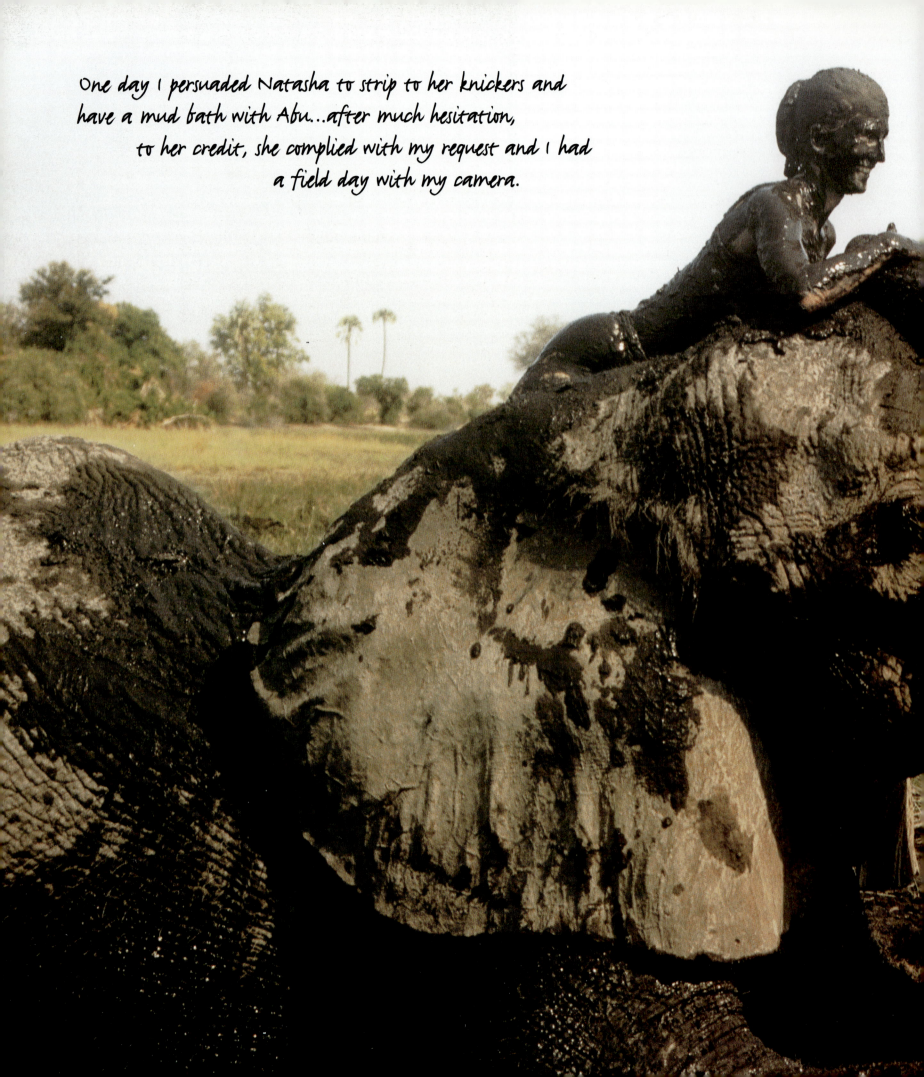

One day I persuaded Natasha to strip to her knickers and have a mud bath with Abu...after much hesitation, to her credit, she complied with my request and I had a field day with my camera.

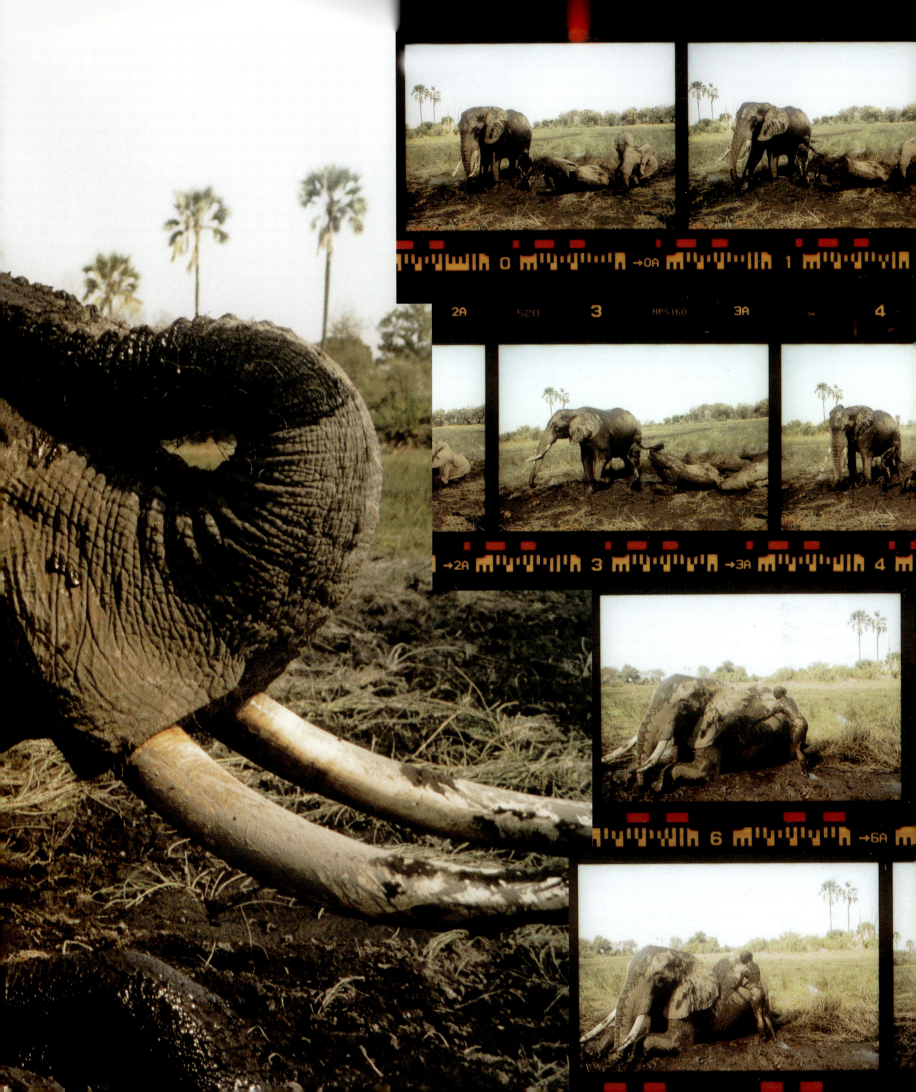

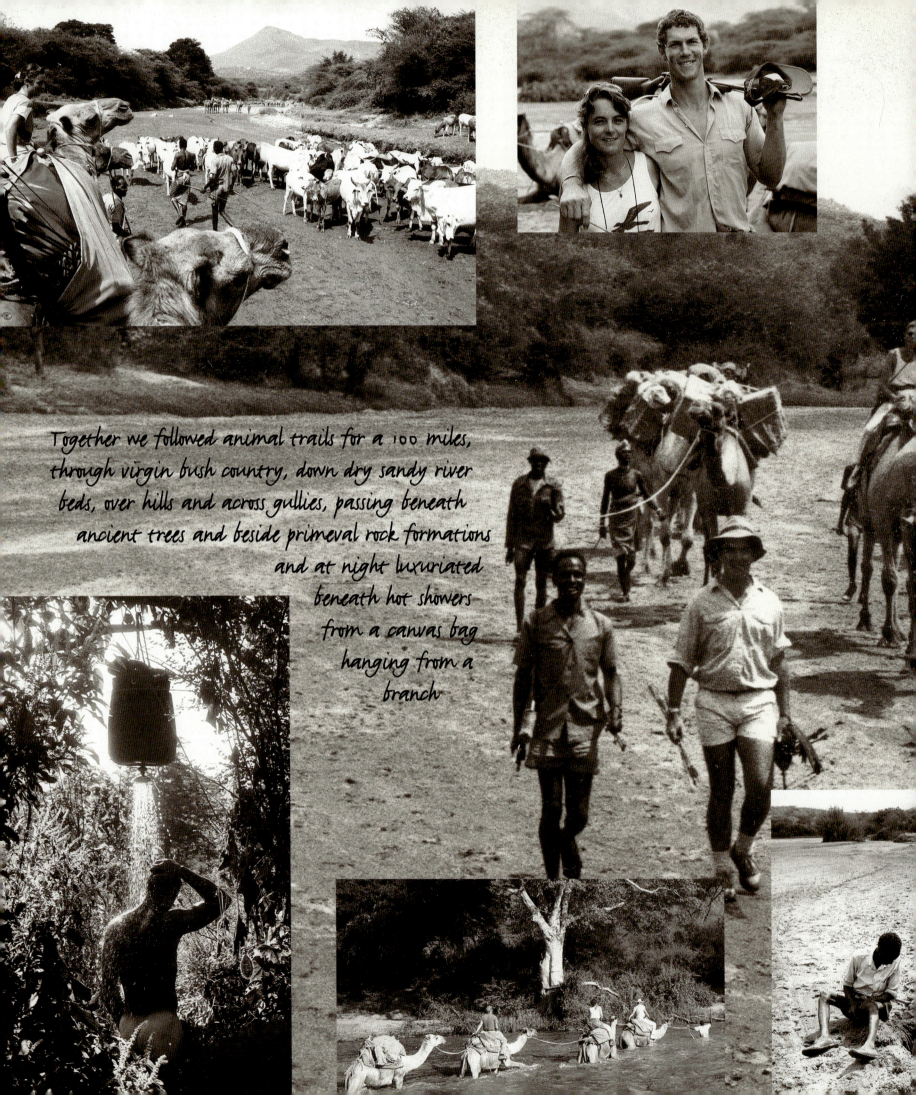

Together we followed animal trails for a 100 miles,
through virgin bush country, down dry sandy river
beds, over hills and across gullies, passing beneath
ancient trees and beside primeval rock formations
and at night luxuriated
beneath hot showers
from a canvas bag
hanging from a
branch

Desert Rose Camel Safari

My friends Simon and Helen who ran the excellent Desert Rose camel safari outfit took me on a ten-day walkabout.

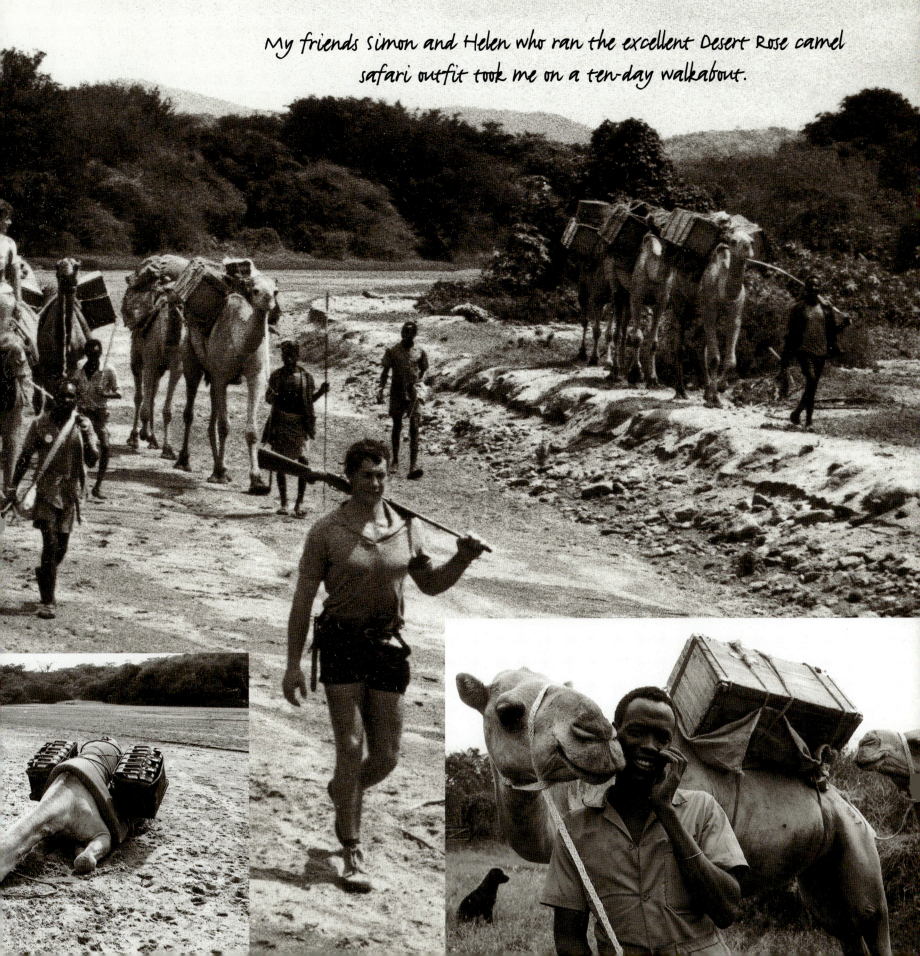

Mountain Odyssey

ONE DAY I happened upon a friend, an unusual sort of chap who lived at the foot of Mount Kenya. Phil Snyder was the warden of its slopes. He was another of these singular men who are attracted to Africa and for whom Africa has been kind as well as ferociously demanding and infuriating. He came from Ohio and resembled one of the bikers from the film *Easy Rider*. His thick jet-black hair fell to below his shoulders and was tied back in a tail by a rubber band. In his right ear he wore a fine gold ring. He was big, muscular and manly with drooping moustaches and was impossibly sexy. He was known as Mountain Madness. He took me with him on one of his mountain walkabouts and I never recovered from the experience. I had never been on a mountain before and felt a bit at odds with it, but he was so much part of it, I soon felt safe and reassured in his presence. I took his hand and followed silently behind him as he led me into a world far removed from anything I had ever experienced. A world where the air was so thin it made my heart beat faster and my lungs ache with every step I took. It rained most of the time, a fine infuriating drizzle that never stopped and when it did the mist it created was so heavy we were never dry. He carried a black umbrella and I placed my feet in his footprints. It was hard to keep up with him since I had to stop all the time to catch my breath and still my beating heart. I felt very vulnerable. He just kept going. At times the fog was so thick he would disappear from sight and then suddenly reappear. He reminded me of a mountain spirit, leading me ever upwards towards the invisible peaks. I became light-headed and quite unquestioning, following the man with the black umbrella; all around us the mammoth mountain vegetation stood out like silent sentinels shrouded in mist, dark guardians of the slopes. At their feet the tufts of long hardy grass, glistening with moisture, fell in soft golden folds all around. Water trickled down the

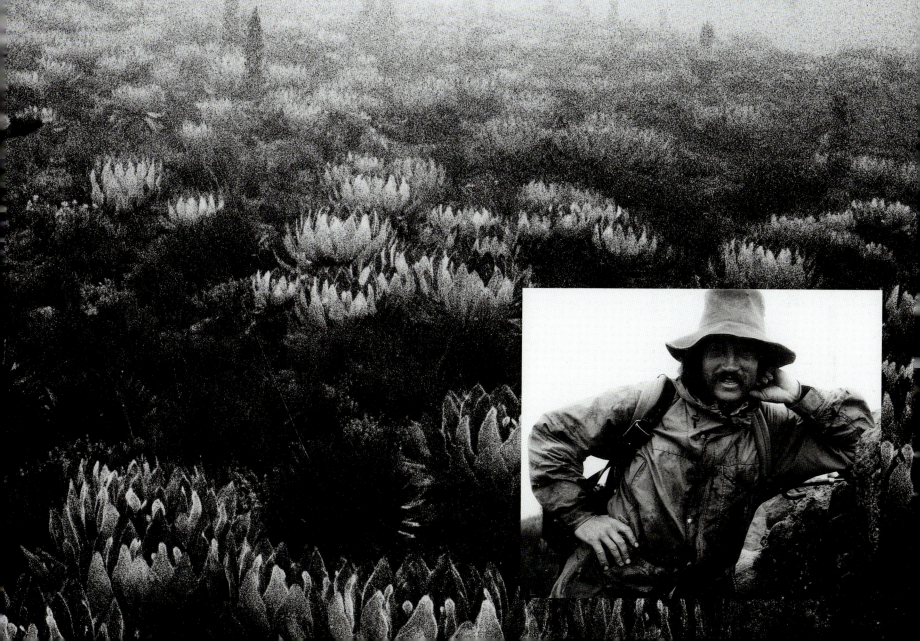

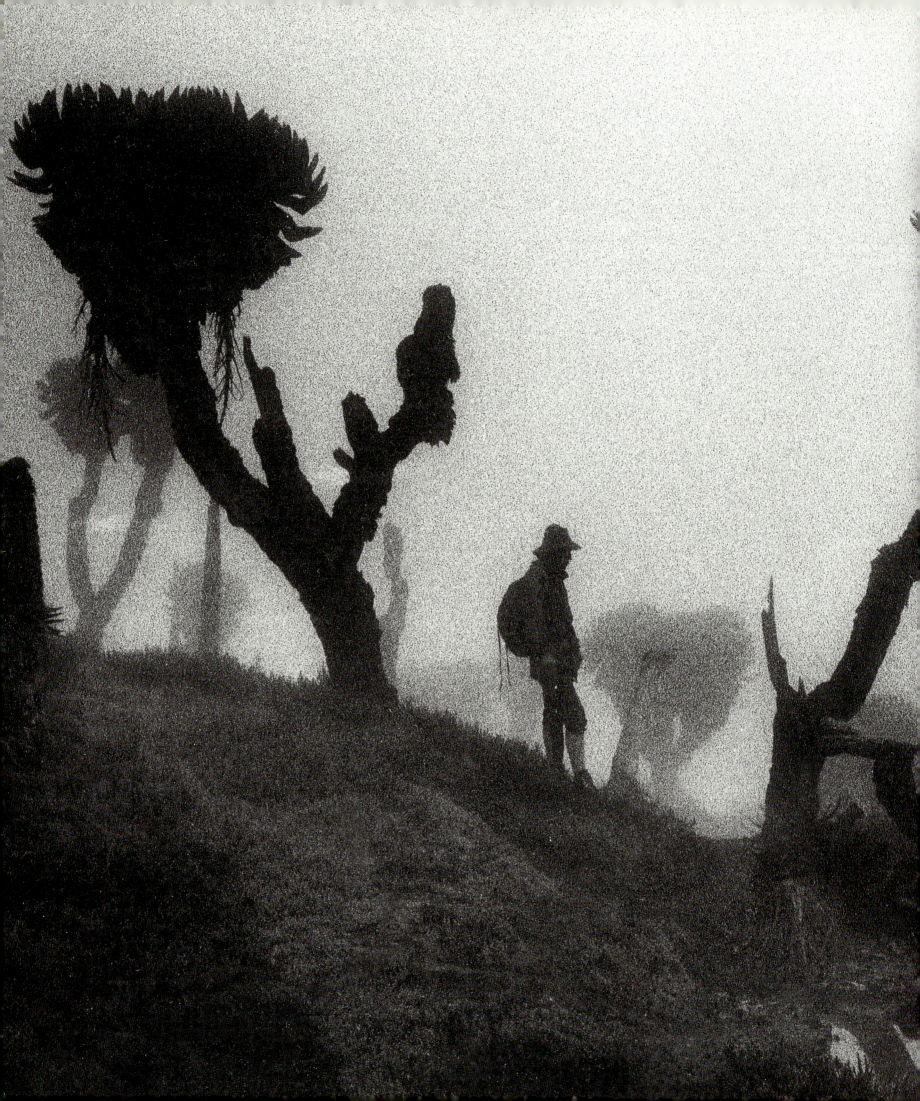

path, tumbling over tiny stones rounded by the ages and seeped into my boots. Clusters of mountain violets nestled in the recesses, bright blooms of white and mauve peeping from beneath the blades of yellow grass. I watched where I trod so as to avoid crushing them under my boots as I squelched and slithered upwards, trying to keep up. As I walked I felt the earth in all its warmth and beauty, time seemed to pass without heeding, there was no boredom.

It was a world of fragile beauty; grace and beauty to the adventurer is like an airy lotus blossom on the ice. My thoughts were clear and I remember thinking 'This mountain is going to steal my identity, it tells me how I feel, I can no longer tell where it ends and I begin.' We moved upwards towards the peaks, every step seemed to rob me of my breath; it became an effort to walk, to talk, even to think. Intellect and senses became dulled, energy drained from the body, there was nothing to do but to walk and think. My mind floated from one incomplete memory to another. I went like a pilgrim inspired by the majesty of the mountain. It was part of the ritual preparation for the meeting with the peaks. I recalled a line in Phil's mountain diary, 'The challenge of the peaks is the challenge of life itself, to struggle ever higher. Challenge is what makes great men and there can be no challenge without the risk of failure.' I remember being impressed as I fell in love with him like so many girls before me had done. He had scaled those peaks 64 times, but had never yet seen the mountains with my eyes, he told me. Now and again he stopped to wait for me to catch up. Strong and silent he belonged to the mountain. The land around us dropped gently towards the distant planes thousands of feet below us. There was no sound, just silence all around.

At night we sought refuge in great caves formed by overhanging rocks. We cut the long grass and mountain heather and made a soft mattress on which we lay our sleeping bags. Tired and aching and exhilarated by the climb, we lay side by side for warmth and looked out at the black African sky hung with myriads of stars, framed by the jagged edge of the cave's gaping mouth. It was dark everywhere, only the glow of the marijuana joint we shared, made us visible to each other. In these moments each cell of your body begins to sing, worlds of spirits awaken and the worlds of dreams take over. At night the mountain becomes a world of silence beyond imagination. He told me stories of his mountain exploits in a soft gentle voice that fatigue and inebriation magnified beyond all proportion until we fell asleep. 'Throughout time, man has aspired to great heights in search of peace of mind and tranquillity of heart,' I heard him say as I drifted off. Here on Mount Kenya, I learned the true meaning of these words.

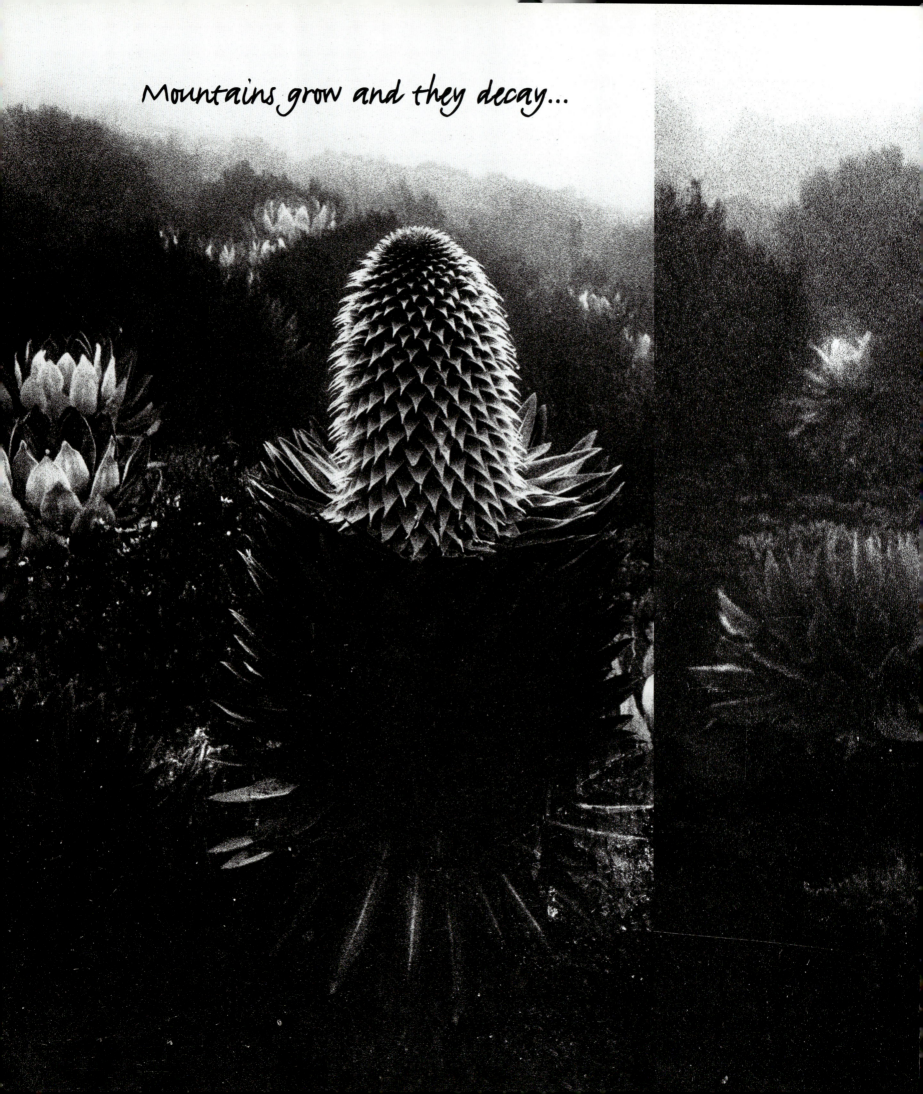

Mountains grow and they decay...

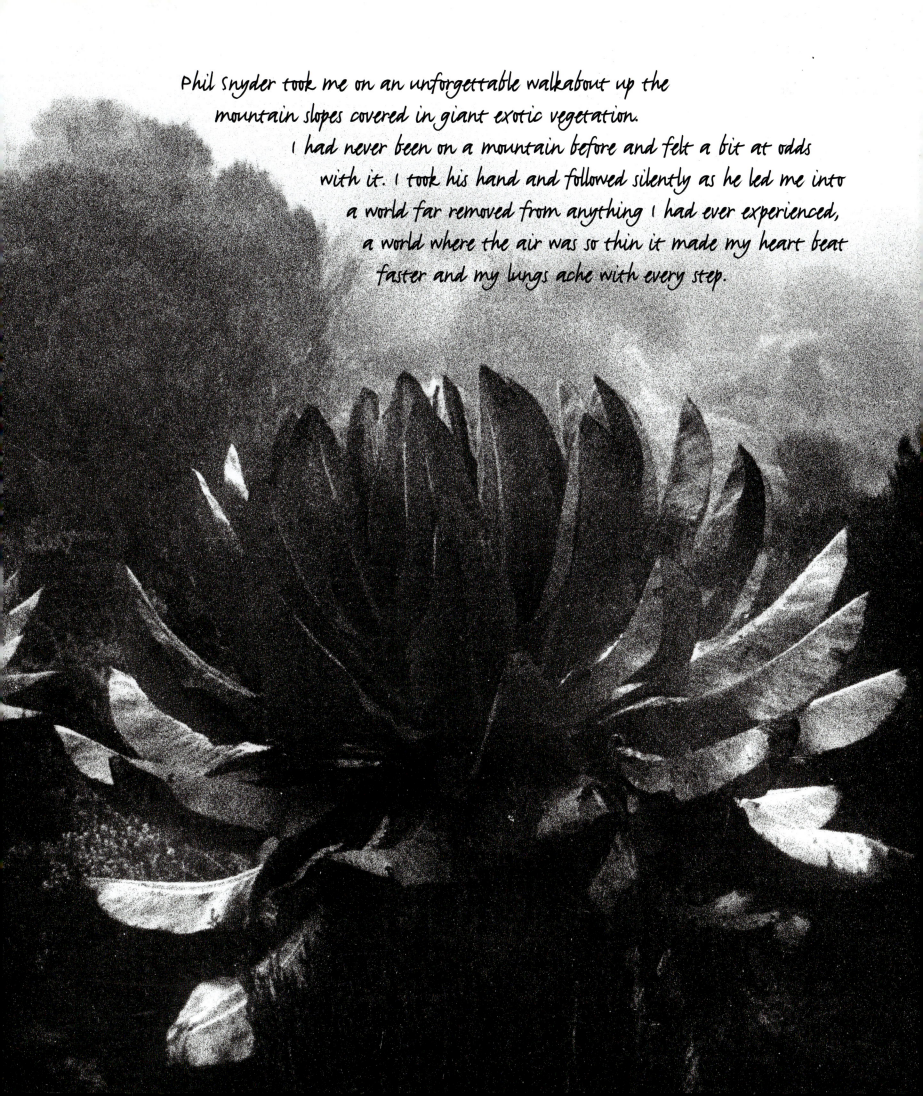

Phil Snyder took me on an unforgettable walkabout up the
mountain slopes covered in giant exotic vegetation.
I had never been on a mountain before and felt a bit at odds
with it. I took his hand and followed silently as he led me into
a world far removed from anything I had ever experienced,
a world where the air was so thin it made my heart beat
faster and my lungs ache with every step.

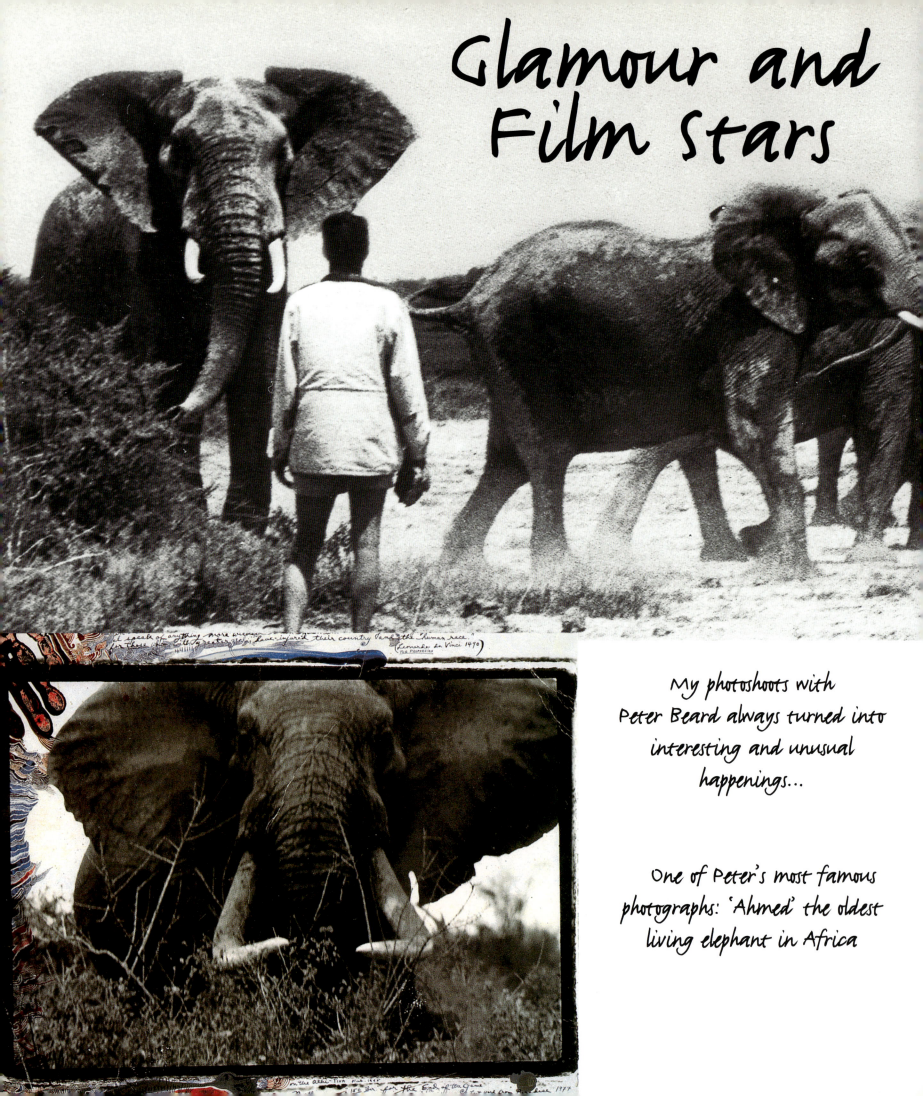

Glamour and Film Stars

My photoshoots with Peter Beard always turned into interesting and unusual happenings...

One of Peter's most famous photographs: 'Ahmed' the oldest living elephant in Africa

Peter approached elephants on foot to get his extraordinary picture...
...until he pushed his luck too far and was trampled almost to death. While he was rushed to hospital semi-comatose with a smashed pelvis and several broken bones, he kept asking if we had got it down on film...

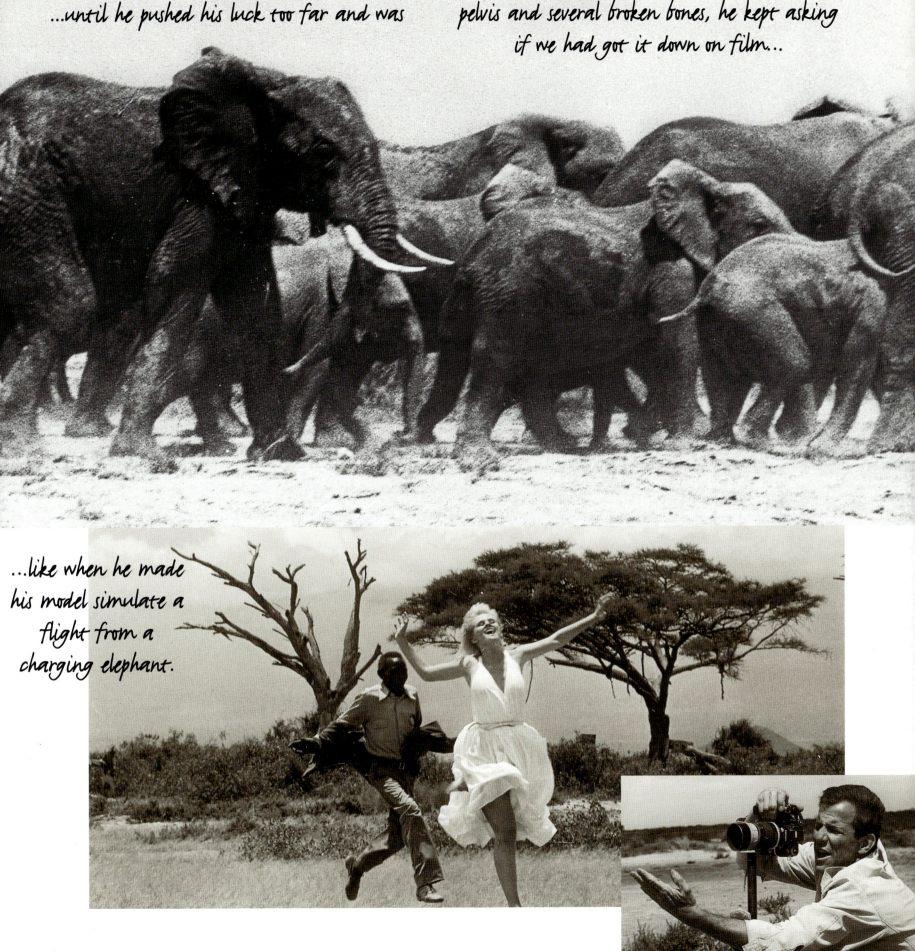

...like when he made his model simulate a flight from a charging elephant.

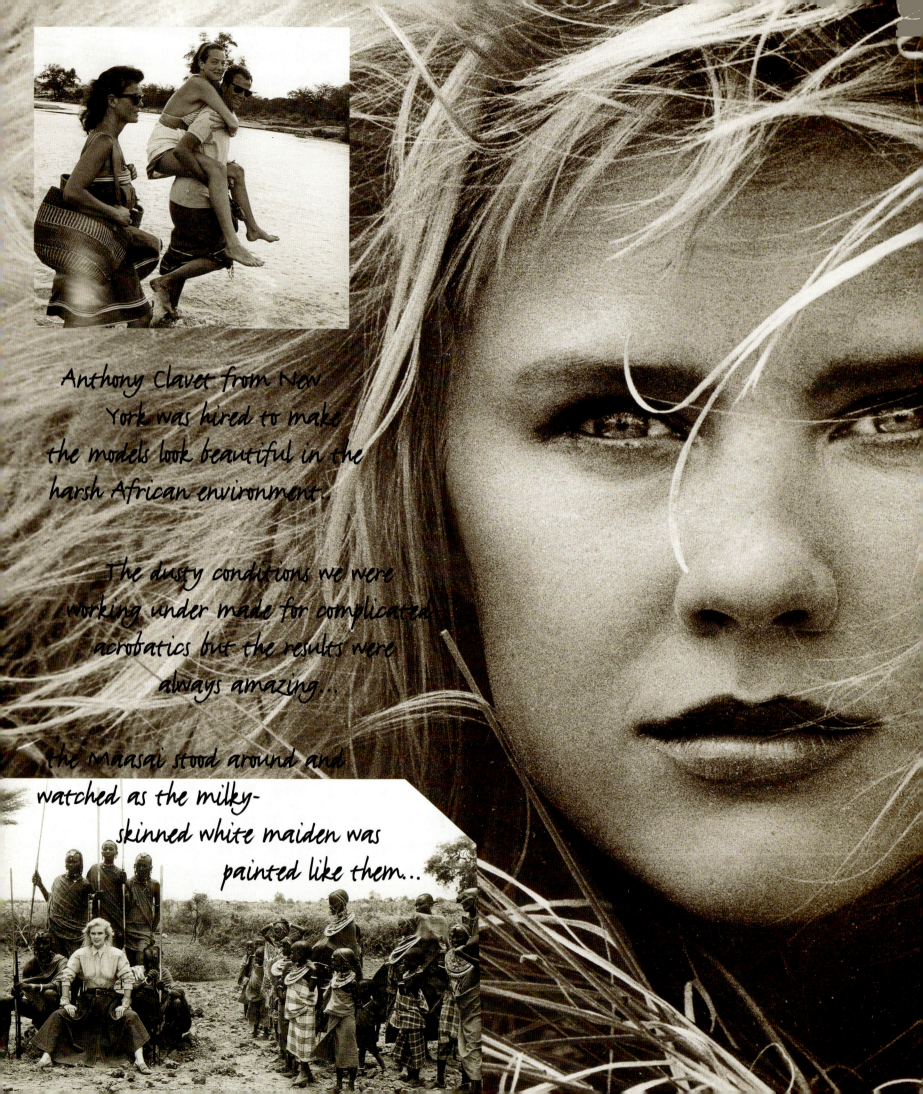

Anthony Clavet from New
York was hired to make
the models look beautiful in the
harsh African environment.

The dusty conditions we were
working under made for complicated
acrobatics but the results were
always amazing...

the Maasai stood around and
watched as the milky-
skinned white maiden was
painted like them...

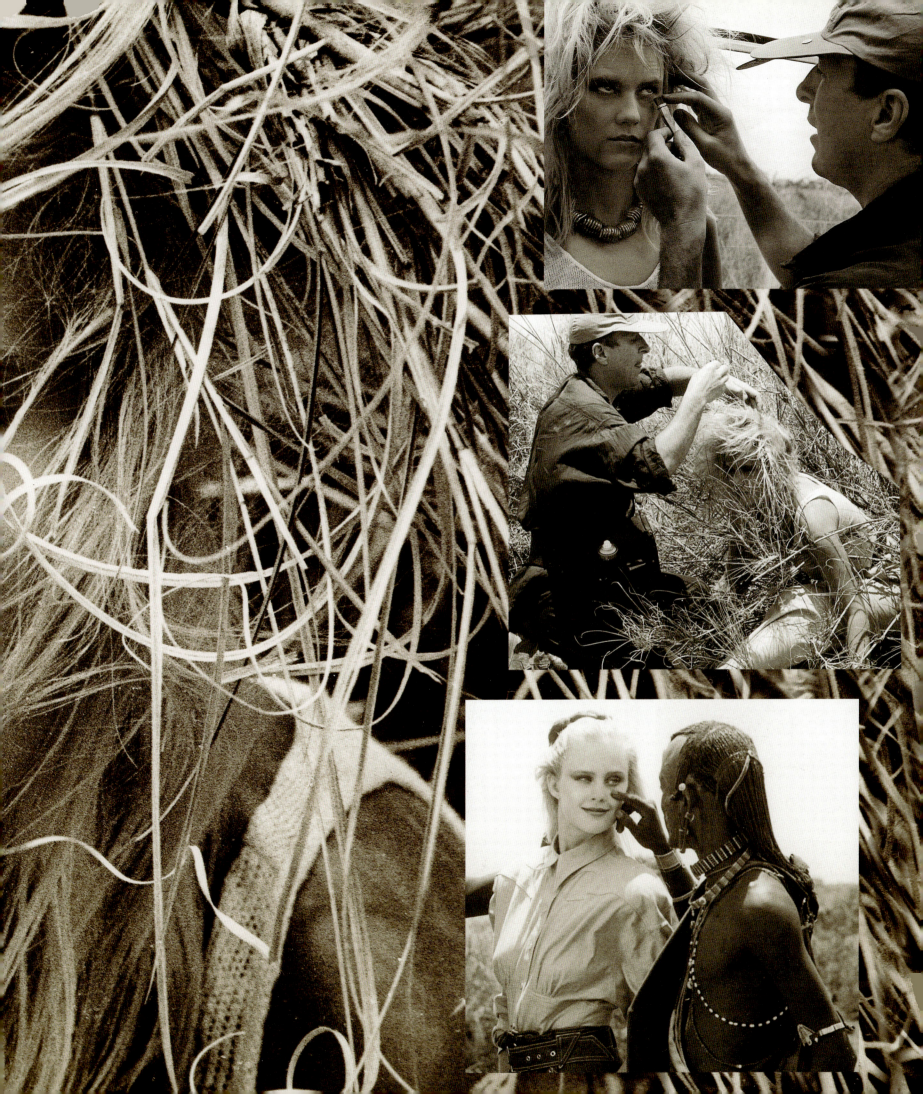

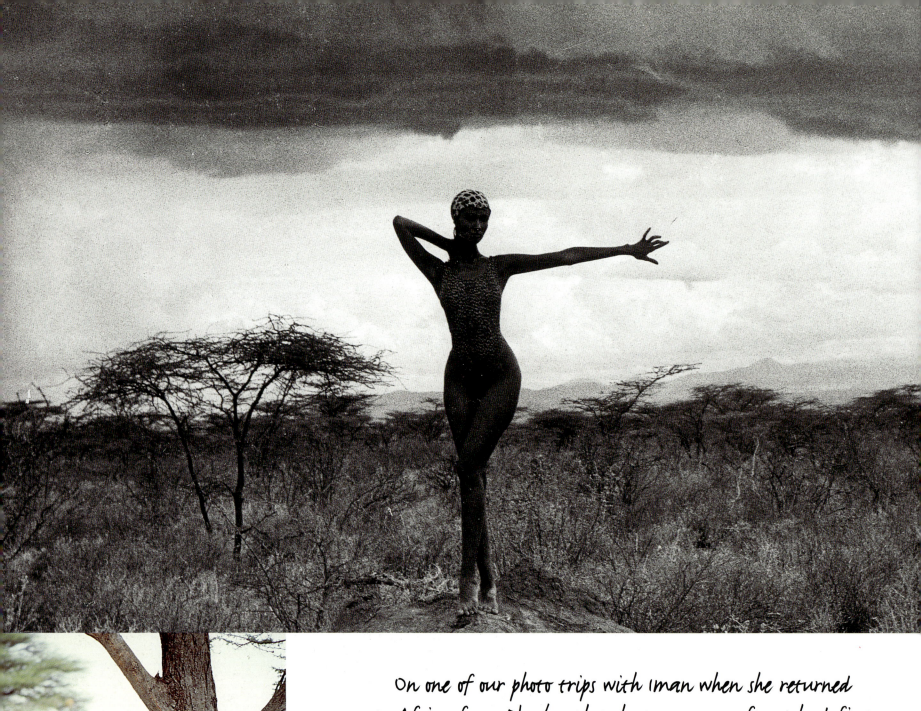

On one of our photo trips with Iman when she returned to Africa for a Playboy photoshoot 10 years after I had first discovered her and Peter had launched her in America, we went to the Samburu Game reserve where we photographed her in the African bush wearing Donna Karen swimwear...the moment I set eyes on her, I recognised her incredible beauty and took the first ever photograph of her...she became the most famous black model in the world and married Spencer, her first husband, who was a basketball star.

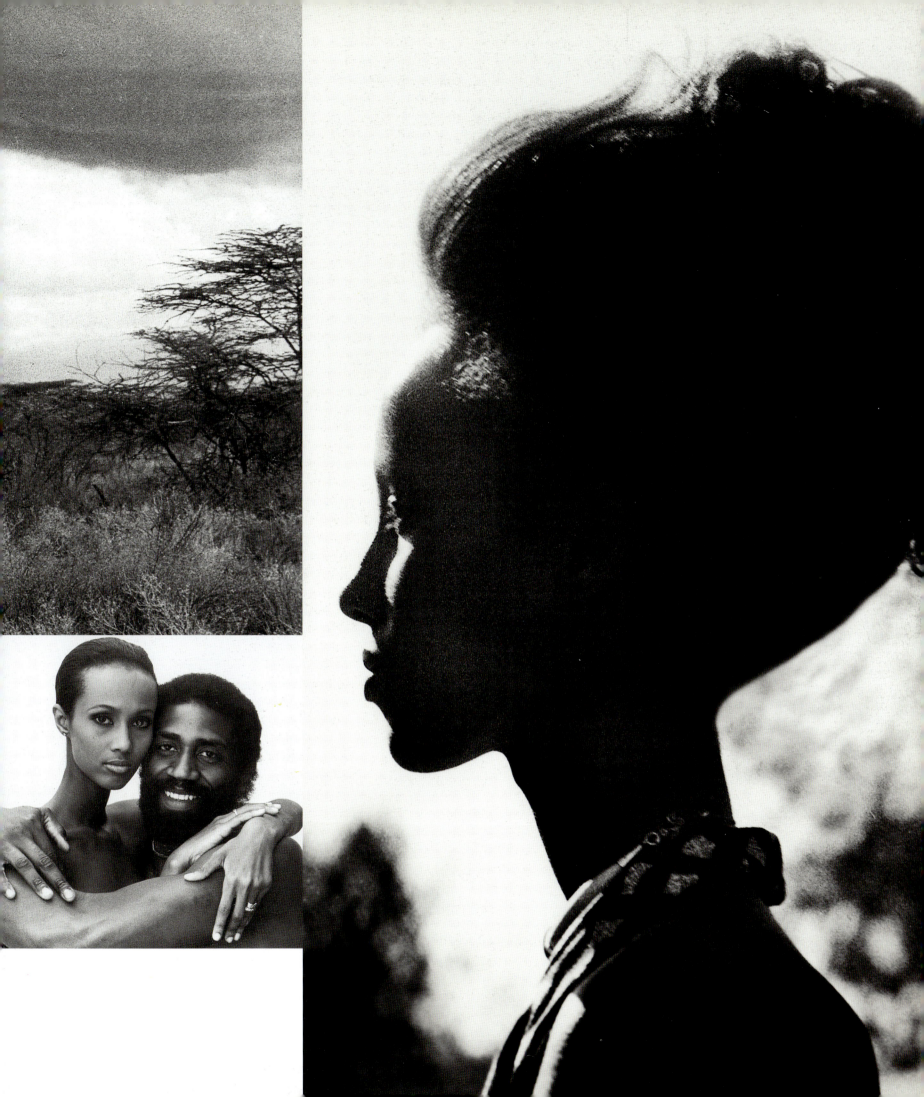

One day as Peter and I were
photographing Iman with one
of the lions of 'Out of Africa'
the animal jumped on its trainer
and pinned him to the ground...

Iman kept her professional
composure...

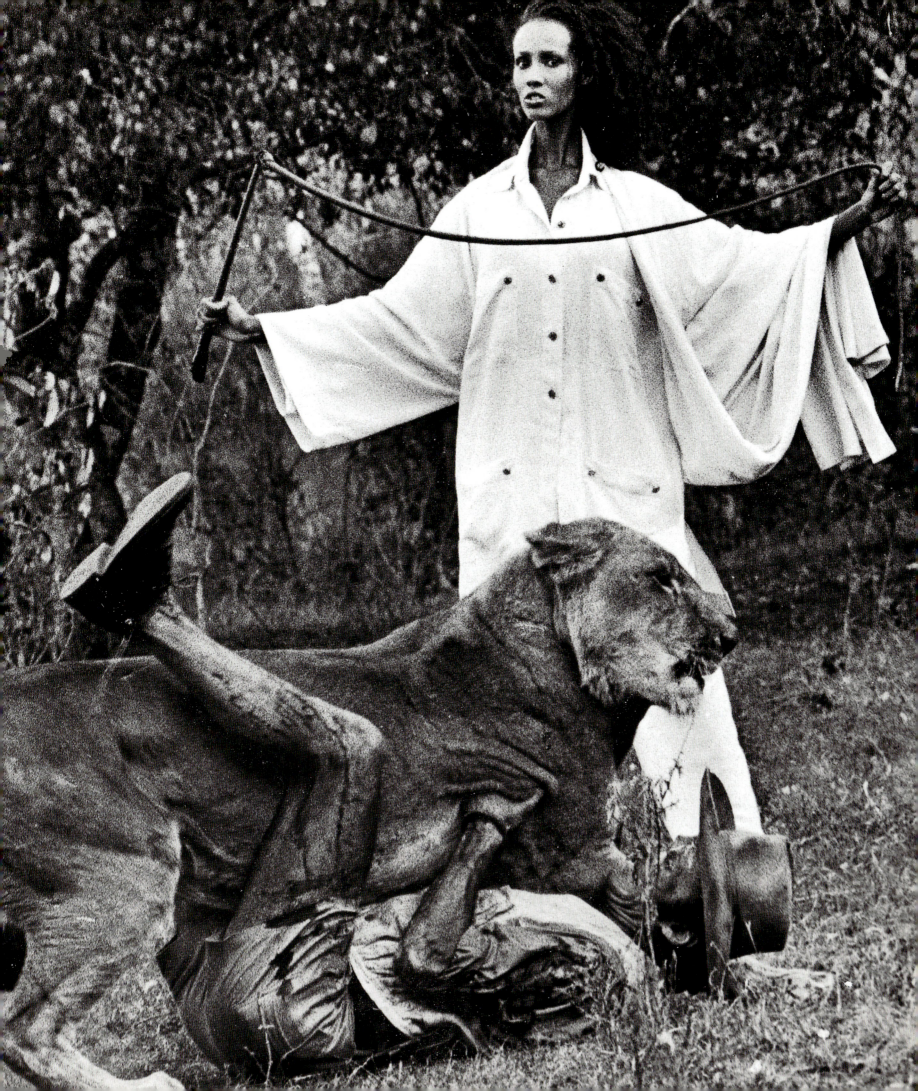

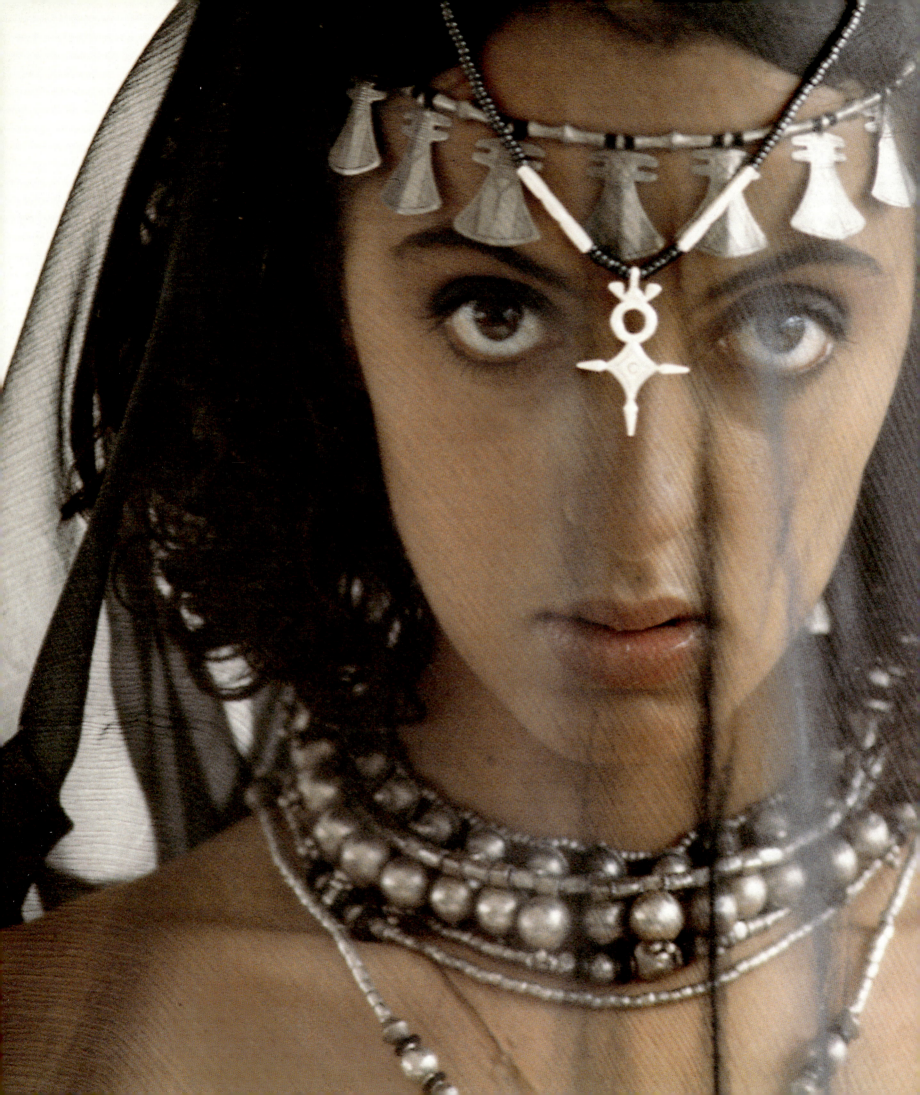

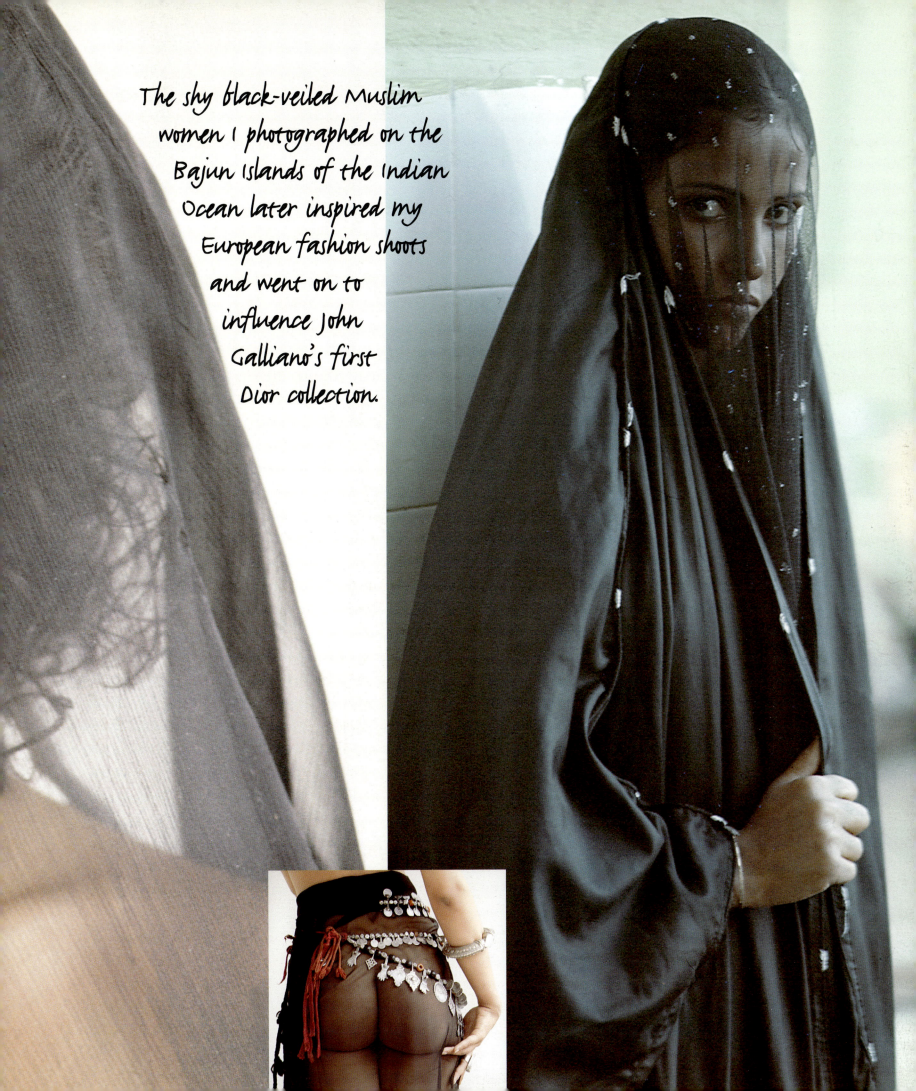

The shy black-veiled Muslim women I photographed on the Bajun Islands of the Indian Ocean later inspired my European fashion shoots and went on to influence John Galliano's first Dior collection.

Black Beauty...

I spent many years observing the singular beauty of the African people,
that had first been pointed out to me by

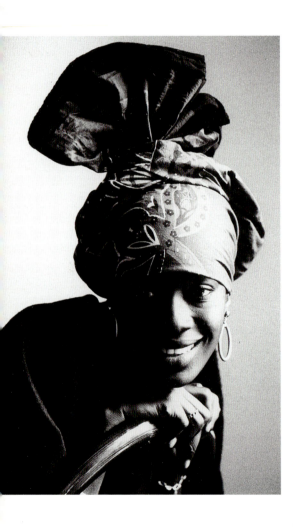
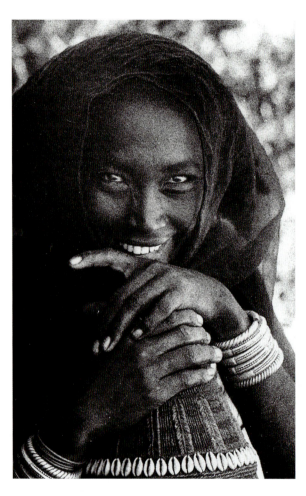
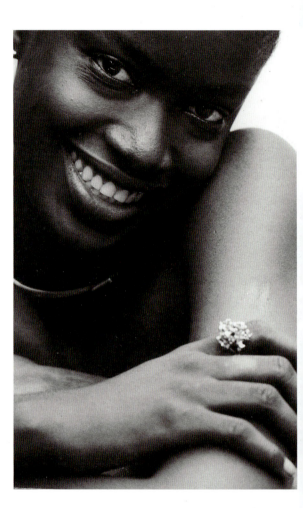

my mother who looked at them with the eyes of an artist...
these girls from Zaire, Eritrea, Ethiopia and Northern Kenya,
all share the same natural allure.

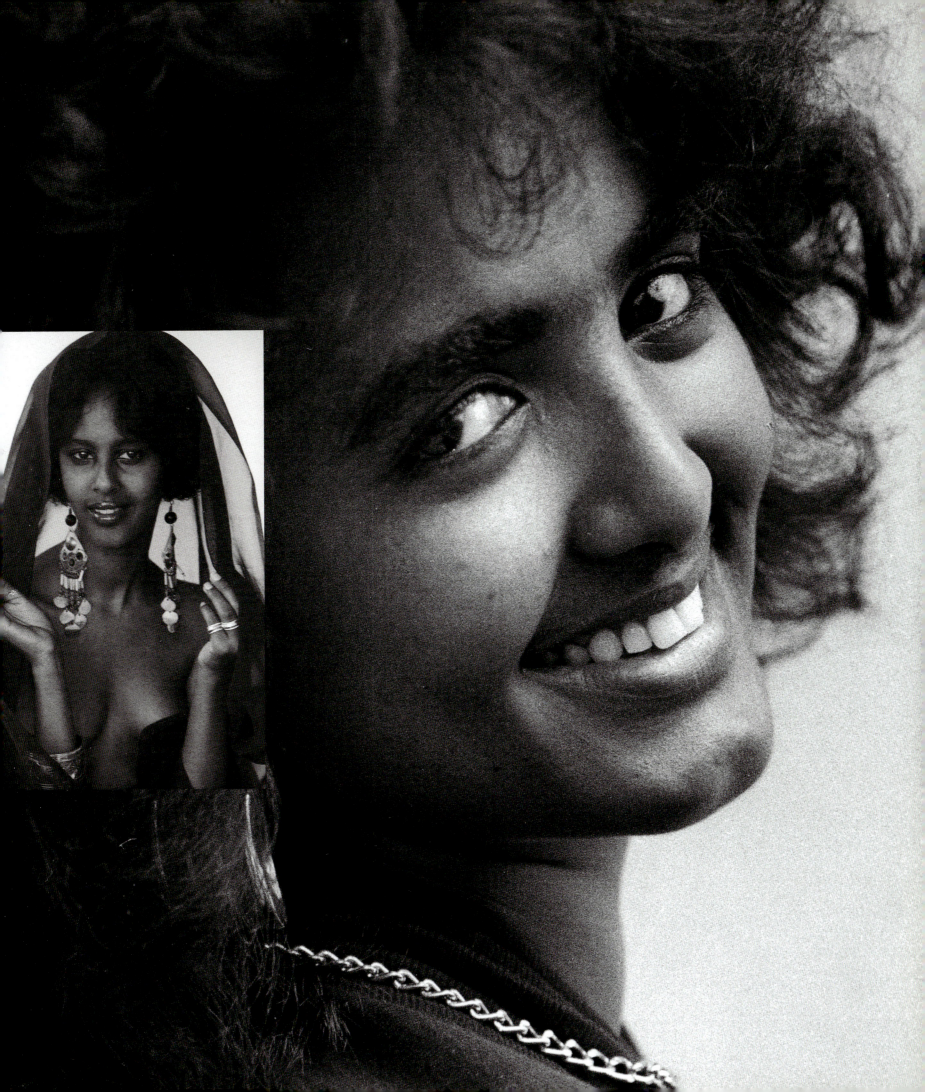

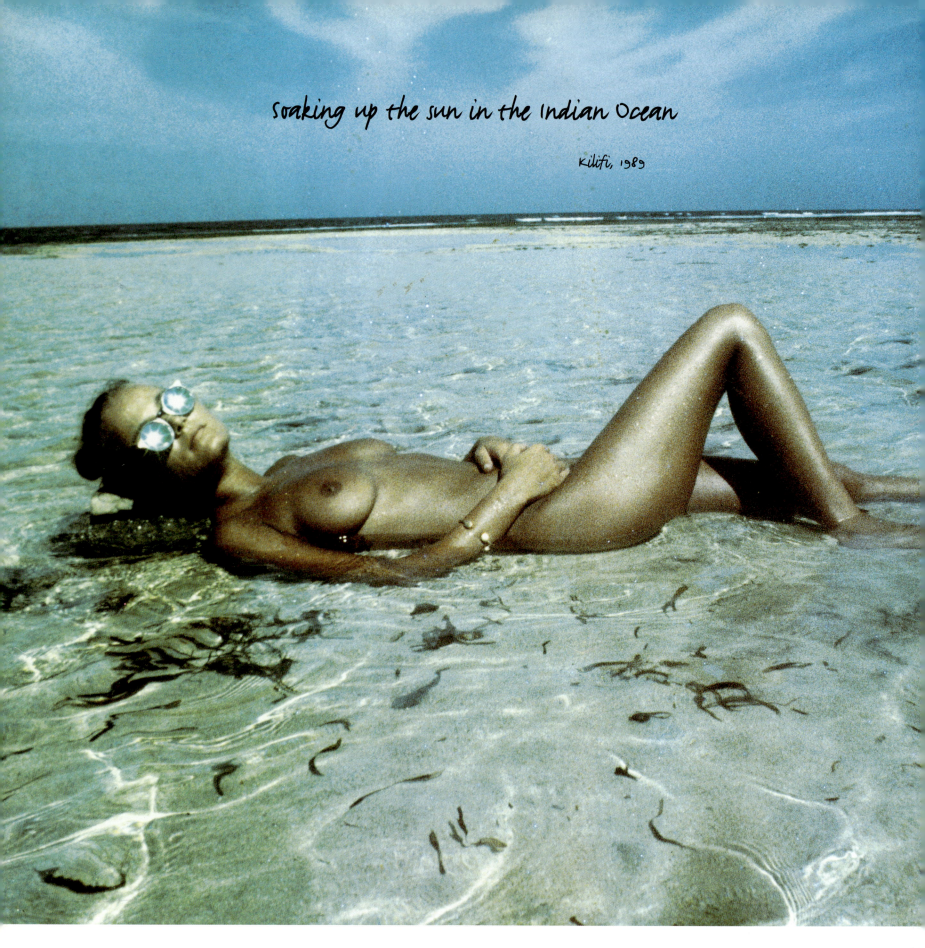

soaking up the sun in the Indian Ocean

Kilifi, 1989

When some of my glamorous friends wanted to be my assistants
I asked them to take off their clothes and pose for me...

...my home in Kilifi on the coast of the Indian Ocean
was a perfect location for such pictures.

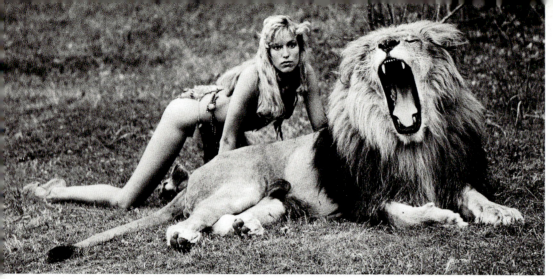

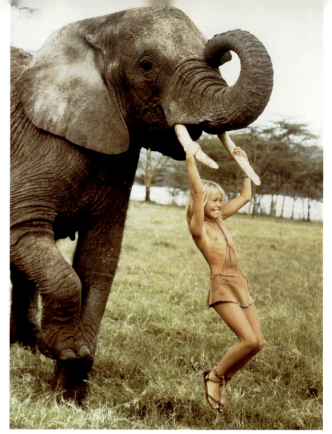

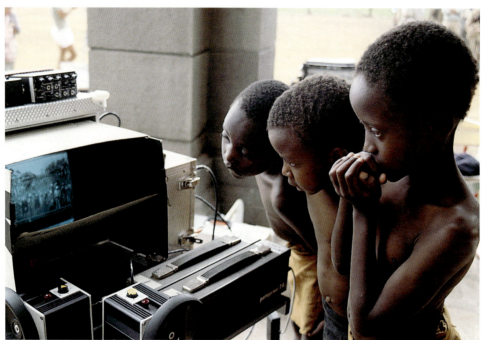

Kenya's ideal film locations
often made for corny films like
the ghastly 'Born Free' series

On several of the sets I worked on as special photographer, the scripts had been
conceived and written in countries that had no affinity with Africa, by people
who had no understanding of the true nature of the land
and their films invariably resulted in false superficially stilted portrayals that
ignored its vibrant nature and true extravagance.

Film-makers came with preconceived ideas which they then tried
to adapt to the environment they found. I have yet to see on film anything
remotely similar to my wilderness experiences.

ONE DAY I exchanged my still camera
for a digital camcorder and tried to capture
in movement what I had until now only frozen
in time. I was now able to record some of the
intangible contents of Africa's magic chalice.
The changing moods of the day, the wind in
the trees, the mutating light, the shimmer
in the waves, the long swaying grass, the
immense skies hung with fairytale cloud
formations, which were the backdrop to my
story. This exciting new tool quickly turned
into an obsession and took over my life.

Kenya was often the setting for films
based on African stories, but they rarely managed
to capture the true and exquisite essence of the
land and its people. When Meryl Streep came
to Kenya to play Karen Blixen in the film
Out of Africa, she looked ready for a *Vogue*
photoshoot each time she stepped onto the set.
The same applied to Stephanie Powers playing
Beryl Markham in her spotless jodhpurs and
long leather boots, her hair and makeup always
impeccable. The Irish actor Patrick Bergen as
Richard Burton trudged across the desolate
landscape of Lake Turkana with Ian Glen as
Speke in *The Mountains of the Moon* and
before that we had Ava Gardner, Clarke Gable
and Grace Kelly in *Mogambo* and Donna Reed
with Victor Mature (instantly renamed Victor
Manure) in *Beyond Mombasa*. All excellent
character actors whose directors invariably
managed to turn them into unlikely fictional
stereotypes instead of allowing them to be the
real people with the raunchy flavour and tough
stance that Africa had imbued them with.
Humphrey Bogart starring opposite Katherine
Hepburn in *The African Queen* was the only
exception. Thank God for the wildlife
documentarists, who somehow always managed
to capture the magnificence of Africa without
personal interpretations. Film companies, like
unruly circuses, provided wonderful photo
opportunities for me which made up for the
indescribable tedium of the sets I worked on.

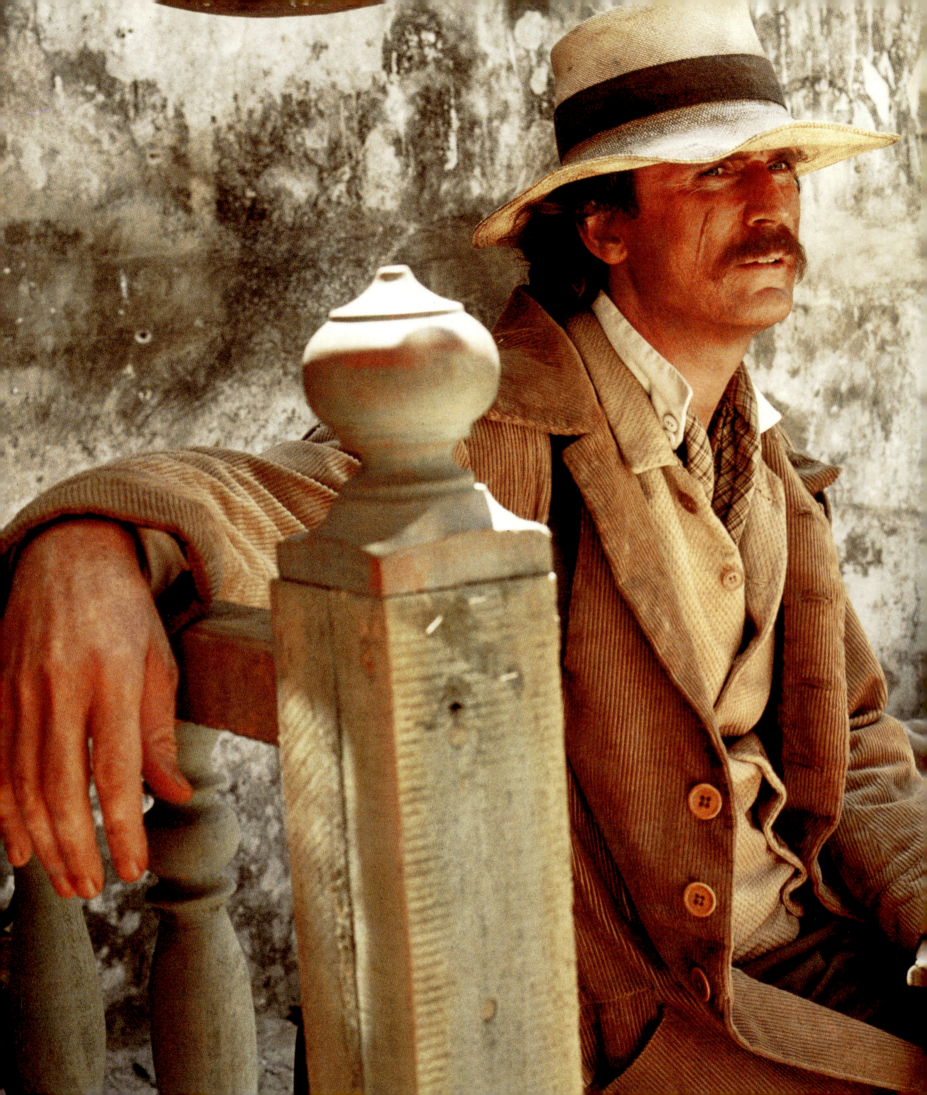

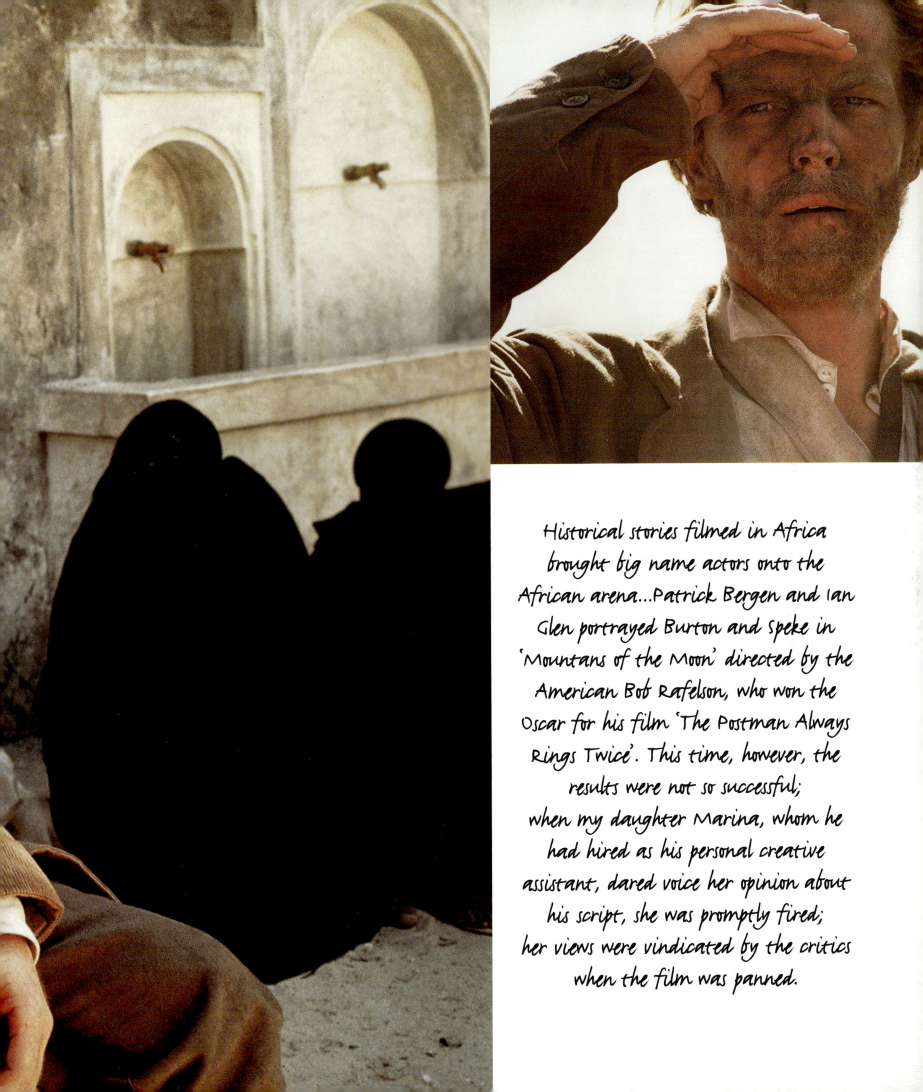

Historical stories filmed in Africa brought big name actors onto the African arena...Patrick Bergen and Ian Glen portrayed Burton and Speke in 'Mountains of the Moon' directed by the American Bob Rafelson, who won the Oscar for his film 'The Postman Always Rings Twice'. This time, however, the results were not so successful; when my daughter Marina, whom he had hired as his personal creative assistant, dared voice her opinion about his script, she was promptly fired; her views were vindicated by the critics when the film was panned.

When Meryl Streep and Klaus Maria Brandauer came to film
'Out of Africa' in the roles of Karen and Bror Blixen, they slipped into the skins
of the famous characters in look and in accent...
it was a delight to watch such talented and professional actors at work...

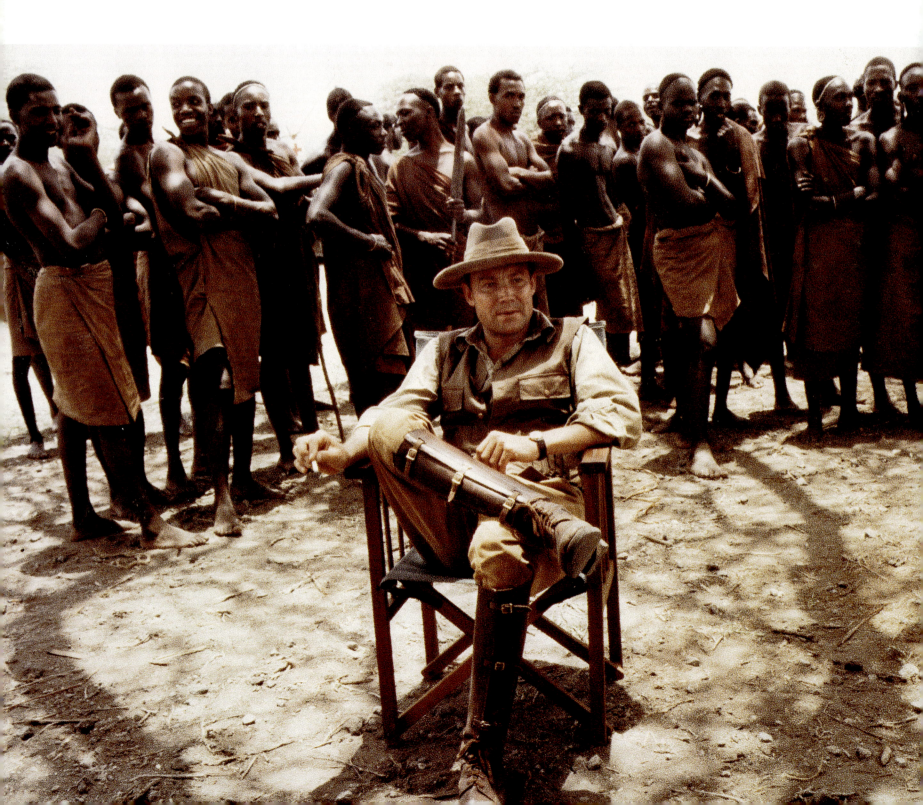

Meryl was every inch the great actress on the set, but off it she was a warm and natural mother of three and endeared herself to all who came in contact with her, especially my daughter Amina whom she hired as her personal assistant and then invited to return to America with her, but Amina declined.

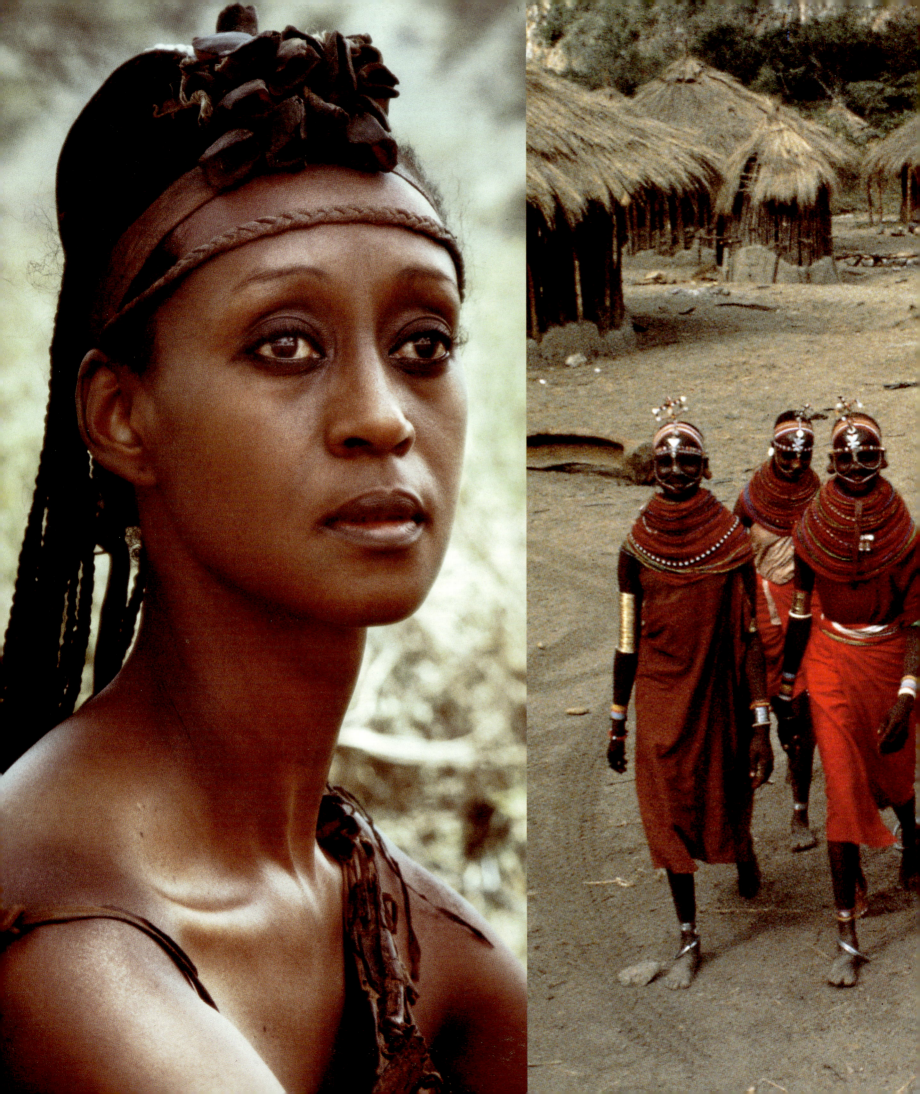

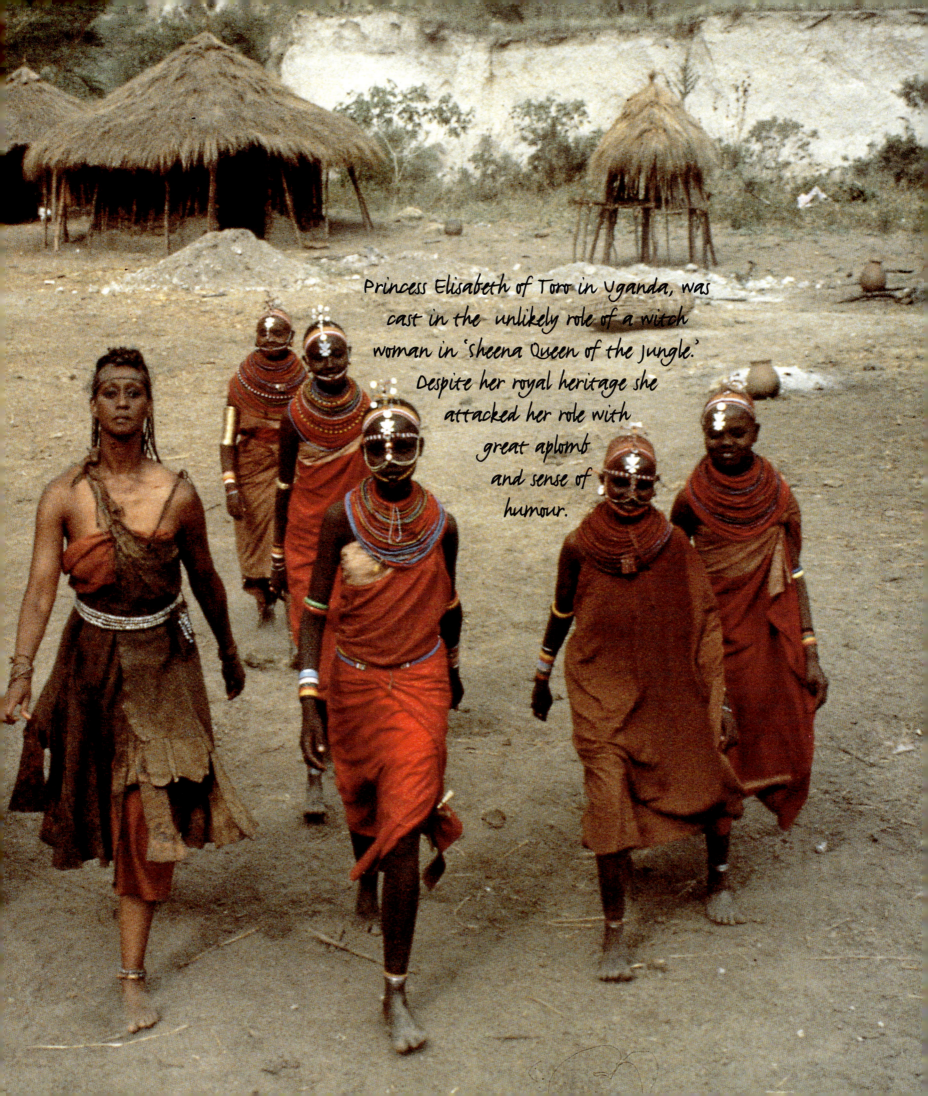

Princess Elisabeth of Toro in Uganda, was cast in the unlikely role of a witch woman in 'Sheena Queen of the Jungle.' Despite her royal heritage she attacked her role with great aplomb and sense of humour.

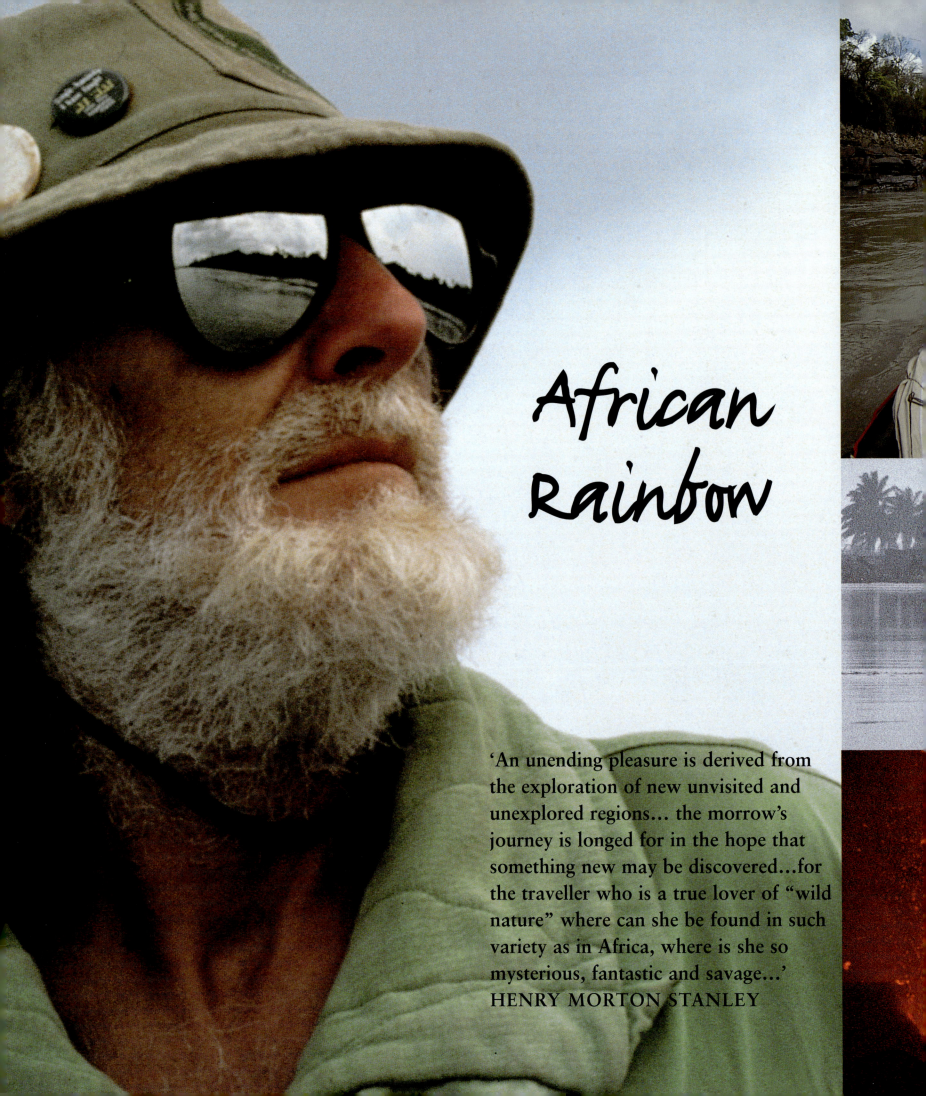

African Rainbow

'An unending pleasure is derived from
the exploration of new unvisited and
unexplored regions… the morrow's
journey is longed for in the hope that
something new may be discovered…for
the traveller who is a true lover of "wild
nature" where can she be found in such
variety as in Africa, where is she so
mysterious, fantastic and savage…'
HENRY MORTON STANLEY

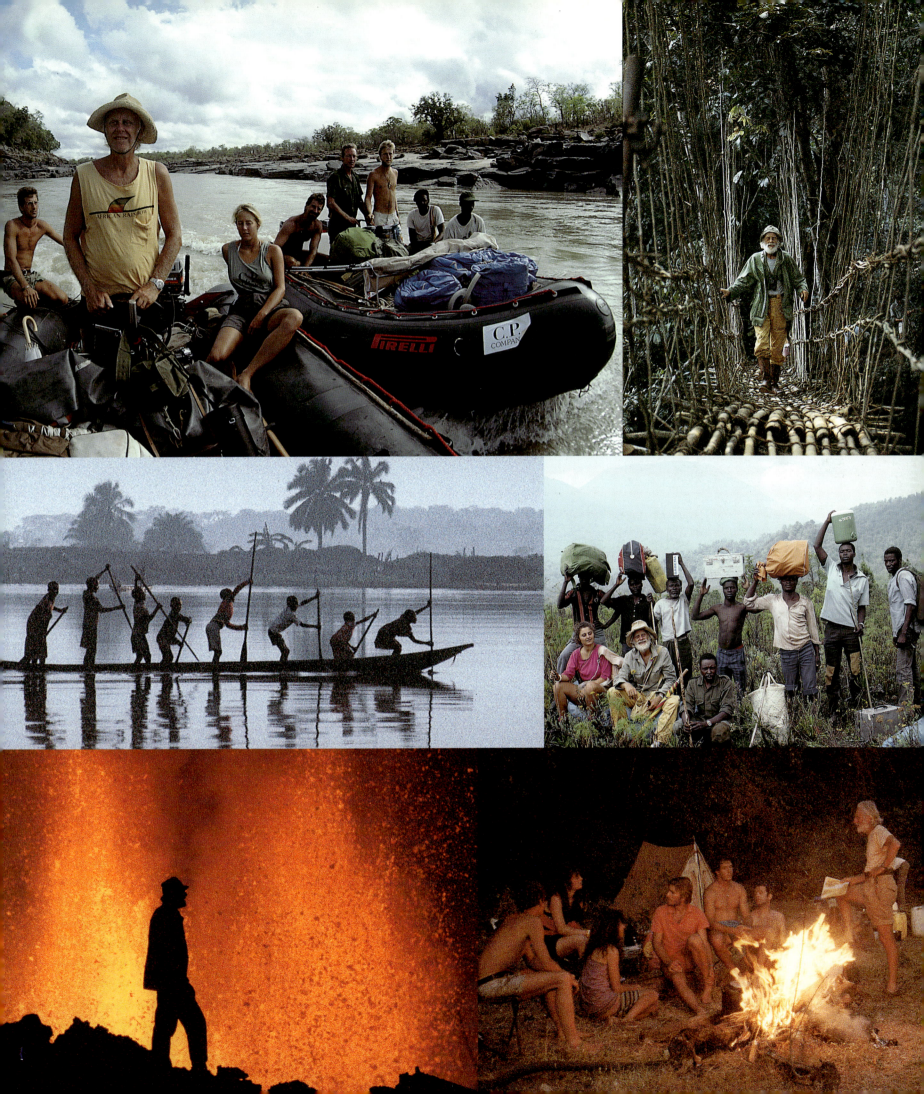

IT WAS THE FUSION of man and his environment that attracted me to Lorenzo's next adventure, his African Rainbow expedition, a transcontinental crossing from the Indian Ocean to the Atlantic on the rivers and lakes of the equator, the first known crossing of Africa by boat, navigating a hazardous and often uncharted course through the waterways that lie between the two oceans.

This expedition had been inspired by a memorable journey I had undertaken myself a few years previously when I descended the Zaire river on a local river steamer, known as *Le Grand Pousseur* – the Big Pusher – that pushed half-a-dozen floating platforms in front of it, laden with several thousand souls and their goods and chattels, for over 1000 miles to and from the capital Kinshasa. The journey lasted ten days during which time we stopped many times along the way, pulling up along the muddy banks or loading passengers and jungle goods midstream from long dugout canoes that raced perilously across the water, propelled by long poles plunged into the water, and then attached themselves like leeches to the moving vessel. Incessant market bartering went on day and night between the jungle people and those on the platforms.

Sometimes the precarious canoes travelling at speed would overturn and those on board who could not swim were washed away by the current, and quite simply drowned in front of our eyes. Every imaginable product was for sale in this floating marketplace. There were live crocodiles, their muzzles tightly bound, tied by one paw to the railings and fish of all sizes, freshly caught or sun-dried, and smoked monkeys and chickens and chimpanzees. Piles of manioc, dried tobacco leaves, bunches of bananas and heaps of shiny green avocado pears were stacked beside basins of slimy tree slugs, water terrapins, boxes of expired medical supplies, syringes and penicillin powders, as well as a huge assortment of second-hand European clothing hanging from wooden clothes pegs and brightly coloured wax printed bolts of cotton cloth. To pass the time people cooked on open charcoal fires and played African dominoes or dressed each other's hair in tiny tightly braided strands, some strummed on guitars, others talked and laughed and argued; from dawn to dusk and all through the night, life on board was never still. The market hummed and bustled and bartered beneath the starry skies, the withering heat or the lashings of rain that fell without warning.

I slept on deck on a roll-out mattress at night because the first-class cabin I had paid for handsomely was too damnably hot and stuffy, and the promised air conditioner did not work. During the day I sat beside the captain in the second officer's chair, high up on the top deck, from where I had a bird's eye view over the river, the dense steaming jungle to either side and the sprawling bawling pontoons in front. It was an extraordinary vantage point from where I could pick out all manner of interesting situations with my long lens; it was cool and airy and clean, and I could not smell the ghastly sickening odour of cooking palm oil. It was indeed like travelling back through time, back to the Africa of Joseph Conrad's *Heart of Darkness*. Little seemed to have changed since he took this same trip and immortalised it in his writings.

I told Lorenzo that my only regret on my journey down the river was my confinement to the steamer that prevented me from exploring the areas on my own. My words fired his imagination and he set up his expedition in order to give me just that possibility. He would provide me with my own personal transport so I could go where I wanted when I pleased he told me. People have said we have a symbiotic relationship.

It took him a year of hard slog and hard talk in Milan to pull it together. I was working on the film *The Mission* in South America, when one day I received a telegram in Cartahena de Indias in Colombia informing me that we were ready for take-off. He had collected half a million dollars, procured four Italian army rubber inflatables from Pirelli, three Fiat Panda cars from Fiat in Turin and six 25hp engines from Mariner. He had also collected a multitude of other smaller items ranging from foodstuffs to medicines and clothes, to rubber petrol containers, tents and safari equipment and a large sum of ready cash. Every possible necessity had been carefully thought out, packed and shipped to Mombasa where it was loaded onto a three-ton truck and two Landrovers and driven to the mouth of the Rufiji river in Tanzania. Lorenzo had also gathered a gaggle of naive but enthusiastic adventurers whom I nicknamed the pilgrims as in Conrad's travel companions. They joined the expedition, but quickly fell by the wayside, unable to cope with the expedition demands. In the end Lorenzo and I were the only ones to complete the eighteen-month crossing from east to west. 'I need a girl like you around,' he had said to me when he first met me many decades before and had asked me to marry him.

To the Arabs who travelled to the East African coast in the nineteenth century from the desert land of sand and mountains of Arabia, the fertility of Africa appeared like a dream. Helped by the monsoon winds that blow each year for six months, alternately from north to south and from south to north, they found in Africa an immense and apparently inexhaustible oasis where they could reap without sowing. Making use of these regular winds they came and went without ever abandoning their

country of origin. The discovery of Africa for these men, whose religion and severe traditions had been adapted to their natural waterless environment, was tantamount to finding all that was missing at home. Their penetration into Africa and subsequent colonisation of the coastal area was ruthless and dearly paid for by the African coastal people, who fled from them with little resistance. The end of the dhow route was the Rufiji delta; Zanzibar and Bagamoyo, north of Dar-es-Salaam in Tanzania, were the end of the main slave route that led inland to Ujiji on Lake Tanganyika and the Congo basin.

In February 1871 Henry Morton Stanley, on assignment for the *New York Herald Tribune*, set out from Zanzibar in search of Livingstone who, it had been presumed, had been eaten by cannibals. According to his diaries he took with him six tons of supplies and equipment which included 350 pounds of brass wire, 20 miles of cloth, a million beads to use as trading currency, two collapsible boats, 71 cases of ammunition, 40 rifles, tents, cooking utensils, silver goblets, champagne, Persian carpets and a bath tub. He hired two hundred porters to carry this massive load, many of whom had served with Burton and Speke, as well as two British seamen he had met on his recent travels, and a young Christian Arab called Selim Heshmy, whom he had picked up in Jerusalem, to act as interpreter. He landed his party in Bagamoyo saying, 'We are all in it now, sink or swim, live or die, no one can desert his duty now' and to the sound of rifles fired in celebration, struck out into the interior at the head of the caravan, carrying the American flag.

Lorenzo related intensely to Stanley and during the course of our own expedition he showed me a side of him which was new to me. He had exactly the same attitude towards his crossing of Africa as Stanley did. They both shared an undaunting purpose and resolve from which no person could deter them. He was so deeply influenced by the Stanley diaries, they gave him the strength and determination he needed for the crossing. Stanley travelled overland and used boats only when it was not possible to do otherwise. Lorenzo decided to travel overland only when it was impossible to navigate.

After much deliberation over maps, we noted that the ideal itinerary was the Livingstone route of 1857, a journey of some 5000 miles. We had to take into consideration the serious political problems in Mozambique. Even with the necessary authorisation this could put our expedition in serious jeopardy. Military-looking craft loaded with equipment and people, navigating in formation towards the interior, could be an irresistible target for any guerrilla group on the lookout with a Kalashnikov waiting for a quarry and some glory. 'Sitting

duck' one of our crew aptly remarked, focusing on our state of mind at the moment. *Audaces fortuna iuvat* (fortune favours the brave), a familiar Latin proverb Lorenzo had learned at school became his battle cry. An almost mystical impulse to go through with it came over him. He was now fifty years old, no longer the adventurous youth who had drifted around the world like a leaf blown by the wind; what he called 'that detestable sense of responsibility', that professional seriousness which usually impedes this kind of enterprise was beginning to settle over him.

Africa lay ahead of us. There was now no turning back. River navigation even in fully developed countries, is quite an adventure. Rivers often deviate from the beaten path, zigzagging in full fluvial freedom, linked to the geographical and geological lie of the land. In Africa this freedom runs wild. From the mouth of the Great Rufigi River on the Indian Ocean in Tanzania into the Kilombero River to the Mbarara Mountains, Lakes Rukwa and Tanganyika and on to Ujiji, the historic meetingplace of Livingstone and Stanley, to Usumbera in Rwanda, where the recent ethnic-cleansing massacres of the Hutus and the Tutzis took place, into Zaire and on the Lualaba River, where Stanley launched his boat, the *Lady Alice* and wrote in his diary:

We saw before us a black curving wall of forest, which beginning from the river banks extends south-east until hills and distance made it undistinguishable...downwards it flows into the unknown to the night's black clouds of mystery and fable...something strange must surely be in the vast space occupied by total blackness on our maps...here lies a broad watery avenue cleaving the unknown to some sea, like a path of light. Suddenly from the crest of a low ridge we saw the majestic Lualaba. It is about 1400 yards wide, a broad river of pale grey colour winding slowly from south to east, a secret rapture filled my soul as I gazed upon the majestic stream. The mystery that for all these centuries nature had kept hidden away from the world of science was waiting to be solved. This great stream must be one of the headwaters of the Congo, for where else could that giant among rivers, second only to the Amazon in its volume, obtain the two million cubic feet of water which unceasingly pours each second into the Atlantic...
...at first the villages were deserted, [Stanley continues] the tribesmen fleeing into the dark forest at the news of the advance of the strange caravan; there wasn't any question about what sort of people lived in them. Row upon row of human skulls lined the palisade around the villages and bones from every part of the human anatomy could be seen scattered around the cooking sites. From time to time a solitary grotesquely painted savage would be caught sight of, peering out from the thick undergrowth and

throughout the day and night we heard the drums beating, telling of their progress, eerie cries calling warriors to assemble in the gloom of the woods and the blare of ivory war horns sounding from another world and then we saw eight large canoes coming up the river along the island in midstream, and six along the left bank. The cannibals gathered along the banks rattling bows and arrows and shrieking 'bo-bo-bo-bo' ('meat, meat, meat, we shall have plenty of meat'). Painted half red and half white, with broad black stripes streaked across them, they came out into the river in their giant war canoes; one which was captured measured 85 feet in length, with a bas-relief of a crocodile, adorning its side.

It was here on the same Lualaba river that we came across half the sunken rusting carcass of a boat. In raised bronze letters on the front of it bore the name of the man who, 60 years before, had invited my parents to Africa, *Le Baron Empain*. It lay there like some prehistoric monster in the mud on the edge of the river, the dense silent jungle rising ominously behind it. We had cut the engines of our inflatables, as we were low on fuel, and were drifting downstream on the current when we came upon it. We threw out an anchor and drew up alongside it. A delicate white heron perched on the disintegrating railings took flight and rose like a dainty ballerina against the dark green jungle backdrop, a flurry of ugly bats rushed out from within the half-sunken cabin. The eerie scene told a silent tale of the ugly Belgian rape of the Congo, so deftly described in Conrad's *Heart of Darkness*.

We shot the rapids at the Stanley Falls in Kisangani and entered the Zaire River. Onwards we travelled on the now-familiar watery terrain I had journeyed on aboard the *Grand Pousseur*, but this time I had my own transport just as Lorenzo had promised, and we were able to indulge in the exploratory freedom denied me on my previous journey.

Before continuing our onward journey towards Kinshasa we spent some days resting and refuelling in Kisangani, a place of particular interest to us, for it had been immortalised in literature, by Joseph Conrad's *Heart of Darkness* and by V. S. Naipaul's powerful story *A Bend in the River*. It was here, in this sprawling ungainly river town, carved out of the jungle, that one of the fiercest battles was fought when the Belgian Congo threw off its colonial shackles and savagely slaughtered hundreds of souls, many of them white missionaries. As I walked through the disintegrating town, once the pride of Belgian colonial rule, with its tarmac streets, pretty houses ringed with well-kept gardens and flowering trees, traces of past violence were still very evident in the cracking walls and decapitated statues of

Belgian dominance. I sensed the hostility in the presence of the army, with their sullen arrogant swagger, their camouflage uniforms, heavy black boots, dark shades and sten guns; bored trigger-happy military guards policed the crumbling streets and the dishevelled army barracks. It sent shivers down my spine and made me uncomfortable to be white, as if a false move or word could unleash the restrained aggression hanging in the air. A sort of uncontested ancient jungle force seemed to still lie beyond the confines of the town, an accumulation of all the anger and vengeance the people had felt towards their white colonial oppressors. The very whiteness of my skin made me feel conspicuous and uneasy, a bit like a red flag does to a bull.

It was from here in Kisangani that the Belgians had fled when the savagery was unleashed, taking with them only what they could carry. What was left behind was plundered and dismantled, those who remained are buried in the cemetery.

I came across three old women pushing a large wooden cart, pulled by a strapping youth. The cart was piled high with bunches of bananas they were transporting to market. The youth seemed to be yoked to the cart like an ox, a leather strap cut into his forehead. He was bent in half, sweating profusely as he strained with the load and reminded me of a donkey I had once seen in Cairo in a similar situation. How far had they come like that, how far had they still to go? It did not seem to have any importance, since there was no alternative. A bunch of laughing kids kicking a stone came scuttling towards me and greeted me in French, grabbing hold of my hands. The eldest could not have been more than seven or eight years old – Zairian street urchins – lovely kids with bright faces of different shades of brown, some with charcoal eyes, some with blond curls and blue eyes, others with straight black hair and light green eyes; children of foreign men who had spawned them and then left them behind with their Zairian mothers in the care of Africa. They did not seem any the worse for it; they simply did not know any other way of life.

Four weeks later we reached Kinshasa, the capital of Zaire and then had to portage our boats around the thundering Zongo Falls, the most spectacular cascade on the river, and the treacherous Inga rapids that had just swallowed up the French Dieuleveux team from *Paris Match* a few months previously, when they fool-heartedly tried to shoot them.

We entered a final labyrinth of magnificent mangroves, whose giant exposed roots bleached white by the sun, resembled carcasses of giant prehistoric crabs confined to an endless liquid graveyard of inky mud. From Matadi, our last camping ground, to Boma and on to Banana on the Atlantic ocean, the Zaire

River stretches from a width of 800 yards to ten miles. We sensed the Atlantic before we saw it. In the last mile where the river runs between Angola on the left and the Zaire on the right we came around a point, the last bend in the river, beyond which lay Banana and the Atlantic Ocean.

A slim slither of land jutted out into the ocean in front of us. It was barely visible; a row of palm trees, silhouetted against the bright light on the sea, seemed to be growing in the waves. This was the Atlantic Ocean at the end of our 3750-mile journey across Africa; we had finally arrived. 'I felt a strange sense of loss, like when a close friend dies or goes away for a long time, or like reading the last page of a good book,' Lorenzo confided to his diary that night.

It was four o'clock in the afternoon, the sunlight bouncing off the sea was blinding. We remained silent. Lorenzo wore an expression of mingled sadness and satisfaction. The deep creases around his blue eyes, his shaggy beard and his frayed straw hat told a tale of adventure, of perseverance, of courage and vision and like Stanley, of a touch of madness. He put his arm around my shoulder and said nothing. His silence spoke louder than words.

The inflatables pulled alongside each other; we switched off the engines and bobbed on the long waves of the Atlantic Ocean. Lorenzo reached for his water gourd, 'Indian Ocean, Atlantic Ocean,' he solemnly intoned as he emptied the gourd of Indian Ocean water he had scooped up eighteen months before in the Rufigi delta where our journey began. He turned and shook each one of us by the hand. 'We made it, thank you,' he said, brandishing the Italian and Zairian flags above his head.

Before he could say any more, two of our crew picked him up and joyfully tipped him overboard to the resounding cheers from the rest of the crew 'I was glad to be with Mirella,' he added later to his diary as if in an afterthought, 'we have seen Africa, as few people have. We completed the crossing in 18 months. It was the greatest journey of both our lives and would be our last great safari.'

After a journey such as this, a feeling of melancholy begins to creep in, giving rise to the unbearable apprehension of returning to mundane life where the unexpected does not exist. Re-integrating ourselves back into the life we had left behind almost two years previously confirmed our concerns. We were amazed how little interest or curiosity we engendered when we tried to share our incredible experience. It was evident by the response, how little others could comprehend the extent of the adventure we had just lived. It made me think of the returning soldiers from the battlefront. How can anyone back home, ever conceive the extent of the horror they had been exposed to or the outrage they had witnessed. They returned like strangers to a foreign land.

The Royal Geographical Society did, however, invite us to give a lecture and a slide show to a captive audience. Standing there at the podium in the dark, we addressed the silent audience in the same way that others – Burton and Speke, Livingstone, Stanley and Baker – had done before us. When the lights came on they gave us a standing ovation and poured onto the stage to shake our hands and buy copies of our *Africa Rainbow* expedition book. Sharing is so much a part of living and adds another dimension to experience; for Lorenzo and me it was a further bonding, one that would help us in our old age, for its memory will stay with us always and will keep us alive and young until the end. 'God makes them and then he couples them,' is an Italian saying.

'...the survival of our wildlife
is a matter of grave concern to
all of us in Africa...these wild
creatures amid the wild places they
inhabit, are not only important as
a source of wonder and inspiration,
but are an integral part of our
natural resources and of our future
livelihood and well-being...'

JULIUS NYERERE
– first president of Tanzania

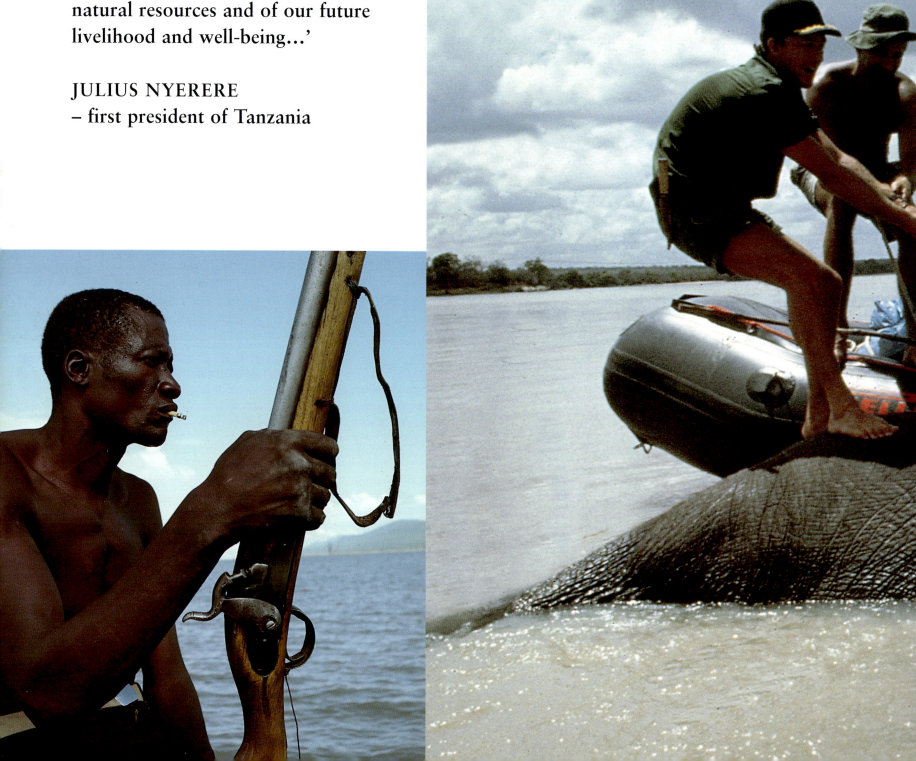

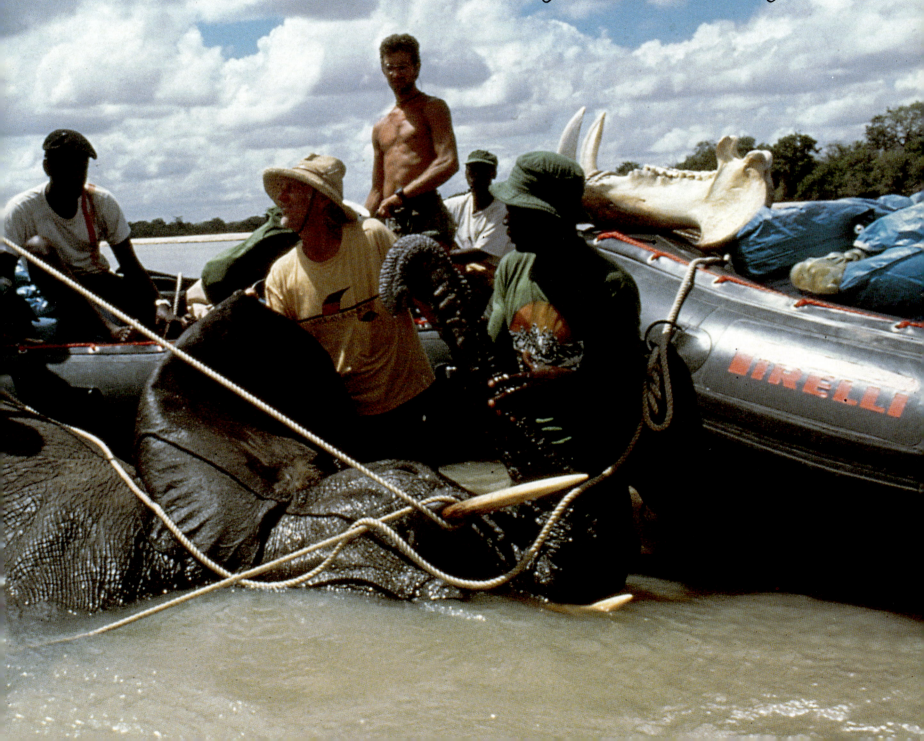

Since the ivory scandal involving President of Kenya, Jomo Kenyatta and
his family was first splashed across the international press, the world sales of
ivory, despite stringent international controls, have totalled
thousands of tons. Profits from these sales financed guerrilla wars and enriched
government officials. In Burundi alone, where statistics show that there
was only one elephant left, 100 tons of ivory tusks from 11,000
elephants killed in Zaire and Rwanda, for which Burundi is a
convenient clearing zone, had left the country.

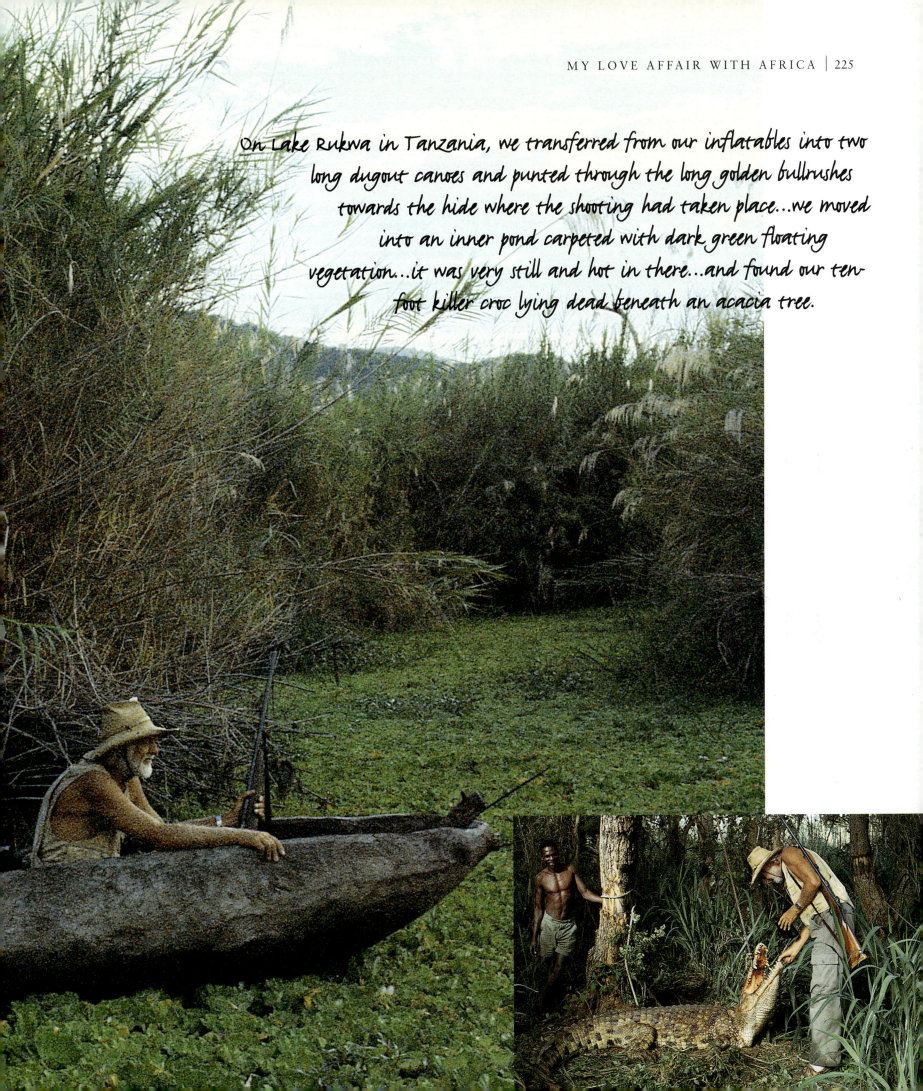

On Lake Rukwa in Tanzania, we transferred from our inflatables into two long dugout canoes and punted through the long golden bullrushes towards the hide where the shooting had taken place...we moved into an inner pond carpeted with dark green floating vegetation...it was very still and hot in there...and found our ten-foot killer croc lying dead beneath an acacia tree.

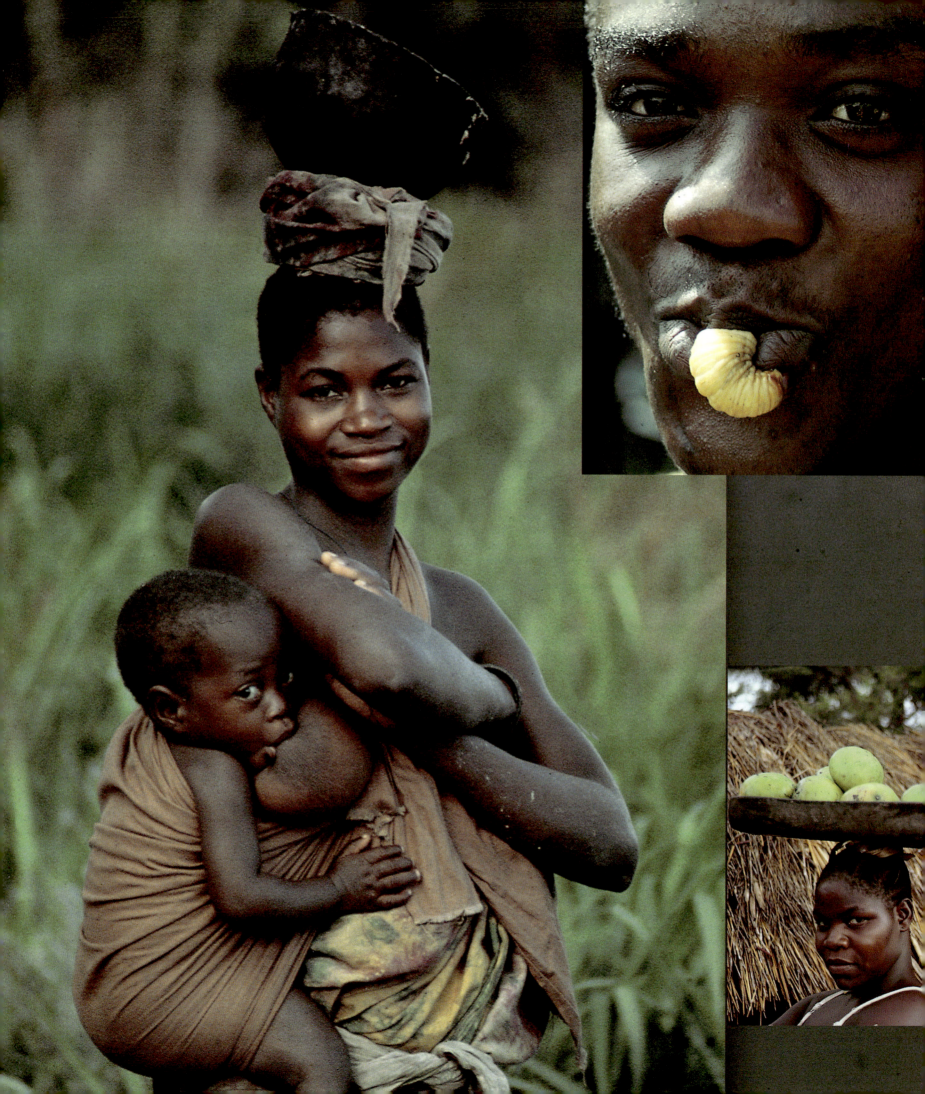

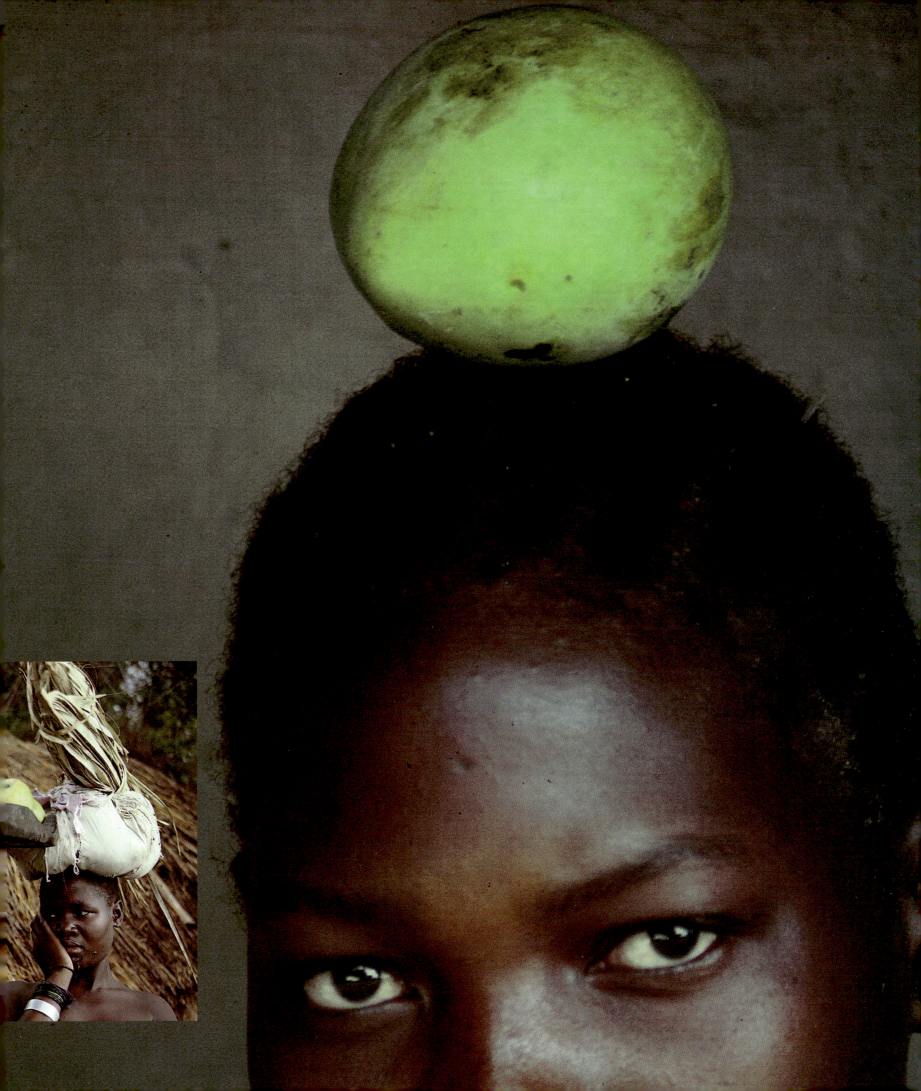

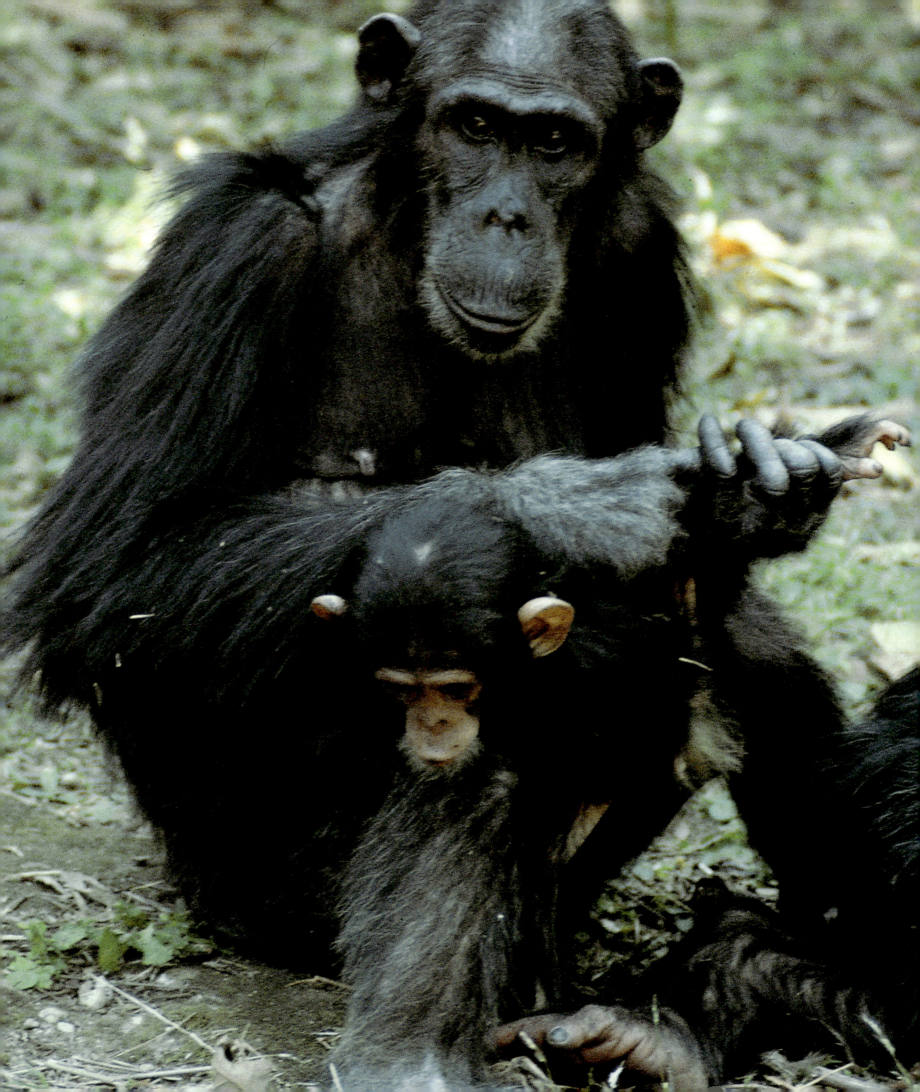

In Gombe Stream on Lake Tanganyika we met up with Jane Goodall who has been studying and monitoring chimp behaviour for over 35 years.

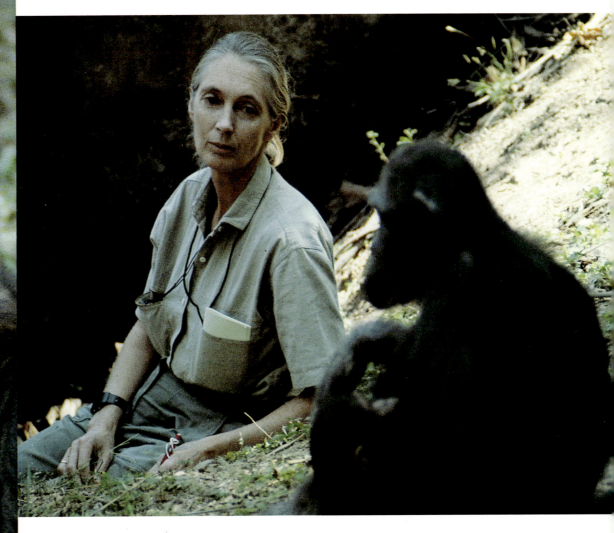

'Biologically chimps are our nearest living relatives,' she told us and one of her central interests is to try and define how childhood experiences affect the adult, so that her findings can be adapted to humans.
We asked her if she spoke 'chimpanzee'; she laughed and told us she could understand it.

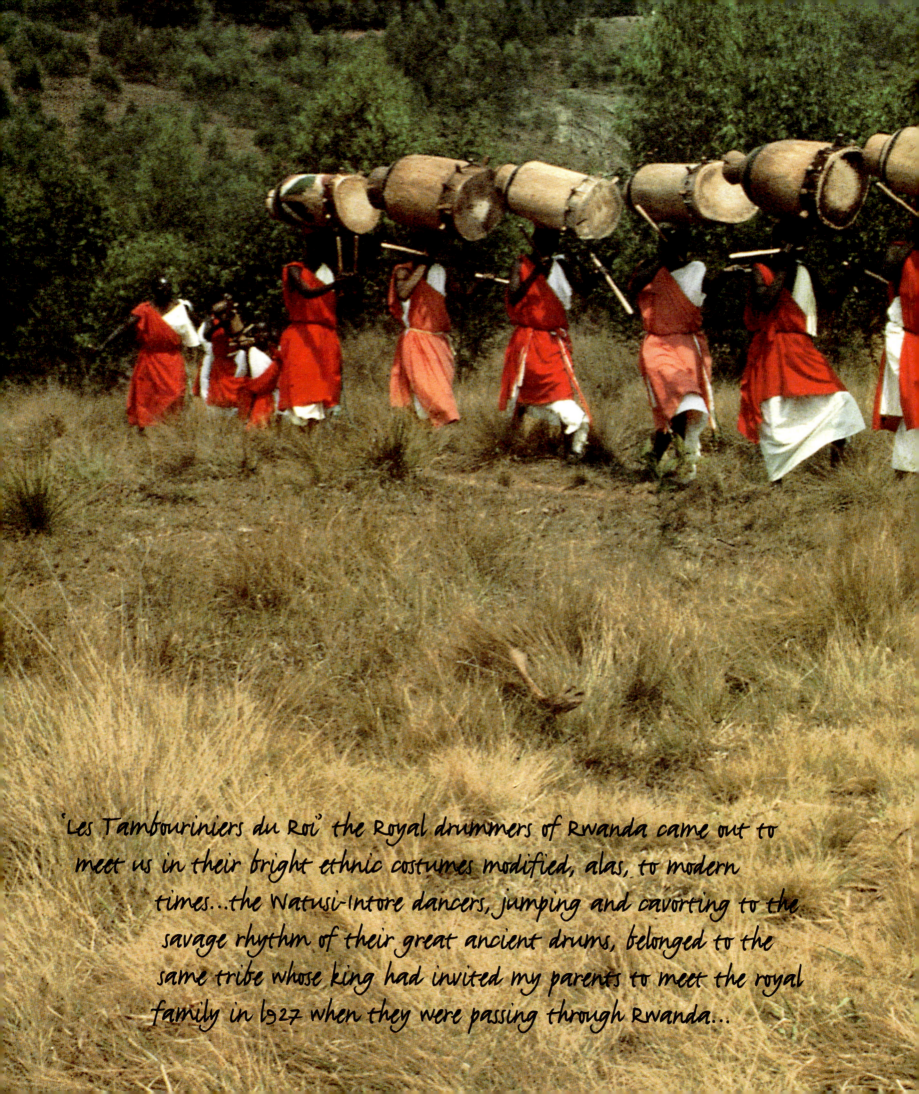

"Les Tambouriniers du Roi" the Royal drummers of Rwanda came out to
meet us in their bright ethnic costumes modified, alas, to modern
times...the Watusi-Intore dancers, jumping and cavorting to the
savage rhythm of their great ancient drums, belonged to the
same tribe whose king had invited my parents to meet the royal
family in 1927 when they were passing through Rwanda...

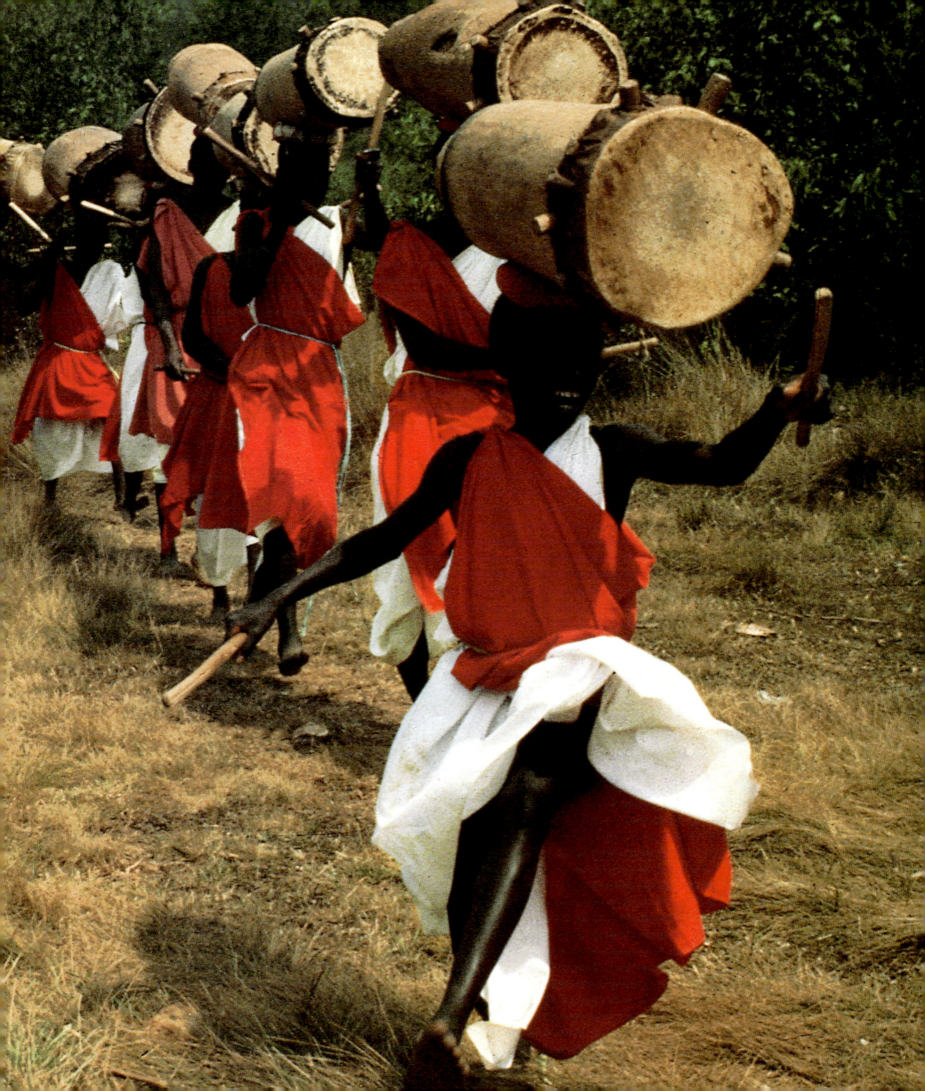

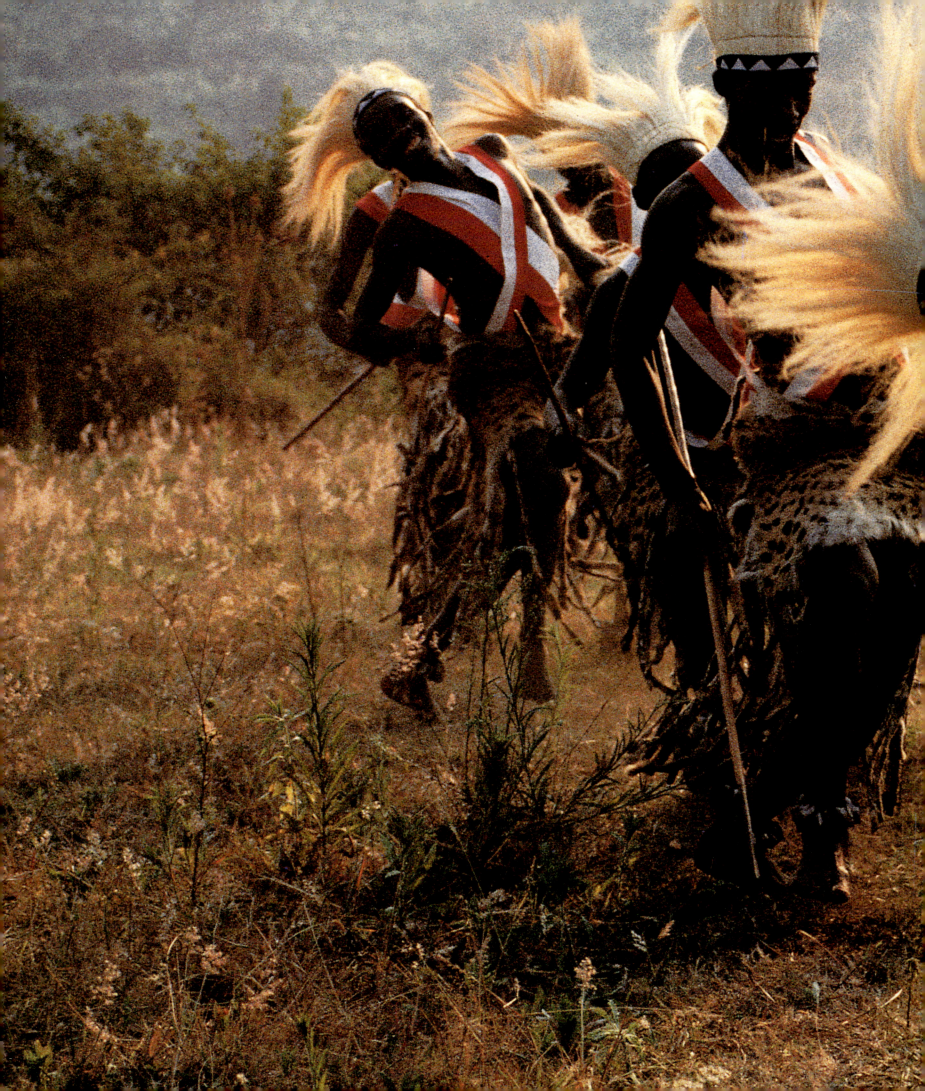

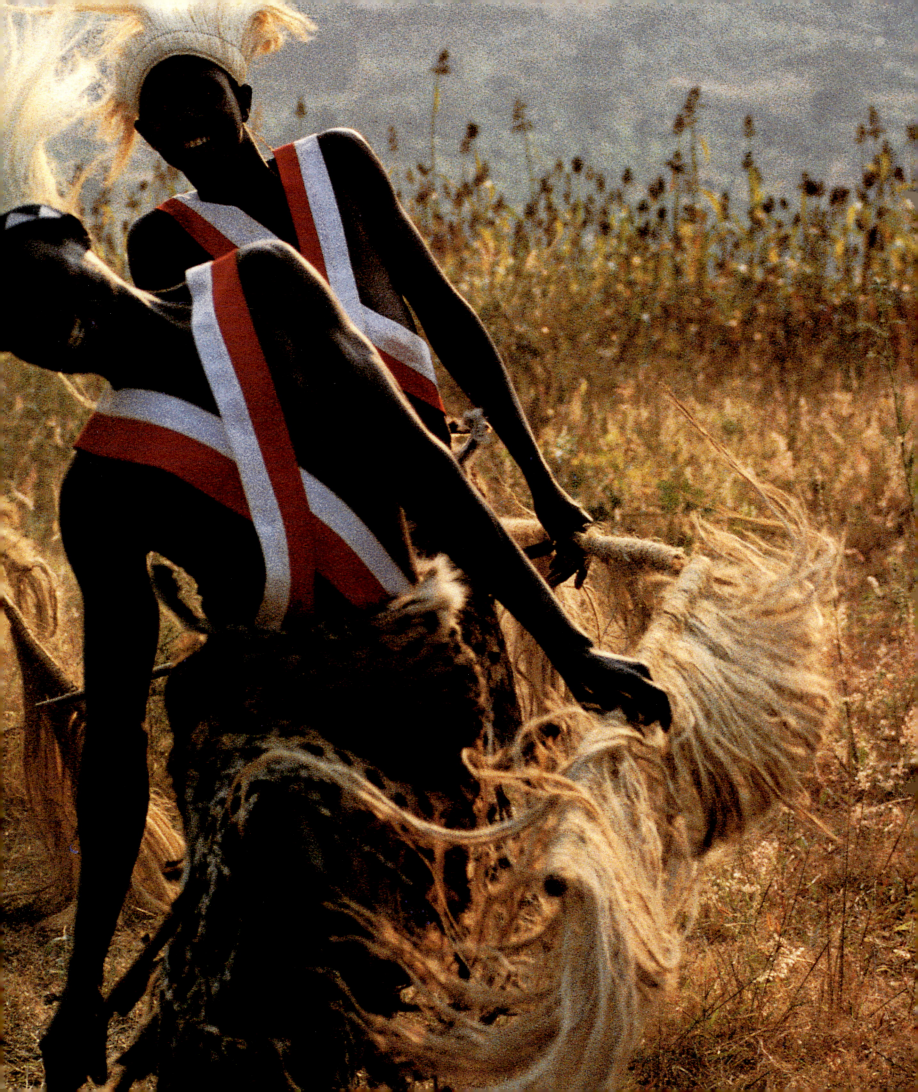

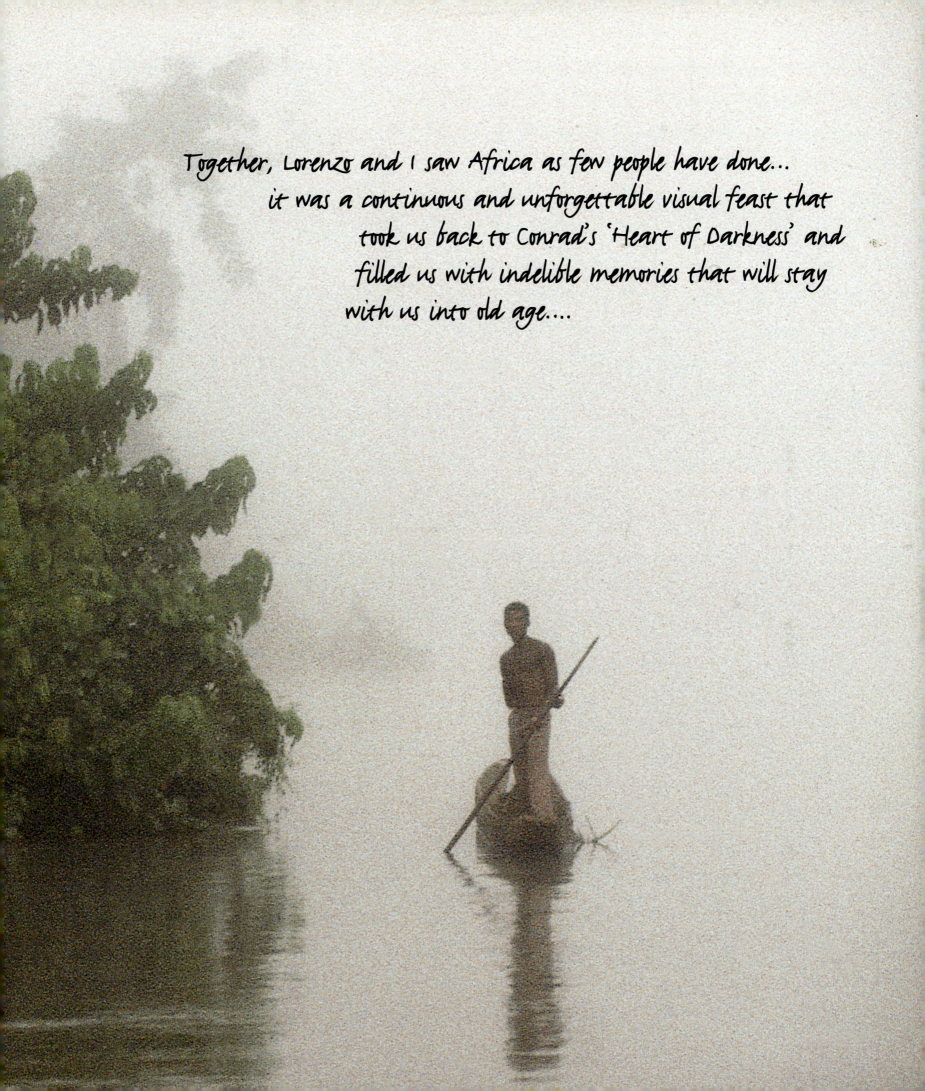

Together, Lorenzo and I saw Africa as few people have done...
it was a continuous and unforgettable visual feast that
took us back to Conrad's 'Heart of Darkness' and
filled us with indelible memories that will stay
with us into old age....

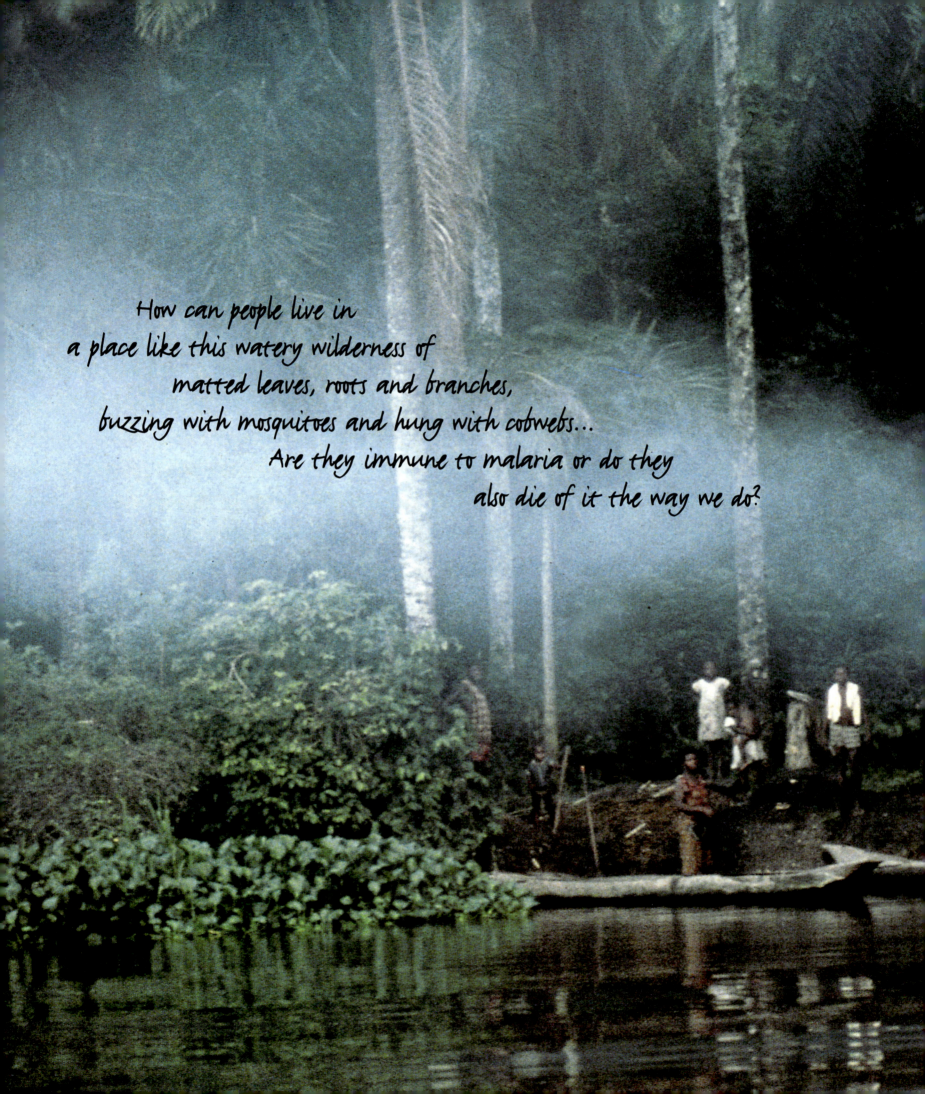

How can people live in
a place like this watery wilderness of
 matted leaves, roots and branches,
 buzzing with mosquitoes and hung with cobwebs...
 Are they immune to malaria or do they
 also die of it the way we do?

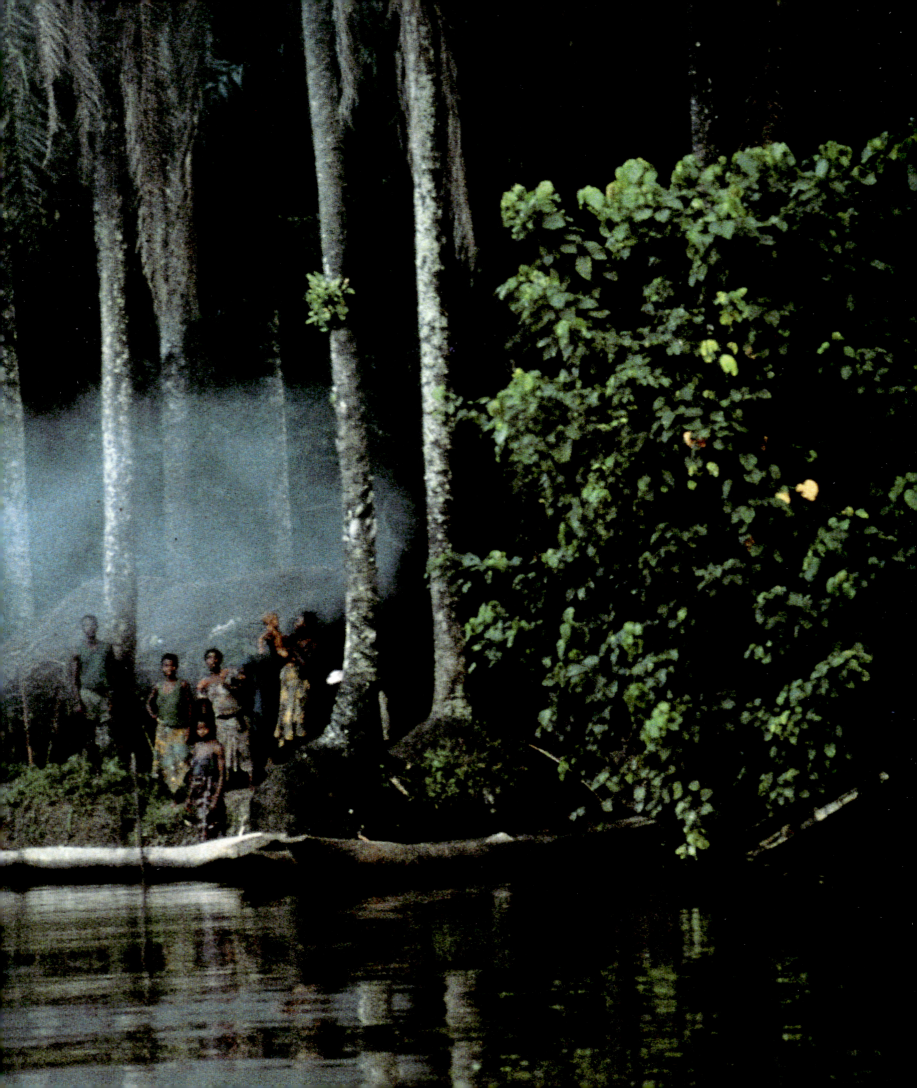

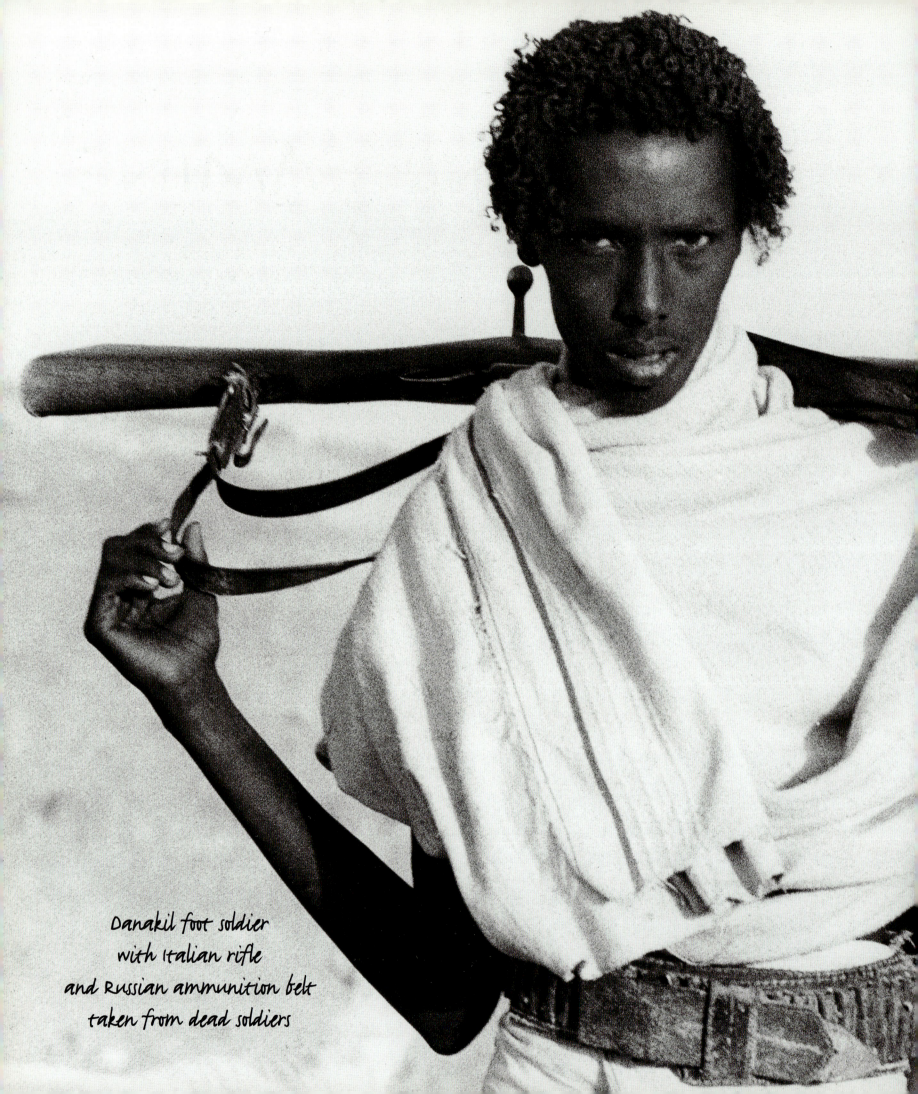

Danakil foot soldier
with Italian rifle
and Russian ammunition belt
taken from dead soldiers

WAR AND FAMINE

MY ADVENTUROUS LIFE as a roving photographer of Africa has been as varied as it has been unusual. Soon after we returned from our *Rainbow* expedition I received a call from the Save the Children fund asking me to document their efforts in eradicating the barbarous custom of female circumcision in the young girls of the Sudan. After the ordeal, I travelled on to Eritrea from Khartoum for a *Sunday Times* story on Africa's longest war, with Jon Swain, the veteran reporter who was depicted in the Oscar-winning film *The Killing Fields*. It was a war the world has chosen to ignore and forget.

I travelled by jeep from Port Sudan on the Red Sea with some returning guerrilla fighters and arrived after an exhausting all-night journey at the Salumona Children's Refuge, hidden in the rugged barren hillside, that houses and cares for the orphaned children and the hopelessly maimed and disabled victims of the war. The sullen murmuring of a rocket barrage rumbled along the mountain valley from the front, two miles away. A jet sighed overhead. There was a thud of anti-aircraft fire, a splash of dirt on the hillside and an explosion like a thunderclap. For a while after the plane had gone the high air ached with the bitter sound of the engines.

Soon a captured Russian army truck drew to a halt by the dry river bed where the guerrillas of the the Eritrean People's Liberation Front (EPLF), had set up a camp and began unloading that day's crop of wounded civilians. They made pitiful bundles: two children with their feet blown off and a woman with napalm burns. From under the bushes, a guerrilla in shorts and sandals emerged, bade us welcome and led us into a cave. Suddenly I realised this is how most of the EPLF fighters live, in caves dug deep in the mountains, under rocks and trees to hide from air attacks.

A few days later I travelled with these same fighters to the front line where I was to photograph them in the trenches. We had travelled all night by jeep from the Salumona Children's Refuge, crawling like snails over the rock-strewn track that wound through the barren mountains, without headlights, picking our way in the moonlight. We pulled up in the army encampment dug into the flank of the mountain about half a mile from the trenches. The fighters erupted from behind coarse

I did not know then that our African Rainbow expedition would be the last time I was to savour the true magic of Africa

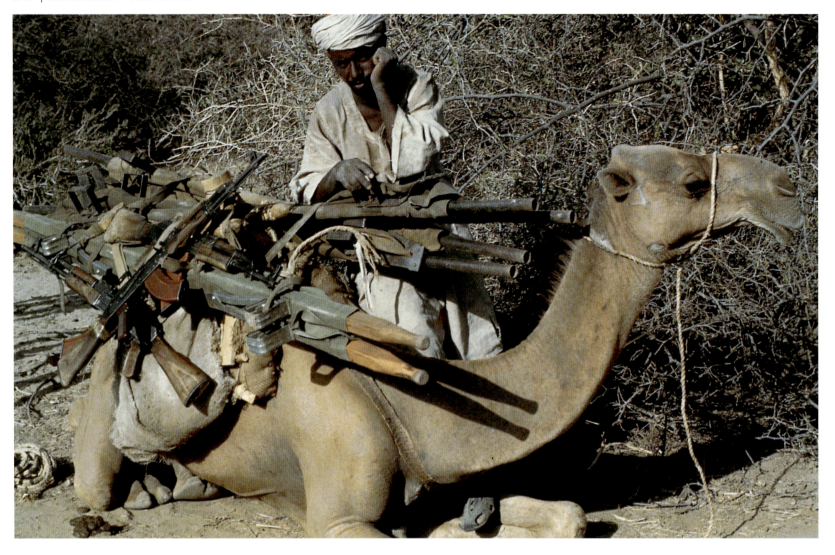

Arms and ammunition, stretchers and medical supplies were ferried to the front lines on the backs of camels, the only available means of transport for the Eritreans.

hessian door hangings and greeted us with beaming sleep-streaked faces, inviting us to come in and rest. They served us a great bowl of fresh diced tomatoes in olive oil sprinkled with parsley and coriander and chopped garlic, accompanied by delicious rough slices of freshly baked bread. Strong black syrupy coffee perfumed with cardamom seeds was poured from a copper coffee pot with a curved beak like snout. It was like being offered manna from heaven after the exhausting eight-hour journey. I managed a few hours of sleep on a sleeping bag thrown on the stone slab floor before sunrise.

Once inside the trenches, the bleak reality of war hit home as we moved bent in half among the young guerrillas sporting ammunition belts across their chests and around their hips, and toting heavy-duty Kalashnikovs. The same smiling faces welcomed us and everyone crowded around me when they heard

I had come to take their pictures. The young men flaunted their macho stances at me while the girls laughed and giggled. It seemed for a brief moment that they had forgotten about the war. They led me into a dip in the trench wall where a pool of sunlight created a small amphitheatre among the rocks. We were so intent in taking a group photograph of them that none of us heard the approaching Mig fighter until the bomb exploded all over us. I can't remember exactly what happened, but suddenly without warning I found myself on my face in pitch darkness pressed to the ground, a terrible pain shooting up my left arm. I could not breathe, and there was this huge weight on top of me. I thought, my God, I've been hit and I am dying. I can't remember how long I lay there until the weight on top of me began shifting and I realised that I was not dead; I was lying beneath a heap of

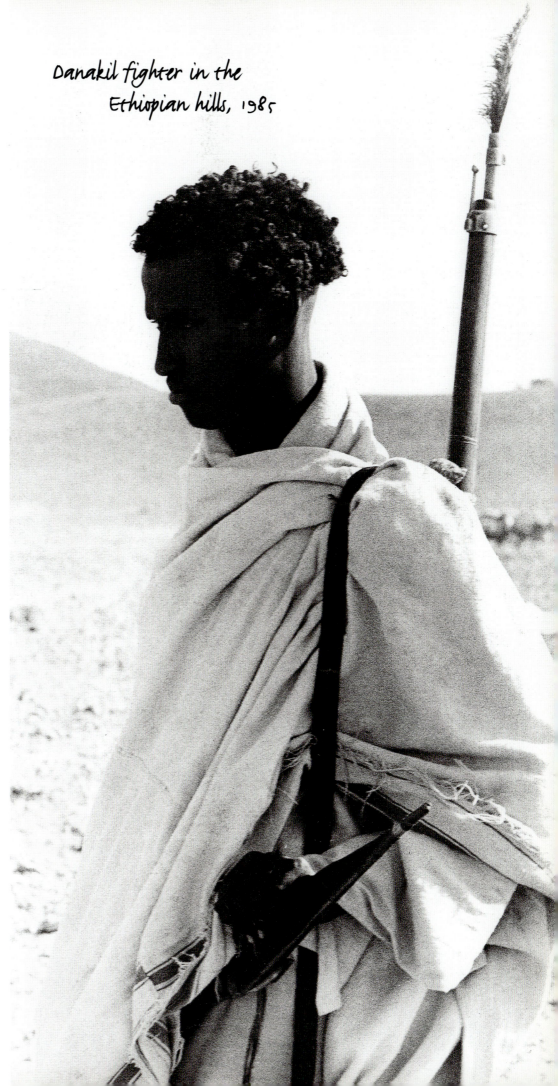

bodies. The fighters had thrown me to the ground beneath them. One by one they struggled back on their feet, three of them had been hit by shrapnel and were covered in blood, their faces caked with sweat and dust and their tousled hair sticking to their foreheads. They pulled me onto my feet, white and shaking; my wrist was at a right angle to my arm, hence the intense pain. The sudden contact with the hard trench had snapped my wrist.

Further up the valley at a place called Orota there is a complete underground hospital dug deep into the mountains. Its team of surgeons were expert in amputation, napalm burns, spinal, abdominal and head wounds. The injured lie in uncomplaining lines on the ground waiting to be treated when dusk falls and the generators are switched on. I had to wait until nightfall before I could be driven there for treatment. The guerrilla soldiers were very attentive; they expertly bound my arm with a wooden splint, gave me a shot of morphine, part of the first-aid kit they kept in the trenches, and saw that I was comfortable in the shade of a tree.

Once in Orota, as I awaited my turn to be X-rayed, I felt very humbled by the seriously injured waiting alongside me lying on the ground. My broken arm seemed so insignificant by comparison. I sat beside a gnarled and broken insesnse tree, its dark red sap oozed from a branch and splashed on a stone where I was sitting. One of the wounded men looked up at me and said, 'You see, in Eritrea even the trees are bleeding.' I remember being immensely moved by his comment.

The nomads are perhaps the most pathetic victims in these senseless African wars. Their camel trains are sprayed with napalm, their tented homes blitzed with cluster-bombs. Their wealth is measured in goats and camels and home is a rough stone hut or a framework of sticks covered in woven matting for easy loading onto a camel for the trek to the next pasture. This was my first head-on confrontation with war and I was deeply shocked by it but at the same time I was inspired by the fearless fortitude of these brave people, fighting and dying to regain their independence from their Ethiopian invaders. It restored my faith in human resolution and endurance and gave me strength to confront many of my own personal demons.

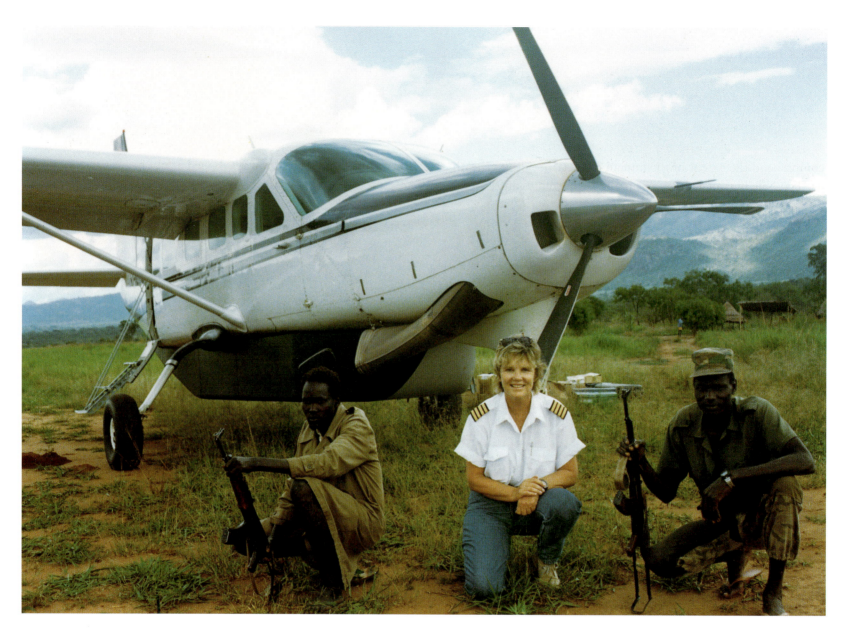

HEATHER STEWART

Heather Stewart's abiding love of Africa and her obsession with flying which first manifested when she was 24 years old, decreed her choice of lifestyle. The risky move from first flying for AMREF, the Flying Doctor Services of Kenya, to transferring *miraa* (khat) into Somalia, was triggered by the necessity to bring up her children as a single mother. 'You got paid very well for the risky business...once a gunfight broke out after I landed...the turbaned men were racing up and down the airstrip high on *miraa* and I just managed to take off again after I had received six bullets in my left engine and one of the shells had torn through the cabin roof behind my head.'

Thirty years later, after four marriages, five children and four grandchildren, she heads Trackmark, the aircharter company she formed, which owns 19 aircraft, has a yearly turnover of £10 million and is the only Kenya-based company of its kind run by a woman. Her customers include the UN High Commission for Refugees, the World Food Program, Médecins Sans Frontières, which between them airdrop 15,000 tons of food each day over the war zones and famine areas of Southern Sudan, at a cost of $1 million a day. Her pilots have been taken hostage by warring factions and aircraft operating in rebel-held areas are targeted by Khartoum bombers. She was once stranded in bush country for four days and had to be rescued by helicopter. 'The sense of doing something so vital however, compensates for such ordeals...I'm dedicated to air relief work and no one yet is doing it full time.'

MANY YEARS LATER I flew over the Sudan with my friend Heather Stewart. A Kenya girl like me, she had been a successful bush pilot since the age of 22, and had set up Trackmarks, an organisation that ferries aid into stricken war-torn countries like the Sudan. I was reporting on the seemingly endless and ongoing famine in war-ravaged southern Sudan.

Despite all I had seen in Eritrea it was still difficult to comprehend the extent of the human drama unfolding beneath us. The Nile meanders over this immense barren country like a liquid nomad with no particular constraints other than the general direction northwards towards Egypt and the far-off Mediterranean Sea. The land is creased and pocked by the irregular writings of the winds and rain on the desert sands. In the far distance the jagged mountains shrouded in heat mist with their deep rocky ravines, made me wonder how humans can live, let alone fight on such hostile terrain. And yet they do and their agony is the agony of Africa, for this extraordinary continent has, since recorded time, had a savage history, as savage as its rugged terrain. One does eventually get hardened to a lot of what we cannot do or do not want to face and need, occasionally, to be reminded of it. My trip to the Sudan with Heather did just that.

She invited me to use her frontier headquarters in Lokichogio on the Kenya border with Sudan as my base and I was grateful for the basic comforts it provided in this harsh environment. I flew to Ajiep in the north on a UN plane. We landed several times en-route to drop or collect passengers, food, medicines and aircraft fuel. These descents brought the reality of my imaginings into stark focus as we hit the ground, bumped impudently over the landing strip and taxied to a halt in the designated parking space. These landings invariably gave me an adrenaline rush as the rawness of Africa's superb wilderness zeroed in around me. The dramatic scenery with its long golden grasses, its gnarled twisted trees, its rolling sand dunes and dramatic skies hung with extravagant rain clouds through which shafts of light poured in like a corny holy picture, provided an incongruous backdrop to the hordes of naked inhabitants that materialised as if from nowhere and swarmed around the aircraft like so many ants. These were the noble Dinka in all their audacious splendor, with their absurdly long naked limbs, their slender necks and sloping shoulders supporting perfect egg-shaped heads with chisled features, soft gentle eyes and the triple welt incised across the forehead, their signature of ritualistic initiation to manhood. Here in front of us were the very people who for centuries have lived on the hostile terrain I had seen from the air and whose very existence was now threatened as the exhausting war between north and south Sudan corroded their livelihood, reducing them to penury and dependence on the white man – at a cost of a million dollars a day.

Here were the people that only a few years before I had photographed peacefully moving around in the smoky atmosphere of their cattle camp on the edge of the Nile. The outrageous human folly of this impossible situation I had come to report on, was evident even before arriving. This mix of beauty and drama had always tugged at my heart and been the reason for the turmoil in my love/hate relationship with Africa.

I spent three days at the UN camp in Ajiep, sleeping on a bedroll beneath a diminutive dome-shaped nylon tent. The heat was intense and the goat and cattle flies competed with the dust that swirled around us for any available uncovered part of my body, crawling in my ears and my nostrils, driving me slowly insane. I spent the day in the children's refuge where the aid agencies battled with the horrors of famine that rolled in from the stricken land around them. Sudan was experiencing a savage transition, torn asunder not only by this absurd war, but by the vagaries of its fickle climate that brought death and destruction in its wake. Impossible drought turned the land to dust, then rain, so heavy it broke the banks of the Nile, flooded everything for miles around. The homes, the crops, the livestock perished and the people wandered like lost souls in search of sustenance. Those who did not fall and die along the way made it to the UN camps where saintly men and women doled out nutrition that prolonged their agony, in the hope that perhaps God would smile down on them and turn their calvary into salvation before it was too late.

What a fierce and brutal hand Fate had meted out to them. They sat around in groups with vacant stares, half alive, or lay in silent bundles in the soft sand, covered by an army blanket waiting passively for someone to minister to them. Many were so debilitated they could not swallow or digest food when it finally became available to them. These people were wet-fed, mixing grain with water so that it went down easier. But in many camps there was a shortage of clean water. Some of the smaller children had to be hand-fed because they had forgotten how to eat. Flies buzzed around them, crawled inside their nostrils and landed without mercy on the dessicated folds of skin that still enveloped the fragile frames of their bodies. There were children of all sizes with spindly arms and legs and swollen bellies, and ageless men and women who resembled the stick people I used to draw as a child. A deathly stillness and silence hung over them as they waited; the only movement came from aid workers going about their hopeless crusade. They looked straight into the lens of my camera with such natural dignity and poise, giving me haunting

images that told a silent tale of hopeless resignation and abandon. At night, I lay sweating and uncomfortable on the hard ground beneath my tent, I stared out into the blackness of the night and thought of them with dismay and confusion, trying to make sense of our individual journeys on this earth; their soulful faces kept me from sleep. Here in south Sudan, God and the Devil, I remembered thinking, were indeed one and the same thing. I thought of something Lorenzo had once said to me as we walked along the shores of Lake Turkana in northern Kenya. 'This is the right place to die,' he said, 'There is no past, no future, no sense of time here.'

Several times a day the great Hercules aircraft that took off each day at dawn from the relief centre in Lokichogio, flew overhead like fat geese and disgorged their cargo of foodstuffs provided by the World Food Program (WFP) – rice and grains and sugar – hundreds of feet above us. The underbelly of the plane would open and wooden pallets stuffed with white 50kg bags would come hurtling through the air and hit the ground like bombs; some exploded in a burst of white powder on impact, the pallets spun like murderous tops through the air and then splintered into lethal shards as they too hit the ground or skidded still intact to a halt in the bushes. This aerial ballet always provided some moments of high drama for the people waiting below. The landing areas had to be cleared of all living creatures to avoid decapitation and the ground staff kept in close radio contact with the pilots, giving them precise unloading directions. Despite these careful manouvres and precautions, insubordination or inattention would sometimes cause tragic accidents that ended lives in most gruesome ways. These airlifts were the lifeline of the Sudan; without them the whole population would have disappeared. 'How long can such humanitarian relief be sustained?' I quizzed my UN friends when they informed me that the cost of these operations was one million dollars a day. Their answers were inconclusive and vague. 'We have a cut-off date,' they replied. 'What happens then?' I asked. 'No one knows, the answer lies in the lap of the gods,' they said for want of anything better. 'As long as the war continues the problem will remain, and for the moment there is no end in sight.'

All over America and in many other places around the world, the horrifying images of Africa's famine have shaken thousands of people out of their complacency. 'We've never experienced anything quite like this,' a spokesman for the Red Cross told me. 'People didn't wait for us to announce our plans for relief in Africa. They wanted to know what they could do right away, but now the interest seems to have diminished' she added soulfully.

For how long can the ravaged images sustain such generosity before inertia and apathy sets in, is the question in everybody's mind. So who is to blame for Africa's crisis?

Forward-thinking Africans like Hilary Ngweno, a columnist for *Newsweek International* based in Nairobi said 'Nature certainly accounts for a good deal of it, but as devastating as it is, it is only part of the story. The destruction and dislocation it has brought could have been mitigated if African leaders had served their nations well in the years before the devastation, instead of mismanaging the economies, squandering national wealth and literally throwing away the future as they jostle with one another for personal power and gain.' 'Why should these so-called leaders have behaved in any other way,' I asked. His assumptions did not address the very core of human nature and greed. I, who for many years have witnessed the slow disintegration of the continent unfold before my lens, have learned that what is happening to Africa is part of her inevitable evolution and that however grim, it is the consequence of much bigger things happening in the world. It is pointless to think that mere mortals can right the wrongs that surface; the immense suffering and loss of life is the price that Africa pays. It seems to me that aid on whatever level and in whatever form is like spitting into the wind, for the enigma of Africa is beyond the reach of man. Those individuals or nations who contest it do so for reasons of gain, naive generosity or in order to assuage personal guilt. An embittered young aid worker once said to me, 'It may sound like a fatalistic defeatist attitude and I have myself often been shouted down, but the evidence speaks louder than words ever can. It is part of the rhythm of the life; in Africa where man and nature are now at odds with each other, it is more apparent and her agony is therefore all the more unbearable.' The delicate balance of nature by which the indigenous people once lived has been tampered with. The Africa I was born to is no longer; her suffering and distraction is part of her inevitable change, part of her march into the twenty-first century. For better or for worse man can no longer stem the tide he set in motion. Unable to stand by, helpless and confounded by circumstances, I personally have opted out, preferring to distance myself rather than heighten my own anguish, so that I can still retain the memory that gave birth to my love affair. The alternative is unacceptable.

While I was in Ajiep I read a passage in a story written by A. A. Gill, in the *Sunday Times* magazine, which could not have been more timely as it perfectly echoed my feelings and the conclusions I had come to. He and I had been in the same area almost at the same time.

'Lokichokio,' he wrote, 'a crazy name, a crazy place, a bored town dropped in a fold in the hills between nowhere and nothing. The line that separates Kenya from the Sudan is purely notional. A year ago this was a collection of huts baking in the wilderness, with a landing strip. Now it is a frontier town, a burgeoning collection of tents and hastily built breeze-block cantonments with bars and swimming pools and rooms with showers. It is a boom town growing to service five Hercules aircraft, tied to the outside world by a thin pot-holed crumbling, rainwashed bandit harassed road that winds 1000 miles to the coast at Mombasa. Everything, fuel, food, loo paper, Coca-Cola – has to be driven or flown into Loki. This is Charityville. In the west we don't get to see the UN at work. We probably think it is a good idea, a bit wasteful, a bit blunt and slow. But we never get to see where all the money and effort actually goes. A lot of it goes here, into these ranks of Toyota Landcruisers and bubbling tarmac, and guards with walkie-talkies and gangs of black labourers, humping white sacks in the midday sun, and the pilots hanging out with ice-cold beers and cokes in the Trailfinder's bar, earning salaries others on the outside can only dream of. And the long lines of dusty tents, each the size of a football pitch, with the letters UN like a 20-ft-high expletive painted on the sides. When this much neat charity lands on your doorstep it changes everything; the economy, the social structure, the landscape. UN, the Ultimate Nino. Looking at Loki it is impossible not to draw the trite conclusion that Africa has simply swapped colonialism for charity and there is very little difference. Both are buttressed with fine words, both in practice are paternalistic and divisive. It is still the white folk in the shade and the black folk humping sacks.

Nothing prepares you for mass starvation, nothing protects you from the truth. The terrible terrible pitiful shock of it. It is not staring at the face of starvation that thuds like a blow to your heart, it is having starvation stare back at you...nothing protects you from the quiet scrutiny of a thousand fly-blown, liver-yellow starving eyes, and nothing protects you from the smile of welcome. What have the Dinka got to smile about? Ajiep is where the buck finally stops. Having been passed hand to mouth around the world it comes to rest in a thorn tree in this hot, dry earth. Here finally is that mythological, nursery tea-time place. Remember all the starving people in Africa...here is the end of the longest queue in the world. When the Dinka look around, there is no one behind them. They are now refugees in their own land, wandering in an arid featureless plain, waiting for famine to organise its paperwork

In this land without electricity or even the last century's

communications, the circling Hercules that drops the food is the semaphored signal for people to start walking. They walk enormous distances in oppressive heat that makes every foot feel like a yard. Through a bush so bereft of natural features, they carry their children with barely any water. We have to drink eight litres a day to avoid dehydration, while the Dinka carry only little carved cups around their necks and sip occasionally. The hardiness is beyond anything you have ever seen on a sports field or running track. Nothing can prepare you for their awful beauty. You couldn't have chosen a more handsome tribe to starve to death. Tall and rangy, blue-black with high cheeks and broad foreheads, they wear elegant earrings and bracelets and simple silver crosses; the men carry orchid-leaf bladed spears and stripling-thin cattle whips. They wear a mixture of swathed and swagged traditional togas and cast-off Oxfam rags. The girls seemed to like the slips and nighties, the mixture of beads and silver and cast-off silk petticoats in faded pastels disconcertingly makes them look like this year's Paris catwalks. Everyone moves with a slow grace. The Dinka are incapable of doing anything without a poised grace. They arrange their limbs with fluid ease, one is always drawn to the curve of a neck or the etiolated fingers cupping a child's head. They gather in tableaux, like Renaissance frescoes with occasional splashes of cerulean from the mens' jellabas.

The news film crews who come to film their plight refer to them as skellies (skeletons). They retire at the end of the day's shooting to the UN relief camp, a collection of small tents set behind a low palisade of thorn bushes; on the other side the starving stood and watched as they shared out the contents of bags; trail mix, repellant, muesli bars, apples, chicken legs. The ITN team brought out a bottle of whisky and told with glee of the American network crew who had set up a grand tent with an awning and collapsible dining table, napery and candles and toasted each other with claret while Dinka stood in a silent circle and watched.

One man's meat is another man's poison. Never has this been more true than in southern Sudan. It provides great copy for the journalists and great pictures for the photographers. It is the sad story of Africa. Seen in the long-term, the Sudan will be forgotten when another disaster replaces it on our screens, leaving no scar on the scorched map. The bones of the dead will turn to dust and will mingle with the sand blown by the wind; it is the price of change in the inevitable evolution of the groaning continent...

Reprinted with the kind permission of A. A. Gill.

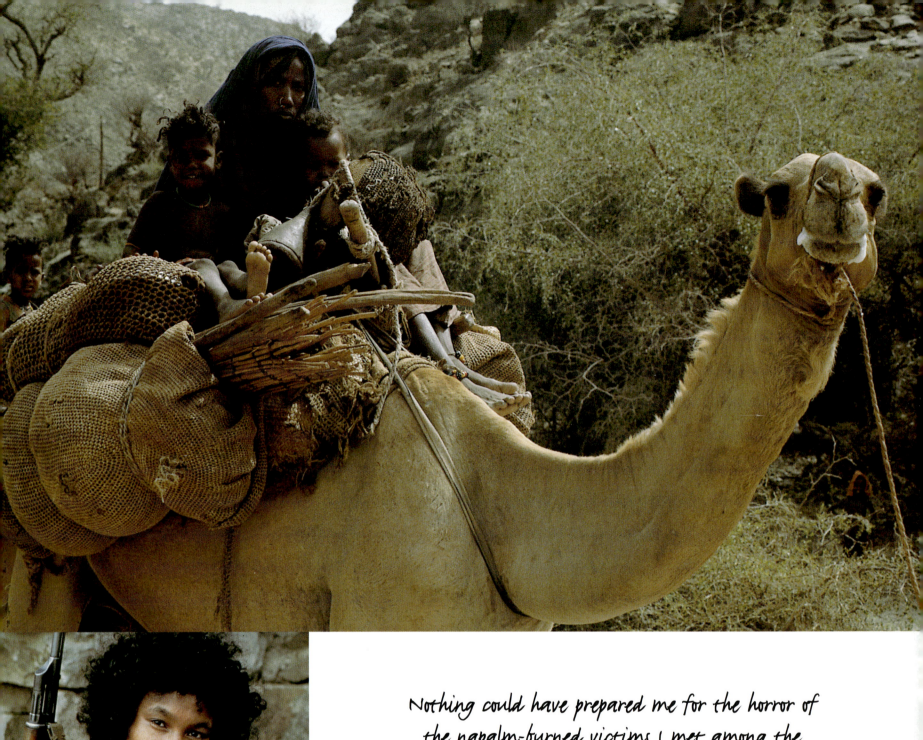

Nothing could have prepared me for the horror of the napalm-burned victims I met among the scattered mountain nomads, fleeing for their lives, shocked and terrified by the inhuman invasion that destroyed their peaceful lives.

The Eritreans nonetheless remained defiant, the women joined the fighting ranks and after 40 years threw off their Ethiopian oppressors. It was known as the 'Longest War in Africa.'

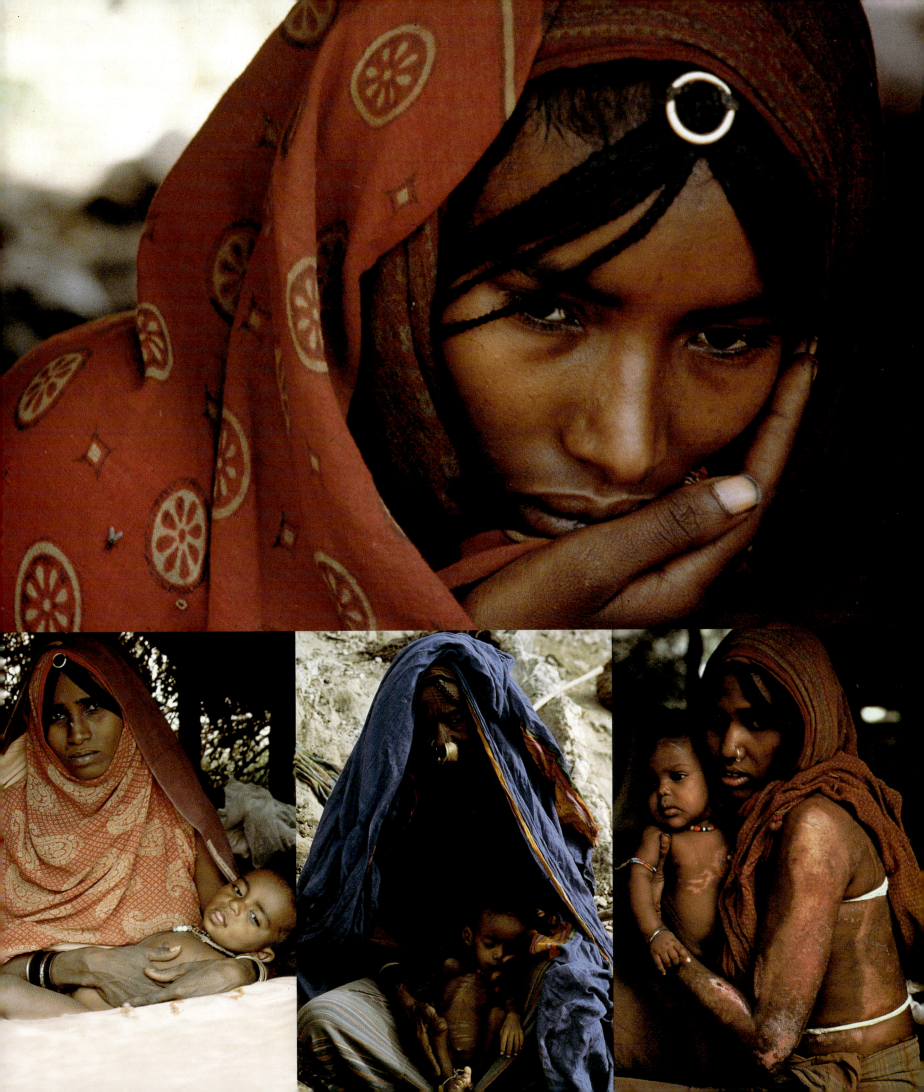

When I returned to the Sudan ten years later, I found the country ravaged by war and famine like in Eritrea...

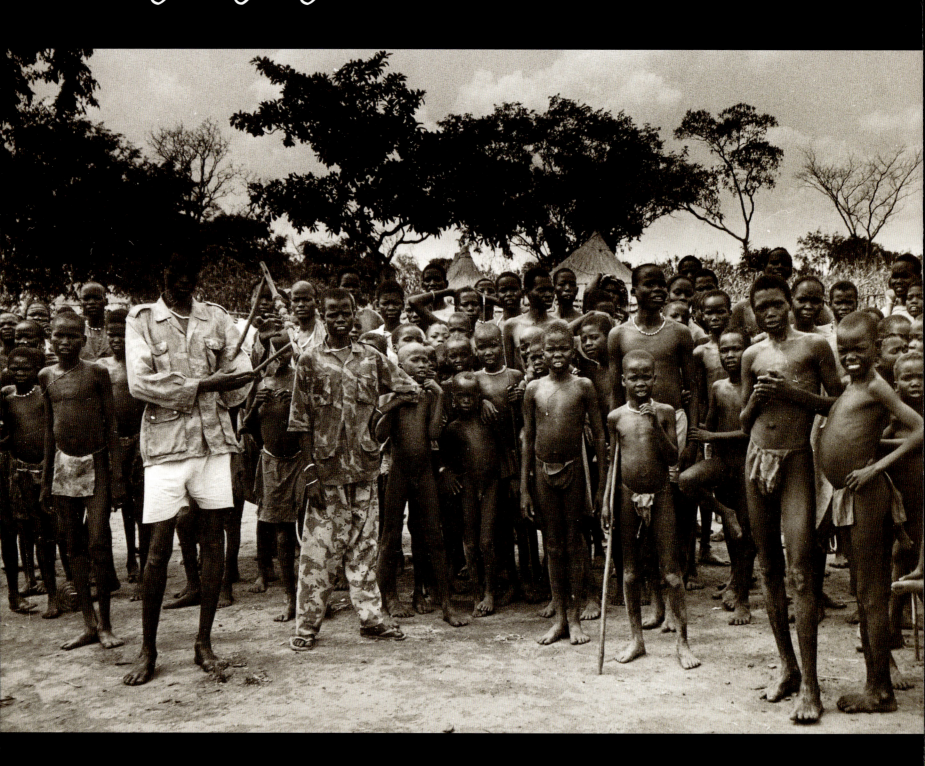

...the suffering Dinka swarmed around our aircraft like so many ants...

It was truly shocking to see how this noble tribe had been reduced to penury and dependence on the white man...

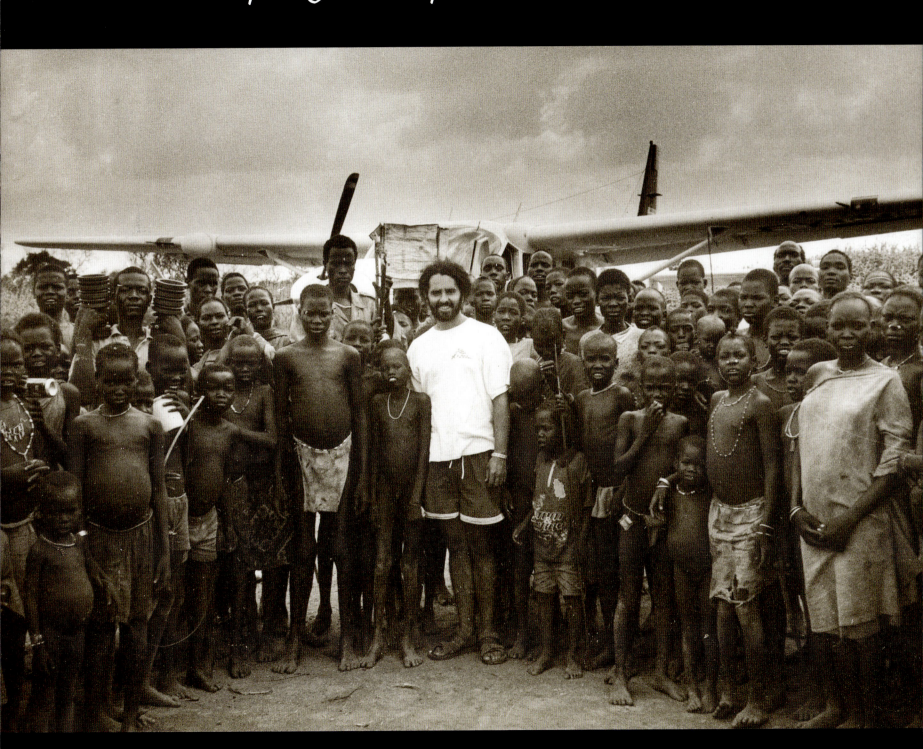

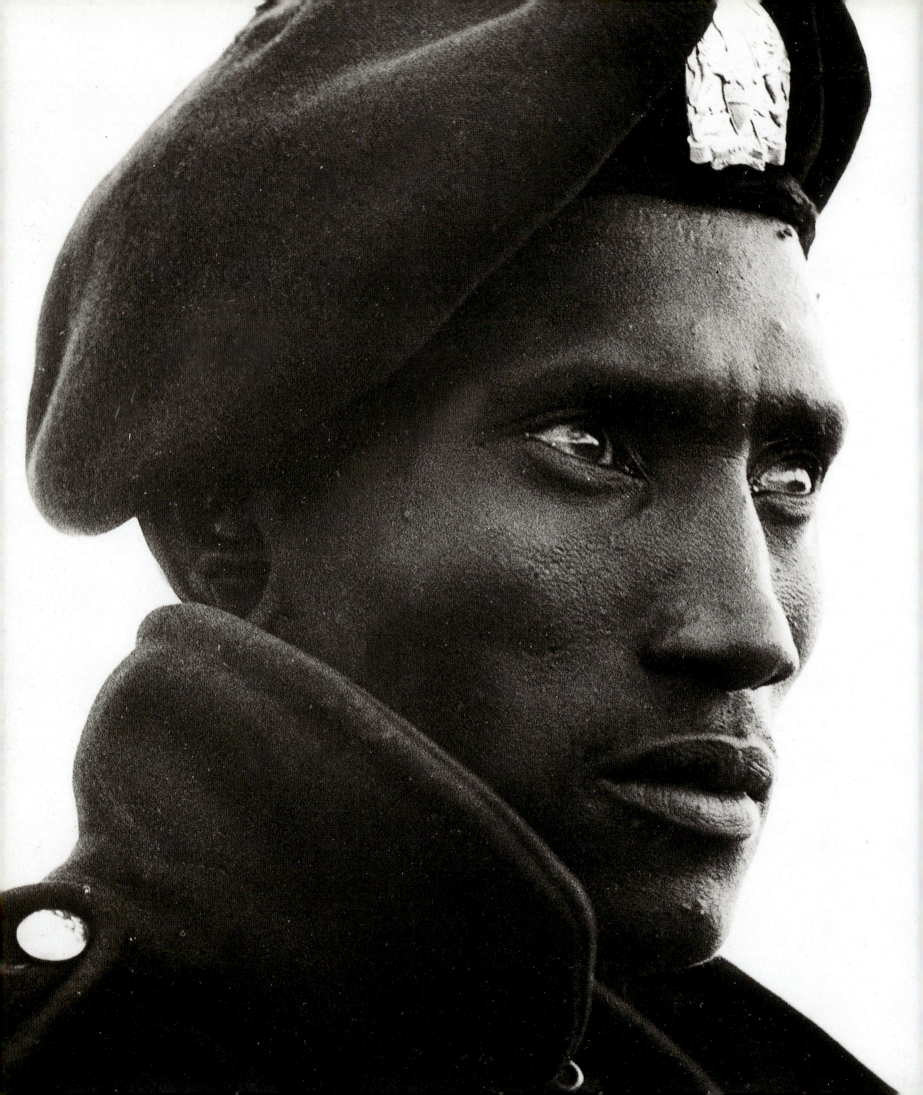

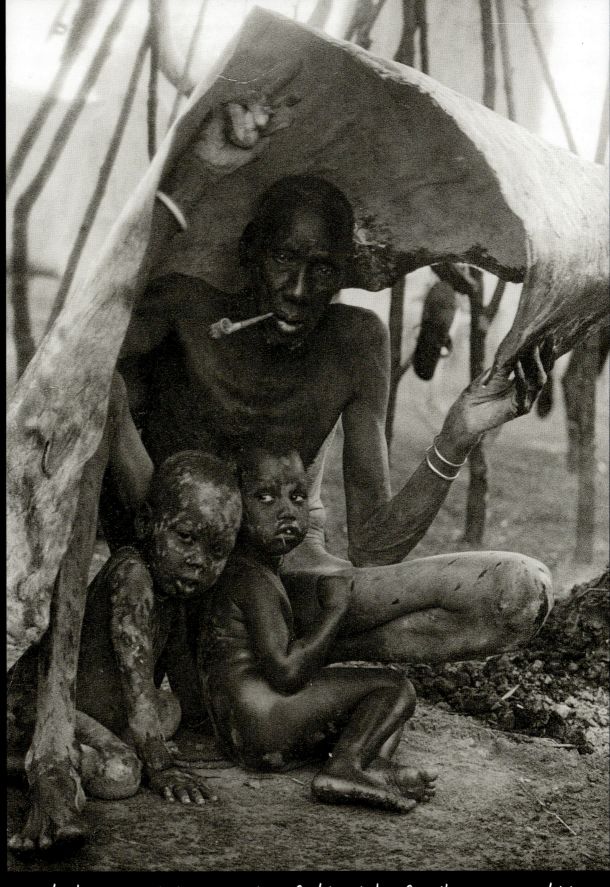

The last remaining possession of this Dinka family was a cowhide under which they sheltered when it rained

Left: Frontier Guard — Northern Kenya

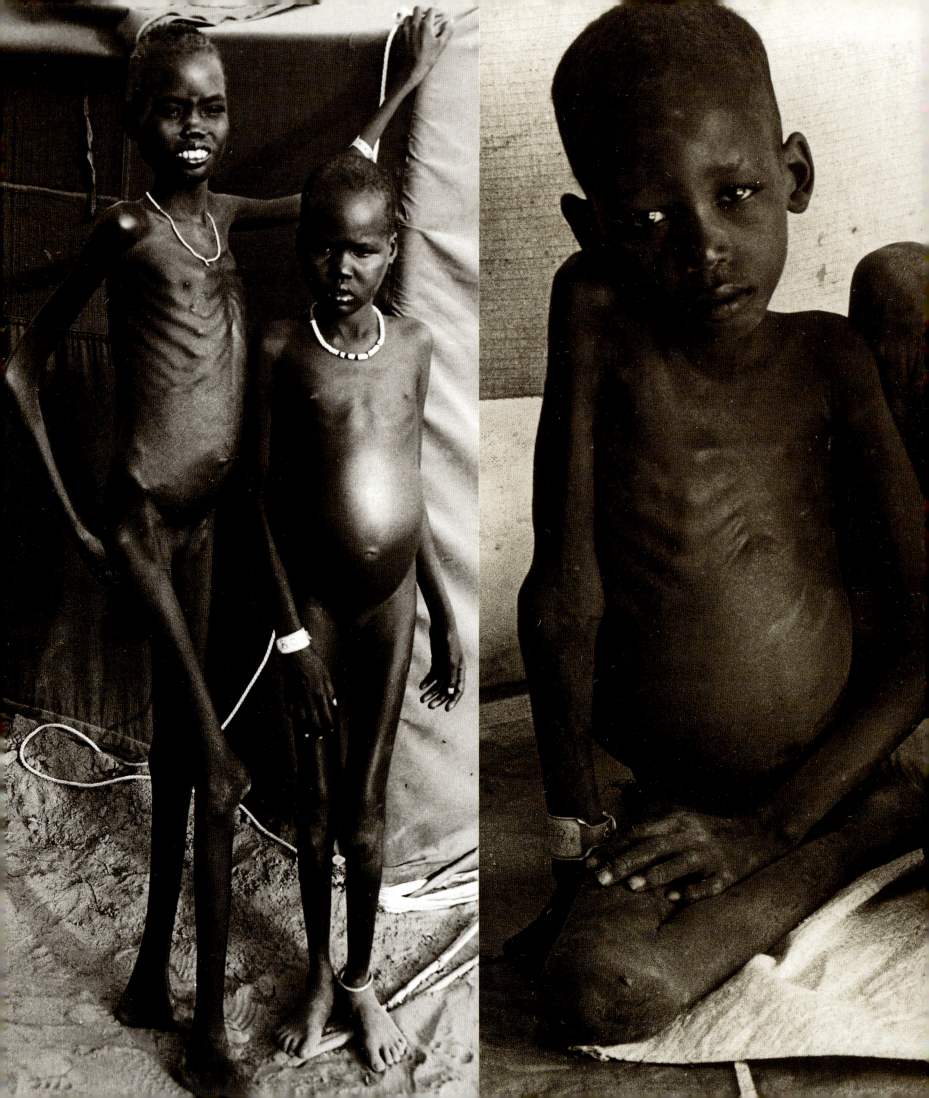

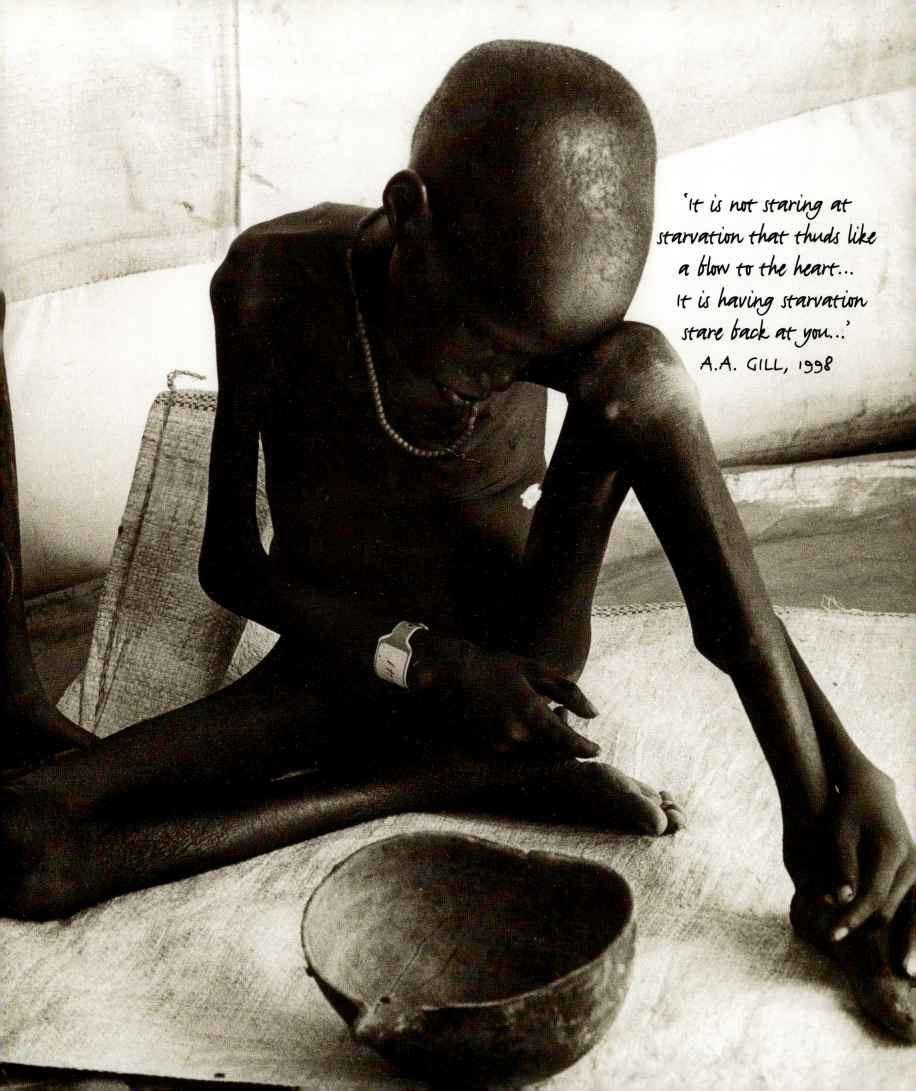

'It is not staring at
starvation that thuds like
a blow to the heart...
It is having starvation
stare back at you...'
A.A. GILL, 1998

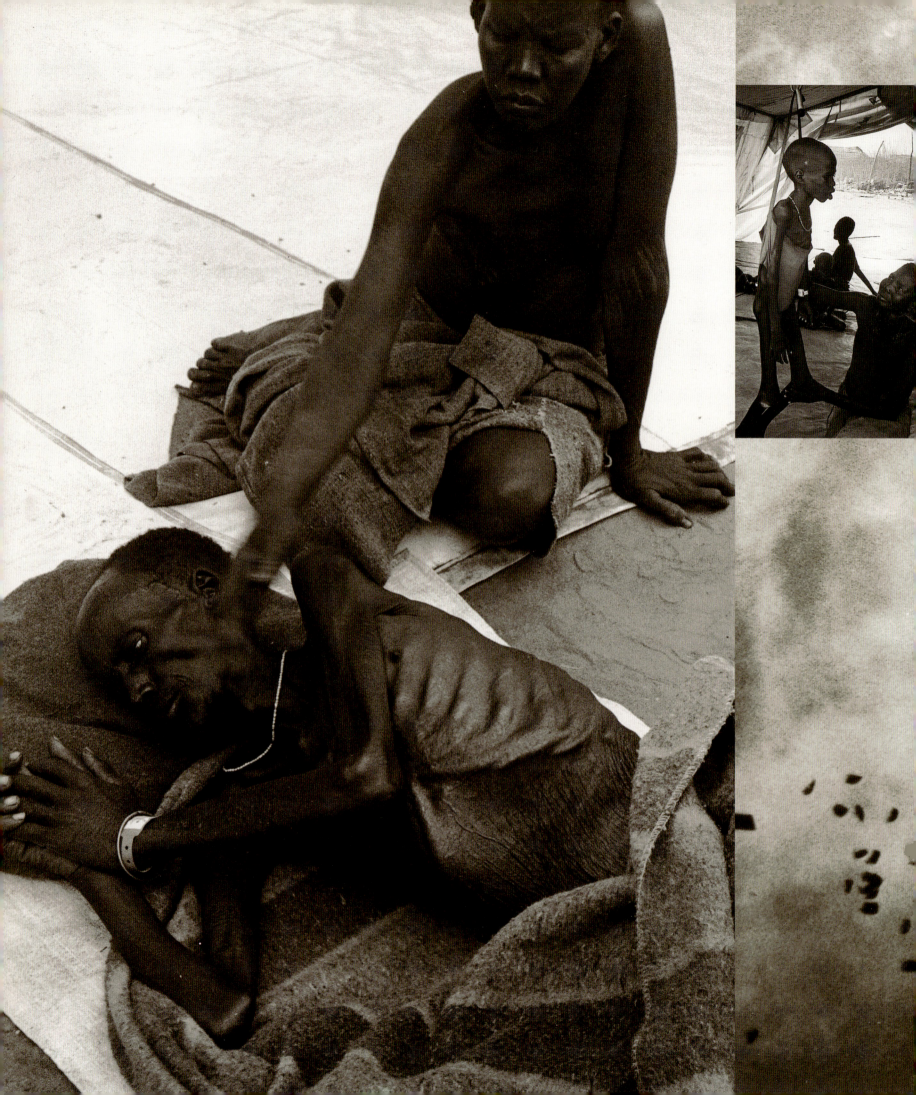

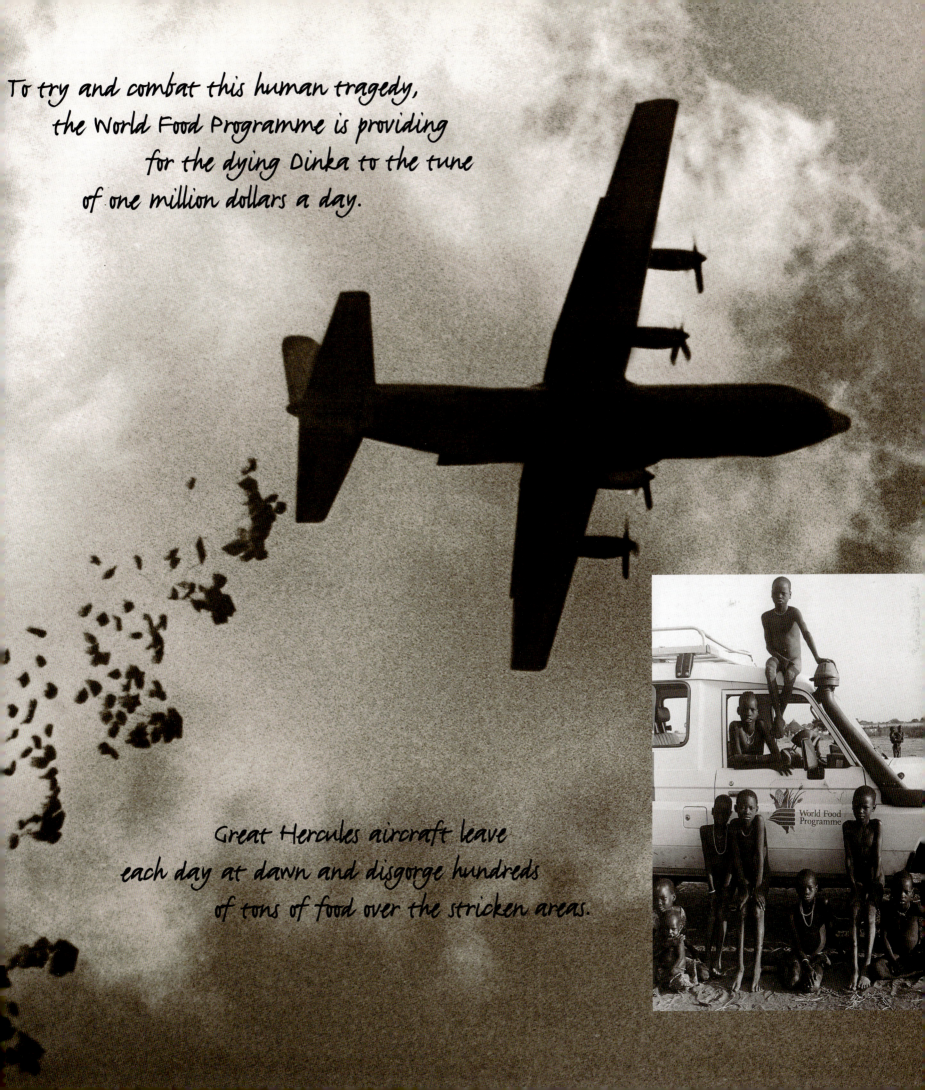

To try and combat this human tragedy,
the World Food Programme is providing
for the dying Dinka to the tune
of one million dollars a day.

Great Hercules aircraft leave
each day at dawn and disgorge hundreds
of tons of food over the stricken areas.

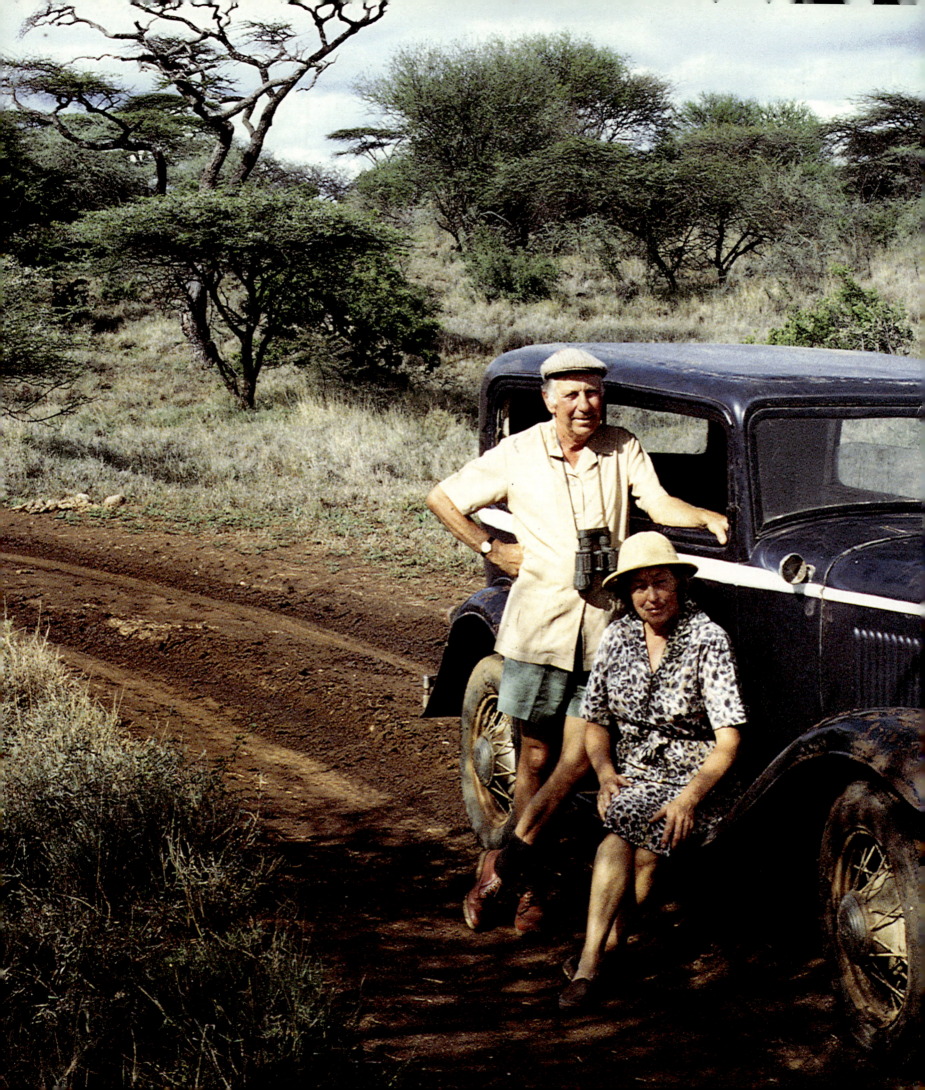

STAYING ON IN AFRICA

Why do they stay? Because most white Kenyans know nowhere else and because Kenya was once the Garden of Eden.

There are those for whom Africa works...

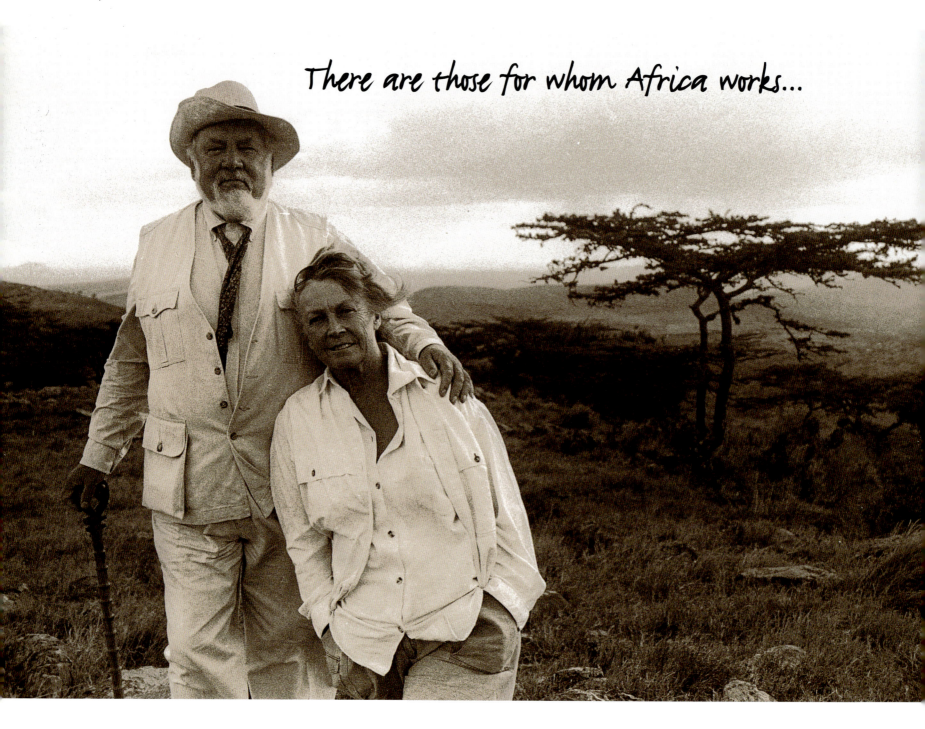

— those for whom it works, it offers a lifestyle unparalleled elsewhere in
the world and more than compensates for the boring inconveniences
they have to deal with on a daily basis.

...and those who become victims of Africa.'

Dick and Diana Hedges were lured to Africa by a slide show of 'such intoxicating beauty' that they were transfixed to the screen and when a shining Combine Harvester appeared, plowing through fields of golden wheat, followed by a gorgeous white girl on a horse with Mount Kenya in the background, they cast their die and have never looked back... 40 years later they admit they have nowhere else to go...

'We're not owners here, Karen,
we're just passing through...'

Denys Finch-Hatton to Karen Blixen in Out of Africa – 1935

THERE ARE THOSE for whom Africa works and those who either outgrow it or become victims of it. I outgrew it and as the new Africa emerges I no longer have any affinity with it. Its human intercourse has not sufficiently adjusted for me to feel at one with it again. Now, I feel it is much like living in the jungle surrounded by hungry animals watching you and waiting to snatch something from you the moment your back is turned or you let down your guard. It reminds me of the time I spent in the Amboseli National Park when I was working on *Vanishing Africa*. I had set up my tent, and without thinking went off to scout the area. When I returned the monkeys and the baboons from the nearby trees had descended on my camp and ransacked it, taking all the food that was not tightly locked away, tearing up the bedding and upsetting the fuel and water containers.

The imbalance between the whites and the blacks, between those who have and those who have not, in today's Africa has an uncanny similarity with this little incident in the park. You have to be perpetually vigilant and can no longer rely on or trust any one person. I am saddened by this state of affairs, for it underlines the growing fundamental impossibility of establishing any human interaction where such disparity of lifestyle exists. There are, of course, exceptions, but these are few and far between.

Those whites for whom Africa works are unfazed by the changing times and attitudes. In Kenya, the lifestyle Africa offers them is different from almost anywhere in the world and more than compensates for the boring inconveniences they have to deal with on a daily basis. Their interaction with the locals, though respectful and friendly, still retains the old master-servant flavour of before, and there is little doubt who calls the tunes they dance to. This is perhaps why Kenya has, until recently, retained the aura of Shangri La it is reknowned for, and for those who for better or worse have cast their lot with the shaky country, there is no question of another life. They refuse to face the evidence of the growing population explosion, maintaining their blind belief that the present situation is a transitory passage, and they keep going. I am not so optimistic, unless as George Adamson said, 'Nature will find a way to deal with it and it will not be pleasant.'

I have basically always liked the Africans and got on well with them, deluding myself that because I have grown up among them, there existed an affinity between us; that I had somehow established a more meaningful relationship with them than that of master and servant, a status I had for many years abhorred and from which I had, for a long time, attempted to distance myself. I had wanted to try and relate to the people in my employ primarily as human beings like myself, not necessarily only as employees. I aimed at establishing respect and friendship, not fear, in daily interaction, to convey a sense of family between myself and them. This made for a seemingly easy-going inter-dependence between us. I wanted them to feel that I was there for them and hoped that in return they were there for me, but to my deep regret, over the past decade, I began to realise that this was but an illusion. After all these years in Africa, time and again, I still got shafted by their cunning, deceptive manipulations, just as if I was virgin to the country. I finally had to recognise and accept that I was still dealing with the very basic primal instincts of survival, in a world where my position and my white skin automatically made me a target.

We were not a family at all; we were opponents on either side of a chasm, in a disparate world, in a now corrupt and lawless community where the more crafty survive. Just like in the jungle. My mother used to say, 'In Africa the whites are an army of occupation, to be tolerated but never accepted.' I always rejected this notion, but now after much deliberation I, too, have to adopt it. What is so distressing is that we are ultimately responsible for this state of affairs and they, not us, will be the losers.

The convenience of servants always carried with it an uneasiness I never felt totally comfortable with; what right had we, more fortunate than they, to pull rank and discharge on them the menial tasks we did not want to do ourselves. And yet we always did and still do; it is part of the colonial inheritance, a silent, unquestioned understanding that existed since the beginnings of human interactions; it is second nature to the domination of the species. I was part of the colonial equation like the rest of them, but deep inside I always resented it. 'Teach the Africans to want,' Cecil Rhodes had once said when he opened up Rhodesia for British Empire exploitation and sowed the seeds of what is happening in Africa today; we are now at the receiving end. It is the reverse of the coin, the natural revenge of an exploited hungry people who, some might say, have finally seen the light. It took me years of passionate living, much observation, denial and delusion to finally accept it.

The growing pains of a new nation are dire – the ensuing chaos and confusion, the crime and lawlessness, the greed, the bribery and corruption at all levels, the senseless wildlife killings, the environmental destruction, the mindless power games, the hopeless destitution and hunger, the lack of concern and forward thinking, are the evidence of dangerous ignorance and a too-rapid

race towards self fulfillment, in a people who are running before they have properly learned to walk.

The outrageous greed and disregard for anything and anyone other than themselves and their immediate families in the top ranks of governments, have created a financial drain the countries that filters down and affects whole populations in varying degrees, threatening the fragile infrastrucure of the land. All those, without exception, who have somehow attained a position of command and authority, however humble, have but one idea in mind, to emulate the example set by the head of state – to milk their positions for all they are worth, for as long as it lasts. Because finances are siphoned off to Swiss bank accounts, salaries are so low they need topping up by whatever means. As a consequence bribery and corruption at every level is the only option. The police force and judiciary, the ministers, the administrators, the teachers, the doctors and the heads of government divisions, extract whatever they can, by fair means or foul, under the guise of their uniforms and titles, while the country collapses and the masses starve.

Those who fall by the wayside become part of the hordes of faceless destitution that moves into the urban centres in ever-increasing waves, searching for employment that does not exist. Their pathetic attempts to eke out a living as best they can, through barter, create the sprawling shanty towns which hang like ever-expanding cobwebs on the periphery of the towns. Cobweb constructions of recyled nylon sheets, gunny bags, corrugated iron, cardboard boxes and discarded wooden cases, ingeniously held together with wire and nails and steel bars. From within these structures every imaginable item is for sale, all prices are negotiable. Africans are a market people and the art of barter is second nature to them. Many have learned skills from contact with the white man and are able to rise slightly above the average street hawker; they provide for the European and affluent African community. Simple wooden and rattan furniture, nursery plants, garden equipment and pottery are displayed along the roads beside heaps of fruits and vegetables, chickens, ducks and turkeys and fire logs. For those less fortunate, abject poverty and hunger and the basic primitive instincts of survival drives them into crime, prostitution and drugs. Is this, I wondered, part and parcel of the natural evolution of a species or does the finger point once more at us? For many years, as a white African, I have ruminated over this dilemma, I have grappled with the contradictions that have confronted me and finally concluded, as Karen Blixen once did herself, that 'in Africa, God and the Devil are one'.

On one of my last trips to Kenya to pack and ship out my belongings, I shared some farewell moments with people I had grown up with, whose offspring had become my friends and fans, and who all still live much as they have always done, in lovely homes surrounded by lush gardens, with servants, dogs, Landcruisers, light aircraft and safari adventures in the bush, living the lifestyle of the white settler more or less as they have always done. Their roots have sunk deep into the African soil, some two and three generations deep; they have grown used to and adapted to the Africa of today. Their children grow up tough and fearless, with an obsessive love of the outdoors and a deep regard for nature. Their women are strong and able to cope in all circumstances. They have little regard for the more frivolous factors of the first world; things like fashion, stylish interiors, expensive furniture and paintings, manicures and hairdressers.

It is the very rawness of Africa that attracts certain kinds of people, they are either crushed by it or find something deep inside their souls that responds to the grandeur and the untamed tangible beauty; the wild raw place where you still hear leopard barking in the bush outside your home and still have your personal *askari* wrapped in a blanket or a cast-off army greatcoat, carrying a spear and a torch who comes to greet you when you arrive home, opens the door of your vehicle and flash-lights you to your front door. Who sits outside in the cold darkness, sometimes in the rain, fighting somnolence, to guard you from night intruders, always smiling and uncomplaining, in exchange for a few hundred shillings a month. Where the unquestioning domestic staff, always smiling and uncomplaining, bring you tea on a tray in the morning, cook your food, wash and iron your clothes, scrub your house and tend the lawns and flowers in your garden. The care and patience with which they understand and tend to children and old people is without equal in the world. I remember making a point of returning to Kenya for the birth of my first child, Marina, because I knew I would find there the smiling good-natured help and support I would be hard pressed to find elsewhere. I watched them deal with my parents when they grew old and crotchety, with such admirable self-effacing tolerance and respect. Gentle, soft spoken and servile, their life and family depend totally on your employ and good graces, their loyalty and servitude is dictated solely by need and then sometimes, either out of dire necessity or foolish greed, they transgress into theft and are instantly liquidated, cast out and made redundant. Others resort to violence and attack, hi-jacking cars at gun point, putting a bullet in your head if necessary, sometimes hacking you to death, if there is no alternative.

'It is the combination of beauty and rawness that lures the last romantics,' my friend Francesca Marciano wrote of Kenya in *The Rules of the Wild*. 'To outsiders it seems like the only place left on

earth where you can still play like children pretending to be adults...a place charged with a kind of sexual energy that seems to trigger something in people who normally wouldn't behave with such abandon and a kind of innocent promiscuity...who act like children playing in the Garden of Eden...but such a lifestyle in such a poor country is almost a moral crime, a fact hardly considered by people who have become accustomed to it and to the acceptance that misfortune may one day come to them...they pay a price...they have become displaced persons everywhere.'

Many of them, resolute, stubborn and hard-working, live off large tracts of land, either as cattle ranchers, wheat growers, horticulturists or floriculturists, others as safari guides or consultants to aid organisations. A special breed of people, those for whom Africa has worked, who have chosen to live on the edge, in a country of extremes, where life and death walk hand in hand, who are not crushed or frightened by the lurking violence and seem to thrive on the danger and the unexpected. People who want and need freedom more than anything, who have broken with convention, who refuse the shackles of the industrialised world and in exchange are now prepared to live behind the barred windows and locked gates of their homes, with self-imposed curfews, armed guards, fierce dogs and security alarm bells, and the very real threat of attack that sometimes leads to death. So entrenched are they in the seductive easy-going lifestyle of servants, balmy weather and social freedom, devoid of restrictions of any kind, they cannot imagine living anywhere else. Some like my brother Dorian simply have no other choice. They are a resilient lot who, unlike me, are prepared to confront, solve, or resolve any controversy that poses a threat to their easy lifestyle. Some rely on the ever-ready sundowner at night to numb their insecurities and help them slip into oblivion so that they can face the next day without having to face themselves. It is telling to note how many whites who live in Africa turn to drink. There must be a reason for that. This is not white man's country.

The photographs I took of some of them coupled with their very individual stories, bear witness to their originality, their off-beat character, and the spirit of adventure and daring with which they wove themselves into the fabric of the country, which, for better or for worse, created a legendary world still being written today. They are known as the Stayers-on.

Growing into an ever-larger circle alongside them are the NAA, the New Affluent Africans, who preen themselves in the image of their white predecessors, casting off, like old clothes that no longer fit them, their African-ness. Educated in expensive schools abroad, speaking pukkah English, dressed to the nines in Armani clothes, they play golf on the rolling lawns of the ex-colonial golf clubs and polo on feisty horses; they dine and dance and mingle with nonchalance and ease in places where a few decades ago they were segregated. They are known as the *Wa-Benzi*, owners of a Mercedes Benz, although many now travel in the latest shiny Range Rovers and some even in helicopters. Intelligent, well-spoken and totally charming, they are a new breed of Africans – lawyers, doctors, bankers, businessmen and sons of government ministers – who may one day become the new leaders of the crumbling nations. If they have learned from the mistakes and sins of their fathers they could one day represent the hope of African salvation and rebirth. It is still too soon to tell. The veneer is still only skin deep. Interestingly all but one refused to let me photograph them or tell me their stories. Are they hiding some transgressions they do not wish made public, I wondered?

It has now become too much for me to handle. I am perhaps tired of fighting Africa. I can understand it, I don't want to defend the white man's role, but I cannot condone what is happening to Africa. I don't want to live with it, so I can but move away and try to forget, or rather remember only what once was. I must distance myself so that I can retain the memory that gave birth to my love affair. Africa no longer sings to me.

Marina's letter, written on one of her last returns to Kenya in 1985, shortly after my parents died, reflected my own presentiments; her intuition and concise assessment of her own predicament, yet again uncannily echoed my own.

My darling Ma,

Home at last and it feels so good again. The minute I stepped off the plane into the African dawn, the experience was an emotional one. Ian came to pick me up at the airport, we spent the morning in Langata, saw the children before they went off to school, had a wonderful old Kenya breakfast and lunch at the old French Cultural Center in town. Nairobi has changed so much I feel quite a stranger. There are so many more Africans in the streets I am overwhelmed. Plenty of smooth young blacks with Rasta hair, tight pants and platform shoes who look at me with suave glances I have never seen before. Everywhere there are scaffolds making progress ever higher as the new Africa surges forth. It is quite astonishing.

We flew to the farm in Ian's plane, keeping low over the watery plains. There has been a lot of rain again and all is green over the crags and steam jets of Hell's Gate, across the lake and down onto the landing strip. It felt so good to be back, to smell the smoke from the night-watchman's fire, the damp earth and

the trees. Last night I slept in your room. All the familiar sights and sounds kept me awake, and then I heard a strange new sound I had never heard before. The moon was full and it was very light outside. From the terrace in front of your room at the top of the house, I watched two hippos coming up the winding steps leading to the front entrance of the house. Breathing heavily they crushed the flowers in their path and moved across the elevated terrace lawn, cropping the grass beside the verandah where we ate our meals.

This morning I followed their footprints down the path, over Mami and Papi's grave and into the lake. This must be the first time in nearly 50 years they have come up to the house. It is silent and safe for them now.

The house and garden have lost nearly all their original pomp and splendour, but like some aged, still beautiful queen, the bone structure remains good. Slowy it is mellowing down and becoming an integral part of Africa, lovely as ever.

The house is clean and well looked after by Mweru but it feels so big and empty now. At every turn Mami and Papi are there, vividly haunting, yet comforting and laughing. It makes me so sad. I walk around the house like a stranger, so full of memories and no matter how much painting and scrubbing has been done, they are both still very much present.

It led me to think a lot. About how this was their dream, their house, their time and place, their little kingdom. They created it to live and play in, in the way of their ancestors, running away from a world whose changes they could not or did not want to face, to Africa, one of the last strongholds of the patrician spirit, of the masters instead of the servants.

And about us, how painful and confusing these last few years have been. We, the children of the future, with no future ahead of us, unsure as to where we belong, eternally hankering to get back to something that is no more, just a beautiful, happy dreamlike memory that will never leave our hearts...we are strangers wherever we go, because Naivasha is where we belong.

Being back has put many things into perspective for me. I used to think it was Kenya I loved and in Kenya I belonged; that after the gruelling years abroad, I would return with all my foreign sophisticated knowledge, to help build up this new nation. But now I realise that it was all a childish dream, born of a need to identify with something. A dream to give me courage as I grope to understand and to relate to worlds and civilisations that seem so hard and foreign. Now I know that it is really Naivasha that I yearned for; this house, the farm, the lake, the hills, trees and animals, the love of my family, so proud and strong and gracious. Everything Naivasha ever stood for; a way

of life that is no more. All I can now do is look at the changes – bushes come down and go up again, it's all just part of life and change – in ten years it will be different again.

In a way we, the third generation are all victims of our grandparents' flight, for now the modern world where all men are to be equal is closing in around us and there is nowhere left to run. We were Roccos and Naivasha made us special. Now the Navaisha we knew is gone, but the feeling remains to give us strength as we seek new horizons.

It is painful, yes; all the more painful because we so love what we leave behind and have a lot to miss. What is past is past, however, and now we must think of the present and look to the future. Our black neighbours could not be more fitting to our thoughts, not one thing is being done to the farm, except for grazing all the grass to the roots, the only income is from makaa (charcoal), as the trees Papi planted are cut down everywhere. Thank God Ma and Pa never saw that. The Africans have now more money in the banks than all of us put together and not one cent is spent on the land.

Everyone asks about you and misses you, but don't come back, there is really nothing for you now and you must think of your future as I must do.

Love, Marina

I always kept this letter of Marina's. Its content and the sentiment it was written with are so like my own. Rereading it after almost fifteen years engulfs me with her emotions and the sense of loss made more poignant by her premature death and my own responsibility in it. Now 15 years later, my decision to leave finally feels right. It has been a long discourse with myself but in the end, just like Marina did, I have evolved away from Africa. My love affair died of natural causes. I have no pain, no remorse, no longing, just the quiet knowledge that it is time to go. Nothing lasts forever. I have had the very best of Africa, and feel fortunate to have been able live it as I did. I don't want to be part of all the ugliness or become one of those embittered ex-colonials who have no regard for the people, and can only look back in anger or regret at the good old times. I'd rather leave the table before I burst.

We buried Marina's ashes on a promontory looking out to sea at the end of the rambling tropical garden that surrounds the home I built with Lorenzo thirty years ago on the Kenya coast. We laid her to rest in the land where she was born beside the sea where she played with us as she was growing up. It seemed like a fitting close to my singular life as a photographer of Africa.

Top left: Breakfast with Jock and Daisy.
Above: Betty Leslie Melville with the Rothschild
giraffe on the lawn of AIFEW in Nairobi.

Top: Lady Pam Scott
Top right: Beryl Markham
Right: Bunny and Jerry Alan

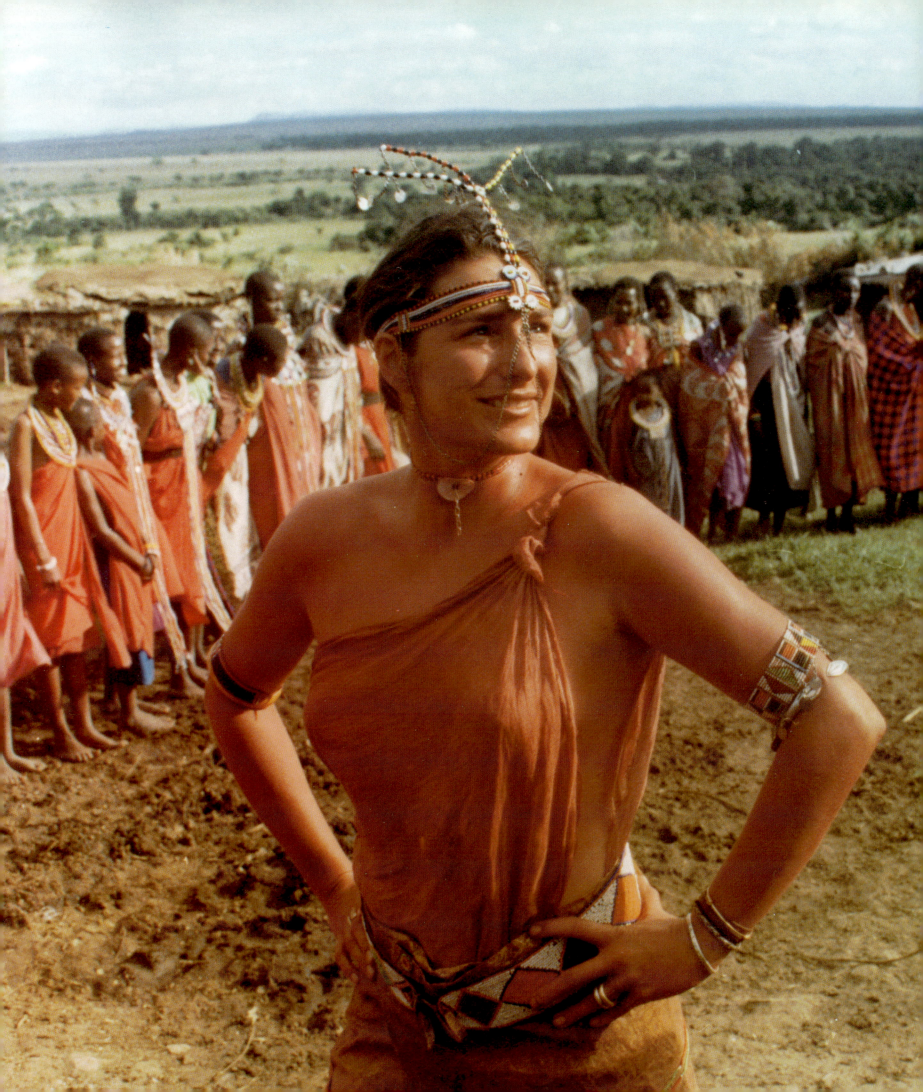

CAROLINE ROUMEGEURE

When Caroline Roumegeure was four years old her eccentric mother Jacqueline, fell in love with a beautiful young Maasai warrior. She divorced her husband and went to live with her new lover in his *manyatta* (village) with her three small children in tow. They married soon after in a Maasai ceremony, blessed with cows' milk and blood. Caroline and her siblings grew up among the Maasai and integrated totally with her new family which grew larger as five more wives and 26 children were added. When she was l6 her mother shipped her off to Paris to finish her studies. Today, 30 years later, Carolyn considers herself a French Maasai woman with strong affinities on both sides – metamorphosing into a Maasai woman when she lives in her mud and wattle hut in the Mara Game Reserve where she makes exotic necklaces and belts from rare beads. When in Paris she is a much sought-after social animal, flirting with and seducing all who gather around her. With the profits from her ethnic jewellery she has bought a light aircraft she uses to visit the tourist lodges in the Mara, selling her wares to rich visitors. But she is a creature trapped between two worlds and reminds me sometimes of a beautiful dhow without a rudder.

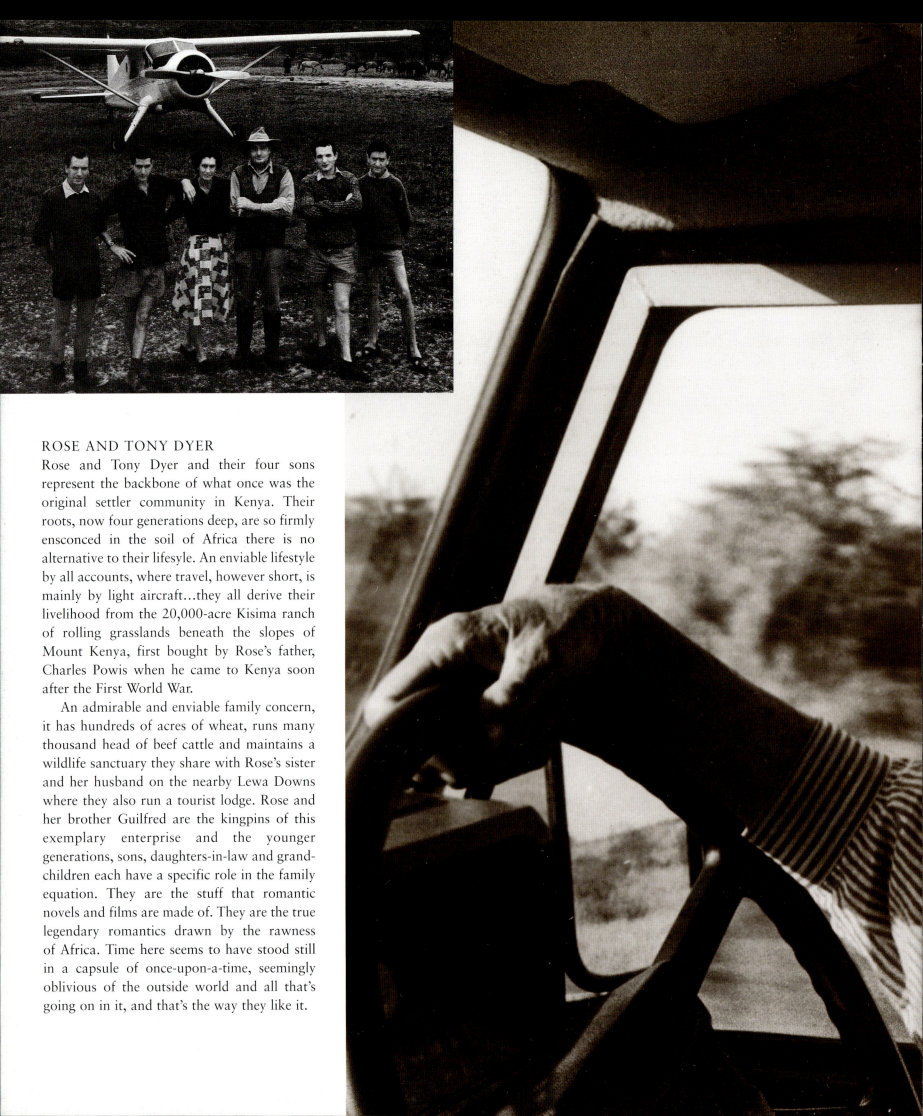

ROSE AND TONY DYER

Rose and Tony Dyer and their four sons represent the backbone of what once was the original settler community in Kenya. Their roots, now four generations deep, are so firmly ensconced in the soil of Africa there is no alternative to their lifesyle. An enviable lifestyle by all accounts, where travel, however short, is mainly by light aircraft…they all derive their livelihood from the 20,000-acre Kisima ranch of rolling grasslands beneath the slopes of Mount Kenya, first bought by Rose's father, Charles Powis when he came to Kenya soon after the First World War.

An admirable and enviable family concern, it has hundreds of acres of wheat, runs many thousand head of beef cattle and maintains a wildlife sanctuary they share with Rose's sister and her husband on the nearby Lewa Downs where they also run a tourist lodge. Rose and her brother Guilfred are the kingpins of this exemplary enterprise and the younger generations, sons, daughters-in-law and grand-children each have a specific role in the family equation. They are the stuff that romantic novels and films are made of. They are the true legendary romantics drawn by the rawness of Africa. Time here seems to have stood still in a capsule of once-upon-a-time, seemingly oblivious of the outside world and all that's going on in it, and that's the way they like it.

'Nothing is simple in Africa...

Nothing is permanent even though it may seem timeless...perhaps that is the fatal attraction
so many feel for the continent as they pass through the endless horizons with the glorious
sunrises and sunsets that encompass the splendour and the calamities of each new day...
Africa is incomprehensible...death and devastation, famine, corruption and wars evaporate
like the visitations of the plague, she remains unfathomable, unaffected, the Dark Continent,
the primordial past...yet everyone of us once had an African ancestor, for Africa is the cradle
of humanity, that much now seems beyond doubt.'

ALAN DONOVAN
Passing Through Africa – 1999

JUNE AND HANS ZWAGER

With 300 irrigated acres of flowers spreading California-style up the former arid land, where once only wild game roamed among the pale green leleshwa bushes, the 10,000-acre Oserian ranch stretches from the shores of Lake Naivasha to the misty Mau range in Kenya's Rift Valley. June and Hans Zwager, the owners of the ranch have turned this piece of Africa into the agricultural showcase of her eastern rim and with the 250 million blooms they produce each year are the largest flower exporters in the world. Hundreds of boxes of freshly cut roses, statis, carnations and lilies leave five times a week for Holland and the UK on their privately owned 707 to be sold the following morning on the streets of leading European capitals.

As citizens of Kenya June and Hans Zwager have sought new ways of identifying their famous Oserian home with the brave new world in the independent Kenya, once the playground of the rich and infamous. Surrounded by their three children and seven grandchildren, the Zwagers adapted the Djinn Palace, formerly the abode of the murdered Earl of Erroll and his glamorous mistress Diana Delamere, to their family needs. The Djinn Palace, a grand Moorish-style building overlooking Lake Naivasha became their home and the seat of their floriculture enterprise. As the children grew up and got married, lavish wedding celebrations took place on the lawns, where rose petals carpeted the bridal pathways, flotillas of pelicans floated along the lake edge and great fish eagles, perched in the tops of tall acacia trees, called out their haunting cries in unison. Ochre-smeared Maasai warriors entertained the guests with ritual dances, twirling with the brides and grooms for luck, and wedding breakfasts were served beneath the ancient fig trees, accompanied by the raucus grunts from the hippo in the papyrus swamp below…

'The greatest single factor in the success of any labour-intensive project is the work force.'

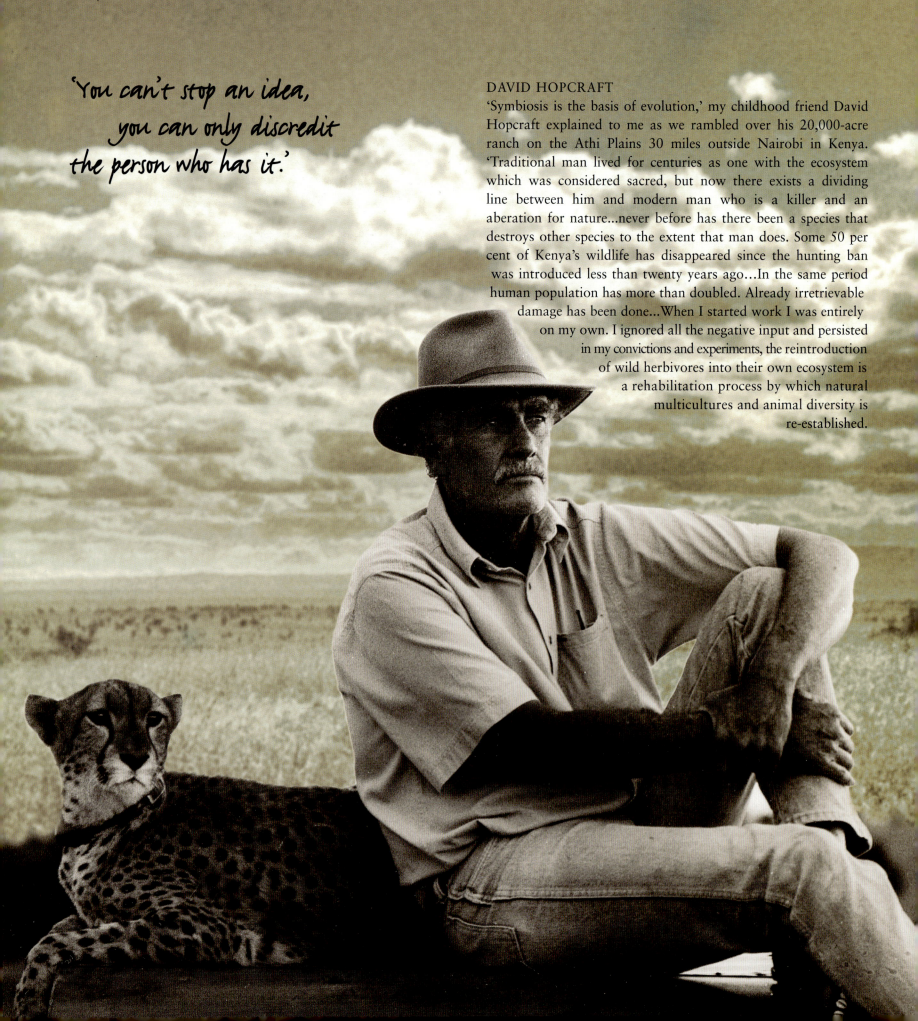

'You can't stop an idea,
you can only discredit
the person who has it.'

DAVID HOPCRAFT

'Symbiosis is the basis of evolution,' my childhood friend David Hopcraft explained to me as we rambled over his 20,000-acre ranch on the Athi Plains 30 miles outside Nairobi in Kenya. 'Traditional man lived for centuries as one with the ecosystem which was considered sacred, but now there exists a dividing line between him and modern man who is a killer and an aberation for nature...never before has there been a species that destroys other species to the extent that man does. Some 50 per cent of Kenya's wildlife has disappeared since the hunting ban was introduced less than twenty years ago...In the same period human population has more than doubled. Already irretrievable damage has been done...When I started work I was entirely on my own. I ignored all the negative input and persisted in my convictions and experiments, the reintroduction of wild herbivores into their own ecosystem is a rehabilitation process by which natural multicultures and animal diversity is re-established.

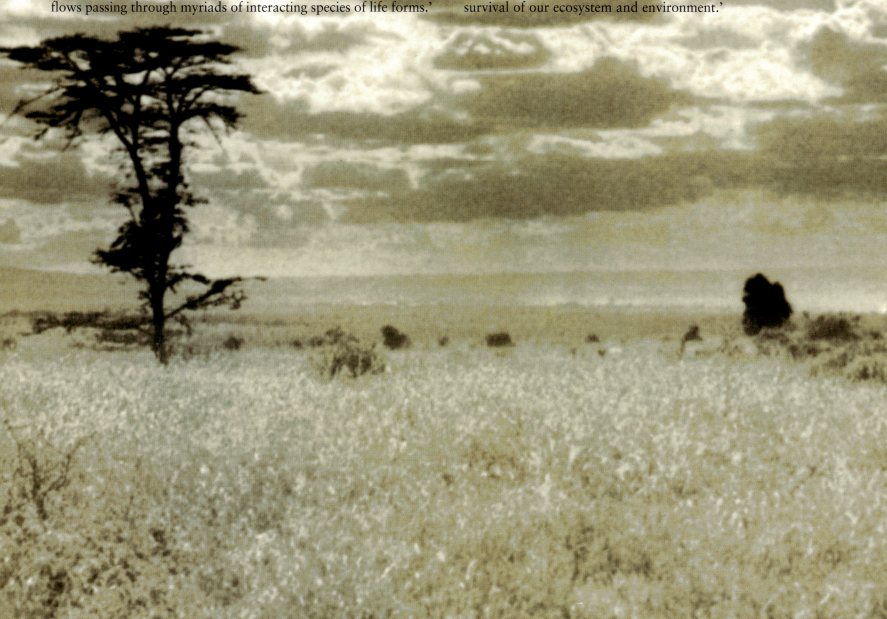

Each animal eats a specific vegetation, whose growth is often accelerated through hormones from the saliva. Food chains are reconstructed allowing diverse species of fauna and flora to flourish...By mixing a large variety of species, the whole vegetation spectrum is utilised – from the treetops with giraffe, the higher bush with eland and kudu and gerenuk, the lower bush with gazelles and impala, the grass itself with both the stem and the leaf-eaters like buffalo, zebra and wildebeeste, the smaller shoots and leaves with duiker and dikdik and the seeds with the ostrich and other game birds...this is an important part of nature's technology...ecosystems are like giant computers with energy flows passing through myriads of interacting species of life forms.'

It took many of the big cattle ranchers almost twenty years to finally understand and accept the necessity of implementing David's theories. They have now elected him chief executive of the National Wildlife Forum of Landowners set up for all those who wish to work with, manage and benefit from Africa's miraculous wildlife ecosystems. David's ranch is now living proof of his theory: 'when left alone, nature bounces back to heal itself and when properly protected, animals and birds multiply so quickly they have to be culled. Sentimentalist who do not see this are the truly efficient foes of conservation...the truth is that Nature is a harsh mother, but only she holds the keys to the rehabilitation and survival of our ecosystem and environment.'

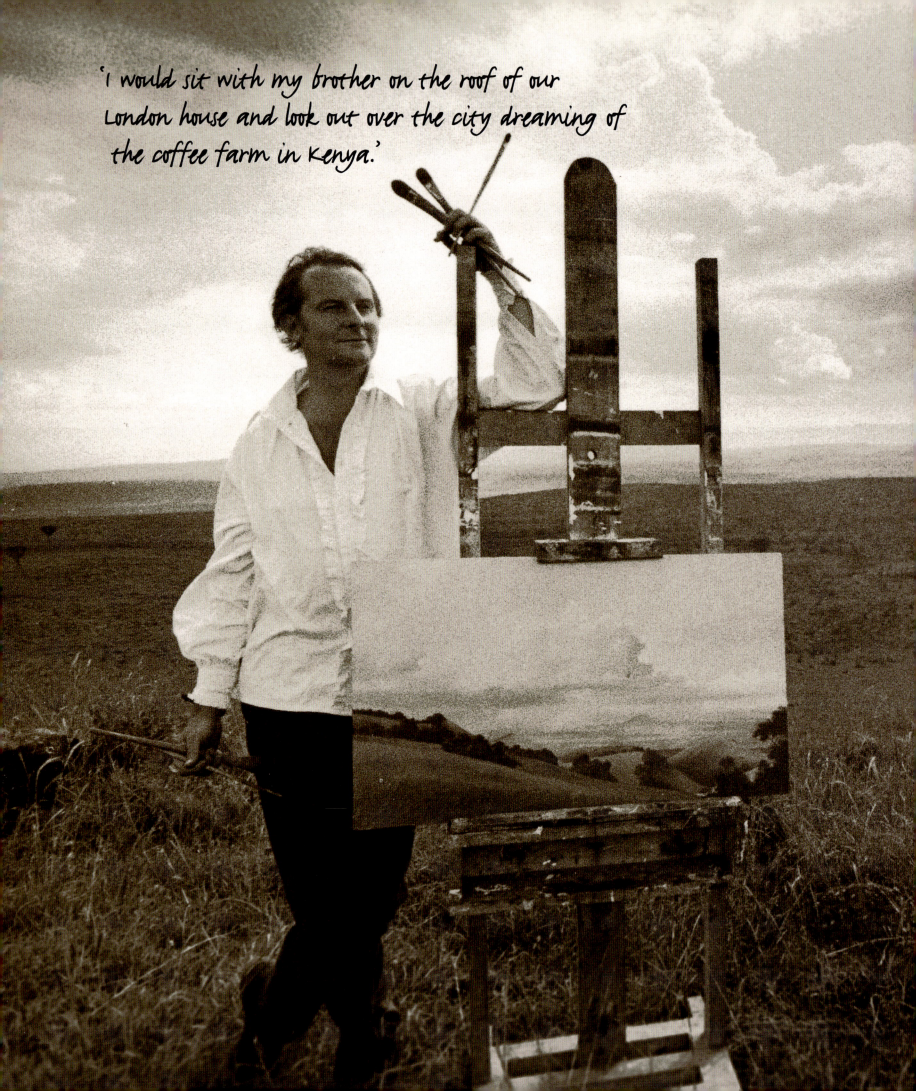

'I would sit with my brother on the roof of our London house and look out over the city dreaming of the coffee farm in Kenya.'

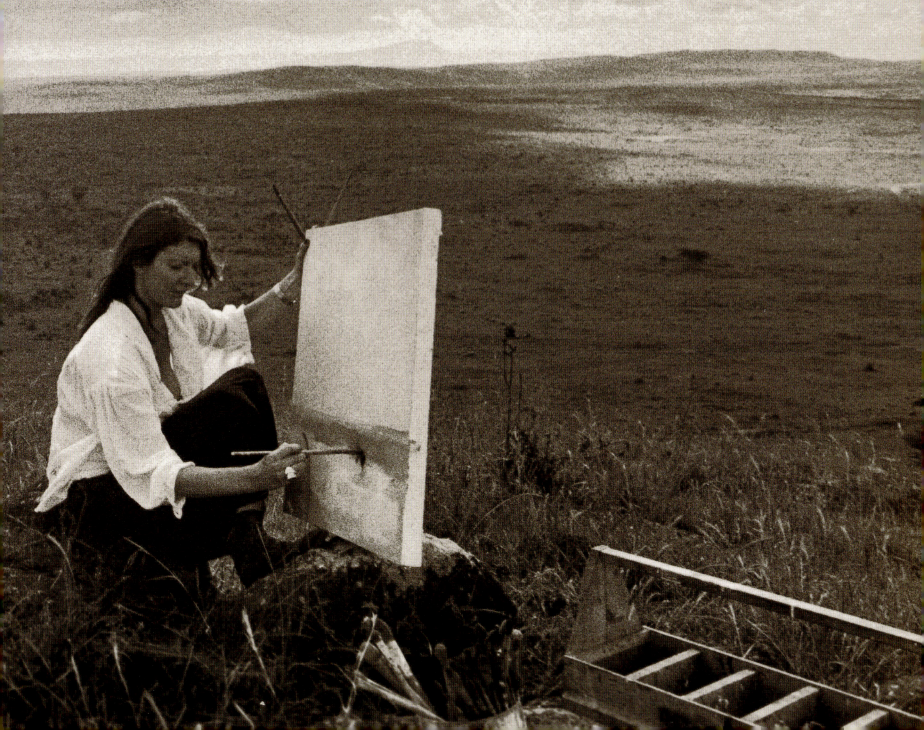

'I only like to paint
in Africa'

DAVID MARRIAN

David Marrian is the youngest of three siblings born in Kenya and he has returned to make a life in Africa as an artist. At the age of l0 he was transferred from a coffee farm facing Mount Kenya to the streets of Kensington in London. 'Our favourite pastime was collecting Kirby grips off the pavements. I suppose it was our response to the First World, coming from Kenya where everything is recycled; we were getting something for free...it replaced picking up shells on the beach...'

PHILIPPA LUMSDEN

'There is more freedom here. In Europe I feel hemmed in and don't feel the excitement and rawness of Africa. I love the dry stark desert areas...the light of the desert is the same everywhere...I can't imagine living anywhere else but Kenya. I have always been a loner...the most important thing in my life is my work...I have had no urge to have children...it all seems like such an invasion of my privacy, like havng huge chunks bitten out of my life.'

(David and Philippa, both second-generation Kenyans were married in 1999)

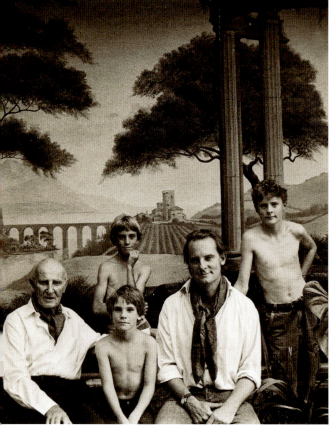

Philippa, with her grandmother Ilsa, who came to Kenya in the twenties, her mother and her stepfather in the garden of the house they built soon after arriving in Nairobi.

Three generation of Marrians, Peter on the left, David and his three sons in front of one of David's paintings of a Tuscan scene.

AN INTERVIEW WITH RICHARD LEAKEY

'I am absolutely certain that in Kenya, wildlife will ultimately be confined to areas either set aside for it by the government and national parks or in private lands where the owner particularly wants to keep wildlife. Wildlife everywhere, as we once knew it, will be gone in a decade. The human population is going to take over all corners of this land except in areas where government and private policy prevent it. I think that if you are living in poverty...the last thing hungry people want is another bush pig or baboon let alone an elephant. When we were young, elephants used to walk across the farms, the farms were big and there were few people, but now the issues are very different; there are many small farms and many more people. They destroy peoples' livelihoods and so have to be shot...

The situation in 1989 when I took charge of the Wildlife Services was pretty dire and I had to put down some draconian rules, but it was already much better when I was replaced in 1994. It deteriorated again after I left but when I was re-instated in 1998 it was nevertheless way ahead of where it had been when I first took office in 1989. There has been a lot of consolidation and I think that in this next term we can put a lot in place and I do believe that unlike many African countries, Kenya will manage to retain its large national parks. The biggest problem was that we ran out of money due to bad management, but we now have a new management team in place, it is like a corporation, everything hinges on management. I am optimistic that if we can create a system that is sufficiently rooted so that a team can run it, as long as they are protected from interference, everything will be all right. We need to establish a tradition of strong leadership.

I come from a high-energy family – both my parents were very strong people working under very arduous conditions; I grew up under these conditions and energy is genetic. My family was originally missionaries and established a very strong affinity with the Africans. My father thought of himself as a Kikuyu; he thought as a Kikuyu, he would talk in his sleep in Kikuyu and when, as children we would awaken him, he would call out in Kikuyu not English. His subconscious thinking was in Kikuyu and I think that was a reflection of his childhood. We are subsequently very rooted in Africa.

I am optimistic about the long-term future of Kenya – I think that as each generation comes through there will be less and less need to be corrupt. There are many good families already today, many middle-income families who don't need to make money on the side. They will inherit houses and farms and many of them are already beginning to think like they did in Europe and America, asking themselves what they can do for their country. There will

be honest people going back to teaching. I have no doubt that we are going to have to fight for this, but I don't think the present is a permanent condition.

Wildlife is no longer being affected by corruption, but by lack of resources; poaching is not corruption, it is lack of resources. There are many people in north-eastern Kenya who are desperately poor, the resource base is appalling; a lot of young men in northern Kenya along the Somali border have got access to weapons and have spread through many parts of Kenya. They have found that stock-raiding, shop-raiding, holding up vehicles and tourists at gunpoint is quite lucrative business. They have got away with it, but now we at KWS are showing them that we can stop them, arrest them, and recover stolen goods. We can stop these problems but in the long-term we have to think of addressing poverty. These problems exist because of poverty. If we can bring development back to this country we can create some programmes of support for these people; if we can get Somalia working again...

As the country evolves one would expect to see new leadership emerging, young, bright intellectual people who will take the country into the next age. But for now there is still a lot of corruption at high levels. We must not forget where we are coming from; we're coming from colonialism, the Cold War, the liberation of Eastern Europe. This country has been cast in a mould, it has to restore itself, there has to be a renaissance...'

'So why do so many people dislike you?'
I really don't know. I think I am a very likeable person, I'm fairly outspoken, fairly direct. I am not a social animal. I usually do what I do because I want to do it. I'm not very flexible, some people leave their mother's womb with the purpose to be liked, others have different purposes; mine was to be effective...it is difficult to achieve both...Maybe it's because I was ill for most of my public life, I felt I was short of time...maybe because I had famous parents...I've always been very single-minded.... I've tried to be fairly compassionate, to be fairly generous within my means as an individual, fairly sincere and I don't think my integrity has been dented...

For the future...hopefully we will not always have to depend on outside funding...I am trying to wean the Kenya Wildlife Service (KWS) from any foreign support...because it is essential that KWS stand on its own feet...I hope that soon KWS will not need any foreign support and will be fully self-supporting, through sales of game park tickets, leases on lodge sites and campsites. What we need is management and I think we can create management that will function without me – big corporations have strong leadership that eventually institutionalised them; there is no reason why we can't do the same.'

RICHARD LEAKEY – 1999

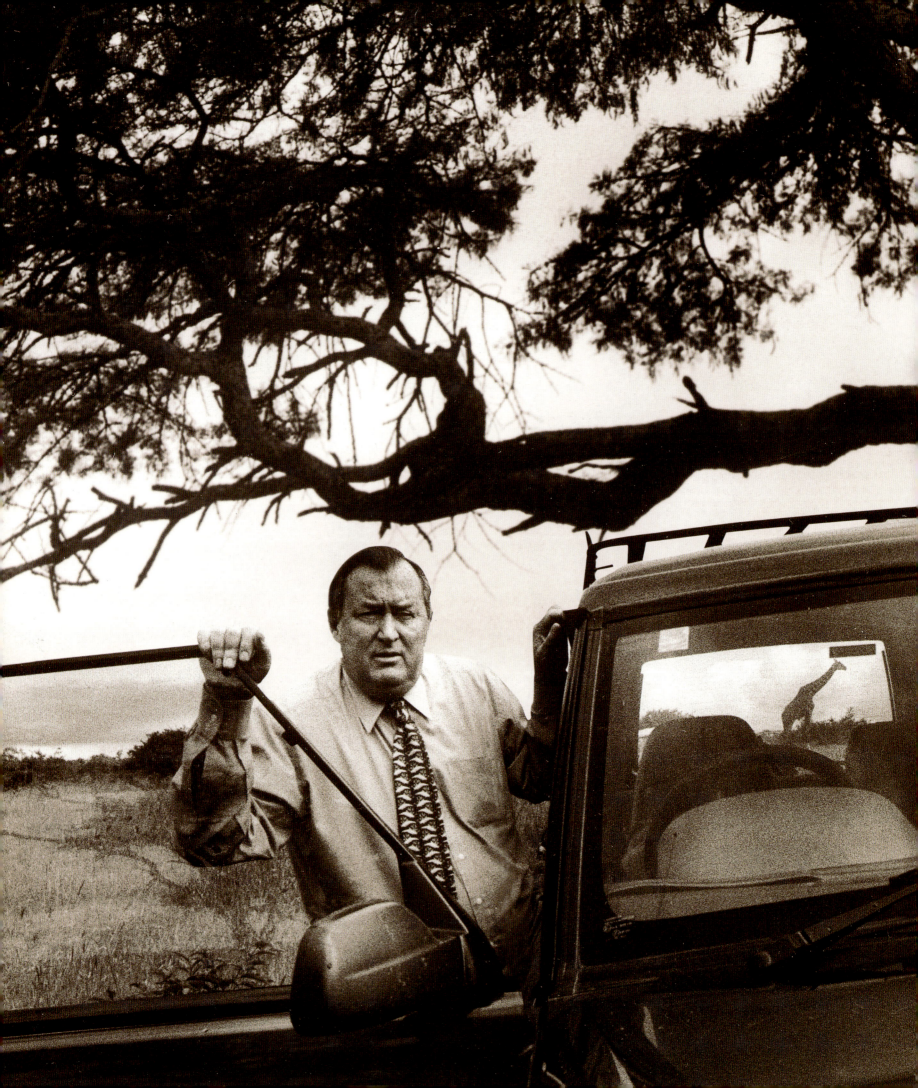

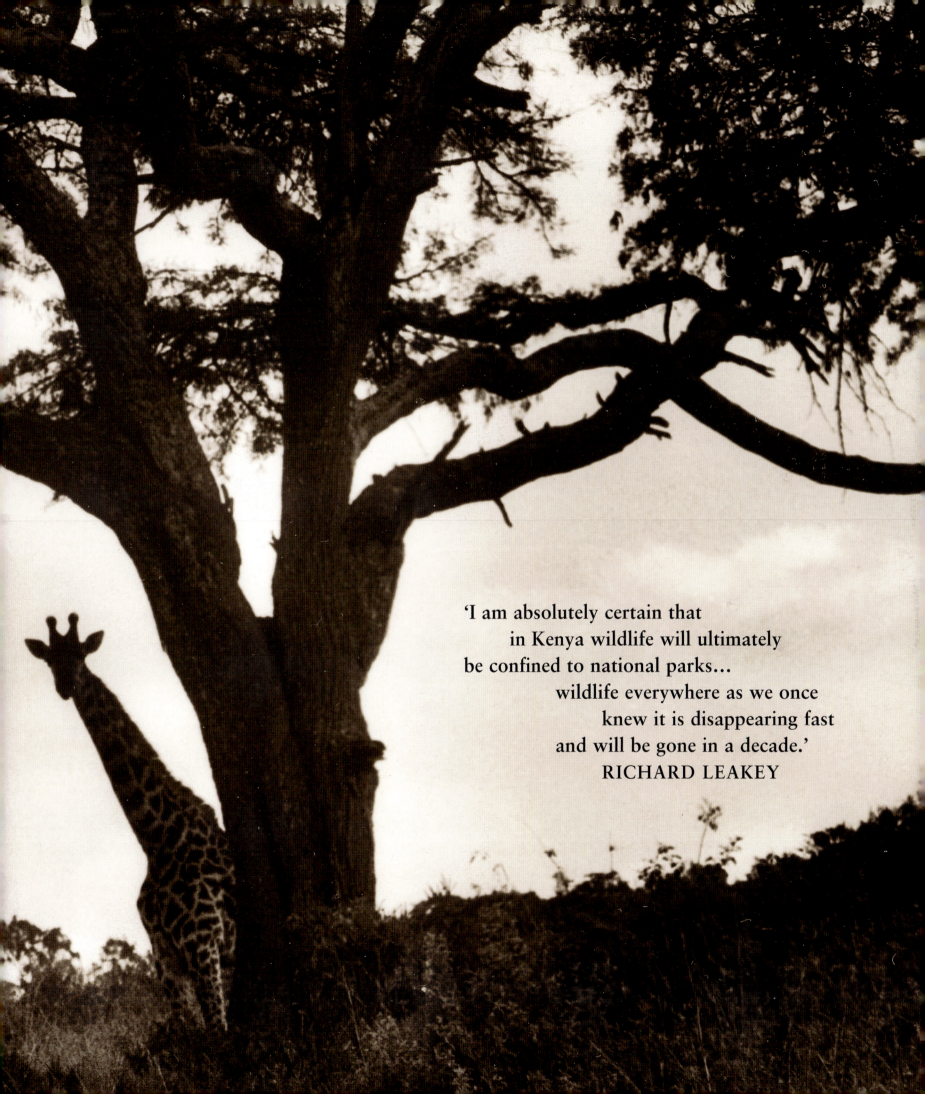

'I am absolutely certain that
 in Kenya wildlife will ultimately
be confined to national parks...
 wildlife everywhere as we once
 knew it is disappearing fast
 and will be gone in a decade.'
RICHARD LEAKEY

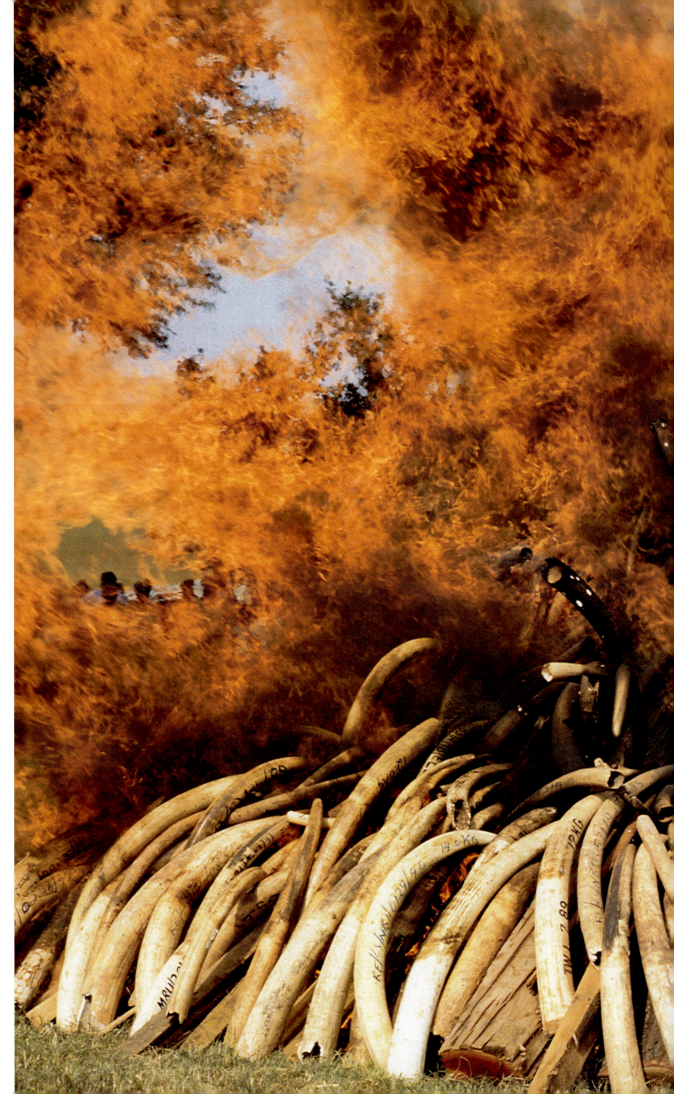

'Even if we control the
population growth, reduce
it to stability 'zero', and bring
up the standards of living of
the majority of the people,
there cannot be wildlife
everywhere...there is real land
hunger...we do however have
huge national parks that
provide enough space for
wildlife...why shouldn't the
people have land if it is not
at the expense of the national
parks....why does Africa have
to have wildlife everywhere
and poverty everywhere...
why can't we have a rich
country with well-off people
and beautiful national parks...
that's the ultimate dream.'
RICHARD LEAKEY

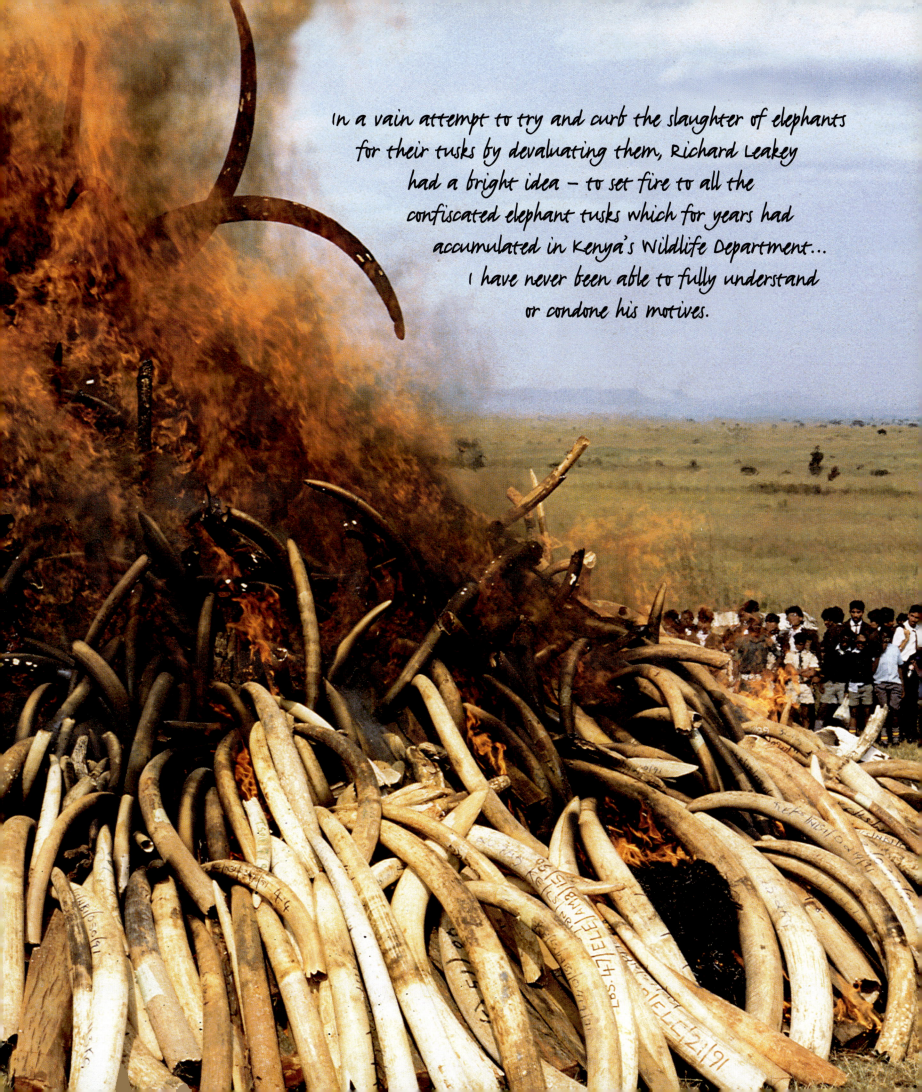

In a vain attempt to try and curb the slaughter of elephants
for their tusks by devaluating them, Richard Leakey
had a bright idea – to set fire to all the
confiscated elephant tusks which for years had
accumulated in Kenya's Wildlife Department...
I have never been able to fully understand
or condone his motives.

WHEN MY PARENTS DIED, their passing seemed to put an end to my African life. The strong family ties that kept bringing me back to them and to Africa where we all grew up were severed. We buried them in the garden they had created around the house they built and had lived in for fifty years; a fitting place it seemed to us. I had watched them grow old and slowly crumble and recorded with my camera the touching passage of their last ten years. Now many years later, as I write about them, the memory of those years springs vividly back to life, and I am surprised at the down-to-earth manner I dealt with them at the time. The ageing process when you live with it on a day-to-day basis in Africa is so much part of life, whether human, animal, vegetable or mechanical, it somehow loses the dramatic countenance it has elsewhere. I can now recognise so much of them in me and in Lorenzo as we begin to enter the home-run ourselves and because of them, I am able to comprehend and accept more fully, and with more benevolence, the natural rhythms of our lives.

After they left us everything changed beyond my wildest imagination. They were no longer there for us to seek advice, to settle our disputes or to guide us with the wisdom of their age and experience. We became the elders, ceding our places to our children; we were now on our own, each one of us for ourselves. I was about to find out the effect that this 'changing of the guard' would have on each one of us, and to taste the bitter pill of family contention and discord. How little, until then, did we know of human nature and the complex formula of the individual – the fears and foibles, the insecurities one hides behind, the barriers of false pretence; the arrogance and the greed that drive one, and with which the individual protects his or her vanity. All the characteristics of human nature surface in these moments and appear in their most primeval forms.

No member of my own family ever returned to Naivasha and Marina died unable to see again what she had so well described in her last letter to me, the place that had made us different, her home beside the lake in Naivasha.

My parents' passing somehow marked the end of the era of exploration in my own life. With their passing went the spirit of adventure of my youth. I began to sense the need for a more stable relationship with myself. My years of passionate living were catching up with me and I was running out of steam. I needed stillness, I yearned for silence and detachment.

The conflict in my creative and family life had provoked horrible torment and turmoil within me, and my two little girls paid the price. In so doing, they nailed me to the cross. A little metal plaque that they gave me which reads 'What is home without a mother?' says it all. I was not there for them when they most needed me, and as a single mother, this was a serious offence, although I was totally unaware of it at the time.

Much of my fanmail came from women who asked me how I had managed to lead the life I did and also have a family. The fact is, I didn't. The creative pull was stronger than the maternal one and I allowed my heart to rule my head with disastrous consequences. In the end, by trying to juggle everything on my own, I failed on all counts. I was a bad mother, a discontented wife and a frustrated photographer. It exhausted me both physically and emotionally. That was the price I paid for the life I have led.

Then I lost my daughter Marina who died of cancer at the age of thirty-six. To this day I am convinced this tragic event was my punishment. No amount of analysis can convince me to the contrary. But Marina bestowed on me one last gift before she went: she taught me about dying and made me proud to be her mother. The strength and dignity, the resolute and fatalistic manner with which she faced and met her end, will be forever the banner I shall carry for her, the example by which I shall now live. No words can define the immense void and incomprehension this immense tragedy has brought me. Now all I have of her is her memory and the photographs I took of her as she was growing up. They have given reason to what I am now doing; capturing the moments you never want to forget before they are gone forever, has become the credo of my life as a child photograper. When Marina was alive I hadn't enough time for her, and now her presence is all around me in the photographs I took of her.

Life and death are stark markers of beginnings and ends. I have the impression as I now write and tell of my life, that I am referring to someone other than myself. It is like re-reading a book you read long ago, or telling a story about someone you used to know. The person I once was, is no longer; she too has died or changed beyond all recognition. Like the snake that sheds its skin, I have taken on a new persona that no longer relates to Africa. My move back to Europe has somehow brought my parents' African odyssey full circle.

Epilogue

"This is no longer your home, but an asset of the company of which we are the major shareholders..."

Before stepping off the African continent for good, I wanted to pay a last visit to what had once been my home. I needed closure, a final adieu that would seal forever that part of my life. I went to Naivasha, to the old homestead where I had spent my childhood years, where I had come of age, where I became an adult, where I spent the first years of my married life with Lorenzo, where my children had spent the first fifteen years of their lives, where my parents grew old and died, where I buried them beneath a peach tree my father had planted.

The tree had grown from a pip he had kept pocketed after having savoured a particularly delicious fruit in a roadside cafe near Naples, on one of his last trips to Italy. He brought it back to Naivasha and planted it in a tin. It sprouted and grew into a sturdy sapling and then he transplanted it into his African garden and watched it grow and flower and produce a huge amount of fruit. But he never managed to eat a single one again. The long-tailed mouse birds that abound in the native vegetation always got to them before he did despite numerous ingenious methods to protect them. But every year the tree flowered and dropped showers of pink blossoms on the lawn beneath it. When my father died we dug his grave beneath the peach tree so that every year it would be covered in pink blossoms.

I needed to find out if I had indeed severed the last ties that bound me to Africa. I had not returned since that fateful day, eight years before, when I was driven from my home and left Naivasha forever. There was no one there when I arrived. No one at all, the place seemed deserted. I had carefully chosen my day so as to avoid any encounter, and was not really surprised by the melancholy atmosphere that hung all about. The great African olive trees spread out their powerful boughs and cast their shade over the mauve jarcaranda blossoms that carpeted the dusty road beneath the towering branches. There was silence everywhere. It was just me and the place I had returned to, almost as if it had been thus orchestrated for my own privacy. As I neared the silent house, standing there like a barren relic from some forgotten time, I heard the putt-putting of an approaching motorcycle. I sat down on the wall at the bottom of the big winding stairway leading up to the house and waited. To my immense joy I recognised the man who walked towards me. He seemed as surprised as I was and clasped my hand with both of his, his face beaming. It was Joseph, the old farm headman who had once worked for me during the years I ran the farm for my parents. He told me he had seen my car arrive and had come to check me out.

Together we walked up the winding stairway. Betrayed by his distress and emotion he spoke of his deep dismay over the goings-on in the family. As he spoke two armed guards appeared from behind the house, their rifles on their shoulders. They had obviously been fast asleep in some hidden corner. When they saw Joseph speaking to me they dropped their guard and came up to shake my hand. I sat with Joseph for a long time on the red murram wall surrounding the house and together we tried to make some sense of the happenings within my family. Poor sweet Joseph with his toothless grin and soft brown eyes, could but contribute his simple version of events. When he left me to return to his hut, I retraced my *via crucis* on that fateful day, when I was driven from my home by my sister at the end of a gun and left Naivasha forever

Index

First published in the United Kingdom in 2000
by Cassell & Co, Wellington House,
125 Strand, London, WC2R 0BB

A CIP catalogue record for this book
is available from the British Library.
ISBN 0 304 35401 5

Art Editor: Briony Chappell
Designed by: Price-Watkins

Printed and bound in Italy

PHOTOGRAPHIC CREDITS
All photographs were taken by and remain
the copyright of Mirella Ricciardi except those listed below:

Pages 26 top, 27 top, 32, 33, 35 second from bottom,
 40 bottom © Percival Collection, In the Dark Ltd, Nairobi, Kenya.
Pages 34, 35 top two and bottom © Cottar Collection, In the Dark Ltd,
Nairobi, Kenya. Page 194 bottom © Peter Beard.

I dedicate this book to my first grandchild,
born to Amina and Michael in October 2000